WINSTON CHURCHILL IN BRITISH ART, 1900 TO THE PRESENT DAY

WINSTON CHURCHILL IN BRITISH ART, 1900 TO THE PRESENT DAY

The Titan with Many Faces

JONATHAN BLACK

BLOOMSBURY ACADEMIC
LONDON · NEW YORK · OXFORD · NEW DELHI · SYDNEY

BLOOMSBURY ACADEMIC
Bloomsbury Publishing Plc
50 Bedford Square, London, WC1B 3DP, UK
1385 Broadway, New York, NY 10018, USA

BLOOMSBURY, BLOOMSBURY ACADEMIC and the Diana logo are trademarks of
Bloomsbury Publishing Plc

First published in Great Britain 2017
This paperback edition published 2019

Copyright © Jonathan Black, 2019

Jonathan Black has asserted his right under the Copyright, Designs and Patents Act, 1988,
to be identified as Author of this work.

For legal purposes the Acknowledgements on p. xxii constitute an extension of this
copyright page.

Cover image © Sidney Strube/Daily Express/N&S Syndication

All rights reserved. No part of this publication may be reproduced or transmitted
in any form or by any means, electronic or mechanical, including photocopying,
recording, or any information storage or retrieval system, without prior permission
in writing from the publishers.

Bloomsbury Publishing Plc does not have any control over, or responsibility for, any
third-party websites referred to or in this book. All internet addresses given in this
book were correct at the time of going to press. The author and publisher regret
any inconvenience caused if addresses have changed or sites have ceased to
exist, but can accept no responsibility for any such changes.

A catalogue record for this book is available from the British Library.

Library of Congress Cataloging-in-Publication Data
Names: Black, Jonathan, 1969– author.
Title: Winston Churchill in British art, 1900 to the present day: the titan with
many faces / Jonathan Black.
Description: New York: Bloomsbury Academic, 2017.
| Includes bibliographical references and index.
Identifiers: LCCN 2016029702| ISBN 9781472592392 (hardback) |
ISBN 9781472592385 (paperback)
Subjects: LCSH: Churchill, Winston, 1874–1965—Portraits. |
Churchill, Winston, 1874–1965—Caricatures and cartoons. | Churchill, Winston,
1874–1965—Influence. | Portraits, British. | BISAC: HISTORY / Europe / Great Britain. |
HISTORY / Military / World War II. | HISTORY / Modern / 20th Century.
Classification: LCC N7628.C54 B59 2017 | DDC 941.084092—dc23 LC record available at:
https://lccn.loc.gov/2016029702

ISBN:	HB:	978-1-4725-9239-2
	PB:	978-1-3500-8139-0
	ePDF:	978-1-4725-9240-8
	eBook:	978-1-4725-9241-5

Typeset by RefineCatch Limited, Bungay, Suffolk

CONTENTS

List of Colour Plates vi
List of Illustrations viii
List of Abbreviations xxi
Acknowledgements xxii

Introduction: The Titan Emerges 1

1 Young Winston: At War and in Politics, 1898–1914 11

2 Disaster and Rehabilitation in the First World War, 1914–1918 27

3 Churchill's Roaring Twenties: From Liberal to Conservative 47

4 Churchill's 'Wilderness Years' – the 1930s 79

5 Finest Hour? Churchill and the Second World War, 1939–1945 93

6 Churchill as Cold War Leader of the Opposition and as Prime Minister, 1945–1955 127

7 Churchill's Twilight Years: Retirement to Finis, 1955–1965 179

8 Churchill's Visual Legacy: Memorials, 1965–1999 205

Epilogue: Churchill for the Twenty-first Century 225

Notes 237
Index 277

LIST OF COLOUR PLATES

Plate 1 Frederick Drummond Niblett (1861–1928) (known as Nibs), *'Winnie': Winston Churchill as Home Secretary,* colour lithograph, *Vanity Fair*, 11 March 1911, Parliamentary Art Collection, WOA 5919. [Image: Parliamentary Art Collection, WOA 5919; www.parliament.uk/art]

Plate 2 Ernest Townsend (1880–1944), *Winston Churchill as First Lord of the Admiralty*, 1915, oil on canvas, 181 × 102 cm, National Liberal Club, London. [Image: by permission of the National Liberal Club, London]

Plate 3 Sir John Lavery (1856–1941), *Winston Churchill as Colonel of the 6th Royal Scots Wearing a French Steel Helmet*, 1916, oil on canvas, 76 × 68.5 cm, National Trust Collection, Chartwell Manor, Kent. [Image: National Trust Images]

Plate 4 Vintage illustration after the painted portrait, *Winston Churchill*, by Sir William Orpen (1878–1931), completed in 1916; lithograph, 1941. [Image: GraphicaArtis/Getty Images]

Plate 5 Ambrose McEvoy (1878–1927), *Winston Churchill*, c. 1919–1920, oil on canvas, 74.4 × 63.8 cm, National Portrait Gallery, London, 6478. [Image: courtesy of the National Portrait Gallery, London]

Plate 6 Walter Richard Sickert (1860–1942), *Winston Churchill*, 1927, oil on canvas, 18 in. × 12 in., National Portrait Gallery, London, 4438. [Image: courtesy of the National Portrait Gallery, London]

Plate 7 Robert Sargent Austin (1895–1973), *Our Heritage: Winston Churchill*, 1943, lithographic poster, 50.8 × 64.2 cm, London Transport Museum, London, 1987/125/. [Image: © TfL from the London Transport Museum collection]

Plate 8 Sir Oswald Birley (1880–1952), *Rt. Hon Winston Churchill MP,
Leader of His Majesty's Opposition*, 1946, oil on canvas, 76 × 64 cm,
Palace of Westminster Art Collection, WOA 2723. [Image: courtesy
of the Palace of Westminster Art Collection; www.paliament.uk/art]

Plate 9 Graham Sutherland (1903–1980), *Study of Churchill in Garter Robes*,
1954, oil on canvas, 101.9 × 60.3 cm, The Beaverbrook Art Gallery,
Canada (1959.223).

Plate 10 Ruskin Spear (1911–1990), *Sir Winston Churchill*, 1956, oil on canvas,
61 × 51 cm, Private Collection. [Image: Bridgeman Images,
MSP99802]

Plate 11 Ivor Roberts-Jones (1913–1996), *Sir Winston Churchill KG, OM, CH*,
1971–1973, 3.6 m high, bronze, Parliament Square, London. [Image:
Jonathan Black]

Plate 12 Banksy (1975?–), *Turf War*, 2003, silkscreen in green and black,
34.5 × 49.5 cm. [Image: Associated News Ltd, Daily Mail
Photographic Archive]

LIST OF ILLUSTRATIONS

Chapter 1: Young Winston: At War and in Politics, 1898–1914

1.1 J. Heymen, *Winston Churchill on Campaign in Egypt*, 1898, photograph, Private Collection. [Image: Jonathan Black] 12

1.2 Edwin Arthur Ward (1859–1933), *Winston Churchill as a Young Man Seated at a Desk*, c.1900–1901, oil on canvas, 40.5 × 51 cm, Private Collection. [Image: courtesy Sotheby's London] 14

1.3 'Spy' Sir Leslie Matthew Ward (1851–1922), *Men of the Day: Mr. Winston Churchill: He can write and he can fight . . .*, Vanity Fair, 27 September 1900, pencil and watercolour on paper, 41.3 × 28 cm. [Image: Associated News Ltd, Daily Mail Photographic Archive] 15

1.4 Mortimer Menpes (1855–1938), *Mr. Winston Churchill, War Correspondent for the Morning Post*, June 1900, pen-and-ink and watercolour on paper, Private Collection. [Image: Jonathan Black] 17

1.5 Edward Tennyson Reed (1860–1933), *La Joie de Vivre: Winston in Full Swing at Question Time*, pencil on paper, 16.5 × 16.5 cm. [Image: Associated News Ltd, Daily Mail Photographic Archive] 18

1.6 Bernard Partridge (1861–1945), *An Elgin Marble, Punch*, 25 April 1906, Private Collection. [Image: Jonathan Black] 19

1.7 Bassano Ltd (1901–1962), *Winston Churchill at his Desk as Home Secretary*, 20 April 1911, photograph, National Portrait Gallery, London, × 81076. [Image: courtesy of the National Portrait Gallery, London] 20

1.8 L. Ravenhill (1867–1942), *Under His Master's Eye, Punch*, 21 May 1913, Private Collection. [Image: Jonathan Black] 22

1.9 Sidney George Conrad Strube (1891–1956), 'I Smell the Blood of an Ulsterman', *Daily Express*, 1 April 1914, Private Collection. [Image: Jonathan Black; copyright: Express Syndication Limited] 25

Chapter 2: Disaster and Rehabilitation in the First World War, 1914–1918

2.1 Sir John Lavery (1856–1941), *Winston Churchill as First Lord of the Admiralty*, 1915, oil on canvas, 76.8 × 63.9 cm, Sir Hugh Lane Collection, Dublin City Art Gallery. [Image: courtesy of Dublin City Art Gallery] 34

2.2 Major Winston Churchill Wearing a French *Casque Adrian* Helmet with General Fayolle, HQ XXXIII Corps, Camblain L'Abbé, France, 15 December 1915. [Image: Hulton Archive/Getty Images] 39

2.3 Sir William Orpen (1878–1931), *Winston Churchill*, 1916, pencil on paper, 26.6 × 22.3 cm, Private Collection. [Image: Jonathan Black] 41

2.4 Photograph of Churchill as Minister of Munitions with female munitions workers at Georgetown Works near Glasgow, 9 October 1918, photograph Q 84077, Imperial War Museum, London. [Image: Picture Library, IWM, London] 45

Chapter 3: Churchill's Roaring Twenties: From Liberal to Conservative

3.1 Sidney George Strube, 'We Don't Know Where We Are Going, But We Are On Our Way', *Daily Express*, 8 September 1919, Private Collection. [Image: Jonathan Black; copyright: Express Syndication Limited] 48

LIST OF ILLUSTRATIONS

3.2 Clare Sheridan (1885–1970), *Head of Winston Churchill MP*, 1919–1920, plaster and bronze casts, 56 cm high, Private Collection. [Image: Jonathan Black] 51

3.3 Sir James Guthrie (1859–1930), *Study of Winston Churchill*, 1919–1921, oil on canvas, 91.5 × 71.1 cm, Scottish National Portrait Gallery, Edinburgh, PG 1131. [Image: Picture Library, National Galleries of Scotland] 56

3.4 Sir James Guthrie, *Some Statesmen of the First World War*, 1924–1930, oil on canvas, 396.2 × 335.3 cm, National Portrait Gallery, London, 2463. [Image: courtesy of the National Portrait Gallery, London] 59

3.5 Sir David Low (1891–1963), 'Winston's Bag: He hunts lions and brings home decayed cats', *The Star*, 21 January 1920, Cartoon Archive, Kent University, LSE 6215. [Image: Jonathan Black; copyright: Associated Newspapers/Solo Syndication] 60

3.6 Sidney George Strube, 'Chief Ear-to-the-Ground Winston', *Daily Express*, 23 January 1920, Private Collection. [Image: Jonathan Black; copyright: Express Syndication Limited] 61

3.7 Sir David Low, 'Winstonsky: The Horrifying Effect of Concentrating on Russian Affairs', *The Star*, 12 August 1920, Private Collection. [Image: Jonathan Black; copyright: David Low/Solo Syndication] 62

3.8 Sir David Low, 'Low's Zoo VI: The Winstonoceros and Its Prey the Socialist Bogy', *The Star*, 10 May 1922, Cartoon Archive, Kent University, LSE 6773. [Image: Jonathan Black; copyright: Associated Newspapers/Solo Syndication] 64

3.9 Sir David Low, 'The New Britannia: Lives and Money wasted on Anti-Bolshevik Adventures, 1918–1920', *The Star*, 11 October 1924, Private Collection. [Image: Jonathan Black; copyright: Associated Newspapers/Solo Syndication] 65

3.10 John Singer Sargent (1856–1925), *Winston Churchill in his Robes as Chancellor of the Exchequer*, 1925, charcoal drawing, 72.5 × 58.5 cm,

National Trust, inv 110-1408, Chartwell, Kent. [Image: National Trust Images] 66

3.11　*Winston Churchill in his Robes as Chancellor of the Exchequer*, 1925, photograph stuck in Trent Park Visitors Book (home of Sir Philip Sassoon), Barnet, 18 July 1925, Private Collection. [Image: Jonathan Black] 68

3.12　Powys Evans (1899–1981), known as 'Quiz', *The Return of Mr. Churchill to the Conservative Party*, 1926, lithograph (from *Eighty Eight Cartoons by Powys Evans*), Private Collection. [Image: Jonathan Black] 69

3.13　Sir David Low, *Winston*, New Statesman, 1 May 1926, Private Collection. [Image: courtesy of a private collection; copyright: Associated Newspapers/Solo Syndication] 71

3.14　Walter Richard Sickert, *Winston Churchill MP*, 1927, pen-and-ink preparatory drawing, 17.8 × 10.2 cm, Walker Art Gallery, Liverpool. [Image: courtesy National Museums, Liverpool] 74

3.15　Spi, *The Amateur Bricklayer*, Reynolds Illustrated News, 7 April 1929, Private Collection. [Image: Jonathan Black] 77

Chapter 4: Churchill's 'Wilderness Years' – the 1930s

4.1　Sidney George Strube, 'Party Disobedience: An Epstein Portrait of Churchill', *Daily Express*, 9 February 1931, Cartoon Archive, Kent University, GS 0171A. [Image: British Cartoon Archive, Kent University; copyright: Express Syndication Limited] 79

4.2　Sir David Low, 'Yah Untouchable!', *Evening Standard*, 19 June 1933, Cartoon Archive, Kent University, LSE 1954. [Image: Jonathan Black; copyright: Associated Newspapers/Solo Syndication] 81

4.3 Sir William Nicholson (1872–1949), *Study for Breakfast at Chartwell II*, 1934–1935, oil on canvas, 98.4 × 120.7 cm, Chartwell Manor, Kent. [Image: National Trust Images; reproduced by kind permission of Desmond Banks] 84

4.4 Eric Kennington (1888–1960), *War God/God of War* (also exhibited as *Mammon*), 1932–1935, 135 × 45 × 40 cm, Portland stone, family of the artist on loan to the Henry Moore Centre for the Study of Sculpture, Leeds. [Image: family of the artist] 86

4.5 J.L. Carstairs, 'The Wood Carvings of M'Bongo M'Bongo. No V – A Struethsayer or Prophet of Doom', *Punch*, 13 September 1934, Private Collection. [Image: Jonathan Black] 87

4.6 Clarice Cliff (1899–1972), *Toby Jug of Churchill as First Lord of the Admiralty*, c. 1938–1939, ceramic, 31 cm high, Private Collection. [Image: Jonathan Black] 90

Chapter 5: Finest Hour? Churchill and the Second World War, 1939–1945

5.1 *After the First Round*, *Simplicissimus* (Munich), 5 November 1939, Private Collection. [Image: Jonathan Black] 94

5.2 Victor Weisz (1913–1966), known as 'Vicky', 'Mr Churchill on the Platform as Vicky Sees Him', *Daily Telegraph*, 29 January 1940, Cartoon Archive, Kent University, VY 3267. [Image: British Cartoon Archive, Kent University; copyright: Telegraph Media Group] 95

5.3 Cecil Beaton (1904–1980), *Winston Churchill As Prime Minister 1940–1945, Winston Churchill at his Desk in the Cabinet Room at No 10 Downing Street*, London, early September 1940. [Image: Cecil Beaton/IWM via Getty Images] 96

5.4 Leslie Gilbert Illingworth, 'Two-Gun Winston', *Daily Mail*, 13 May 1940, Private Collection. [Image: Jonathan Black; copyright: Associated Newspapers/Solo Syndication] 97

5.5 Sir David Low, 'All Behind You Winston', *Evening Standard*, 14 May 1940, Cartoon Archive, Kent University, LSE 2772. [Image: British Cartoon Archive, Kent University; copyright: Associated Newspapers/Solo Syndication] 99

5.6 Leslie Gilbert Ilingworth, 'Westfront Hurricane, Mr Churchill Last Night: "We are Rady to Face It"', *Daily Mail*, 20 May 1940, Private Collection. [Image: Jonathan Black; copyright: Associated Newspapers/Solo Syndication] 100

5.7 Sidney George Strube, 'Go To It', *Daily Express*, 8 June 1940, Private Collection. [Image: Jonathan Black; copyright: Express Syndication Limited] 102

5.8 Walter Stoneman (1876–1948), *Prime Minister Winston Churchill in No. 10 Downing St*, 3pm, 1 April 1941, photograph, 27.5 × 20.9 cm. [Image: Walter Stoneman/Hulton Archive/Getty Images] 104

5.9 Anon, *Comrades in Arms*, photograph of an exhibition, Charing Cross Railway Station, Summer 1942, Imperial War Museum, London, D7027. [Image: Imperial War Museum, London] 105

5.10 Visitors in front of *Prime Minister Winston Churchill MP* by Yousuf Karsh (1908–2002), completed in 1941; photograph, 1989. [Image: Ritter/ullstein bild via Getty Images] 107

5.11 Sir Frank Owen Salisbury (1874–1962), *Prime Minister Winston Churchill*, 1942, oil on canvas, 110.5 × 85.1 cm, National Trust, inv 1102450, Chartwell Manor, Kent. [Image: National Trust Images; copyright: Estate of Frank O. Salisbury. All rights reserved, DACS 2015] 108

5.12 Sergeant Morris, *Prime Minister Winston Churchill wearing a Siren Suit with Field Marshal Montgomery*, 19 May 1944, photograph, Imperial War Museum, London, H 38661. [Image: Imperial War Museum, London] 110

5.13 Sir William Reid Dick (1879–1961), *Head of the Prime Minister, Winston S. Churchill*, 1942, bronze, 47 cm high, Imperial War Museum, London, ART 16789. [Image: Imperial War Museum, London] 111

5.14 Alfred Egerton Cooper (1883–1974), *Profile For Victory: Sir Winston Churchill*, 1942, oil on canvas, 76 × 56.5 cm, Churchill Room, Carlton Club, London. [Image: Jonathan Black] 113

5.15 Claire Sheridan (1885–1970), *Sir Winston Churchill, KG, DL, OM, CH, PC, MP*, 1942, bronze, 55 × 35.5 × 3.2 cm, Chartwell Manor, Kent. [Image: National Trust Images/Nick Guttridge] 118

5.16 Sergeant Johnson, *Lance-Corporal J. Leigh, 6th Seaforth Highlanders, with his mascot, 'Churchill', Italy, 7 February 1944*, photograph, Imperial War Museum, London, NA 11797. [Image: Imperial War Museum, London] 123

5.17 Known as 'Kem' (1904–1988), *Hitler's Nightmare, Le Petit Parisien*, 6 April 1944, Private Collection. [Image: Jonathan Black] 125

5.18 Sir David Low, 'Cheer Up. They Will Forget You but They Will Remember Me Always', *Evening Standard*, 31 July 1945, British Cartoon Archive, Kent University, LSE 1253. [Image: Cartoon Archive; copyright: Associated Newspapers/Solo Syndication] 126

Chapter 6: Churchill as Cold War Leader of the Opposition and as Prime Minister, 1945–1955

6.1 Sir Jacob Epstein (1880–1959), *Head of His Majesty's Opposition, Winston Churchill*, 1946, bronze, 31 × 19 × 24.5 cm, Government Art Collection, GAC 16547. [Image: courtesy of the Government Art Collection, London] 129

6.2 Henry Mayo Bateman (1887–1970), *Winston Churchill à la Picasso*, c.1949, pen-and-ink and watercolour on paper, 25.5 × 22.3 cm, Private Collection. [Image: Jonathan Black] 132

6.3 Gabriel (1912–1997), *Daily Worker*, 2 March 1950, Private Collection. [Image: Jonathan Black] 134

6.4 Kukrinikzi, *Iskustvo* (Moscow), 1951. [Image: Jonathan Black] 135

6.5 Sir David Low, 'Arh, Cut it Out, I'm Growling. Ain't That Enough?' *Daily Herald*, 26 July 1951, Cartoon Archive, Kent University LSE7914. [Image: British Cartoon Archive, Kent University; copyright: Associated Newspapers/Solo Syndication] 137

6.6 *Sketch of Sir Winston Churchill* by Oscar Nemon (1906–1985), undertaken during the course of their first meetings at La Mamounia Hotel. [Image: courtesy of the Nemon Estate] 138

6.7 Oscar Nemon, *Prime Minister Sir Winston Churchill*, 1952–1956, 56 cm high, marble, Royal Collection, Windsor Castle. [Image: Royal Collection Trust, London/Her Majesty Queen Elizabeth II, 2015] 144

6.8 Sidney George Strube, 'A Man in his Time Plays Many Parts', *Daily Express*, 29 November 1953, Cartoon Archive, Kent University, GS 0936. [Image: British Cartoon Archive, Kent University; copyright: Express Syndication Limited] 145

6.9 Sir David Low, 'Grand Old Evergreen', *Manchester Guardian*, February 1954, Private Collection. [Image: Jonathan Black; copyright: Associated Newspapers/Solo Syndication] 146

6.10 Oscar Nemon, *Seated Sir Winston Churchill*, 1954–1959, bronze, 141 × 110 × 86 cm, the Guildhall, London, unveiled February 1959. [Image: Jonathan Black] 148

6.11 Oscar Nemon, *Seated Sir Winston Churchill*, 1954–1955, plaster cast, unveiled at the Guildhall, London, 21 June 1955, Private Collection. [Image: Jonathan Black] 150

6.12 Graham Sutherland (1903–1980), *Portrait of Sir Winston Churchill*, 1954, oil on canvas, 147.3 × 121.9 cm, destroyed by Lady Churchill, 1955–1956. [Image: Keystone Pictures USA/Alamy Stock Photo] 158

6.13 Graham Sutherland, *Head Study of Winston Churchill*, 1954, oil on canvas, 40.3 × 30.5 cm, National Portrait Gallery, London, 5332. [Image: courtesy of the National Portrait Gallery, London] 159

6.14 Graham Sutherland, *Study of the Head of Churchill*, 1954, pencil, pen-and-ink, black chalk and watercolour on paper, 37.5 × 30.5 cm, The Beaverbrook Art Gallery, Canada (1959.229) 160

6.15 Graham Sutherland, *Study of Churchill – Grey Background*, 1954, oil on canvas, 61 × 45.7 cm, The Beaverbrook Art Gallery, Canada (1959.221) 161

6.16 Graham Sutherland, *Study of Churchill – Pink Background*, 1954, oil on canvas, 61 × 50.8 cm, The Beaverbrook Art Gallery, Canada (1959.222) 162

6.17 Graham Sutherland, *Study of Churchill Smoking a Cigar*, 1954, oil on canvas, 30.2 × 25.1 cm, The Beaverbrook Art Gallery, Canada (1959.225) 163

6.18 Graham Sutherland, *Head Study of Winston Churchill*, 1954, oil on canvas, 34.5 × 31.1 cm, National Portrait Gallery, London, 5331. [Image: courtesy of the National Portrait Gallery, London] 164

6.19 Edward Ardizzone (1900–1979), *Sir Winston Churchill Speaking in the House of Commons*, 1955, pen-and-ink and watercolour on paper, Chartwell Manor, Kent. [Image: National Trust Images] 174

6.20 Michael Cummings (1919–1997), *Daily Express*, 2 March 1955, Cartoon Archive, Kent University, MC0104. [Image: British Cartoon Archive, Kent University; copyright: Express Syndication Limited] 176

Chapter 7: Churchill's Twilight Years: Retirement to Finis, 1955–1965

7.1 Bernard Hailstone (1910–1987), *Study of the Head and Shoulders of Sir Winston Churchill*, 1955, oil on canvas. [Image: PA Images/Alamy Stock Photo] 181

7.2 Bernard Hailstone, *Head Study of Sir Winston Churchill*, 1956, chalk on paper, 44.5 × 30.5 cm, National Portrait Gallery, London, 4458. [Image: courtesy of the National Portrait Gallery, London] 182

7.3 Anon, *Winston Churchill Speaking at Walthamstow Stadium, General Election Address, July 1945*, photograph, Imperial War Museum, London, HU 59722. [Image: Imperial War Museum, London] 183

7.4 Michael Cummings, 'Cheer Up Winston. At least you've never been painted by Picasso, or Salvador Dali, or Sir Alfred Munnings or sculpted by Reg Butler or Henry Moore', *Daily Express*, 4 May 1957, Cartoon Archive, Kent University, MC0307. [Image: British Cartoon Archive, Kent University; copyright: Express Syndication Limited] 186

7.5 David McFall (1919–1988), *Sir Winston Churchill: The Rocquebrune Head*, 1958, bronze, 31 cm high. [Image: courtesy of the Estate of David McFall RA] 188

7.6 David McFall, *Bust of the Rt Hon. Winston Churchill*, 1958 © Royal Academy of Arts, London; Photo: Paul Highnam] 191

7.7 David McFall, *Sir Winston Churchill*, 1958–1959, 2.59 m high, standing bronze figure, Salway Hill and Broomhill Walk, Woodford Green, Essex; unveiled October 1959. [Image: courtesy of the Estate of David McFall RA] 192

7.8 John Musgrave Wood (1915–1999), known as 'Emmwood', 'If They Come Back to London I Shall take a Rifle and Put Myself in a Pill Box and Shoot till I Have No More Ammunition', *Daily Mail*, 12 September 1960, Cartoon Archive, Kent University, MW 0752. [Image: British Cartoon Archive, Kent University; copyright: Associated Newspapers/Solo Syndication] 198

7.9 Juliet Pannett (1911–2005), *Sir Winston Churchill Seated in the House of Commons, 6 February 1964*, 1964, pencil on paper, 22.9 × 15.2 cm, National Portrait Gallery, London, 4474. [Image: courtesy of the National Portrait Gallery, London] 201

7.10 Gerald Scarfe (1936–), *Sir Winston Churchill on his Last Day in the House of Commons, 27 July 1964*, 1964, pencil on paper, Private Collection. [Image: courtesy of Gerald Scarfe] 202

Chapter 8: Churchill's Visual Legacy: Memorials, 1965–1999

8.1 Oscar Nemon, *Sir Winston Churchill*, 1966–1969, 2.1 m high, fully-rounded cast bronze, Members Lobby of the House of Commons, London, Parliamentary Art Collection, WOA S23. [Image: Parliamentary Art Collection, WOA S23; www.parliament.uk/art] 207

8.2 Franta Belsky (1921–2000), *Sir Winston Churchill*, 1969–1971, 2.43 m high, bronze, Westminster College, Fulton, Missouri; unveiled 16 May 1971. [Image: Phil Wahlbrink/WahlbrinkPHOTO/Alamy Stock Photo] 209

8.3 Ivor Roberts-Jones (1913–1996), *Second Maquette for the Parliament Square Churchill Statue*, 1970, bronze, 80 cm high, Private Collection. [Image: courtesy of the Estate of Ivor Roberts-Jones] 212

8.4 Ivor Roberts-Jones, *Sir Winston Churchill KG, OM, CH*, 1976–1977, 2.74 m high, bronze, British Place, New Orleans, USA. [Image: Sara Ayres] 218

8.5 Oscar Nemon, *Married Love: Winston and Clementine Churchill*, 1976–1990, bronze, Garden of Chartwell Manor, Kent; unveiled in November 1990 by the Queen Mother. [Image: courtesy of the Estate of Oscar Nemon] 219

8.6 Lawrence Holofcener (1926–), *Allies* (President Franklin Delano Roosevelt and Sir Winston Churchill), 1995, bronze, 137 × 183 cm, New Bond Street and Grafton Street. [Image: Jonathan Black] 221

8.7 Ivor Roberts-Jones, *Head of Sir Winston Churchill KG, OM, CH*, 1995–1996, bronze, 53 × 84.5 cm, Zizkov Town Hall, Prague, Czech Republic. [Image: courtesy of the Estate of Ivor Roberts-Jones] 223

Epilogue: Churchill for the Twenty-first Century

E.1 Churchill in Parliament Square with a turf Mohican, May 2000. [Image: Associated News Ltd, Daily Mail Photographic Archive] 226

E.2 Nicholas Garland (1935–), 'You Do Your Worst and We Will Do Our Best', *Daily Telegraph*, 3 May 2000, Cartoon Archive, Kent University, 54074. [Image: British Cartoon Archive, Kent University; copyright: Telegraph Media Group] 227

E.3 Marcus Harvey (1963–), *Punk Churchill*, 2008, bronze, 2.5 × 1.3 × 1.5 m, Burger Collection, Hong Kong. [Image: courtesy of Marcus Harvey] 229

E.4 Ralph Steadman (1936–), *Churchillian Cat*, 2010, pen-and-ink and watercolour on paper, Private Collection. [Image: courtesy of Ralph Steadman] 232

E.5 David Low (1891–1963), 'Tasty Morsels', *The Star*, 22 March 1927, Cartoon Archive, Kent University, DLO 150. [Image: British Cartoon Archive, Kent University; copyright: Associated Newspapers/Solo Syndication] 233

E.6 Sarah Haines (1979–), *Winston Churchill Trying On A Fez*, 2010, screen print, 29.7 × 29.7 cm, Private Collection. [Image: courtesy of Sarah Haines] 234

Every effort has been made to trace copyright holders and to obtain their permission for the use of copyright material. The publisher apologises for any errors or omissions in the above list and would be grateful if notified of any corrections that should be incorporated in future reprints or editions of this book.

LIST OF ABBREVIATIONS

BAG Canada	Beaverbrook Art Gallery, Fredericton, New Brunswick, Canada
CAC, CCC	Churchill Archives Centre, Churchill College, Cambridge
HMI, Leeds	Henry Moore Institute for the Study of Sculpture, Leeds
IWM, London	Imperial War Museum, London
LHA, KCL	Liddell-Hart Archive, King's College, London
NLC, London	National Liberal Club, London
NPG, London	National Portrait Gallery, London
RA, London	Royal Academy of Arts, London
TGA, London	Tate Gallery Archive, London
WCSC	Winston Churchill Statue Committee of the Palace of Westminster

ACKNOWLEDGEMENTS

The author wishes to offer his sincere thanks to the following for their much-appreciated help in the realisation of this book:

Frances Arnold (Bloomsbury Publishing); Desmond Banks (Estate of Sir William Nicholson); Ksenya Blokhina (DACS); Sophie Bridges (Archivist, Churchill Archives Centre, Churchill College, Cambridge); Jennifer Camilleri (Royal Academy of Arts, London); Dr Margarita Cappock (Deputy Director, Hugh Lane Collection, Dublin City Art Gallery); Diana Chaccour (National Portrait Gallery, London); Shona Corner (National Galleries of Scotland); Paul Cox (Assistant Curator, National Portrait Gallery, London); Murray Craig (Clerk of the Chamberlain's Court, City Corporation of London); Alexandra Dane (Estate of David McFall RA); Julie Davies (Gerald Scarfe Website); Sarah Dick (Registrar, Beaverbrook Art Gallery); Emily Drewe (Bloomsbury Publishing); Emma Goode (Bloomsbury Publishing); Kirstie Gregory (Henry Moore Institute, Leeds); Emily Green (Assistant Curator, Palace of Westminster Art Collection); Sarah Haines; Marcus Harvey; Erika Ingham (Heinz Archive & Library, National Portrait Gallery, London); Jenny Liddle (The National Trust); Trine Lyngby-Trow (Royal Academy of Arts, London); Professor Fran Lloyd (Kingston University); Clive Marks (Government Art Collection, London); Laura Miller (Deputy Clerk, Chamberlain's Court, City of London); Manjusha Nair (National Galleries of Scotland); Jonathan Orr-Ewing (Hon. Secretary, Carlton Club, London); Dr Allen Packwood (Director of the Churchill Archives Centre, Churchill College, Cambridge); Nathan Pendlebury (Liverpool Museums); Siân Phillips (Bridgeman Images); Dr Philip Pothen (Arts and Humanities Research Council UK); Hilary Robinson (The National

Trust); Rodney Seddon; Ralph Steadman; Andrew Roberts; Agata Rutkowska (Royal Collection Trust, London); Dr Seth Alexander Thevoz (Hon. Librarian, National Liberal Club, London) Dr Richard Toye (University of Exeter); Melanie Unwin (Deputy Curator, Palace of Westminster Art Collection); Lydia Wingfield-Digby (Sotheby's, London); Dr Jon Wood (Henry Moore Institute, Leeds); Adia Wright (SWA Sobel Weber Associates Inc., New York); Lady Aurelia Young (Estate of Oscar Nemon).

Special thanks are owed to my parents for their unwavering and, as ever, generous support.

For all mistakes of fact and infelicities of style and expression – the author is entirely to blame.

This book has been published with the generous assistance of the Arts and Humanities Research Council of the UK and Kingston University's Visual and Material Culture Research Centre, Faculty of Art, Design and Architecture

Introduction: The Titan Emerges

The reader may well ask why they should embark on yet another publication exploring the extraordinary life of that celebrated British statesman, author and icon Sir Winston Leonard Spencer-Churchill (1874–1965). Almost every aspect of his numerous achievements and failures have been subject to in-depth study, popular and grimly academic; his daughter, Mary, has written about him as a painter[1] while there have been at least two books charting his life through newspaper cartoons.[2] This book, however, is the first to take a close and searching look at how Churchill has been presented in British art, from when he first leapt to public prominence around 1900 during the Second Anglo-Boer War, to our time and the enduring fascination he holds for leading contemporary artists.

Over the years Churchill has been drawn, painted, sculpted and photographed by many of the nation's most talented artists, such as Sir John Lavery, Sir William Orpen, Ambrose McAvoy, Walter Richard Sickert, Sir William Nicholson, Sir Oswald Birley, Graham Sutherland, Feliks Topolski, Ruskin Spear, Banksy, Marcus Harvey, Sir William Reid Dick, Sir Jacob Epstein, Oscar Nemon and Cecil Beaton. He also consistently attracted the amused and admiring attention of many of Britain's foremost cartoonists of the twentieth and twenty-first centuries ranging from David Low, Sidney George Strube,

'Quiz' (Powys Evans) and 'Poy' (Percy Frearon) to H.M. Bateman, 'Vicky' (Victor Weisz), Michael Cummings, Nicholas Garland, Gerald Scarfe and Ralph Steadman.

This book also provides a timely opportunity to discuss surprising, intriguing and revealing images of Churchill by less well-known artists such as Edwin Ward, Ernest Townsend, Edward Tennyson Reed, Sir James Guthrie, Eric Kennington, Frank Owen Salisbury, Robert Sargent Austin, Franta Belsky and Ivor Roberts-Jones. The following chapters will explore the extent to which Churchill first crafted an image of himself to appeal to the press in his early years as a rising star in the political firmament and what portraits of him made during the First World War reveal as to his inner emotional turbulence in the wake of resignation in May 1915 as First Lord of the Admiralty over the mismanagement of the Dardanelles Campaign. Not coincidentally, it was after this resignation that he took up painting as a form of nerve-soothing relaxation. His image in the 1920s as a controversial Secretary of State for War and Colonial Secretary (1919–1922), and then as a surprising and unexpected occupant of No. 11 Downing Street as Chancellor of the Exchequer will also be considered. During the 1930s, even in the very depths of his so-called 'wilderness years', he would remain an enduring object of fascination to artists when not only frequent newspaper and magazine cartoons but also objects such as Toby jugs and ceramics kept his name before the public. The production of images of him reached predictable peaks during the Second World War, when he dominated British politics as an inspirational Prime Minister (May 1940–July 1945), then towards the end of, and shortly after, his second term as Prime Minister (October 1951–April 1955). Further portraits and the first statues in his honour were unveiled in the decade after his retirement in April 1955. Concluding chapters will comment on images of Churchill created after his death, in January 1965, by which time one can detect a struggle to define the 'mythic' Churchill – the statesman almost as super hero – before moving to consider Churchill's continuing potency as a symbol and source of controversy into the twenty-first century.

Friends, contemporaries and colleagues of Churchill noted during his life that he was a man of many moods and indeed many faces with a wonderfully mobile and expressive physiognomy. Labour MP Emanuel Shinwell, a close observer of Churchill from when he first arrived in the Commons in 1922, later concluded that in parliamentary debate Churchill had frequently displayed the verbal dexterity and comic timing of a gifted music hall performer.[3] Indeed, it should be no surprise to learn that Churchill had been a devotee of the London music halls from his days as a subaltern in the British Army in the late 1890s.[4] Leslie Hore-Belisha, his sometime ally within the Conservative Party, was also very struck by Churchill's theatrical as well as oratorical gifts in the Chamber of the Commons. Indeed, from an early age, Hore-Belisha had noticed Churchill's distinctive style; when he first met him in 1904, he was struck by how elegantly Churchill was dressed 'with his long frock coat with silk facings and ... large winged collar with a black bow tie'. This meeting had a significant impact on Hore-Belisha's imagination, so much so he was to recall: 'I followed everything Churchill did ... I scanned the pictures for his latest dress. To my mother's consternation I even went so far as to buy – and wear in private – a large winged collar.'[5] Hore-Belisha later heard Churchill speak as Chancellor of the Exchequer at the Oxford Union and noted 'he gave every impression of supreme self-confidence ... However, a self-confident manner is often a mask which conceals internal terror, as I myself know well.'[6] In 1953 he pondered the extent to which Churchill had been complicit in the fashioning of his own inimitable public image and concluded he

> naturally and without apparent effort looks and behaves like someone important. He is 'news' and looks news ... In appearance, in manner, in dress and, above all in speech, he is an individualist ... His unusual hats, which startled the public fancy in his early years, have given place to the cigar, an equally precious gift to the cartoonist. Perhaps such foibles call

attention to himself. But what of his 'V' sign? There we have his knack of evoking patriotic emotion. It is a gesture of genius ... He evidently understands that an appeal can be addressed to the eye as well as to the ear.[7]

It is revealing that Hore-Belisha should have commented on the significance of Churchill's 'unusual hats' since Churchill himself had been fully aware of how his being photographed wearing a hat that was slightly too small for him while walking on a Southport beach with his wife during the General Election campaign of February 1910 had suddenly captured the public imagination. As he wrote in his 1931 article 'Cartoons and Cartoonists' for the *Strand Magazine*:

A very tiny felt hat – I do not know where it had come from – had been packed with my luggage. It lay on a hall table and without thinking I put it on. As we came back from our walk, there was the photographer and he took this picture. Ever since the cartoonists ... have dwelt on my hats, how many they are; how strange and queer and how I am always changing them and what importance I attach to them ... it is all rubbish ... why should I complain? Indeed, I think I will convert the legend into reality by buying myself a new hat on purpose![8]

Thereafter, he was indelibly associated in the public mind with a penchant not only for different hats but also a wide array of different uniforms and distinctive modes of dress such as academic robes and his celebrated tailor-made version of the one-piece boiler suit – known during the Second World War as his 'siren suit'. In his June 1931 article for the *Strand Magazine* Churchill frankly acknowledged: 'One of the most necessary features of a public man's equipment is some distinctive mark which everyone learns to look for and to recognise.' There had been in the past Disraeli's forelock, Gladstone's collars, his father Lord Randolph Churchill's luxuriant moustache, Austen Chamberlain's monocle and Stanley Baldwin's homely pipe. He added, disingenuously: 'these

properties are of the greatest value. I have never indulged in any of them, so to fill the need cartoonists have invented the legend of my hats'.[9]

In the same article Churchill also acknowledged that in a modern democracy not being readily recognisable to a mass audience in the press could be highly injurious to a successful political career: 'Just as eels are supposed to get used to skinning, so politicians get used to being caricatured. In fact, by a strange trait of human nature they even get to like it ... they are quite offended and downcast when the cartoons stop. They wonder what has gone wrong ... They fear old age and obsolescence are creeping upon them.'[10]

Forty years after the photograph of Churchill had been taken on the beach in 1910, Evelyn Waugh's fictional Guy Crouchback in *Men At Arms* (published in September 1952), when asked early in 1940 for his views on Churchill, immediately thought of him as: 'a professional politician, a master of sham-Augustan prose, a Zionist, an advocate of the Popular Front in Europe, an associate of the press lords and of Lloyd George.' Crouchback then proceeds to describe Churchill to a fellow army officer as: 'Like Hore-Belisha except that for some reason his hats are thought to be funny ...'.[11]

It is most revealing that Waugh, through Crouchback, thought of Churchill in relation to the 'press lords and Lloyd George'. From his earliest days as a soldier-cum-war-correspondent between 1895 and 1900, Churchill had paid close attention to the power of the press to create, inflate and then break reputations. Friends and colleagues, such as Hore-Belisha, noted that in office he would avidly consult the morning and evening editions of the papers.[12] Three of his closest habitués were 'press lords': Max Aitken, Lord Beaverbrook (1879–1964), owner of the *Evening Standard* and *Daily Express*,[13] Harold Harmsworth, Lord Rothermere (1868–1940), owner of the *Daily Mail*,[14] and William Berry, Lord Camrose (1879–1951), owner of the *Daily Telegraph*. Churchill would stay in their English country houses and in later years in their villas on the Côte d'Azure.

By the end of the First World War, Churchill was dining regularly at Beaverbrook's country mansion at Cherkley Court in Buckinghamshire.

Beaverbrook collected cartoons of Churchill by cartoonists who worked for him such as David Low – who also happened to be a favourite of Churchill's.[15] After Churchill's retirement, he obsessively collected studies of him by Graham Sutherland for the painter's ill-fated portrait of the Prime Minister commissioned by both Houses of Parliament to honour his eightieth birthday.[16] Intriguingly, when Alfred Duff Cooper, who had known Churchill since 1914, first met Beaverbrook early in December 1918, he noted in his diary that the then Minister of Information was 'extraordinarily animated and full of life. He talks incessantly and amusingly ... He reminds one a little of Winston.'[17]

From 1922 onwards Churchill often stayed as a guest at Rothermere's villa, La Dragonniere, at Cap Martin on the French Riviera.[18] It would be Rothermere who in 1935 introduced Churchill to the La Mamounia hotel in Marrakech, Morocco. Thereafter it became it one of his favourite holiday destinations.[19] In later years, from the summer of 1948, Churchill and his wife often stayed as guests at Beaverbrook's villa on the French Riviera, La Capponcina near Monte Carlo.[20]

Lord Rothermere was to commission one of the finest and most revealing portraits of Churchill ever painted, that by Sir William Orpen in 1916.[21] Lord Camrose and his son Michael (later Lord Hartwell) also collected portraits of Churchill from the early 1930s such as McEvoy's enigmatic depiction of Churchill from c.1919–1920 and Sickert's striking 1927 oil (fittingly enough, both are now in the collection of the National Portrait Gallery in London). In 1947 Camrose headed a group of subscribers who bought Churchill's beloved Chartwell Manor for the nation for £43,600 (Camrose was the largest contributor with £15,000) – enabling Churchill to live there for the rest of his life for the relatively diminutive rent of £350 per annum.[22]

Waugh also drew attention to the importance of Churchill's close association with the 'Welsh Wizard', the spell-binding orator David Lloyd George who had smoothed the way for Churchill to cross the floor and defect to the Liberals in May 1904. He and Lloyd George were close colleagues in Asquith's Liberal

government (1906–1915) and, after his appointment as Prime Minister in December 1916, would rescue Churchill from political oblivion first by appointing him Minister for Munitions in July 1917 and then promoting him successively to become Secretary of State for War and then Colonial Secretary until the collapse of his government in October 1922.[23]

It is noticeable that during his career Churchill paid close attention to figures who had captured public attention not only for their oratorical gifts and tangible achievements but also for their appearance and their skill in managing their image in the press. Such individuals included Lloyd George, known for his unfashionably long flowing white hair and ability to woo and influence press barons such as Lords Northcliffe, Rothermere and Beaverbrook,[24] as well as Benito Mussolini, Field Marshal von Hindenburg and T.E. Lawrence.

Churchill's cousin, the sculptor Clare Sheridan, who had attempted to sculpt Il Duce in the early 1920s, recalled that thereafter Churchill would often ask her for her opinion of the Italian Fascist leader.[25] Indeed some British political commentators in the 1930s unkindly suggested that, given the opportunity, Churchill would have relished emulating Il Duce by coming to power in a dramatic coup.[26]

It is clear from the chapter Churchill devoted to Lawrence in his 1937 book of essays *Great Contemporaries* how much he admired him for his exploits in Arabia and also how effectively he had caught the eye during the tumult of the Paris Peace Conference in 1919 by wearing distinctive Arab dress:

> He wore his Arab robes and the full magnificence of his countenance revealed itself. The gravity of his demeanour; the precision of his opinions; the range and quality of his conversation; all seemed enhanced to a remarkable degree by his splendid Arab head dress and garb. From amid the flowing draperies his noble features, his perfectly chiselled lips and flashing eyes loaded with fire and comprehension shone forth. He looked what he was, one of Nature's greatest princes . . .[27]

Churchill also was fully aware of Lawrence's later incarnations as Private in the Tank Corps and Aircraftman Second Class in the Royal Air Force, noting: 'Whether he wore the prosaic clothes of English daily life, or afterwards in the uniform of an Air Force mechanic, I always saw him henceforth as he appears in Augustus John's brilliant pencil sketch.'[28] One of the few pieces of sculpture Churchill would unveil, not a portrait of himself, would be in October 1936 of Eric Kennington's bronze low-relief tablet in memory of the time Lawrence had spent as a student at Oxford High School. At the same time Churchill sat on the Committee of the Lawrence Memorial Fund and was an early champion of Kennington's proposal that the memorial would take the form of a recumbent tomb effigy of Lawrence wearing his by now trademark robes of a prince or sheriff of the Arabian Hejaz.[29]

Field Marshal Paul von Hindenburg, head of the German army and, virtually, head of state between 1916 and 1918, possessed less immediately obvious charisma than Lawrence and wore far fewer uniforms. However, Churchill's essay on Hindenburg in *Great Contemporaries* suggests he was greatly impressed by the workings of the press machine behind the Field Marshal. This had created his powerful public image during the First World War, building on his much-trumpeted victory at the Battle of Tannenburg in August 1914. Hindenburg was twice elected as President of the German Weimar Republic (in 1925 and 1932), both times with large majorities despite, on the latter occasion, facing a formidable adversary in Adolf Hitler – who had established his own elaborate publicity machine.[30]

Touring Bavaria in August 1932, in the footsteps of his ancestor John, First Duke of Marlborough, Churchill had been struck by the degree of veneration Hindenburg enjoyed in the eyes of the local people and the frequency with which the Reich President's heavy, moustachioed face was represented in public.[31] Writing in 1934 one can sense that Churchill almost hoped that some of the Hindenburg magic would rub off on him and that he would, one day, be as feted as the German leader had been at the time of his death in August 1934.

Hindenburg! The name itself is massive. It harmonises with the tall, thick-set personage with beetling brows, strong features and heavy jowl, familiar to the modern world. It is a face that you could magnify tenfold, a hundred fold, a thousand-fold and it would gain in dignity, nay even in majesty; a face most impressive when gigantic. In 1916 the Germans made a wooden image of him colossal, towering above mankind; and faithful admirers, by scores of thousands, paid their coins to the War loan for the privilege of hammering a nail into the giant who stood for Germany against the world. In the agony of defeat the image was broken up for firewood. But the effect remained – a giant; slow-thinking, slow-moving but sure, steady, faithful, warlike yet benignant, larger than the ordinary run of men.[32]

Churchill was, in actual fact, in error concerning the date when the massive wooden statue of Hindenburg was erected in the centre of Berlin: this took place in August 1915. The 42.5 foot (13 metre) statue of Hindenburg was the work of sculptor Georg Marshall. It was carved from Russian alder wood in six weeks with the help of over 80 assistants and was officially unveiled on 4 September 1915.[33] The manner in which Hindenburg was presented to the German people during the Great War was not far removed from how Churchill would be projected to the British people as Prime Minister in posters and photographs commissioned by the Ministry of Information during the Second World War.

In his profile of the Field Marshal, Churchill praised Hindenburg for having returned to Germany's highest political office in 1925 at the age of 78: 'out of the confusion and miseries of vanquished Germany Hindenburg was suddenly raised to the summit of power. The German people in their despair saw in him a rock to which they might cling.'[34] Churchill, aged 60 in November 1934 and out of office since 1929, could be writing the script anticipating how the British people would turn to his leadership and 'rock-like' determination in May 1940. Recent study has in fact revealed how Hindenburg in 1925 and 1932 benefited

from the support of a truly innovatory public relations and publicity apparatus – one so effective that it won the grudging admiration of Hitler and his propaganda chief Josef Goebbels.³⁵

Clare Sheridan, a confirmed 'Winston-watcher' from some time before the First World War and who was to make two portrait busts of him (in 1919–1920 and in 1942), was well aware of her cousin's lasting fascination with larger–than-life 'great men', such as Mussolini and Hindenburg – whom she thought of as a 'wooden titan'. In later years Churchill was to remind Sheridan of a 'weary titan' bowed down by the crushing burden of his responsibilities. She had been put in mind of the term by her friend and fellow Churchill admirer, the artist Eric Kennington, who was to refer to the Prime Minister a number of times in the early 1950s as 'Atlas' – the mightiest of the Titans in Greek mythology holding up the world.³⁶

Sheridan had known Churchill better than most; she had seen the great statesman wrestling with the mountain of state papers, but she had also seen the private man with his quicksilver and often whimsical sense of humour. She was firmly of the opinion, which anticipates the central argument of this book, that if indeed Churchill was a titan, he was truly one of many moods and many faces: stern, commanding, obstinate, sulky, petulant, confident, amused, beguiling and eminently appealing. As Sheridan once noted, a single sitting with her mercurial cousin could provide material for a dozen portraits; as we shall see, this quality over the years was to fascinate a rich variety of this nation's most talented artists.³⁷

1

Young Winston: At War and in Politics, 1898–1914

From his early adult years Churchill seemed acutely aware of his public image, of the need to have an impressive carte de visite made by the Cairo 'Photographers to the Khedive' no less. In J. Heymen's photograph (Figure 1.1) he is every inch the dashing British cavalry officer, a Lieutenant in the 4th Hussars, attached to the 21st Lancers for the Sudan Campaign.[1] Evidently this was taken indoors in Cairo with a canvas backdrop depicting unconvincing pyramids and a few cursory and flimsy-looking papier-mâché rocks in the foreground. He signed and dated one photograph 'September 1898', so he had posed after the Battle of Omdurman, where the slaughter he observed there of perhaps as many as 10,000 Dervish sickened and exhilarated him in equal measure. Towards the end of the battle he had participated in the killing, shooting three to five Dervish dead at close quarters with his 1896 pattern 7.6 mm Mauser semi-automatic pistol.[2] The same pistol may well be in the holster he is wearing on his right-hand side attached to a lanyard looped around his neck. He had certainly witnessed the havoc modern weaponry used en masse could inflict on the human body. He may well have owed his own life to this non-regulation pistol he took into battle which gave him a distinct advantage over his Sudanese opponents – armed only with sword and spear they still succeeded in killing and seriously wounding nearly a fifth of the attacking Lancers. The 21st also lost over a third of its horses in the charge.

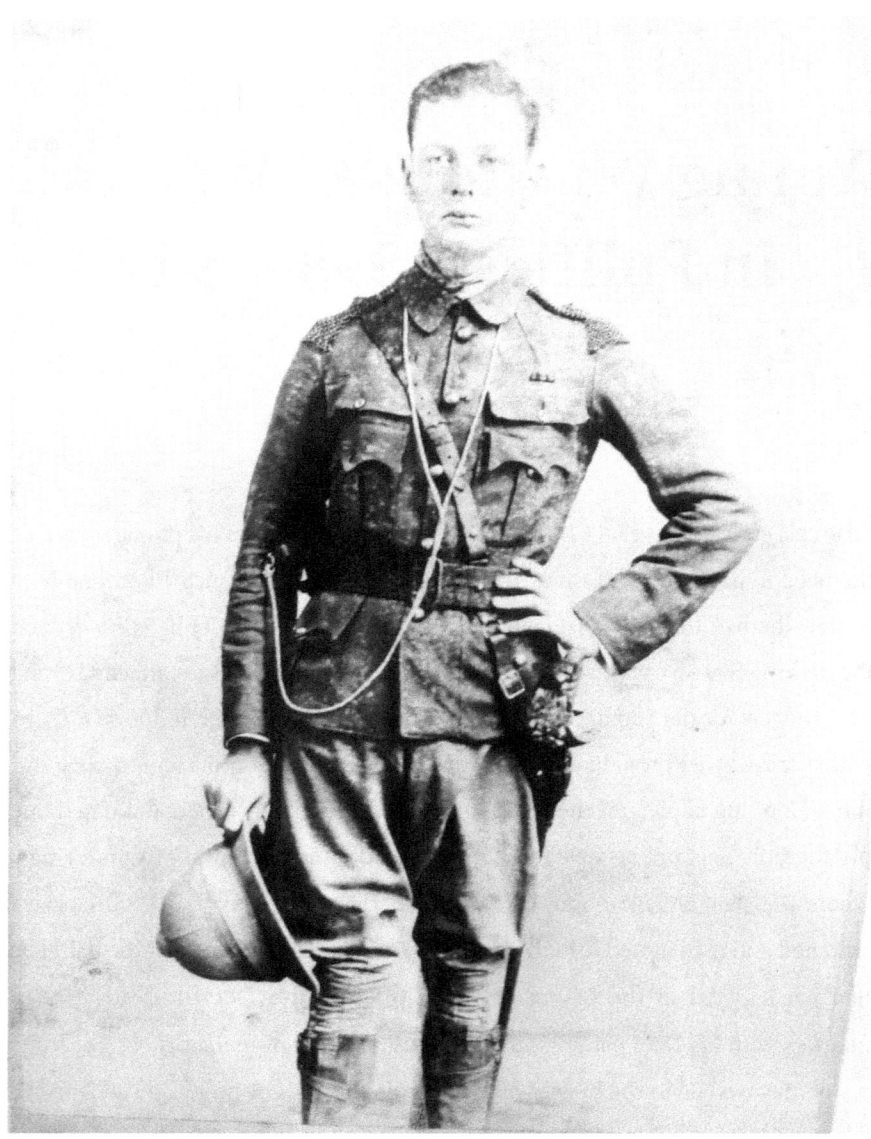

FIGURE 1.1 *J. Heymen*, Winston Churchill on Campaign in Egypt, *1898. Photograph of Churchill in British army uniform, taken in a studio in Cairo with one of the Great Pyramids at Giza painted on a backdrop, while some unconvincing papier-maché rocks are scattered in front of him in the foreground.*

Churchill, however, was able to keep circling Dervish at bay, away from striking his horse, by firing his Mauser pistol and its entire ten-round magazine.

Many years later, in November 1954, Churchill's personal doctor Lord Moran reflected Churchill had throughout his life driven himself to face danger, to test himself because he had been physically unimpressive as a boy and young man: 'he had been bullied at school, he was not tall, un-muscular with delicate hands. Moreover, he spoke with a lisp and slight stutter. Consequently he had resolved to become tough, to test his nerve under fire ... When the [Second World] war came and he was cast for the part of a tough he knew his lines ... the intimidating scowl ... was made to order.' The nation had pictured him 'defying the overwhelming strength of a warrior race. He liked the part, it was the role he had dreamed would fall to him and he was soon playing it for all he was worth'.[3]

Edwin Arthur Ward's *Winston Churchill as a Young Man Seated at a Desk* (c.1900, Figure 1.2) is possibly the first portrait of an adult Winston Churchill, painted by an artist who had also painted Winston's father Lord Randolph as Chancellor of the Exchequer in 1886. Ward in his 1923 memoirs *Confessions of a Savage* remarked on how struck he was that young Winston dressed in a remarkably similar manner to his late father – long black jacket, black waistcoat and plain black bow tie. Churchill may even have been depicted working on his first book – a reverential biography of his gifted if wayward and unstable father who had died from suspected syphilis in January 1895.[4] The biography was published in 1906. Churchill was keen to be portrayed as a scholar and man of letters. He always regretted that he had not attended university and much of the knowledge he was to draw upon so impressively in his speeches for years to come had been self-acquired after he left Harrow in 1893.[5]

By the time Sir Leslie Matthew Ward's 'Men of the Day' picture (Figure 1.3) was published, Winston had been elected Conservative MP for Oldham in October 1900 at the age of only 25. He was already an acclaimed author: *The Story of the Malakand Field Force* had been published in May 1898[6] (Winston

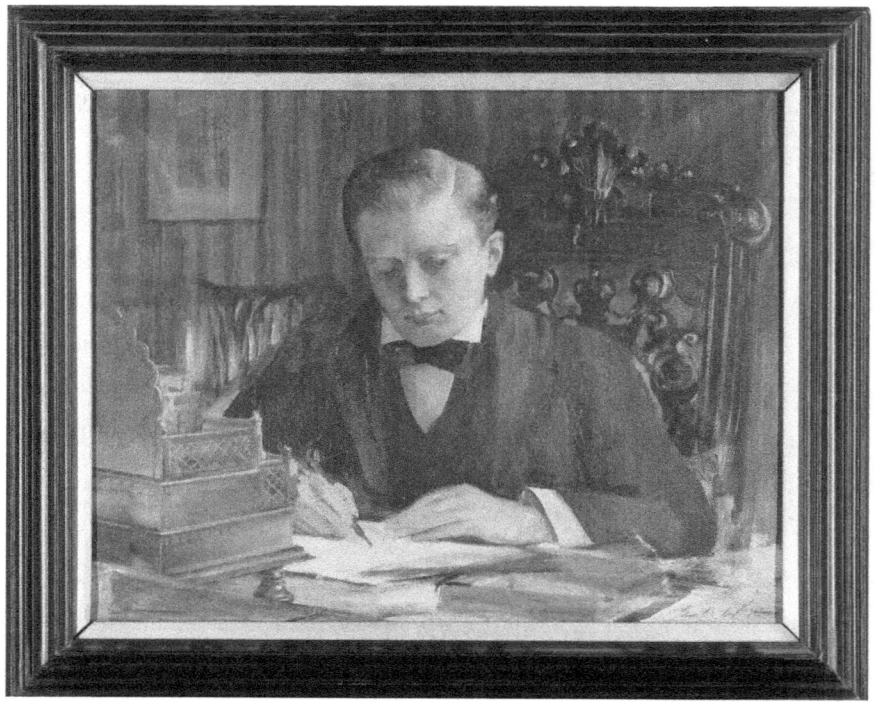

FIGURE 1.2 *Edwin Arthur Ward (1859–1933)*, Winston Churchill as a Young Man Seated at a Desk, *c.1900–1901, oil on canvas, 40.5 × 51 cm, Private Collection.*

covered the Swat Valley Campaign for the *Daily Telegraph* between July and October 1897). He had also fought with distinction in the Battle of Omdurman in September 1898:[7] his account of the British re-conquest of the Sudan from the forces of the Mahdi as a special correspondent for the *Morning Post* was published as *The River War* in November 1899 to highly positive reviews.[8] As correspondent in South Africa for the *Morning Post* he had been captured by the Boers in mid-November 1899 after distinguishing himself in the defence of a British armoured train they had ambushed.[9] He then staged a daring escape from his POW camp in Pretoria and made his way across 280 miles of enemy territory to safety in Portuguese Mozambique.[10] On his return to South Africa he promptly rejoined the British Army as a war correspondent and as a volunteer temporary Lieutenant with the South African Light Horse.[11] Between January and June 1900 he came

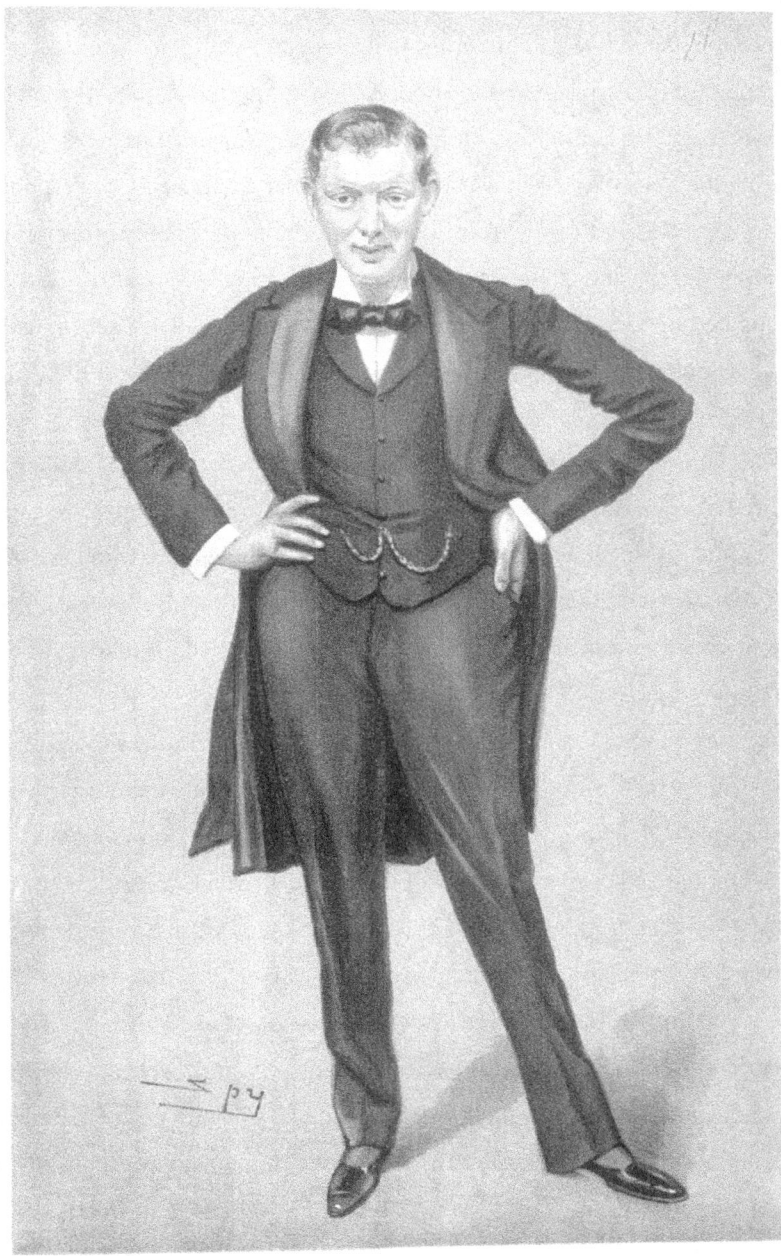

FIGURE 1.3 *'Spy' Sir Leslie Matthew Ward (1851–1922)*, Men of the Day: Mr. Winston Churchill: He can write and he can fight . . ., Vanity Fair, *27 September 1900, pencil and watercolour on paper, 41.3 × 28 cm.*

under fire in several engagements including Spion Kop, Potgeiter's Ferry and Diamond Hill.[12] While still in South Africa he published *London to Ladysmith*, an account of his early months in South Africa, in May 1900.[13] Shortly before he left Cape Town for London on 7 July 1900 he sat for Mortimer Menpes, who was covering the Boer War for an Australian newspaper as war artist/correspondent (Figure 1.4). Menpes produced a series of portraits of fellow correspondents including Kipling and Conan Doyle. Winston was by far the youngest and most opinionated of Menpes's sitters. His next book, *Ian Hamilton's March*, derived from his South African war despatches was published in October 1900 – just in time for electoral success at Oldham – and proved a best-seller.[14]

Soon after entering the House of Commons in November 1900 Churchill acquired a reputation as a forceful speaker and formidable debater. He gave up his practice of speaking from memory and without notes when his mind suddenly went blank during a speech on Trades Unions Rights on 22 April 1904. Thereafter he ensured he had meticulously prepared notes to hand when speaking in the House.[15]

Later the veteran Conservative politician Earl Winterton was to recall that, even in his early days in the Commons, Churchill had come to be regarded as a gifted speaker. He had first come to Winterton's attention around 1904, shortly after Churchill had 'crossed the floor of the House', in other words defected from the Conservatives to the Liberal Party. He made 'many witty and some brilliant interventions in debate ... especially from 1904 onwards at the expense of the Tories. His motives were suspect ... he was thought of as similar to his father, brilliant but unstable and a dangerous man with whom to work'. In those days Churchill 'suffered ... from a slight defect in speech ... it consisted of a slurring of the pronunciation of the letter "s". The House of Commons is normally kind but can, on occasions, be brutal to a Member who is not *persona grata* to it'. Generally, Churchill 'made no attempt to dispel the suspicion and dislike with which he was regarded by the majority of the House of Commons. He seemed to enjoy causing resentment. He appeared to have ... a "chip on his shoulder" ...'.[16]

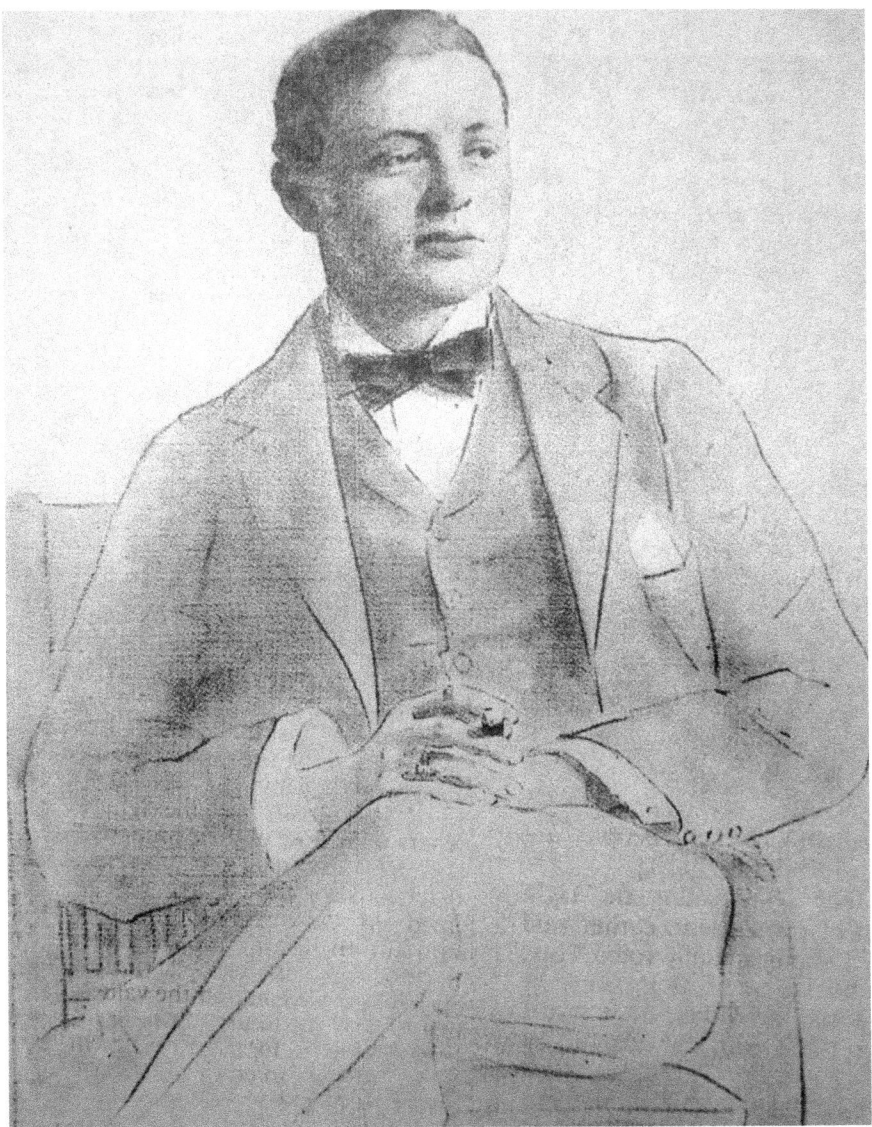

FIGURE 1.4 *Mortimer Menpes (1855–1938)*, Mr. Winston Churchill, War Correspondent for the Morning Post, *June 1900, pen-and-ink and watercolour on paper, reproduced in* War Impressions *published in 1901.*

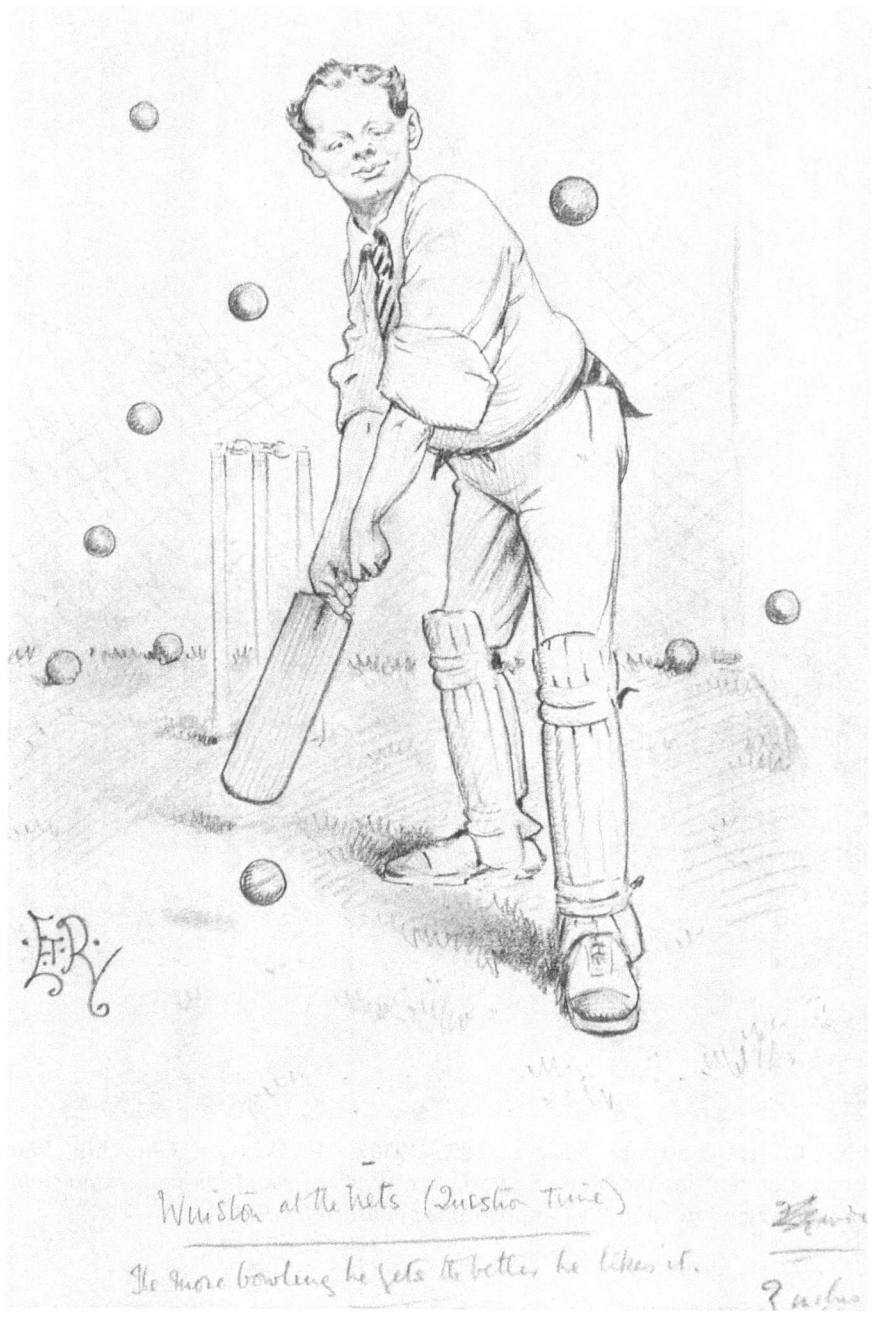

FIGURE 1.5 *Edward Tennyson Reed (1860–1933),* La Joie de Vivre: Winston in Full Swing at Question Time, *pencil on paper, 16.5 × 16.5 cm; reproduced in* Punch, *c.1906.*

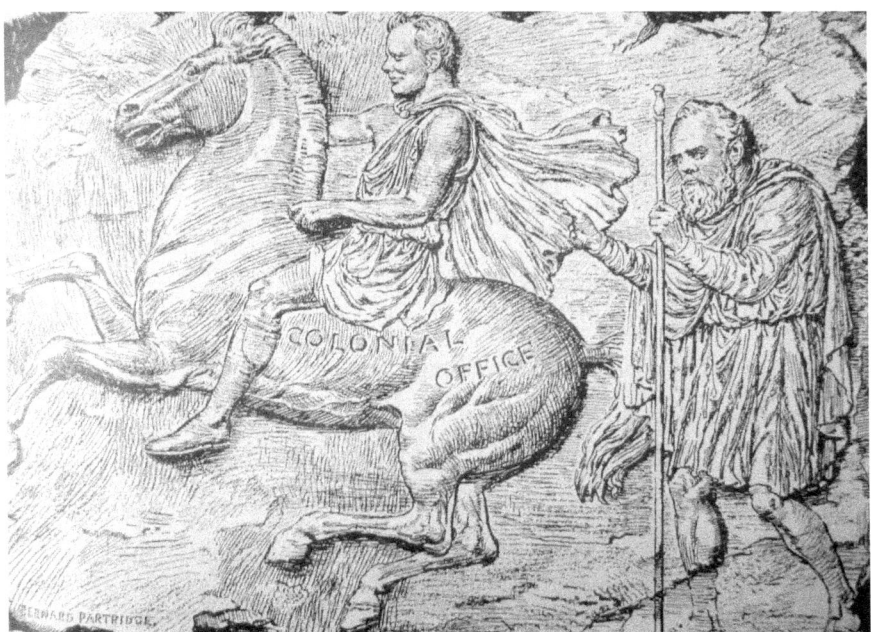

FIGURE 1.6 *Bernard Partridge (1861–1945),* An Elgin Marble, *Punch, 25 April 1906.*[17]

In December 1905, Winston had been appointed Under-Secretary of State for the Colonies with the Ninth Earl of Elgin as his laconic chief (see Figure 1.6).[18] Somehow he contrived to obtain an invitation to the Imperial German Army's annual manoeuvres in September 1906 as a personal guest of the Kaiser. Elgin wondered how he had managed it, but nothing surprised him concerning his restless subordinate.[19]

Earl Winterton later judged that by the time Churchill had been Home Secretary (February 1910–October 1911) and then First Lord of the Admiralty (appointed October 1911), he had become

> a first class Parliamentarian. He had mellowed and matured ... He had studied and learnt to recognise the varying moods of the House. He could be as formidably aggressive as ever when the occasion demanded it; but he made full use of the qualities of tact, persuasion and conciliation ... His

command of the beauty and imagery which reside in the English language was manifest. He delighted the House with his magnificent epigrams and great sense of humour and it did not resent his occasional outbursts of scowling rage even when they appeared unnecessary; for they were so soon followed by amiability and a cheerful grin.[20]

From his appointment in February 1910, Winston was perceived as a combative Home Secretary, not one to be intimidated by militant trade unions, rioting workers and pistol-wielding anarchists, and was committed to prison reform.[21] He was perceived as opposed to female suffrage; in fact he was in favour of widening the franchise to men and women, but would not stand for suffragettes breaking the law by indulging in acts of violence.[22] In November 1910 he was widely believed to have ordered the use of troops against striking miners in

FIGURE 1.7 *Bassano Ltd (1901–1962)*, **Winston Churchill at his Desk as Home Secretary,** *20 April 1911, photograph, National Portrait Gallery, London, x81076.*

Tonypandy, South Wales. He had been asked by the Chief Constable of Glamorgan to approve the deployment of troops; Churchill did, but ordered them not to proceed any further than Swindon. He did order constables of the London Metropolitan Police to reinforce under-pressure local policemen. However, when troops did arrive in the area, they did not open fire on the strikers as popularly imagined.[23] Many years later the half-Welsh sculptor of the Churchill statue in Parliament Square, Ivor Roberts-Jones (1913–1996), reflected that the erroneous perception that Winston had ordered soldiers to fire on striking Tonypandy miners had poisoned his reputation in South Wales.[24]

In January 1911 he attracted praise and derisive criticism in equal measure for his involvement in the Sidney Street Siege.[25] He later wrote, somewhat disingenuously, that once he came under fire from the anarchists it had not been at all easy to withdraw: 'I should have done much better to have remained quietly in my office. On the other hand it was impossible to get into one's car and drive away while matters stood in such great uncertainty and, moreover, were extremely interesting.'[26] During the summer of 1911 the country was wracked by a series of strikes and Winston was vocal in his fears that the trade unions were trying to overthrow the existing social order. The perception of Churchill as an implacable foe of the striking working man, even if he had downed tools with a legitimate grievance, was born.[27]

Asquith had been quick to recognise Churchill's talents; on becoming Prime Minister in April 1908 he promoted Churchill to become President of the Board of Trade. He was aware that his daughter Violet, who first met him in 1906, was more than a little in love with Churchill. She believed her feelings were reciprocated but Churchill proposed to and was accepted by Clementine Hozier in August 1908 (they married the following month).[28] Violet Asquith, later Lady Bonham Carter, was to recall Churchill telling her: 'We are all worms. But I do believe that I am a glow worm'. She informed her father that 'Winston was a genius', to which he dryly replied: 'Well, Winston would certainly agree with you there ... He is not only remarkable, but unique.'[29]

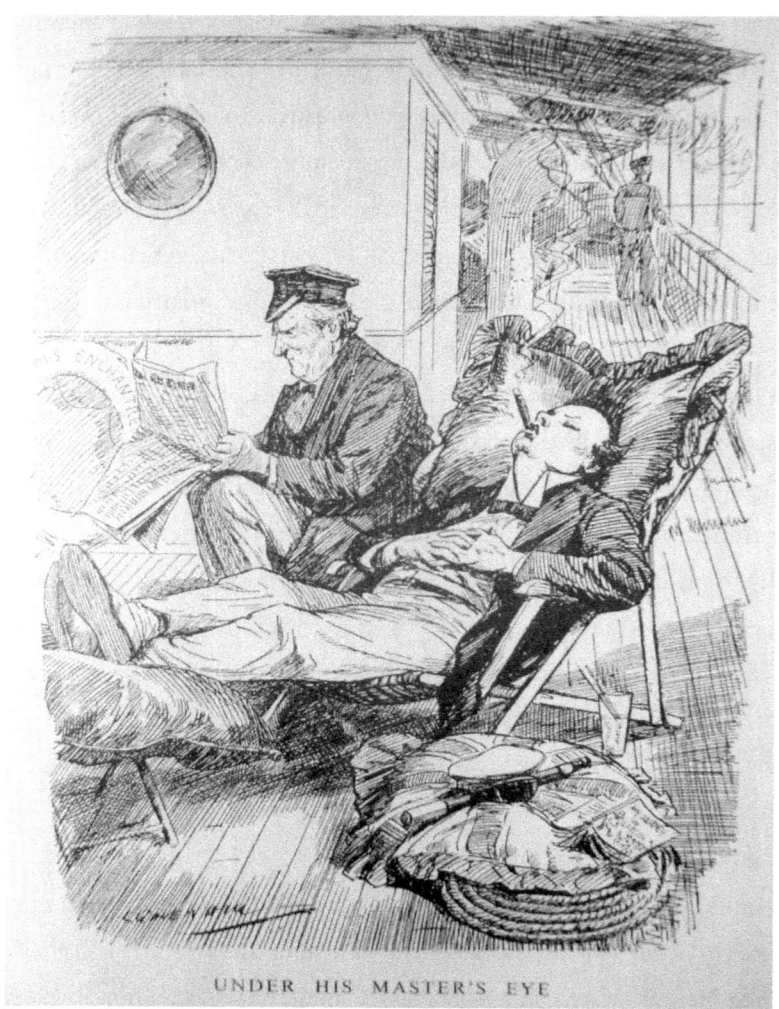

FIGURE 1.8 *L. Ravenhill (1867–1942)*, Under His Master's Eye, Punch, 21 May 1913.

This appears to be one of the earliest images depicting Churchill savouring one of his large Romeo y Julieta Cuban cigars which was soon to become his trademark (alongside his supposed penchant for wearing 'eccentric hats'). Churchill later commented he had started smoking cigars while covering the anti-Spanish insurgency in Cuba in November 1895 as it gave one something useful to do and occupy the mind while

under fire.³⁰ During his so-called 'wilderness years' in the 1930s Churchill brandished an unlit cigar and informed a startled Conservative backbench MP: 'never forget your trademark'.³¹

Ravenhill presents Churchill as the epitome of a well-dressed, languid and rather louche club man about town – know at the time as a 'knut'; the term was popularised by the music hall song which celebrated 'Gilbert the Philbert – the Knut with a K'.

However, in the early years of the war Asquith began to harbour doubts about his restless First Lord of the Admiralty: one could admire his energy and self-confidence but sometimes judgement was conspicuously lacking. Early in October 1914 he noted of Churchill: 'He is a wonderful creature, with a curious dash of schoolboy simplicity ... and what someone said of genius – a "zigzag of lightning in the brain". And later that month: "I can't help being fond of him ... he is so resourceful and undismayed...."'

By February 1915 Asquith was struck by how few really close political friends and allies Churchill had. There was 'no personal following ... his future [will be] one of the most puzzling enigmas in politics....'³² Even before the Dardanelles Expedition proved a disaster, in late April 1915, Asquith pondered whether Churchill, for all his energy, was becoming a liability in the running of the nation's war effort. For one thing he was simply was not trusted by his peers. Asquith concluded: 'I am really fond of him but I regard his future with many misgivings ... He will never get to the top in English politics with all his wonderful gifts; to speak with the tongues of men and angels ... is no good if a man does not inspire trust.'³³

As for his mercurial subordinate, Churchill was to pay Asquith a handsome tribute in his essay written in 1934 and printed three years later in *Great Contemporaries*: 'Mr. Asquith was probably one of the greatest peace-time Prime Ministers we have ever had. His intellect, his sagacity, his broad outlook and civic courage maintained him at the highest eminence in public life.' He

did, however, add: 'But in war he had not those qualities of resource and energy, of prevision and assiduous management, which ought to reside in the executive. Mr. Lloyd George had all the qualities which he lacked.'[34] Largely for that very reason, Churchill had supported Lloyd George's toppling of Asquith as Prime Minister in December 1916.[35]

Churchill was regarded in the spring of 1914 as unsympathetic to the Ulster Unionists and a champion of the Third Home Rule Bill. His image was evidently associated with a penchant for violence, even brutality. As Home Secretary (1910–1911) he was thought to be too keen to call on troops to confront striking workmen and that he had even given permission for the soldiers to open fire on them – as supposedly occurred at Tonypandy in South Wales in November 1910. In actual fact, Churchill had authorised the use of troops, at the specific request of the Chief Constable of Glamorgan, but had issued strict instructions they were not to use their firearms on the strikers. Regular army troops shot dead two striking railwaymen in Llanelli but this was against Churchill's instructions. Troops were not to become involved in industrial disputes; their purpose was to prevent the breakdown of law and order such as swiftly repressing incidents of looting and arson.[36] Regarding Northern Ireland, Churchill made himself very unpopular with Ulster Loyalists by stressing he would not allow the British state on the ground to be intimidated or usurped in any way by Edward Carson's Protestant Ulster Volunteers protesting against the prospect of imminent introduction of Home Rule for the entire island of Ireland. The week before Sidney George Conrad Strube's[37] *Daily Express* cartoon, entitled 'I Smell the Blood of an Ulsterman' (Figure 1.9), was published, Churchill very publicly ordered the Royal Navy's 3rd Cruiser Squadron to move within easy sailing distance of Belfast and let it be known that, at the first sign of violence from the Volunteers, he would order parties of armed Royal Marines to land and occupy Belfast's shipyards and key public buildings.[38]

Within four months of the publication of this cartoon Britain would be at war with Imperial Germany. It was a conflict that, in part, Churchill welcomed.

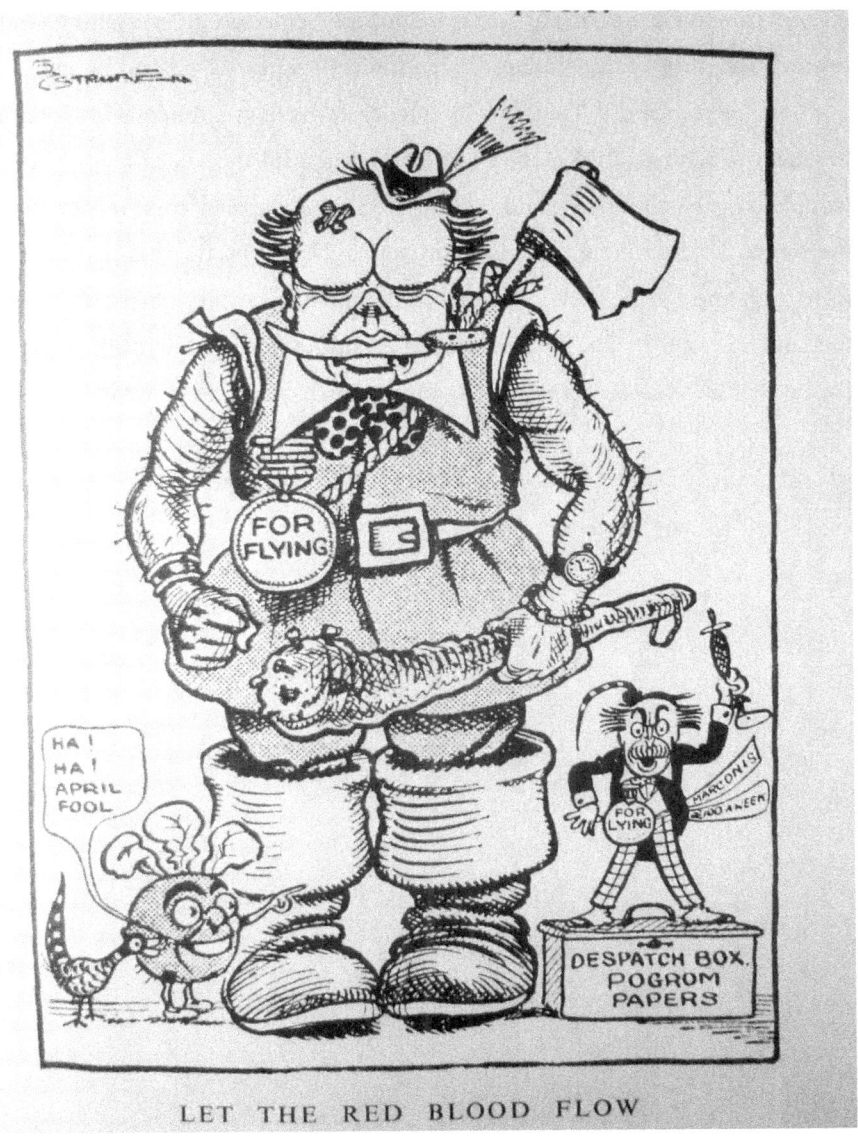

FIGURE 1.9 *Sidney George Conrad Strube (1891–1956), 'I Smell the Blood of an Ulsterman'*, Daily Express, *1 April 1914.*

As he wrote to Clementine as war was about to be declared: 'Everything tends towards catastrophe and collapse. I am interested, geared-up and happy. Is it not horrible to be built like that? The preparations have a hideous fascination for me. I pray to God to forgive me for such fearful moods of levity – Yet I would do my best for peace and nothing would induce me wrongfully to strike the blow....'[39] Excitement in his mind was undercut by uncertainty; he had risen high and quickly to occupy one of the most important offices of state in the land. He was, by far, the one among Asquith's ministers with the highest public profile.[40] Much was expected of him; much could yet go wrong.

2

Disaster and Rehabilitation in the First World War, 1914–1918

Churchill had started his political career as a Conservative – elected MP for Oldham in October 1900 – but in May 1904 he 'ratted' (i.e. crossed the floor of the Commons) to join the Liberals.[1] Indeed, he very purposefully chose to sit next to David Lloyd George.[2] He was appointed First Lord of the Admiralty by Prime Minister Asquith in October 1911. Churchill certainly welcomed the use of Admiralty House and access to the 4,000-ton Admiralty yacht *Enchantress*. Indeed, he was to spend eight months of the next three years travelling on the yacht.[3]

Ernest Townsend's portrait, *Winston Churchill as First Lord of the Admiralty* (Plate 2), had been commissioned in April–May 1915 and paid for by an anonymous donor who described themselves as a 'Liberal and admirer of Mr. Churchill'. The donor had first approached Ernest Townsend to paint the portrait early in the spring of 1915 and the artist had readily agreed. If the National Liberal Club was agreeable, the portrait would be donated to the Club on completion.[4] The Art and Library Committee of the Club, after a brief discussion, accepted the 'generous offer' on 21 July 1915.[5] By then, of course, Churchill was no longer First Lord – he resigned from the post on 26 May 1915

and became Chancellor of the Duchy of Lancaster.[6] He remained a member of the Club having been elected on 6 January 1906; he had been proposed by no less than David Lloyd George – then Chancellor of the Exchequer.[7]

The donor was to maintain their anonymity through what was to prove a long and rather tortuous process as the Club eventually took delivery of the painting and then debated endlessly as to where it should hang within its premises. However, occasional hints indicate that the donor was male, a 'British-born subject', a member of the NLC and a 'member of one of the Houses of Parliament'; he was almost certainly a Liberal MP.[8] It is quite possible that the donor was the decidedly rakish and raffish wealthy man about town Baron (also known as Count) Maurice Arnold 'Fruity Tuty' de Forest (1879–1968), a friend of Churchill's for some time before he married Clementine Hozier in 1908.[9] De Forest, a pioneering racing-car driver and aviation enthusiast, had an extraordinary life story.[10]

De Forest and Churchill appear to have been very friendly by 1908 – that year he and his new wife Clementine spent time on his yacht during their honeymoon. Between 1910 and 1913 they stayed at least three times at De Forest's castle in southern Moravia in the Austro-Hungarian Empire. Churchill and his wife campaigned for De Forest in January 1910 when he ran unsuccessfully as Liberal candidate for Southport – it was during this campaign that Churchill was photographed wearing the hat that was slightly too small for him, thereafter prompting cartoonists to depict him wearing a wide variety of often outlandish head gear.[11] De Forest was especially touched that Churchill stoutly defended him from racist and anti-Semitic remarks directed against him by the winning Conservative opponent. Later that same year Churchill and his wife spent six weeks sailing the waters of the eastern Mediterranean on De Forest's large yacht.[12] Churchill supported De Forest when he divorced his second wife, the Hon. Ethel Gerard, for adultery in 1911. To pursue a wife for adultery was almost unheard of for a man of De Forest's wealth and social background. De Forest compounded what society regarded as conduct

unacceptable for a gentleman by then making it known he blamed his mother-in-law for encouraging her daughter to betray him with a younger man. This resulted in a sensational trial in which De Forest was accused of libel and defamation by his wife's family. De Forest lost the case and was asked to resign from the Reform Club. Churchill was so outraged by this action that he also resigned from the Club and offered David Lloyd George's resignation as well – which came as news to Lloyd George, whom Churchill had not consulted beforehand. As Roy Jenkins has revealingly remarked, De Forest was 'one of the several louche (and in this case slightly mysterious) characters for whom Churchill had a partiality. He liked bounders...'.[13]

Churchill also prominently campaigned for De Forest when he stood in a by-election in July 1911 as Liberal candidate for West Ham North, which he won with a considerable majority. He would hold the seat for the Liberals until the General Election of December 1918. If the anonymous donor was, in fact, De Forest, he may have wanted to commission a portrait of Churchill in the spring of 1915 as a heartfelt thank-you for helping him through a difficult period in the early months of the First World War. De Forest was still under a cloud in high society after the 1911 divorce case and subsequent libel trial. With his Austro-Hungarian title he soon became the object of malicious gossip that he was an enemy sympathiser, even a spy, at the time that the First Sea Lord, Prince Louis of Battenberg was forced to resign in October 1914 on the grounds of his holding a German title.[14] Churchill, as First Lord of the Admiralty, was unable to protect Battenberg but he did fiercely attest to De Forest's patriotism, blocked moves by the Home Secretary to have him deported as an 'undesirable individual' and allowed him to volunteer for the Royal Naval Volunteer Reserve, despite the fact he was too old. Given his passion for motoring he soon joined the RNAS Armoured Car Division, equipping it with a squadron of Rolls Royce armoured cars at his own expense and serving alongside Churchill's close friend Oliver Locker-Lampson MP (who late in 1915 would commission John Lavery to paint Churchill as a

Major in the British Army wearing a striking French steel helmet; this was presented to Churchill as a gift from all the officers of the RNAS Armoured Car Division – see below).

De Forest[15] may have thought of Townsend for the portrait commission because the artist had recently painted some impressive work, along with Ernest Shepherd, for the Park Lane home of the rich Anglo-Jewish Conservative MP for Hythe, Sir Philip Sassoon – who had also been friendly with Churchill and his wife from around 1914.[16]

Towards the end of October 1915, Townsend informed the NLC that there had been one sitting already with Churchill and a further six were planned. The Art Committee also raised the possibility of commissioning the artist to paint a replica of the portrait which would then be presented to Churchill. However, discussion of this subject soon petered out over the question of how much this additional painting should cost and who would pay for it.[17] Two months later the artist wrote to the Art Committee chairman that the portrait would be finished any day after 20 December 1915, but by then Churchill had resigned from the Liberal coalition government as Chancellor of the Duchy of Lancaster.[18] Indeed, by December 1915, he was serving as a Major in the British Army attached to the 2nd Battalion of the Grenadier Guards in France.[19]

However, it appears the portrait was not actually finished until mid-February 1916 when Townsend wrote that the portrait could not be handed over to the NLC, but he would first like to exhibit it at that year's Royal Academy show (which took place during April and May).[20] Permission for this was granted and the portrait was eventually delivered to the NLC in late June 1916; one of the Art Committee members described it, with rather faint praise, as 'all right'.[21]

In the portrait, Churchill emerges in the form of a late Pre-Raphaelite hero from fable and legend, the uniform of First Lord of the Admiralty reminiscent of the elaborate armour worn by a knight as imagined by Burne-Jones, Waterhouse or Spencer Stanhope – although when Townsend painted him late

in 1915 Churchill had not been First Lord for over five months. Pensive, yet giving the impression of being self-assured, a hint of the barely suppressed warrior in the detail of one finger resting on the hilt of his ceremonial sword (perhaps an indication that he was already considering leaving the government and returning to probably dangerous active service with the Army in France) – this is one of the more glamorous, even slightly other-worldly interpretations of Churchill's image. Townsend paints him as an icon – yet a somewhat unconvincing one – from which much of the glitter of success has been removed by events. Ironically, by the time it was completed and then exhibited at the RA in the spring of 1916, Churchill's reputation had never been at a lower ebb; perhaps one can detect in his eyes just a suspicion that he may never again wear the impressive uniform of such a high and prestigious government office?[22]

For the next six months there was much discussion as to when an official presentation ceremony for the portrait should take place and where it should hang inside the club.[23] By late January 1917 there was a hint that enthusiasm for Churchill had cooled – he was widely regarded as being hand-in-glove with Lloyd George, who had recently and abruptly replaced the Liberal leader Asquith as Prime Minister with help from the Conservatives. The NLC remained a bastion of pro-Asquith sentiment. On 30 January 1917, the Art Committee decided that the 'time was inopportune for a public ceremony' for the portrait to be presented and that, for the time being, it should hang in the club's committee room – far from a prominent position.[24]

Churchill's stock suddenly rose impressively when, on 18 July 1917, Lloyd George appointed him Minister of Munitions.[25] Indeed, at the end of the month this very fact was noted by the Chairman of the NLC's Art Committee, who added that 'now was the time to contemplate an unveiling of the picture'. The Committee also decided that the portrait should now hang on the west wall of the club's main dining room, where it could be regularly inspected by the majority of the membership as they entered and departed.[26] The committee made several unsuccessful attempts to discover the identity of the donor while

trying to obtain from Churchill some dates when he could be present for the official unveiling of the portrait. However, Churchill for much of 1918 was understandably busy with the war effort. The Allies faced the very real prospect of defeat between March and June 1918 as the Germans launched one massive attack after another on Franco-British positions.[27]

Discussion of what to do with the Churchill portrait languished as the schism between Liberals who supported Asquith and those who backed Lloyd George grew ever wider. In December 1920, by which time Churchill was Secretary of State for War in Lloyd George's Conservative-dominated coalition government, the Art Committee resolved that neither the 1913 portrait of Lloyd George it had been given, nor the Townsend of Churchill, be displayed within the club, such was the animus from members towards those two gentlemen.[28] Lloyd George's portrait was taken down but Churchill's lingered in the relative obscurity of the upper committee room.[29] Sometime after 22 February 1921 Churchill's portrait was taken down and joined the Lloyd George in a 'dry, well-ventilated place [probably one of the Club's cellars] ... encased in blankets. . .'.[30]

After Lloyd George's government fell in October 1922, triggered by a Conservative backbench revolt, Churchill tacked in the direction of Asquith's Liberals after losing his Dundee seat as an ally of Lloyd George in the General Election of November 1922.[31] This appears to have partially redeemed him in the eyes of the membership of the NLC as the Townsend portrait was retrieved from storage and, by July 1923, was hanging in the club's elegant and much-used smoking room. In the General Election of December 1923, Churchill stood unsuccessfully as a Liberal candidate, on the Asquith wing of the party.[32]

In September 1924, however, he 're-ratted', from the Liberals to the Conservatives, standing as a 'Constitutionalist' allied to the Conservative Party for the seat of Epping in West Essex. He took the seat comfortably in the General Election of October 1924 and then joined the Conservative Party, where he remained for the rest of his life.[33] Three weeks after he accepted

Stanley Baldwin's offer to become Chancellor of the Exchequer, Churchill resigned from the National Liberal Club and by the end of the year his portrait was gone from the smoking room – back to a 'dry, well-ventilated place', cocooned in blankets.[34]

Churchill's portrait remained in storage until May 1940 when he became Prime Minister with the whole-hearted support of the then leader of the Liberal Party and a close friend of Churchill, Sir Archibald Sinclair (Churchill made him his Secretary of State for the Air in May 1940). It was then retrieved from storage and placed in the main staircase lobby (the same spot where it hangs today). However, barely a year later, at 1.50 am on the morning of 11 May 1941 the club was hit by a German bomb which demolished much of the main staircase and peppered the portrait with steel fragments.[35] The portrait was removed for 'urgent and extensive restoration'. The painting had been successfully repaired by late April 1943 and Churchill and his wife attended the formal unveiling of the portrait at 2.30 pm on 22 July 1943 with the club president, the Marquess of Crewe, officiating.[36] It must have been rather an odd experience for Churchill, already Prime Minister for over three years and First Lord of the Admiralty for a second time (September 1939–May 1940), which had exposed some serious flaws in his organisational abilities to inspect a portrait of himself painted nearly 28 years previously when he was 41 (as opposed to 68 in July 1943): younger, slimmer, with more hair, not the rotund figure of pensionable age but the rather dashing warrior, sword at his side rather than a Mauser pistol more suited to the murderous warfare of 1915.

Also present at the ceremony were Sir Archibald Sinclair and his wife, Churchill's long-time political ally Robert 'Bob' Boothby and, rather appropriately, his favourite cartoonist David Low, an NLC member for many years who had drawn Churchill since 1920 in a multitude of guises and different forms of dress.[37]

Churchill's friend Alfred 'Duff' Cooper dined with John and Hazel Lavery (1880–1935) at their house in Cromwell Place, South Kensington, on 20 April

FIGURE 2.1 *Sir John Lavery (1856–1941)*, Winston Churchill as First Lord of the Admiralty, *1915, oil on canvas, 76.8 × 63.9 cm, Sir Hugh Lane Collection, Dublin City Art Gallery.*

1915. He also met Churchill and his wife, Clementine, there. Belfast-born Lavery mentioned in passing that he had recently started work on a portrait of the First Lord of the Admiralty (Figure 2.1). Cooper was very keen to ask Churchill about the landings for the Dardanelles Campaign which were to begin in five days time. However, 'he had to sit to Lavery after dinner...'.[38]

Historian Jeremy Black has concluded that while the Dardanelles Campaign was not entirely Churchill's brain child, he seized upon it in its earliest stages and made it his own. He provided the momentum to see that it would become a reality. However, he was in all probability in error when he assumed that British battleships in the Sea of Marmara firing upon Constantinople would have led to the Ottoman Empire abandoning its alliance with the central powers. It was unlikely that they would have compelled the surrender of the Sultan even if his palace had been smartly demolished by British 15-inch shells. This was one example of where Churchill's dynamism, optimism and energy were not channelled by sober judgement and a grasp of necessary logistics.[39]

Within three weeks of the landing of British and Dominion troops it was becoming painfully clear that the Gallipoli campaign was in deep trouble.[40] On 19 May 1915 Lady Violet Bonham-Carter wrote in her diary that earlier in the day she had met Churchill: 'he sat down on a chair – as I have never seen him – really despairing for the moment – with no rebellion or anger left. He ... simply said, "I am finished ... I'm done. What I want above all things is to take some active part in beating the Germans. But I can't – it's been taken away from me."'[41] Two days later Prime Minister Asquith told Churchill, 'you are not to remain at the Admiralty'. On 22 May, Asquith offered Churchill the Chancellorship of the Duchy of Lancaster – the least important ministerial position but at least he would have a voice in the War Cabinet. Four days later Asquith announced the formation of a new Liberal/Conservative coalition government and Churchill's move from the Admiralty.[42] That same day, 26 May 1915, Churchill had to also leave Admiralty House; his other London home, 33 Eccleston Square, was being let to his brother Jack and wife Gwendoline (known as 'Goonie'), so he and the family moved to 41 Cromwell Road, South Kensington – close to where the Laverys lived at 5 Cromwell Place.[43] Churchill himself was later to recall how, after stepping down from the Admiralty, he fell victim to the grip of a deep depression – his 'black dog'[44] as he memorably gave it physical expression.[45]

During the summer of 1915 Churchill was to take up painting, at the urging of Hazel and John Lavery, in large part in an urgent effort to take his mind off the unfolding Dardanelles debacle.[46] In his December 1921 article, 'Painting as a Pastime', Churchill wrote feelingly of how in June and July 1915, while staying at Hoe Farm, near Godalming in Surrey, 'the Muse of Painting came to my rescue'.[47]

Four years later, in his 1925 article on 'Hobbies', Churchill wrote that, after leaving the Admiralty:

> One dwelt in a sort of cataleptic trance, unable to intervene, yet bound by the result. At a moment when every fibre of one's being was inflamed to action, I was forced to remain a spectator of the tragedy, placed cruelly in a front seat. I do not know how I should have got through those horrible months, from May 'til November [1915] when I resigned from the Administration, had it not been for this great new interest which sprang up in my mind and kept my fingers busy and my eye alert. Some experiments one Sunday with the children's paint box led me to procure the next morning a complete outfit for painting in oils. During all that summer I painted furiously. I have never found anything like it to take one's mind for a spell off grave matters ... Two or three hours pass in a flash. One forgets that one is standing up, or that it is luncheon time. One forgets utterly the work of the past and of the worry of the future....[48]

Lavery belonged to a generation of British artists who came to prominence in the 1890s and at the turn of the twentieth century, such as William Nicholson, William Orpen and Augustus John whose pictorial realism had been moulded by their admiration for the French Impressionists of the 1870s and 1880s such as Manet, Monet, Degas and Pisarro. In his 'Painting as a Pastime', published in December 1921, Churchill specifically praised two artists whom Lavery revered, Manet and Monet, along with Cézanne and Matisse, stating: 'They have brought back to the pictorial art a new draught of joie de vivre and the beauty of their work is instinct with gaiety and floats in sparkling air'.[49]

During the Anglo-Irish Treaty negotiations in London in December 1921 Churchill looked to both Lavery, a Belfast-born Roman Catholic, and his wife Hazel – who came from an Irish-American background – for advice on the plight of Roman Catholics in Northern Ireland and how the subject would be regarded by Irish-American opinion in the USA.[50] Despite the fact that Churchill approved of the partition of Ireland and the creation in 1922 of Northern Ireland, which both Laverys certainly did not, they remained on friendly terms.[51] Churchill and his wife were both distressed to hear of Hazel Lavery's unexpected death in January 1935.[52]

Lavery's 1916 portrait of Churchill (Plate 3) was still in his possession at the time of his wife's death and in June 1935 he donated it in Hazel's memory to the Hugh Lane Collection in Dublin. It may not be a coincidence that the then Director of the National Gallery of Ireland, his friend the art historian Sir Thomas Bodkin (also Director of the Barber Institute, 1935–1953) was later to contribute the essay 'Churchill The Artist' to the 1953 volume *Churchill by his Contemporaries*.[53]

The idea for Lavery's portrait of Churchill wearing a *Casque Adrian* helmet appears to have originated with a friend of Churchill's and a remarkable man in his own right, Oliver Locker-Lampson (1881–1954), Conservative MP for Huntingdon (1910–1921). A pioneer racing-car enthusiast, in September 1914 he had volunteered, with Churchill's blessing, for the Armoured Car Division of the Royal Naval Air Service (RNAS) – a unit which owed its existence very much to Churchill's fascination with new military technology. Locker-Lampson donated a Rolls Royce armoured car and went on to command with distinction Number 15 Squadron of the Division in northern France and in the vicinity of Dunkirk in 1914–1915. In late September 1915 he wrote to Churchill that he had recently seen a painting of armoured cars from the RNAS Armoured Car Division by John Lavery for sale in London. Locker-Lampson had immediately thought of 'getting the officers of the armoured car squadrons to club together and buy it for you'. However, to his great displeasure, he had discovered that the

work had been 'bought privately by somebody else, so ... we are now contemplating buying and presenting you with your portrait by Lavery'.[54] Locker-Lampson gathered that Lavery had tentatively already started a portrait of him but work on this had been delayed as Churchill was contemplating leaving the government and joining the army in France. Would he be able to spare Lavery the time for one or possibly two sittings and 'and is this a picture you would like?' Locker-Lampson planned that the portrait, if completed in time, could be presented to Churchill 'in a room in the House of Commons' towards the end of November 1915.[55]

However, this gathering had to be postponed as Churchill suddenly resigned as Chancellor of the Duchy of Lancaster and on 18 November 1915 he left to serve in France as a Major with the Oxfordshire Hussars. He was soon attached to the 2nd Battalion of the Grenadier Guards and he quickly made it known he had high hopes of commanding an Infantry Brigade.[56] Early in December 1915 he took two trips to the front with a new friend, Edward Louis Spiers, to observe the French Army in action. On 5 December they went to see General Fayolle of the Tenth Army near Arras (see Figure 2.2). That day Churchill was given a relatively new French steel helmet, known as a *Casque Adrian*.[57] The shape of the helmet greatly appealed to Churchill on the grounds it would most likely protect his 'valuable cranium'.[58] A few days later he even boasted to his wife that: 'My steel helmet is the cause of much envy. I look most martial in it – like a Cromwellian – I always intend to wear it under fire – but chiefly for the appearance.'[59]

Lavery's portrait depicts Churchill wearing his cherished 'Cromwellian' *Casque Adrian* and the uniform of a Lieutenant-Colonel in the British Army. Though Churchill was able to take a brief Christmas leave (24–27 December 1915) in London, and proudly show off his *Casque Adrian*, complete with recently acquired dent provided by a glancing German shell fragment, there had not been time to resume sittings with Lavery.[60] Churchill was back at the front by 29 December and heard on New Year's Day 1916 he had been

FIGURE 2.2 *Major Winston Churchill Wearing a French* Casque Adrian *Helmet with General Fayolle, HQ XXXIII Corps, Camblain L'Abbé, France, 15 December 1915.*

temporarily promoted from Major to Lieutenant-Colonel in order to take command of the 6th Battalion Royal Scots Fusiliers.[61] He took formal command of the battalion on 5 January 1916[62] but did not lead them into front line trenches at Ploegsteert (known as 'Pulgstreet' to British troops) until 27 January 1916.[63]

In command Churchill impressed the battalion adjutant, A.D. Gibb, in later years Regius Professor of Law at Glasgow University. Gibb, writing in 1924, judged him to have been

> a popular officer ... As a soldier he was hard-working, persevering and thorough ... he loved soldiering; it lay very near his heart ... How often have we heard him say by way of encouragement in difficult circumstances, 'War is a game to be played with a smiling face' ... He is a man who is apparently always to have enemies. He made none in his old regiment, but left behind him there men who will always be his loyal partisans and

admirers and who are proud of having served in the Great War under the leadership of one who is beyond question a great man.[64]

He acknowledged to his wife he was serving in a quiet sector of the front but danger was ever close at hand. Writing to Clementine on 16 February 1916, he noted in passing that two of his headquarters staff had recently been wounded, adding, 'I do not fear death or wounds and I like the daily life out here; but the impudence and complaisance [of British High Command] makes me quite spiteful sometimes.'[65] After the war he would write of survivng a couple of very near misses from shell fire while serving with the Royal Scots in his article 'Plugstreet', first published in Nash's Magazine in April 1924.[66]

Churchill would next see Lavery again during a 13-day period of leave, 6–19 March 1916, that he was given to 'attend to parliamentary business'.[67] Indeed, a fortnight before his leave began he made particular mention in a letter to his wife that he was looking forward to seeing the artist again and having an opportunity of 'at least one day's painting in Lavery's studio'.[68]

Churchill returned to London, this time for good, on 7 May 1916. By then the 6th Royal Scots had been amalgamated with the 7th Battalion of the same regiment and he found himself without a unit to command.[69] He spent his last day in the trenches, wearing his *Casque Adrian*, on 6 May 1916 – despite the fact his battalion had been equipped with British Army-issue steel helmets just prior to their manning the line at Ploegsteert.[70] It is likely Lavery completed this portrait of 'warrior Winston' soon after Churchill's return to London in May 1916, as within a month he would start sittings for William Orpen for another portrait (Figure 2.3).

In his sober khaki and purposeful *Casque Adrian* Churchill looked every inch the experienced front-line officer. However, within a fortnight of his return from France he was wearing elegant civilian garb and speaking with typical forthright eloquence in the House of Commons in favour of a British independent air force.[71] Some of his contemporaries found this sudden transition from politician to front-line soldier and then back again puzzling,

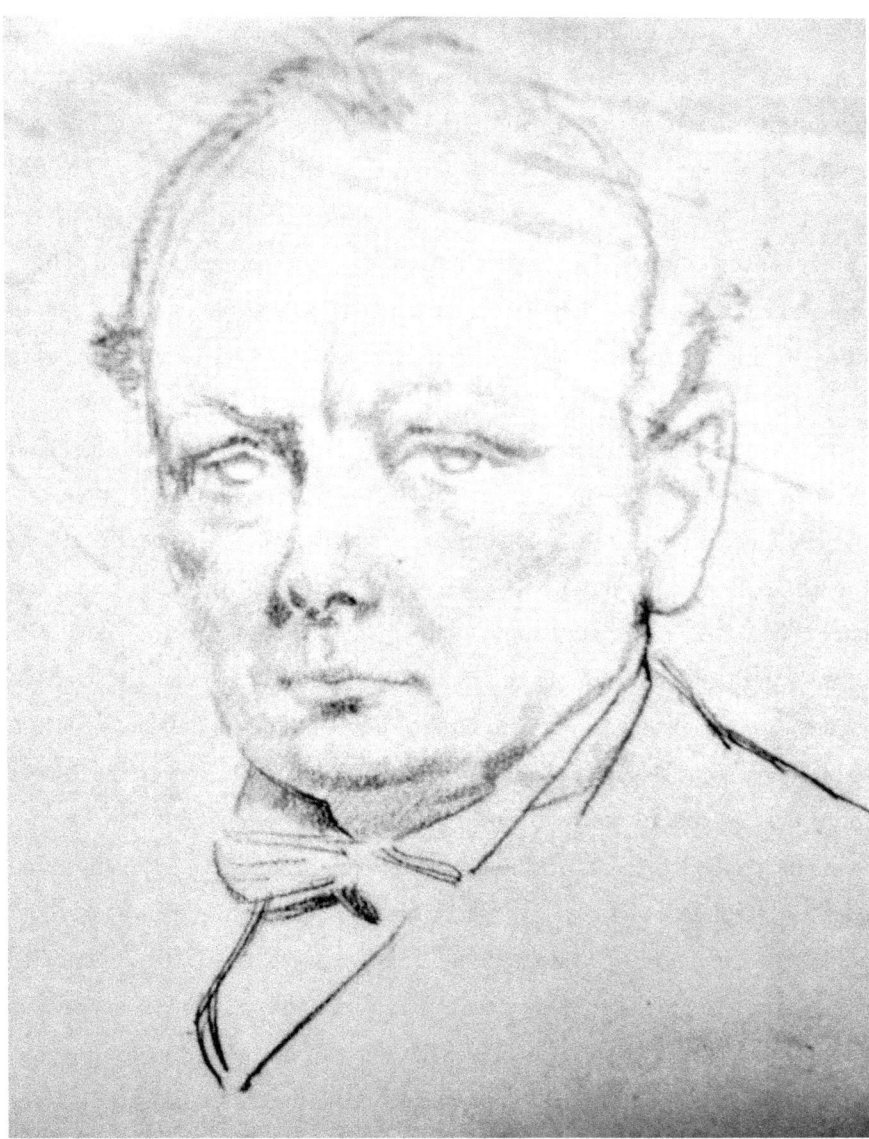

FIGURE 2.3 *Sir William Orpen (1878–1931),* Winston Churchill, *1916, oil on canvas, 148 × 102.5 cm, Trustees of the Churchill Chattels Trust; pencil preparatory drawing in a Private Collection, 26.6 × 22.3 cm.*

even as evidence of insincerity and shallowness. Sir Philip Sassoon's friend and editor of *The Times*, Geoffrey Robinson, had seen Churchill in uniform in person and 'on canvas' (presumably Lavery's portrait) and then in the Commons giving a bravura performance. Writing in August 1916 Robinson found he had to ponder: 'The simple fact that he [Churchill] left for the trenches amid the applause of an emotional House of Commons . . . and was back again in politics almost before there was time to turn around . . . The attempt to get the best of both worlds as soldier and politician was absolutely characteristic of a thoroughly unstable character.'[72]

In the summer of 1916, newspaper magnate Lord Rothermere commissioned William Orpen to paint Churchill wearing the well-cut if somewhat old-fashioned and Edwardian clothes he usually wore for the Commons (Plate 4).[73] In all Churchill gave Orpen eleven sittings during a period he was later to describe as 'a very unhappy time of my life'. The painting was a favourite of the sitter's and adorned his London dining room until the end of his days. Winston was at his most sombre in Orpen's portrait but it remained, according to his then private secretary Sir Edward Marsh and later successor in the role Sir John 'Jock' Colville, by far his favourite portrait of his younger self.[74]

As he sat to Orpen, Churchill was striving mightily hard to clear his name over the Dardanelles fiasco. However, Prime Minister Asquith would not allow publication of the relevant documents. Then, early in July 1916, a possibility that Winston might become Minister of Munitions fell through.[75] Winston had never felt more depressed, more banished utterly from the centre of important events. He turned again to painting for solace while his hatred of Asquith grew. On 15 July 1916 he wrote from Blenheim Palace to his brother Jack: 'Asquith reigns, supine, sodden and supreme . . . Tho' my life is full of comfort, pleasure and prosperity, I writhe hourly not to be able to get my teeth effectively into the Boche. . .'.[76] Clementine Churchill had never seen her husband more depressed. She later told his eminent biographer, Sir Martin Gilbert, 'The Dardanelles haunted him [her husband] for the rest of his life. He always believed in it.

When he left the Admiralty he thought he was finished ... I thought he would never get over the Dardanelles. I thought he would die of grief.[77]

The portrait was exhibited at the RA in May 1917 (number 160) where it was admired by the courtier Reginald, Lord Esher. He mentioned the portrait in passing later that month when he wrote to the Conservative MP Sir Philip Sassoon. Orpen's skill as a portraitist had prompted him to speculate on

> the degree to which his [Churchill's] clever but unbalanced mind will in future fulfil its responsibilities He handles great subjects in rhythmical language and becomes quickly enslaved by his own phrases ... The power of Winston for good and evil, and is, I should say very considerable. His temperament is of wax and quicksilver and is [a] strange toy [which] amuses and fascinates l[Lloyd] George who likes and fears him.[78]

In his 1921 article on 'Painting as a Pastime' Winston referred in passing to his admiration for Orpen's pictorial judgement: 'Sir William Orpen advised me to visit Avignon on account of its wonderful light. ...' Winston did indeed go there in 1931 for a painting holiday.[79]

While he was Prime Minister (1940–1945) Orpen's portrait hung inside 10 Downing Street. It can be clearly seen in Cecil Beaton's photograph of Clementine Churchill taken early in September 1940. A year later Churchill was photographed in Ottawa and it is intriguing and perhaps revealing that, given a few minutes for the photograph, he automatically, instinctively assumed the pose of the Orpen portrait painted a quarter of a century previously; left hand on hip, shoulders slightly hunched, the head inclined slightly forward, a heavy gold watch chain stretched across the stomach almost serving as a form of defensive armour.

In February 1949, Sir John Rothenstein, then Director of the Tate Gallery, studied the painting with Churchill. 'When I praised his portrait by Orpen for the closeness of the observation it showed, he said: "Yes, it is good; he painted it just after I'd had to withdraw our forces from the Dardanelles and I'd got

turfed out; in fact, when he painted it, I'd lost pretty well everything."'[80] For what was to prove their last meeting, in 1958, Clare Sheridan found a depressed and unwell Churchill staring at the Orpen portrait. She tried to cheer him up but he grunted in a low tone, 'in the end it has all been for nothing'. Sheridan remonstrated with him: he had seen off Hitler and been right about Communism which had completely deceived her. He, however, was still preoccupied with the events of 1915:

> If the Dardanelles had come off it might have been a different story for the whole world ... So many brave men have died since through stupidity. We could have ended the whole thing back in 1915 ... we had to fight those Nazis – it would have been too terrible had we failed. But in the end you have your art. The Empire *I* believed in has gone.

She left him with his eyes still fixed on the Orpen portrait.[81]

On 18 July 1917, against considerable opposition from the Conservative Party, Lloyd George appointed Churchill his Minister of Munitions.[82] Immensely relieved to find himself rescued from political oblivion, Churchill relished the opportunity to make a success of his new position. Under his authority the Ministry doubled in size, from 12,000 to 25,000 employees by the end of the war in November 1918. Churchill revealed a distinct flair for publicising its activities to the wider British public.[83] More than most of his colleagues he proved himself willing to work closely with the Ministry of Information to improve public understanding of how vital Munitions was to the nation's war effort. He displayed a very real 'common touch', willing to place himself with just a single detective as a bodyguard in the centre of crowds of hundreds of munition factory workers – some of whom had until recently been on strike for improved pay and conditions.[84] Touring some recently restive Glaswegian shell-filling factories that were part of his Ministry in the autumn of 1918, he ensured photographers from the Ministry of Information were close at hand to record his easy-going civility and 'puckish' grin charming the local 'munitionettes' (Figure 2.4).

FIGURE 2.4 *Photograph of Churchill as Minister of Munitions with female munitions workers at Georgetown Works near Glasgow, 9 October 1918; Imperial War Museum, Q 84077.*

Just over a month after this photograph was taken, the First World War came to an end. Lloyd George judged Churchill to have been a success as Minister of Munitions and, after winning the General Election of December 1918 promoted him to become Secretary of State of War and the Air.[85] The Prime Minister greatly admired Churchill's drive and energy but became increasingly concerned that he was becoming obsessed with crushing the Bolshevik regime in Russia. Lloyd George worried that his opinionated subordinate would plunge Britain into a full-scale conflict with the Bolsheviks which could only further damage a British state still recovering from the ravages of the First World War.[86]

3

Churchill's Roaring Twenties: From Liberal to Conservative

In his *Daily Express* cartoon of 8 September 1919 (Figure 3.1), Sidney George Strube, one of Churchill's favourite cartoonists by the early 1930s,[1] neatly and amusingly visualises the very real dilemma over British policy towards the new Soviet Russian regime Churchill confronted as Secretary of State for War in September 1919.[2] The previous July, directed by Lloyd George, the British War Cabinet had voted that all British forces currently in Russia fighting on the side of the anti-Bolshevik Whites had to be out of the country by the end of October 1919.[3] Officially, therefore, as Secretary of State for War, Churchill was to ensure no further British troops were committed to the White cause in Russia. At the time, however, Churchill was doing his utmost to expand the existing British Military Mission to the White Volunteer Army in South Russia and south-eastern Ukraine.[4]

A fortnight after the cartoon was published, Lloyd George discovered what Churchill had been up to and sharply reprimanded him in cabinet. He complained that Churchill's anti-Bolshevik 'obsession' – Lloyd George wondered why Churchill was 'irrational' about the Bolsheviks, perhaps because he was the grandson of a Duke and the Bolos (Bolsheviks) had a habit of

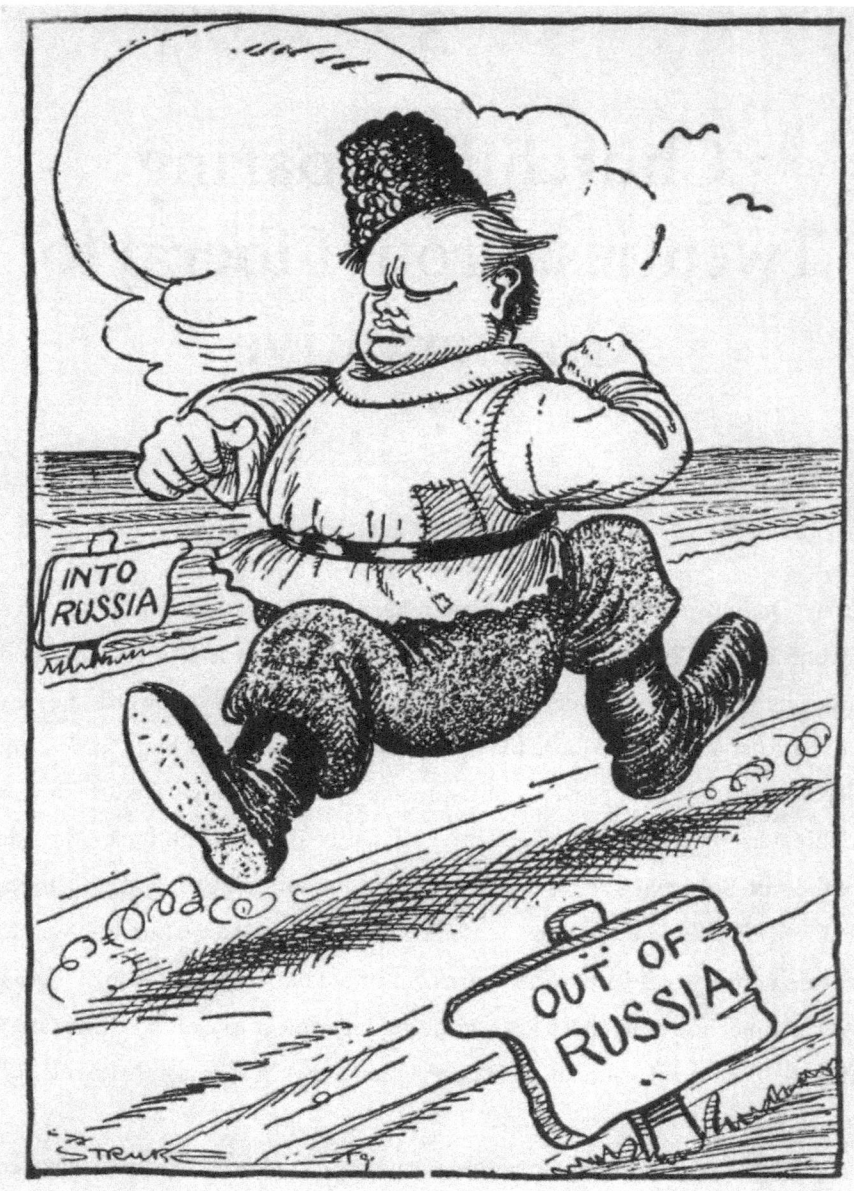

FIGURE 3.1 Sidney George Strube, 'We Don't Know Where We Are Going, But We Are On Our Way', Daily Express, *8 September 1919.*

cheerfully murdering Grand Dukes – had already cost the British taxpayer £100 million the nation simply could not afford.[5] The evening of the cabinet meeting the Prime Minister sent his War Secretary a plea: 'I wonder whether it is any use my making one last effort to induce you to throw off this obsession which if you will forgive me for saying so, is upsetting your balance ... The re-conquest of Russia would cost hundreds of millions. It would cost hundreds of millions more to maintain the new government until it established itself.'[6] Such a level of expenditure on the White cause in Russia might well have provoked a revolution in Britain. Two months to the day after the cartoon appeared, Lloyd George, with great fanfare in the Guildhall, announced that all military and financial assistance to the Whites in the Russian Civil War had ceased.[7] However, by the spring of 1920, Churchill was surreptitiously encouraging the recently established Polish government, under General Pilsudski to attack Red Russia.[8]

Sheridan was Churchill's first cousin – her mother Clara Frewen (née Jerome) was Jennie Jerome, Lady Randolph Churchill's elder sister.[9] She had been friendly with Churchill since the early years of the twentieth century when he encouraged her to write.[10] He was also friendly with her future husband, Wilfrid Sheridan, whom she married in October 1910. She later recalled that she saw quite a bit of Churchill after Wilfred was killed in action in France in September 1915. He felt protective towards Sheridan, his 'gallant Coz', as a relative and a widow, bringing up two small children and striving to make a name for herself as a sculptor.[11] He helped her to rent, late in 1916, a studio in St. John's Wood. He then steered a commission her way to model the head of the recent Prime Minister, Herbert Henry Asquith for the Oxford Union.[12]

The idea that Churchill should sit for Sheridan, however, came from another of Churchill's first cousins, Frederick 'Freddie' Guest (1875–1937), the Winchester-educated third son of Ivor Guest, 1st Baron Wimbourne, and Lady Cornelia Spencer-Churchill – daughter of the 7th Duke of Marlborough and sister to Churchill's father Lord Randolph.[13] In 1919, Guest was Chief Whip to the Coalition Liberals led by David Lloyd George and widely feared as 'the

rudest man in the House of Commons'.[14] In November that year he proposed that Sheridan produce a series of portrait heads of his political friends and allies such as F.E. Smith, Lord Birkenhead (then the Lord Chancellor) and Churchill (as Secretary of State of War) (Figure 3.2). He paid for the portraits to be cast in bronze and then displayed in a sort of 'temple of worthies' he had erected in the garden of his large home, Templeton House in Roehampton.

Circumstances for sittings for both portraits were not at all ideal as Churchill claimed he had little time for them, while Sheridan had embarked on a passionate affair with Smith, who was anxious to conceal this development from both his wife and the press. Sheridan later recalled that she found herself modelling every Sunday in December 1919 not one but three portraits at the same time at Guest's Roehampton home: one of her host, one of 'FE' and one of Winston – who was invariably painting as he was scrutinised by Sheridan and sometimes simultaneously sketched by a mutual friend, the painter Ambrose McEvoy. Sunday was the only day Churchill claimed he could spare for 'sittings', though they were hardly sittings at all as he stubbornly looked out of the window at a cedar tree which had taken his fancy and which he was determined to capture in paint.[15]

Later in the 1920s Sheridan described how: 'McEvoy would try to paint Winston while Winston painted me and I modelled him [in clay]. No one would keep still for the other and it was small wonder that no one got very far. Of all the portraits I have ever done Winston's was the hardest, not because his face was difficult, but because it was for him a physical impossibility to remain still... Sunday was his only day to paint and so I waited and watched. I snatched at times and moments, I did and undid and re-did... Smith would often pop his head round the door and beseech him "to give her a chance... it's for me Winston".'[16]

> Winston would be contrite and promise and say he was sorry ... and he would sit compassionately for three minutes and begin to fidget. Not only would he not keep still for me but more usually he expected me to keep still

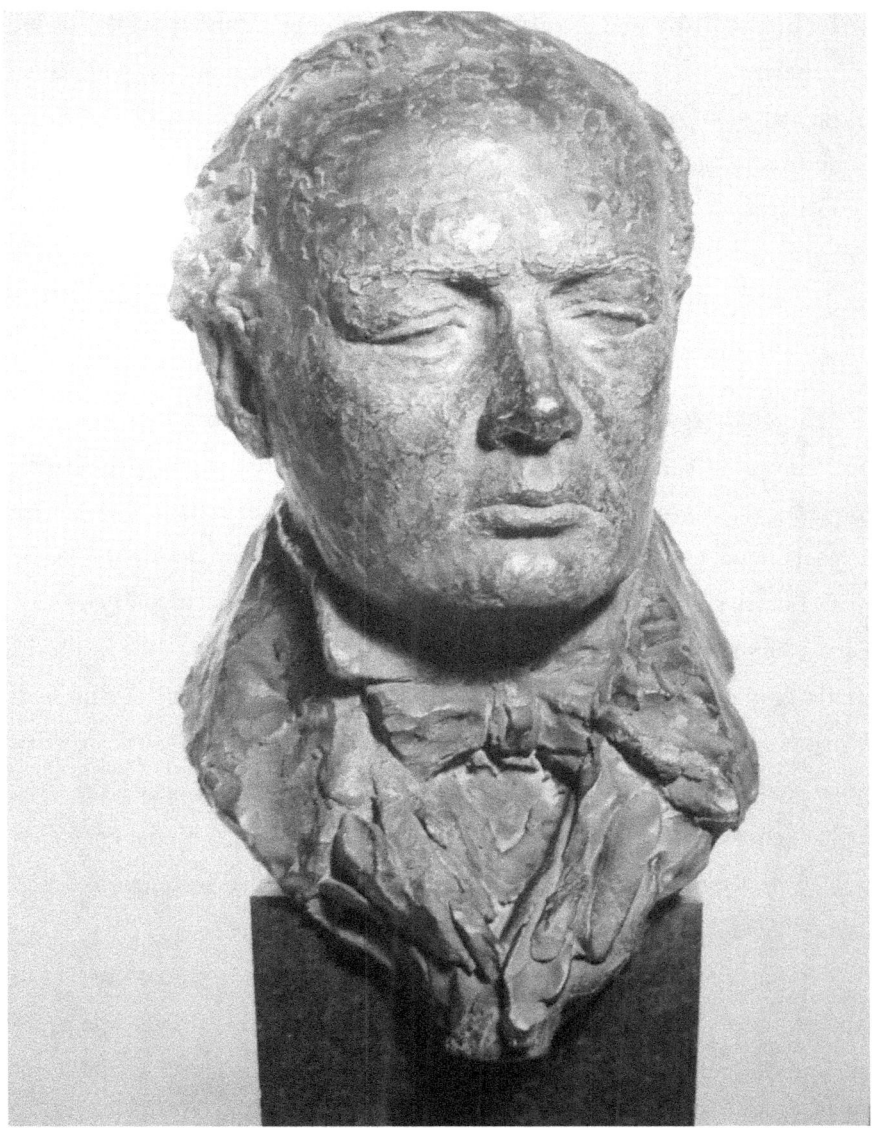

FIGURE 3.2 *Clare Sheridan (1885–1970)*, Head of Winston Churchill MP, *1919–1920, plaster and bronze casts, 56 cm high, 1919, Private Collection.*

for him!.... Now and then Winston, remembering me and that I was trying to portray him, would stop still and face me with all the intensity with which he had been painting. These were my momentary chances which he called sittings! When the light faded he would leave his canvas and turn excitedly to the window [to look at the cedar tree he was painting] for the sunset background. During one of those passionate moments of trying to catch the dying colour he said to me, without turning 'Sometimes, I could almost give up everything for it'.[17]

She would beg Churchill to 'sit still on the revolving stand, but he just could not. He would suddenly wander off to look out of the window completely forgetting that he was supposed to be posing...'. It was 'not until the day that she coaxed him on to the stand and he started to knead a piece of clay himself did he really remain still'. He exclaimed with delight: '"But you can do anything with it!" Four hours later he was still absorbed in his little clay figure ... the head was nearly finished.' Then they were 'alerted by the dressing [for dinner] gong' and Winston sprang to his feet. Coming down to dinner Churchill looked at Sheridan 'quizzically' and declared: 'you'll never get four hours from me again'. The artist replied relieved: 'I won't need to, it hardly needs touching.' After dinner her efforts were inspected by Guest, FE and Winston. Guest then invited 'his guests to dance, or they could listen to Winston ... Choose – you cannot do both!'[18]

She was trying to finish the head in her St. John's Wood studio but had to fend off the enamoured Smith. Sheridan's mother was scandalised – she wrote to Churchill's mother and 'begged her to ask Winston to speak to FE about it but she says he does not care. He adores Clare, thinks she can do no wrong at all after all she has suffered [the death of her husband at Loos] and he is *devoted* to Lord Birkenhead – you know how he always stands by his friends. So, whatever scandal these two create together is in Winston's view no scandal at all – they are "splendid"....'.[19] Sheridan defended her conduct on the grounds that she was 35 years old and 'after what I have been through this is a happy interlude – Winston, FE and myself – we *get on together*'.[20]

The affair with Smith continued at full pace during the spring and summer of 1920. On 17 August, Sheridan gave a luncheon in honour of Churchill, whose head had been recently cast, Ambrose McEvoy, who had recently finished his portrait of Churchill, and Agnew of the Gallery who had offered a Sheridan a solo show in October. Sheridan's brother Oswald was also present and that evening noted in his diary that 'Winston was interesting about the Bolsheviks...'. The French had just recognised Baron Wrangel, whom Churchill greatly admired, as head of the White Movement. The French were to be applauded but he feared the White cause had run its course. 'He said: nobody hated Bolshevism more than he, but Bolsheviks were like crocodiles. He would *like* to shoot everyone he saw, but there were two ways of dealing with them – you could hunt them, or let them alone and it was sometimes just too expensive to go hunting for them forever.' Oswald thought this revealed a very different side to 'our fire-eating Minister for War'.[21]

Only three days previously, on 14 August 1920, Sheridan had met Lev Kamenev, head of the Soviet Trade Delegation in London. She had made it clear she would like to model his head – even though at first she thought he resembled a 'French bank manager'. Kamenev was delighted that 'a cousin of Winston Churchill' wanted him to sit for a portrait. Within three weeks she and Kamenev were having an affair and she was determined to go to Moscow to sculpt the heads of Lenin and Trotsky. Her brother Oswald did not approve and thought the 'Bolshies a degenerate lot'. In his diary he reflected: 'she has got "Bolshevism" badly – she always reflects the views of the last man she's met – and I think it may cure her to go and see it ... if I thwarted her by telling Winston, she'd never confide in me again...'.[22] He thought his sister was playing with fire when it came to Winston. If he found out, he could withdraw her passport, stop her leaving the country (she had obtained a visa to go as far as Stockholm), or even have her arrested. Churchill thought Sheridan would soon be joining him and the Lord Chancellor for a cruise on Smith's yacht.[23]

By the last week of September 1920 Sheridan was in Soviet Russia, first Petrograd and then Moscow where she produced a series of portraits of

Bolshevik leaders from late September to late October 1920 (Zinoviev, 'Iron' Felix Dzerzhinsky, Lenin and then Trotsky). She was back in London by 23 November 1920; Winston was furious with her and her statements to the press that Communism was good for Russia, though she had not been converted nor did she think Communism would work in Britain. Lenin had sat for her for five hours in the Kremlin on 7–8 October 1920; he told her that Churchill was 'the most hated Englishman in Russia'. He was also the Soviet state's most dangerous opponent as he had 'all the force of the capitalists behind him'. On 8 October he stared long and hard at a photograph she gave him of her recent head of Winston. Winston had recently referred to the Red Army as 'an army of fleas' – he would learn soon enough how these fleas would carry the contagion of Bolshevism westwards.[24]

Trotsky, as Commissar for War and Churchill's Soviet counterpart, sat for Sheridan between 18 and 20 October 1920. During the sitting on 19 October he joked he would take Clare hostage and threaten to shoot her if England did not make peace with Russia. He was impressed when she said Winston would simply say 'then shoot'. She stated: 'Winston is the only man I know in England who is made of the stuff that Bolsheviks are made of. He has fight, force and fanaticism.' Trotsky studied her photo of the head of Churchill, the one she had previously shown Lenin, and said he could see her estimation of her cousin's character in the face. Churchill was probably the only capitalist leader who understood how dangerous the Bolsheviks really were.[25]

Back in the UK early in November 1920 Sheridan tried to contact Churchill but he would not see her. She feared she might be arrested; it would seem she was put under surveillance by MI5 and reports were sent to Churchill (until he became Colonial Secretary in February 1921). Churchill did not see much of her during 1920–1921. However, on 27 January 1921, he wrote to Sheridan:

> You did not seek my advice about your going and I was not aware that you needed any on your return ... It was almost impossible for me to bring myself to meet you fresh from the society of those whom I regard as fiendish

criminals. Having nothing to say to you that was pleasant, I thought it better to remain silent until a better time came. But that does not at all mean that I have ceased to regard you with affection, or to wish you most earnestly success and happiness ... While you were flushed from your adventure, I did not feel you needed me and, frankly, I thought I could not trust myself to see you. But no one has felt more sympathy, or admiration, for your gifts and exertion than I have and I should be very sorry if you did not feel that you could not count on my friendship and kinship.[26]

He did not purchase a cast of the head that had so intrigued Lenin and Trotsky; Sheridan later recalled that Guest bought a bronze Winston for his 'Roehampton temple' while she was pleased with it as a portrait – one could 'almost hear that formidable machine [of his brain] ticking'.[27]

* * *

Ambrose McEvoy's enigmatic and rather haunting portrait of Churchill (Plate 5) remained in the possession of the artist until his death in 1927. Thereafter it was owned by his daughter who was based in Toronto. In December 1943 she offered the portrait to Churchill but he declined on the grounds he could not accept gifts from private individuals while in office.[28] In December 1953 the portrait was included in an exhibition at the Leicester Galleries where it was bought by William Ewart Berry, 1st Viscount Camrose (1879–1954). Berry was owner of the *Sunday Times* from 1915; in 1924 he purchased the *Sunday Graphic* and *Sunday Chronicle*, and in 1927 the *Daily Telegraph*; and ten years later he took over the *Morning Post* and amalgamated it with the *Post*. He was raised to the peerage in 1921; in June 1929 he was made Baron Camrose, then Viscount Camrose in January 1941. From early in the First World War Camrose supported Churchill politically and financially; in the late 1920s he helped him after he lost a large sum of money speculating on the New York Stock Exchange.[29] In 1946–1947 Churchill almost went bankrupt and nearly had to sell his beloved Chartwell. Camrose helped to raise nearly £45,000 to buy Chartwell Manor from Churchill for the nation and then allowed him to live there for the rest of his life at a nugatory rent.[30]

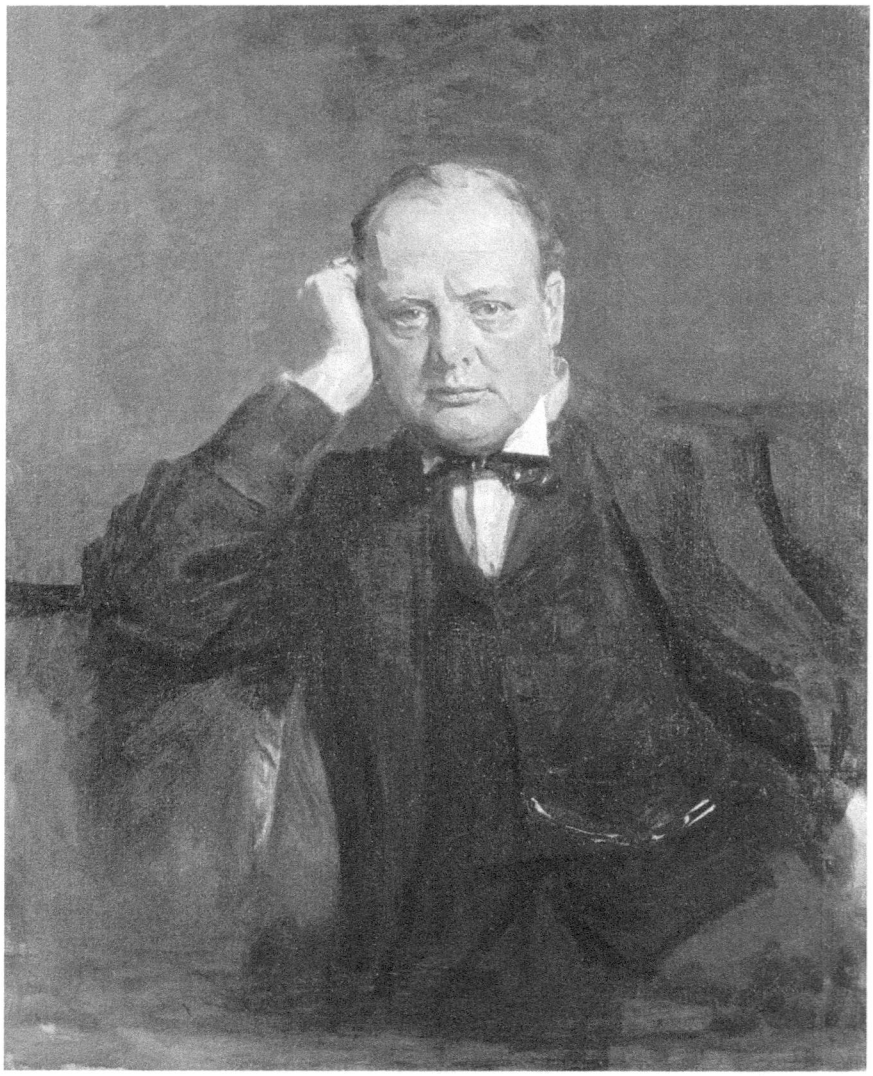

FIGURE 3.3 *Sir James Guthrie (1859–1930)*, **Study of Winston Churchill**, *1919–1920, oil on canvas, 91.5 × 71.1 cm, Scottish National Portrait Gallery, Edinburgh.*

Sir James Guthrie's sketch of 1919–1920 (Figure 3.3) shows Churchill looking serious, even severe; he is putting on weight and fast losing his hair. His very pose rather accentuates the prominence of his stomach on which lies the heavy gold watch chain – already something of an anachronism after the First

World War when younger men had taken up the wristwatch as more practical given the demands of trench warfare. Churchill does seem to be leaning slightly forward as if under a great weight. He had a multitude of problems with which to wrestle as Secretary of State for War from early January 1919: urgent demobilisation of a near mutinous British Expeditionary Force in France; a deteriorating security situation with the imminent threat of guerrilla war throughout much of Ireland; British troops were required to occupy the German Rhineland while he was increasingly worried that British-backed, anti-Bolshevik White forces would be defeated in the Russian Civil War.[31] The sketch portrait is certainly more convincing and compelling than the more idealised concept in the final vast canvas – with Churchill dominating the centre, head picked out in a shaft of bright sunlight. Guthrie later in the 1920s recalled the sketch was painted, amidst multiple interruptions, between the spring of 1919 and spring of 1920. During the early part of the period his sitter would suddenly disappear off to Paris to participate in the great Peace Conference – Churchill was particularly exercised that he wanted to expand British anti-Bolshevik activities in Russia whereas Lloyd George wanted them to be smartly wound up. Meanwhile, Churchill wrestled with finding enough experienced soldiers to serve in southern Ireland and in the Rhineland.

Guthrie described Churchill as one of the most engaging, charming, stimulating and yet infuriating sitters he had ever faced. Appointments would be made and then cancelled at the last minute; when Churchill was present he found it almost impossible to sit or stand still, pacing around his room at the War Office, a newspaper in one hand while one huge cigar after another was smoked. Just as he came to rest, seated or leaning against his desk piled high with maps and official papers, the telephone would ring or a messenger would appear at the door, prompting Churchill to spring to his feet for another rapid circumnavigation of the room and another visit to look out of the window for signs of activity in the courtyard below. Guthrie had the distinct impression that Churchill was awaiting the imminent arrival in that courtyard of the latest batch of volunteers for Russia or Ireland. Once they had materialised he would

most likely inspect them, drill them and then march them to the necessary railway station for departure to ultimately confront the King's enemies.[32]

Guthrie thought his restless sitter had a personal antipathy towards the Bolsheviks (dubbed 'Bolos') and Sinn Feiners (known as 'Shinners'). British troops had been evacuated from North Russia by the end of October 1919; Churchill, however, contrived to keep sending a trickle of British officer and NCO volunteers to the White Army in South Russia until late March 1920.[33] He had also encouraged the controversial recruitment of volunteers to supplement the Royal Irish Constabulary, known as 'Black and Tans' and as 'Auxis' (Auxiliaries) from April–May 1920. Some of these troops would shortly be involved in possible war crimes against ordinary Irish civilians.[34]

Guthrie evidently found Churchill one of the outstanding personalities he sketched for *Some Statesmen of the First World War* (Figure 3.4). The composition was inspired by the backdrop of the Peace Treaty signing at Versailles; Churchill, in actual fact, had not occupied that prominent role. Indeed, he could only be present at the express wish of the Prime Minister. He was only allowed to address the Supreme Allied War Council twice, on 14–15 February 1919, and his proposal, to establish an 'Allied Council for Russian Affairs' was rejected by the Americans who had been made aware that it was opposed by Lloyd George.[35] By the time Guthrie's huge canvas was exhibited for the first time, in London in October 1930, Churchill would no longer be in government; he was still an MP, but within a year he had resigned from the Conservative Shadow Cabinet over his opposition towards any form of self-rule for India.[36]

New Zealander Sir David Low arrived in London in November 1919 and between then and 1927 worked as the lead cartoonist for the left-liberal newspaper *The Star*. A brilliant draughtsman, Low would become one of the finest cartoonists to work in Britain in the twentieth century. He later recalled in his autobiography that on arriving in London, Churchill soon caught his attention as a talented politician somehow immune to his past record of failure and mishap and an intelligent conservative absolutely determined to defend

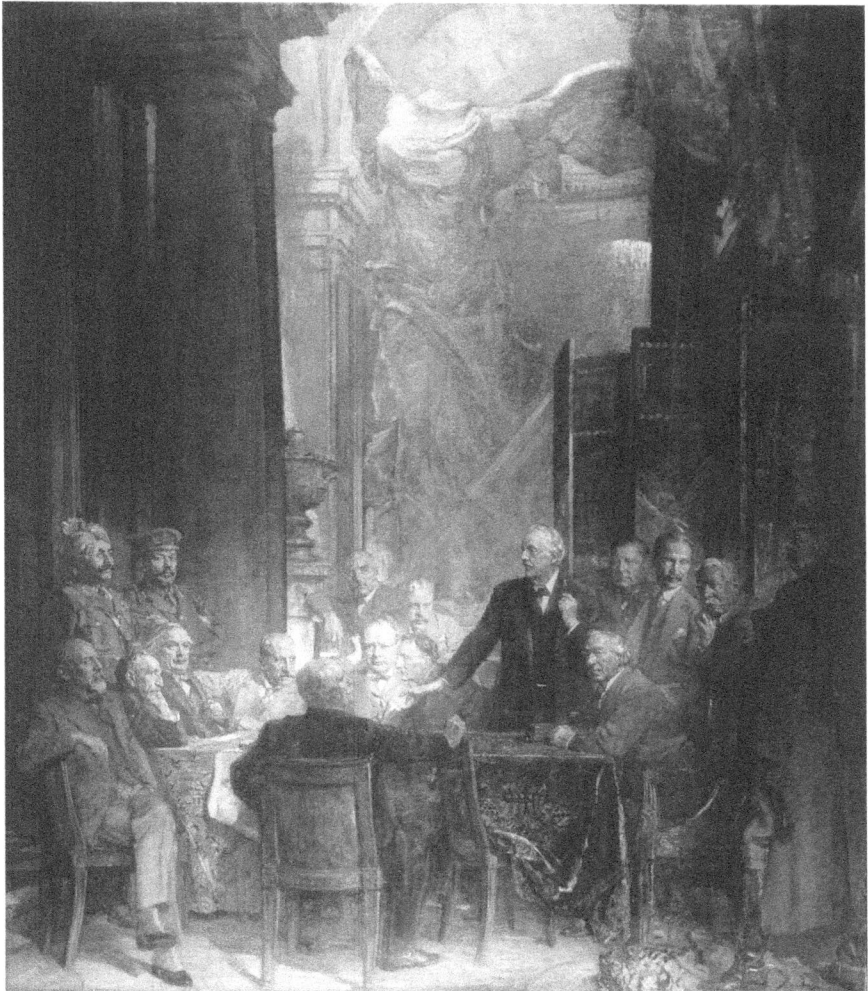

FIGURE 3.4 *Sir James Guthrie,* Some Statesmen of the First World War, *1924–1930, oil on canvas, 396.2 × 335.3 cm, National Portrait Gallery, London.*

and preserve the existing social order (Figure 3.5). A persuasive and appealing orator but a reactionary to the core all the same was Low's verdict, having met Churchill at a dinner party in 1922.[37]

Churchill was half-American, on his mother's side, and his mother, Jennie Jerome, was reputed to have had a Cherokee ancestor.[38] In his gentle way, Strube seems to be hinting in Figure 3.6 that there was something savage,

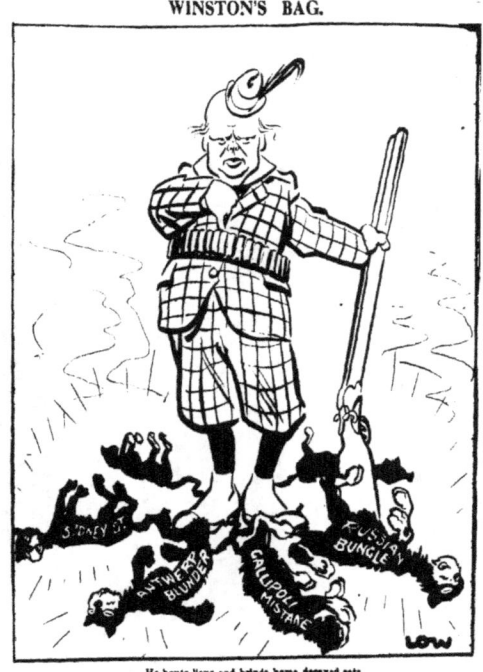

FIGURE 3.5 *Sir David Low (1891–1963), 'Winston's Bag: He hunts lions and brings home decayed cats', The Star, 21 January 1920.*

excessive and unbalanced about Churchill's vehement anti-Bolshevism. His relish for combat in the Commons was interpreted as a desire for further war, this time against the new Soviet regime. Without the backing of the Prime Minister, a direct assault on Lenin's Russia was not possible. However, Churchill was widely suspected of seeking a proxy struggle to be waged by Poland and in April 1920 the Poles did indeed invade the Ukraine, advancing as far as Kiev.[39]

In Figure 3.7 Low appears to be suggesting that Churchill has become so obsessed with the dictatorial Soviet leaders that he would be tempted to try to emulate them in a British context. He would not be too resistant to the possibility of assuming supreme and unchallenged power for himself (Low could not have anticipated that within two months Lenin and Trotsky would be closely examining a photograph of Churchill's portrait bust by his cousin

FIGURE 3.6 *Sidney George Strube, 'Chief Ear-To-The-Ground Winston' (Churchill as Red Indian chief holding tomahawk can hear 'a little war coming in the East'),* Daily Express, *23 January 1920.*

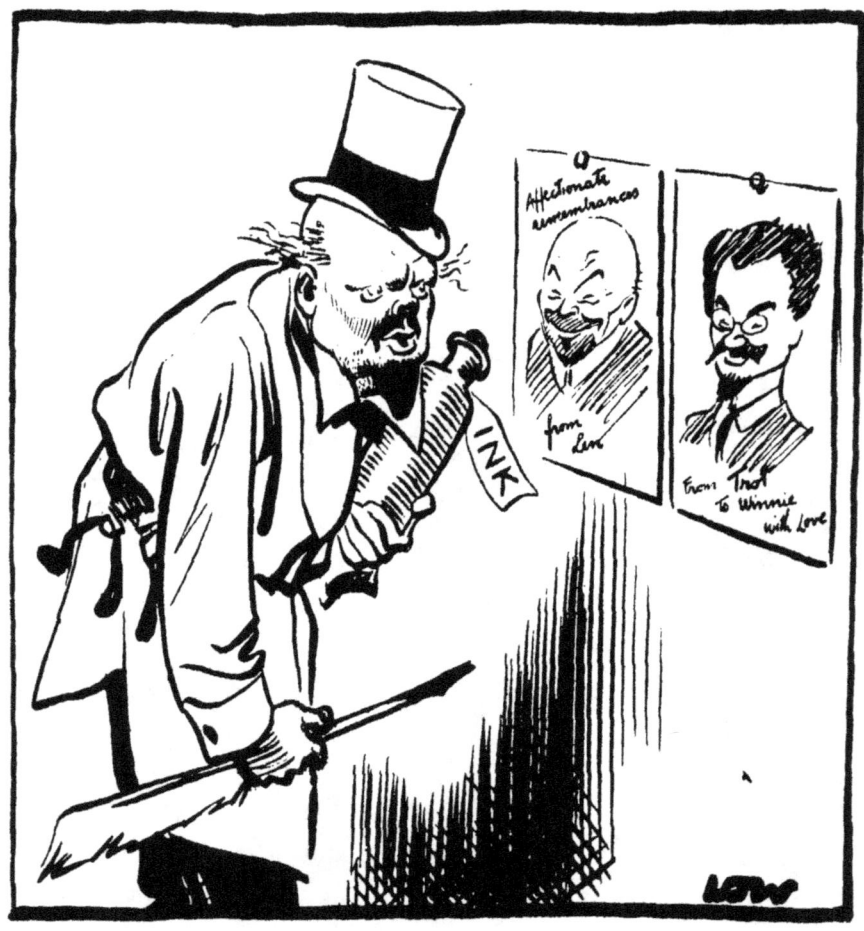

FIGURE 3.7 *Sir David Low, 'Winstonsky: The Horrifying Effect of Concentrating on Russian Affairs', The Star, 12 August 1920.*⁴⁰

Clare Sheridan).⁴¹ By the time this cartoon was published, Churchill's Eastern policy seemed destined to utter failure; the Poles under Marshal Pilsudski had been inexorably pushed back from Soviet territory and the Red Army had advanced to the eastern suburbs of Warsaw. Alarmists in Britain predicted the Polish capital would fall and the Reds would overrun all of Poland to advance on Berlin and into the very heart of Europe.⁴²

Despite the best efforts of the British Trade Unions, Churchill as Secretary of State for War was determined to send the Poles as much military equipment as possible, derived from British Army war surplus.[43] However, four days after the cartoon was published the Poles launched a massive counter-attack from their lines to the south-east of the capital which took the advancing Red Army completely by surprise. By the end of the month the Russians had been routed and were in headlong retreat.[44] From his earliest images of Churchill, Low implied there was something a little unhinged, irrational as well as politically calculating about his oft-expressed anti-Bolshevism; the Red Scare could be deployed to shore up the flagging fortunes of the coalition government.[45]

Low delighted in depicting Churchill in all manner of outlandish animal guises; his cartoon of 10 May 1922 in *The Star* (Figure 3.8) was the first occasion he presented him as a rhinoceros, tough of hide, short of sight but extremely keen of smell. In the late spring and early summer of 1922 Churchill was actually much more preoccupied with Irish Nationalist terrorism within the UK. On 22 June 1922, his close wartime colleague and now prominent Ulster Unionist Field Marshal Sir Henry Wilson was assassinated on his own doorstep in Belgravia by two Irish gunmen opposed to the terms of the recent Anglo-Irish Treaty of December 1921.[46] Churchill became convinced that anti-Treaty nationalists would soon make an attempt on his life. For several nights he took to the attic at Chartwell Manor, recently purchased and still under extensive reconstruction, and barricaded himself behind an iron sheet with a loaded revolver close at hand.[47]

Churchill had lost his Dundee seat in the General Election of November 1922;[48] he stood for the last time as a Liberal candidate in Leicester West in December 1923[49] but without success. He then stood as an anti-socialist candidate for St George's Westminster and came close to victory over his Conservative opponent – signalling to the party leadership that he would be a highly useful addition to its ranks in government.[50] Despite Low's cartoon (Figure 3.9) in October 1924 presenting Churchill's career to date in a decidedly

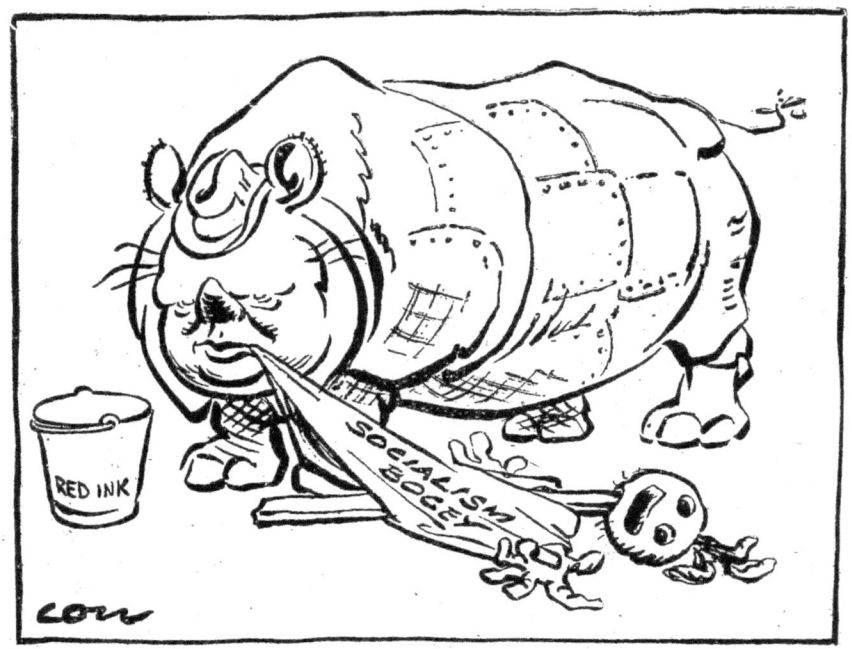

FIGURE 3.8 Sir David Low, 'Low's Zoo VI: The Winstonoceros and Its Prey the Socialist Bogy', The Star, 10 May 1922.

baleful and negative light, Churchill would be elected in that month's General Election by a handsome majority for the seat of Epping (West Essex); he would hold the seat with a few minor wobbles for the next 40 years.[51] He was accepted back into the ranks of a highly wary Conservative Party largely at the behest of its canny leader, Stanley Baldwin, who became Prime Minister early in November 1924. Much to Churchill's amazement, Baldwin promptly offered him the major cabinet post of Chancellor of the Exchequer – for once, taken completely by surprise, he accepted.[52]

John Singer Sargent's *Winston Churchill in his Robes as Chancellor of the Exchequer* (Figure 3.10) is a sensitive, low-key and appealing portrait of

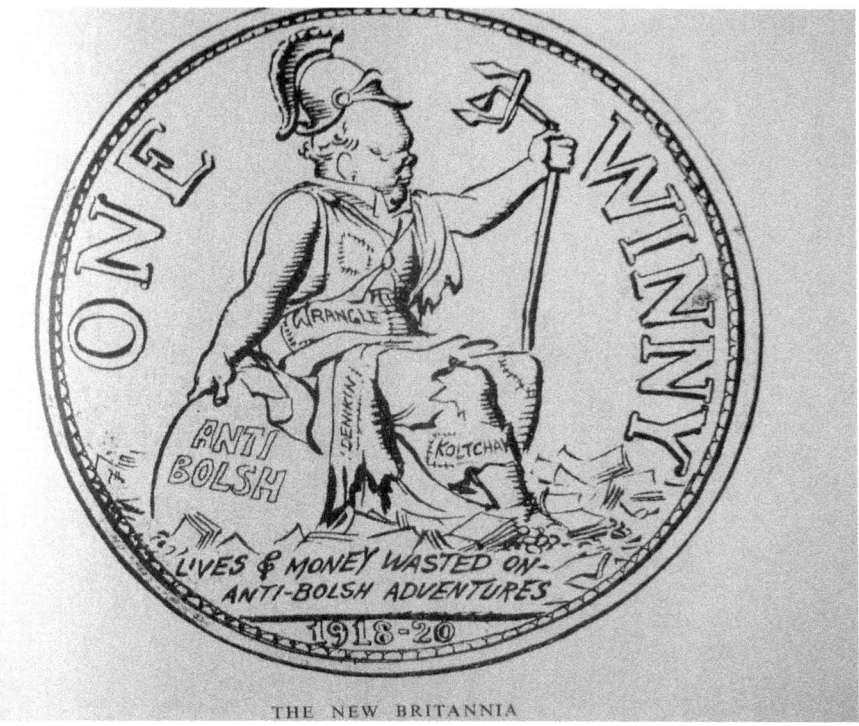

FIGURE 3.9 *Sir David Low, 'The New Britannia: Lives and Money wasted on Anti-Bolshevik Adventures, 1918-20',* The Star, *11 October 1924.*

Churchill who seems almost diffident in the splendid sartorial finery of his office. Had the artist sensed that his usually ebullient and supremely self-confident sitter was not at ease as Chancellor? Managing the finances of the nation must have been especially daunting to a man whose own finances were invariably under strain and over-stretched. During this period he also instinctively doubted the 'conventional wisdom' urged by the establishment led by Sir Montagu Norman, Director of the Bank of England, that he should return Britain to the Gold Standard.[53] After much soul-searching and seeking advice from strongly opposed alternative voices such as John Maynard Keynes, Churchill implemented a return to gold in April 1925.[54] He later acknowledged he had made a mistake and should have remained true to his initial reservations, however unorthodox.[55]

FIGURE 3.10 *John Singer Sargent (1856–1925)*, Winston Churchill in his Robes as Chancellor of the Exchequer, *1925, charcoal drawing, 72.5 × 58.5 cm, National Trust, Chartwell, Kent.*

Sargent probably drew Churchill in his robes as Chancellor early in 1925 at the behest of Sir Philip Sassoon (1888–1939) who had been friendly with Sargent since 1907 and with Churchill and Clementine since around 1913 – Sir Philip invited her to stay at his house at Port Lympne in Kent to recover from the difficult birth in October 1914 of her third child, Sarah.[56] In 1922 Sassoon recommended the architect Philip Tilden, who had recently remodelled his house at Port Lympne, to Churchill who was looking for someone to redesign the interior of Chartwell Manor.[57] Sassoon and Churchill shared a keen interest

in air power and in November 1924, as Churchill became Chancellor of the Exchequer, he urged Baldwin to make Sassoon Secretary of State of the Air – which the Prime Minister duly did.[58] Shortly thereafter, Sassoon, who encouraged Churchill's painting activities, lent him a number of paintings by Singer Sargent which he knew Churchill admired and wanted very much to copy.[59] The portrait of Churchill must have been one of Sargent's last formal commissions as he died on 14 April 1925.

Early the previous month, as he was settling into Number 11 Downing Street, Churchill wrote to his wife: 'Philip [Sassoon] came here last night and fell into raptures over the Sargent drawing. I was hard put to it to reconcile truth and politeness. I wanted to point out the awful concavity of my right cheek. However, one must not look a gift portrait in the mouth.'[60] This would imply the drawing was a gift from Sassoon: a pleasant surprise, though the recipient had his reservations as to the absolute accuracy of the likeness. Evidently, Sassoon was pleased with the portrait as two months later he had a photograph of it glued into the Visitors Book at his country house in Middlesex, Trent Park (Figure 3.11), as a double tribute to a painter Sassoon regarded as the equal of El Greco and Velazquez[61] and the politician he admired tremendously for his energy, determination and mischievous good humour.[62] They also shared a passion for black swans.[63]

It is interesting what Powys Evans's skilful image (Figure 3.12) implies as to the dynamics of the intriguing relationship between Baldwin and Churchill. The latter was almost painfully aware that the former had saved his political career in October 1924 and had allowed him to return to the protective fold of the Conservative Party which remained extremely wary of the returning prodigal.[64] Churchill in his stylised fur-lined overcoat seems to tower menacingly over the tranquil, seated, informally dressed, pipe-smoking Baldwin. Evans is also drawing upon visual tropes already applied to depictions of the self-consciously sinister and enigmatic Greek-born international arms dealer and occasional philanthropist Sir Basil Zaharoff (1849–1936), never without an over-large and

FIGURE 3.11 *Photograph of Figure 3.10 stuck into the Trent Park Visitors Book, 18 July 1925.*

FIGURE 3.12 *Powys Evans (1899–1981)*, The Return of Mr. Churchill to the Conservative Party, *1926, lithograph (from* Eighty Eight Cartoons by Powys Evans*), Private Collection.*

luxuriantly fur-trimmed overcoat. Yet the political reality was that Baldwin, despite criticism of his low-key, rather placid, phlegmatic, uncharismatic public manner within the party, was in complete control of the Conservative Party. Churchill, in actual fact, had been the supplicant looking to the Prime Minister to return him to a cabinet position, however lowly – Baldwin cunningly and accurately calculated that his front benches needed an accomplished Commons performer, which Churchill undoubtedly was, and yet his potential for producing fireworks in office would be considerably curbed as he wrestled with the new and challenging brief of being Chancellor.[65] Evans also draws attention to Baldwin's highly successful prop – his pipe, which he was invariably photographed either holding or in the laborious process of lighting.[66] Low interpreted the pipe as a prop of genius to imply Baldwin was an ordinary common sense man of the people with predictable simple pleasures and not at all the millionaire Black Country iron manufacturer and industrialist he was in reality.[67]

As it transpired Churchill would be given the chance of engaging the Trade Unions in noisy confrontation at the time of the brief General Strike of 3–12 May 1926.[68] Just two days before the strike officially began, Low's incisive portrait of Churchill seated, smoking a cigar was reproduced in the *New Statesman* (Figure 3.13).

Low later recalled that he first met Churchill early in 1922 at a dinner given by then then Prime Minister, Lloyd George: 'Sitting opposite me was Winston Churchill. This was the first time I had seen him ... at close quarters. He belongs to that sandy type which cannot be rendered properly in black lines. His eyes, blur, bulbous, and heavy-lidded, would be impossible. The best one could do with him was an approximation....'[69]

Low's estimation then, which did not change significantly thereafter, was that Churchill was: 'An upholder of Democracy ... when he was leading it. Impatient with it when he was not. Consequently, not naturally a good politician – but astute from experience. As might be expected from his origins and temperament, inwardly contemptuous of the "common man" when the

FIGURE 3.13 *Sir David Low,* Winston, New Statesman, *1 May 1926.*

"common man" sought to interfere in his own government; but aware of the need to appear sympathetic and compliant to the popular will. In those days whenever I heard Churchill's dramatic periods about democracy, I felt inclined to say "Please define". His definition, I felt, would be something like "government of the people, for the people, and [for] paternal ruling-class chaps like me".'[70]

Low remembered Churchill as 'one of the most energetic mis-educators of public opinion in the early 1920's, when his dislike of political radicalism from below took him within hail of Fascism, when the rabbits of the TUC were held up as Russian bears and the idea of a Labour Government was alleged to mean the enthronement of Bolshevism at Westminster. I could never accept him as a Democrat in the Lincolnian sense. Winston's characteristics were confidence in himself and love of country. His defence of England was always against threatening foreigners rather than against threatening "isms" or "ologies" which did not worry him ... A high sense of the dramatic; a talent for self-advertisement and, to cap it all, imagination and guts.'[71]

Low found Churchill 'witty and easy to talk to until I said that the Australians were an independent people who could not be expected to follow Britain without question. His eyes bulged a little, his face seemed to rise and hang in the heavens and he ended the subject with a piece of rhetoric to which there could be no reply. His ideas of how I worked were fantastic. He thought I made a drawing in half an hour and I had some trouble in explaining that it would take longer than that to put the lines down on paper without appearing to draw at all. But for all that he had a genuine appreciation of quality in caricatural draughtsmanship. He flattered me by recalling some of my old cartoons which I thought forgotten. Once, on another and later occasion, he made me blush by advancing across a room full of people with pencil and paper, ostentatiously pretending to make a sketch of me. For all his playfulness I find that I wrote at the time of these first impressions: "Churchill is one of the few men I have met who even in the flesh give me the impression of genius. [George Bernard] Shaw is another ... each thinks the other is much over-rated."'[72]

Within a few days of this portrait being published, the General Strike began and Low's sympathies were very much on the side of the strikers. He got into trouble with his soon-to-be employer Lord Beaverbrook for the relish with which he proceeded to bait leading Conservative 'prima donnas' and opponents of the strike including F.E. Smith (the Lord Chancellor), Sir William Joynson-Hicks (the Home Secretary) and, especially, Churchill.[73]

Churchill met Walter Richard Sickert, the German-born master of British Post-Impressionism, thanks to his wife Clementine. Estranged from her husband, Clementine's mother, Lady Blanche Hozier, had taken her and her three siblings for a summer holiday to Dieppe in 1899. There Clementine encountered the, to her eyes, extremely dashing Sickert. Three years later they met again and Sickert was permitted to take her round the Paris Salon of 1902. Ironically, given how much her future husband admired the American artist, Clementine felt she had disgraced herself in Sickert's eyes by stating how much she admired the works of John Singer Sargent.[74] Thereafter they lost touch. However, Sickert re-established contact with Clementine early in the summer of 1927 when he read that she had been knocked down by a car in Westminster. The painter called on her at 11 Downing Street and his ready wit and verbal dexterity greatly appealed to both Churchills. Sickert was soon invited to return and to visit Chartwell.[75] With conspicuous lack of success Churchill tried to advise the painter how to put his finances on a sound basis. Sickert visited Chartwell several times, during August and September 1927, wearing red socks with his evening dress and singing risqué music hall songs after dinner. Churchill produced a small painting of Sickert from a photograph taken on 29 August 1927 on a camera given to him by his scientific adviser Professor Frederick Lindemann. Shortly thereafter Sickert painted, on his own initiative, a portrait of Churchill (see Plate 6) derived from a photograph and from pen-and-ink studies derived from the same photograph (see Figure 3.14).[76]

The result, painted in a lurid yet eye-catching combination of cobalt and pink, was completed early in February 1928 in Sickert's studio at 27 Highbury

FIGURE 3.14 *Walter Richard Sickert,* Winston Churchill MP, *1927, pen and ink preparatory drawing, 17.8 × 10.2 cm, Walker Art Gallery, Liverpool.*

Place[77] and promptly exhibited at a solo show Sickert held at the Saville Gallery, London. There it was admired by, among others, Virginia Woolf[78] and the art critic Frank Rutter, who described the canvas in the *Sunday Times* as 'the most brilliant portrait Mr. Sickert has yet executed'.[79]

The gossip columns reported that Lord Ivor Churchill (1898–1956), another of Churchill's many cousins[80] – he was the second son of the 9th Duke of Marlborough – bought the canvas for Churchill for the hefty sum of £300. Apparently, however, Churchill did not take to the portrait. He objected that it made him look 'crapulous' and 'bilious' and resemble a bookie – not the sort of mental association one wanted as Chancellor of the Exchequer.[81] Even more importantly, Churchill's private secretary, Edward Marsh, and Clementine did not care for the work at all. Both thought Sickert had made Churchill resemble the notorious fraudster Horatio Bottomley (1860–1933), 'carousing in a public house.' Any association with Bottomley, swindler, muck-raking journalist, disgraced Liberal MP for Hackney South (1906–1912) and editor of the rabidly jingoistic magazine *John Bull*, which he had founded in 1906, would have been untimely; Bottomley had only recently been controversially released from prison early in 1927 for good behaviour. He had served only five of the seven years to which he had been sentenced in May 1922. He attempted to resuscitate his career in high finance but this did not prove a success and by the end of the decade he was bankrupt once more.[82]

It is interesting that Sickert's portrait should have so readily brought the dubious and discredited figure of Bottomley to Clementine's mind; he had recently taken to the music hall stage to defend his reputation while Churchill was a connoisseur of music hall songs and acts.[83] Churchill's close friend F.E. Smith also had a sneaking admiration for Bottomley's oratorical gifts while acknowledging his villainy was plain even at a great distance. To some extent Bottomley, as venal and mendacious founder of *John Bull*, had corrupted this long-established symbol of bluff common sense, English patriotism and love of country in the minds of many – especially the Bloomsbury-orientated

intelligentsia.[84] However, in the 1930s, as we shall see, in ceramic form Churchill would be presented as an updated John Bull-style figure: tubby, combative and truculently scowling at a world in which, regrettably, too many maliciously intentioned foreigners lurked.[85]

Sickert was oblivious to the Churchill's negative response to the oil and gave Clementine a preparatory pen and ink drawing for the portrait – which she later destroyed (Graham Sutherland later told Mary Churchill that her mother had so loathed the drawing she had 'put her foot through it...' and would have done the same, if able, to the oil painting).[86]

By 1931 the painting had been sold to the collector and Conservative MP for Bath, the Hon. Baillie Hamilton.[87] Between 1936 and 1950 it was owned by Lord Camrose and then his son Michael Berry (later Lord Hartwell in his own right). In July 1950 the Sickert was bought at auction by the National Art Collection Fund.[88] After a lengthy spell in the British Embassy in Paris (where it was the object of much speculation from visitors – could this really be *the* Winston Churchill?)[89] and the office of the Minister of Works, the painting was given to the National Portrait Gallery in March 1965.[90]

As for the subject of the portrait, he does not seem to have retained any animus towards Sickert. Indeed, in May 1940, he found time, amidst all the disasters befalling the British war effort, to ensure that Sickert was awarded a small pension from the Royal Bounty Fund as the painter was yet again in dire financial need.[91]

During the summer of 1928 Winston found it restful to experiment in building brick walls at Chartwell while completing the fourth volume of his history of the First World War, *The World Crisis – The Aftermath*.[92] As 'Spi' indicates (Figure 3.15), Churchill had yet to devise his own form of boiler suit to wear while wielding mortar and trowel. Indeed he rather invited ridicule by being photographed working on his walls wearing a suit, collar and tie, complete with highly polished spats and jaunty Homburg hat.[93] However, in the cartoon Spi pokes gentle fun at the Chancellor of the Exchequer as amateur

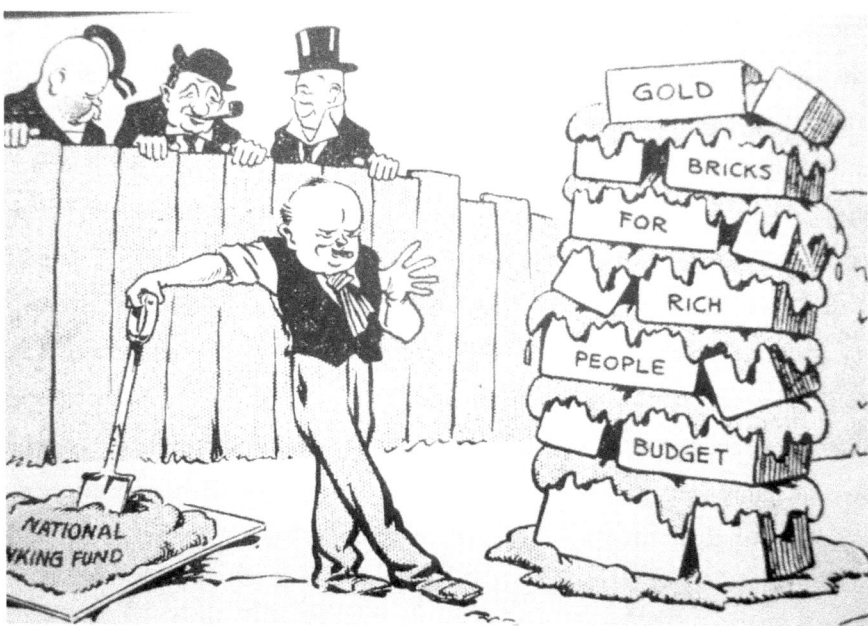

FIGURE 3.15 *Spi, The Amateur Bricklayer, Reynolds Illustrated News, 7 April 1929.*

proletarian by depicting him as a typical Edwardian navvy: in shirt sleeves, unbuttoned waistcoat, heavy cord trousers and spotted scarf around his neck (rather than Churchill's usual spotted bow-tie).

Churchill's intensive bricklaying activities at Chartwell were first reported in the London *Evening Standard* early in September 1928. This led the local convenor of the Amalgamated Union of Building Trades Workers (AUBTW), one James Lane of Battersea, to invite Winston to join the Union. Churchill was initially unsure as to whether he had been laying bricks for long enough under the tutelage of local man Benjamin Barnes. He decided to submit his application complete with joining fee of 5 shillings. On 10 October 1928 he was formally inducted into the AUBTW as a bricklayer. However, on 26 October the Executive Council of the union voted that Winston had not been eligible to become a member when he made his application. On 1 November 1928 Winston protested that his application had been made in

good faith, and had been accepted; his cheque had been cashed and as far as he could determine he was a properly constituted member of the AUBTW.[94] There the matter remained: Winston believed himself a member of the union; indeed, he had the acceptance letter framed at Chartwell. However, the union insisted he was not a member; nor, after his conduct during the General Strike of May 1926,[95] did its leadership, or membership, want him.[96]

Churchill lost his post as Chancellor with the defeat of the Conservative Party in the General Election of May 1929.[97] Fervently opposed towards any plan for even granting a small amount of Home Rule to India and to the prospect of further British disarmament, he found himself increasingly out of step not only with Ramsay MacDonald's new minority Labour government but also with the leadership of his own party, under Stanley Baldwin.[98]

4

Churchill's 'Wilderness Years' – the 1930s

By the early 1930s Jacob Epstein had long been established as the avant-garde sculptor most regularly reviled in the press for his 'distorted' and 'degenerate' carvings.[1] Strube amusingly imagines how Epstein might have portrayed some of the leading political personalities of the day (see Figure 4.1) such as Labour

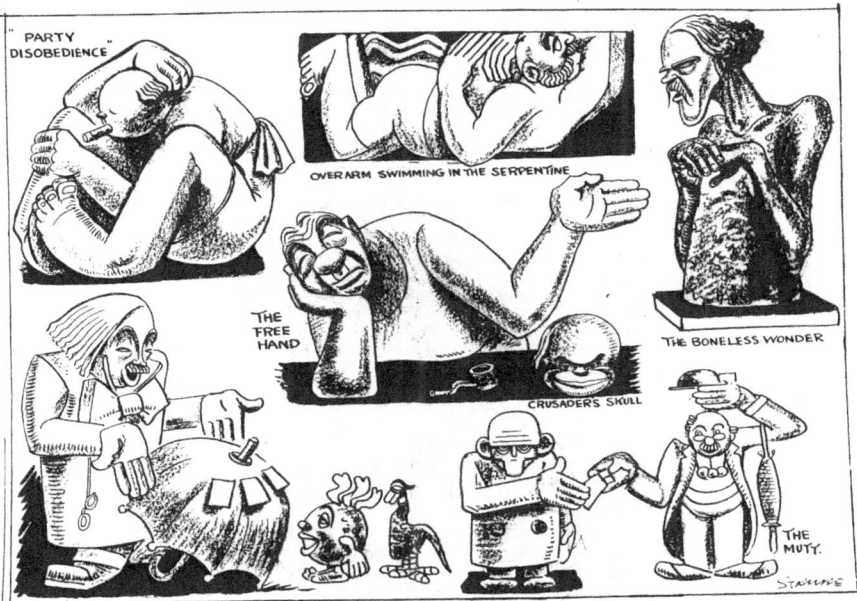

FIGURE 4.1 *Sidney George Strube, 'Party Disobedience: An Epstein Portrait of Churchill'*, Daily Express, *9 February 1931.*

Prime Minister Ramsay MacDonald – whom Churchill had already derisively characterised in the Commons as 'the boneless wonder'.[2] The cartoon touches on the fact that recently Churchill had been in bad odour with Baldwin's Opposition leadership over the question of granting possible self-rule to India. Indeed, the previous month he had resigned from Baldwin's Shadow Cabinet over the issue and was now moving to associate himself with the far-right 'diehard' wing of the Conservative Party.[3] Churchill was already being perceived as an isolated figure both in the Commons and in his party; perhaps this is why Strube imagines him carved by Epstein in a defensive ball – though this form of carving was more representative of the work of Epstein's immediate contemporary Frank Dobson (1886–1963).

Churchill's vehement opposition to any form of self-rule for India between 1931 and 1935 has often been interpreted as a low point in his career and a catastrophic lapse in judgement.[4] He further strained his relations with the party leadership by associating himself so closely with the most reactionary 'diehard' wing of the party.[5] Infamously, in February 1931, Churchill had declared to the British press that it was 'alarming and nauseating to see Mr. Gandhi, a seditious Middle Temple lawyer, now posing as a fakir of a type well-known in the East, striding half-naked up the steps of the Vice-Regal Palace ... to parley on equal terms with the representative of the King-Emperor'.[6] In an earlier attack on Gandhi, Duff Cooper noted at dinner one evening in November 1920: 'Winston was in his best form, ragging Edwin [Montagu] about Gandhi who said he ought to be lain bound hand and foot at the gates of Delhi and then trampled on by an enormous elephant with the new Viceroy seated on its back.'[7]

According to Low, Churchill particularly disliked being depicted as an Indian 'Mahatma Windhi' in the simple homespun garb of Gandhi (see Figure 4.2): 'Churchill supplied enough vehement opposition to the idea of Indian self-government to invite pertinent comment ... As a result I came in for some of the anger flying about. Churchill wrote me off, in his book *Thoughts and Adventures*, 1932 as a "green-eyed Antipodiean radical ... particularly

FIGURE 4.2 Sir David Low, 'Yah Untouchable!', Evening Standard, *19 June 1933.*

mischievous ...'.[8] Low later recalled that when he met Gandhi in London at the time of the 1931 India Conference, 'he was waving the evening paper about with a cartoon of mine on the meeting of Gandhi and Windhi...'[9] Low recalled from that meeting that Gandhi evidently feared Churchill's influence on British opinion.[10]

Churchill would later candidly admit he had never cared much for the Indians he had encountered as a soldier there in the late 1890s. In September 1942 he told his Colonial Secretary, Leo Amery: 'I hate the Indians. They are a beastly people with a beastly religion.'[11] Expressing such an unpleasant view so vehemently, it is not surprising that he has been accused of deliberately overlooking, or underestimating, the seriousness of the 1942–1943 Bengal famine during which at least 1.5 million Bengalis starved to death.[12]

According to Churchill's youngest daughter, Mary, Lady Soames, 'William Nicholson first came into Winston and Clementine's life in the summer of 1934 ...'[13] He had been commissioned by a group of their friends to paint a

'Conversation Piece' portrait featuring the two of them as gift for their silver wedding anniversary (September 1933).[14] Apparently, Nicholson jumped at the chance of painting such a work as he had become jaded with conventional single-figure portraits and the 'conversation piece' was enjoying a revival of interest in the UK in the early 1930s alongside the eighteenth-century British pictorial tradition closely associated with the format. In March 1930, for example, Churchill's friend, the Tory MP and aesthete Sir Philip Sassoon, whom Churchill had known since before the outbreak of the First World War, held an exhibition at his London home, 25 Park Lane, devoted to 'English Conversation Pieces'.[15] The following year the art critic George C. Williamson published a book, *English Conversation Pieces*, with a foreword by Sassoon.[16] It may indeed have been the case that with his excellent contacts within the British art world of the day that it was Sassoon who suggested Nicholson as the artist to paint Churchill and his wife for their silver wedding anniversary gift.[17]

Mary Churchill later noted that Nicholson decided early in the commission to depict Churchill and his wife breakfasting together in the ground floor dining room at Chartwell – something which in reality they hardly ever did: 'my father specifically attributed the happiness of their union in part to this very fact!'[18] She considered the composition a 'delightful picture and the artist caught my parents' attitudes and likenesses. For me it also evoked the charm of that dining room on a sunny day with the door open into the garden, one of my all too numerous bantams strolling in on the lookout for crumbs and Tango the adored cat sitting on the newspapers on the table'.[19]

Churchill's beloved Tango, also known as 'Mr Cat', died in June 1942 just before news arrived of the fall of Tobruk to the Germans. The staff at 10 Downing Street deliberately did not tell Churchill of the cat's demise 'until news from the battlefront was better.'[20]

In the sketch (Figure 4.3), now at Chartwell, Nicholson clearly presents Churchill wearing an early version of his own bespoke all-in-one zip-up boiler suit which he later made famous in his early days as Prime Minister as his 'siren

suit' to wear amidst the alarms and uncertainties of the bombing of London. This is probably the first formal art image to depict Churchill in his siren suit. In 1934–1935 the garment was closely associated with mechanics in the UK and on the Continent; Churchill conceived his – made especially for him by Austin Reed on Regent Street – to wear while bricklaying in the garden at Chartwell.[21]

Hemingway mentions French working men wearing the 'mono' overall in his novel *The Sun Also Rises* (published in October 1926). He associated it with the garb of working men, skilled with their hands, who had fought in the First World War and survived. They had lost faith in most things apart from their technical ability.[22] Within two years of this sketch the one-piece overall of the worker had acquired a certain vogue among the British left-wing intelligentsia as it as closely identified with the impromptu uniform of Spanish Republican militiamen and women, memorably photographed in August–September 1936 by Gerda Taro and Robert Capa and sketched by the British artist, Felicia Browne (the first British subject to be killed in the Spanish Civil War).[23] Was Churchill thus trying to cultivate a form of sartorial proletarian chic? He would soon be seen in the company of the Soviet ambassador, Ivan Maisky.[24] However, only Churchill would nonchalantly wear his tailor-made siren suit with the most elegant pair of spats, as Nicholson depicts. He would not be joining the toiling workers anytime soon.

During his initial visits to Chartwell, in 1934–1935, Nicholson was a welcome guest: 'Nicholson soon became a favourite with the whole Churchill family; sittings for the picture were a pleasure, not a tribulation ...' When he was not sketching her father and mother, he would chat to Churchill's youngest daughter Mary: 'He would also draw my pug-dog, and he never tired of sketching our beautifully marked marmalade cat ... William was a considerable dandy and he dressed with meticulous and unconventional fastidiousness; he wore extremely elegant, delicately spotted shirts and canary-coloured waist coats. His charm, like all else about him, was subtle and his friendship for all

its warmth and generosity was neither intimate nor hearty ...' Her mother soon became 'devoted to "S'William" as we called him after he was knighted in 1936', while her father preferred to call him 'Cher Maitre'. Nicholson often visited Chartwell until the outbreak of the Second World War and Churchill's return to political office.[25]

In 1942 Nicholson asked to borrow the oil painting for a retrospective exhibition at the National Gallery. Looking at the composition again he 'took against the painting ... and started to repaint it, but failing to get it right, he destroyed it ... Fortunately, the highly advanced sketch for the picture survived and this still hangs in the dining room at Chartwell today'.[26] A second sketch of the scene would be purchased in the late 1930s by Lord Methuen, who in 1932–1933 had been a pupil at a short-lived art school run by Walter Sickert.[27]

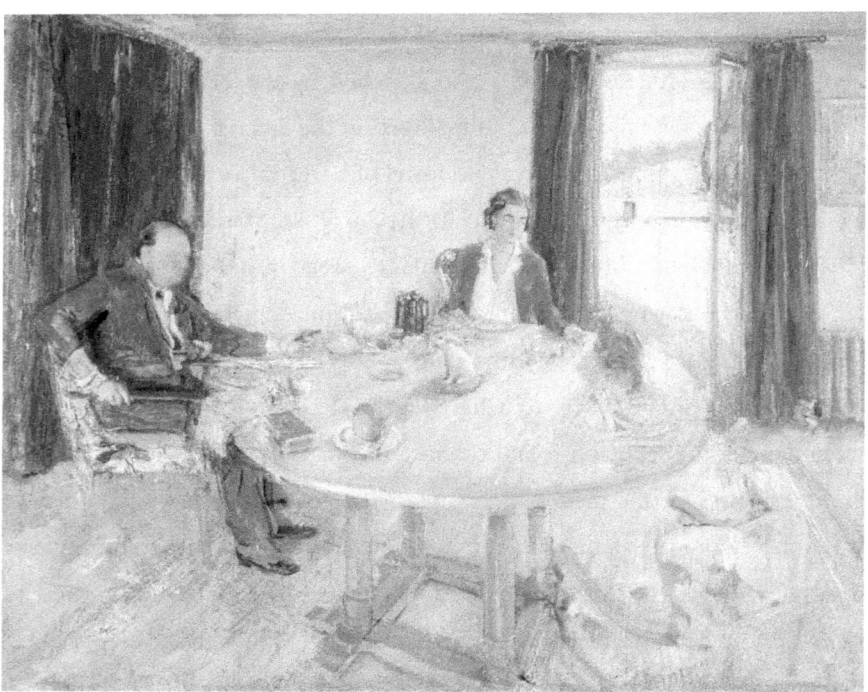

FIGURE 4.3 *Sir William Nicholson (1872-1949)*, Study for Breakfast at Chartwell II, *1934–1935, oil on canvas, 98.4 × 120.7 cm, Chartwell Manor, Kent.*

Eric Kennington first met Churchill in Cairo early in March 1921 – he had been invited as a guest of T.E. Lawrence who was then working as an adviser to the Colonial Secretary on Arab affairs. Kennington had wanted to draw Churchill then, but the Colonial Secretary could not spare the time.[28] Kennington drew Churchill's chief military adviser, Major-General Sir Edmund Ironside, who was known as 'Tiny' as he was six foot four.[29] Churchill greatly admired the portrait when it was exhibited alongside those of two-dozen Arab sitters Kennington had been commissioned to draw by Lawrence and which were exhibited at the Leicester Galleries in October 1921 – Churchill attended the opening night.[30]

Between 1933 and 1935, Kennington carved a satirical figure, *God of War*, in Portland stone which appears to have been inspired by an intriguing combination of Churchill and Mussolini (see Figure 4.4). Indeed, the artist took particular note of a speech Churchill made to the British Anti-Socialist and Anti-Communist League in London on 17 February 1933, during which he referred to Mussolini as a 'Roman genius ... the greatest law-giver among living men' who had shown 'many nations how they can resist the pressures of Socialism and ... indicated the path that a nation can follow when courageously led'. The Fascist regime had established a 'centre of orientation' to guide countries 'engaged in a hand-to-hand struggle with Socialism ...'.[31] Later in the decade he mused that, from certain angles, Churchill even bore a certain physical resemblance to Il Duce.[32]

During the period Kennington worked on the figure, cartoonists occasionally depicted Churchill as secretly hungering to be a British Mussolini – one of whom was David Low, who contributed an essay alongside Kennington to the 1934 publication *Sermons by Artists*.[33] Meanwhile, J. L. Carstairs, in September 1934, imagined Churchill in the guise of a primitive, glowering tribal African war deity, sword in one hand and pen in the other (see Figure 4.5). Churchill had been urging the coalition government of the urgent need to rearm in the face of a resurgent Germany since shortly after Hitler came to

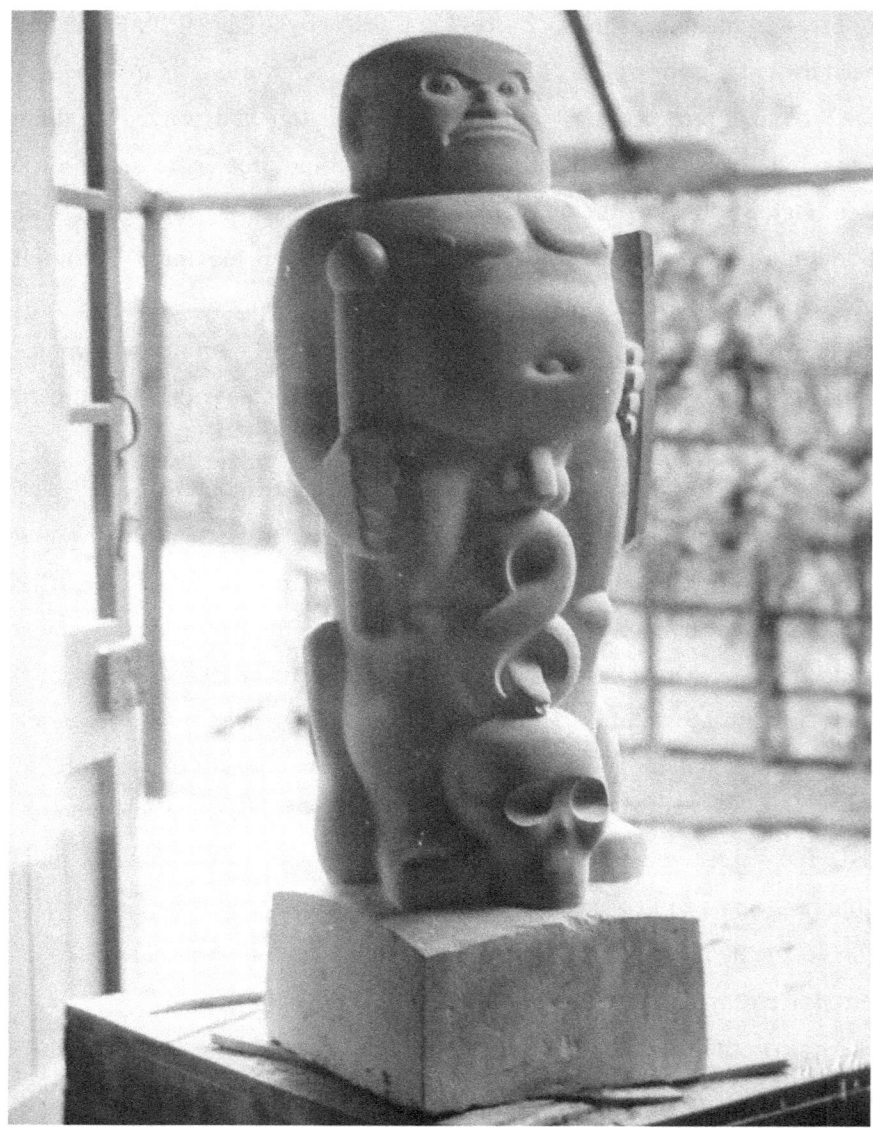

FIGURE 4.4 *Eric Kennington (1888–1960)*, War God/God of War *(also exhibited as* Mammon*), 1932–1935, Portland stone, 135 × 45 × 40 cm, family of the artist on loan to the Henry Moore Centre for the Study of Sculpture, Leeds.*

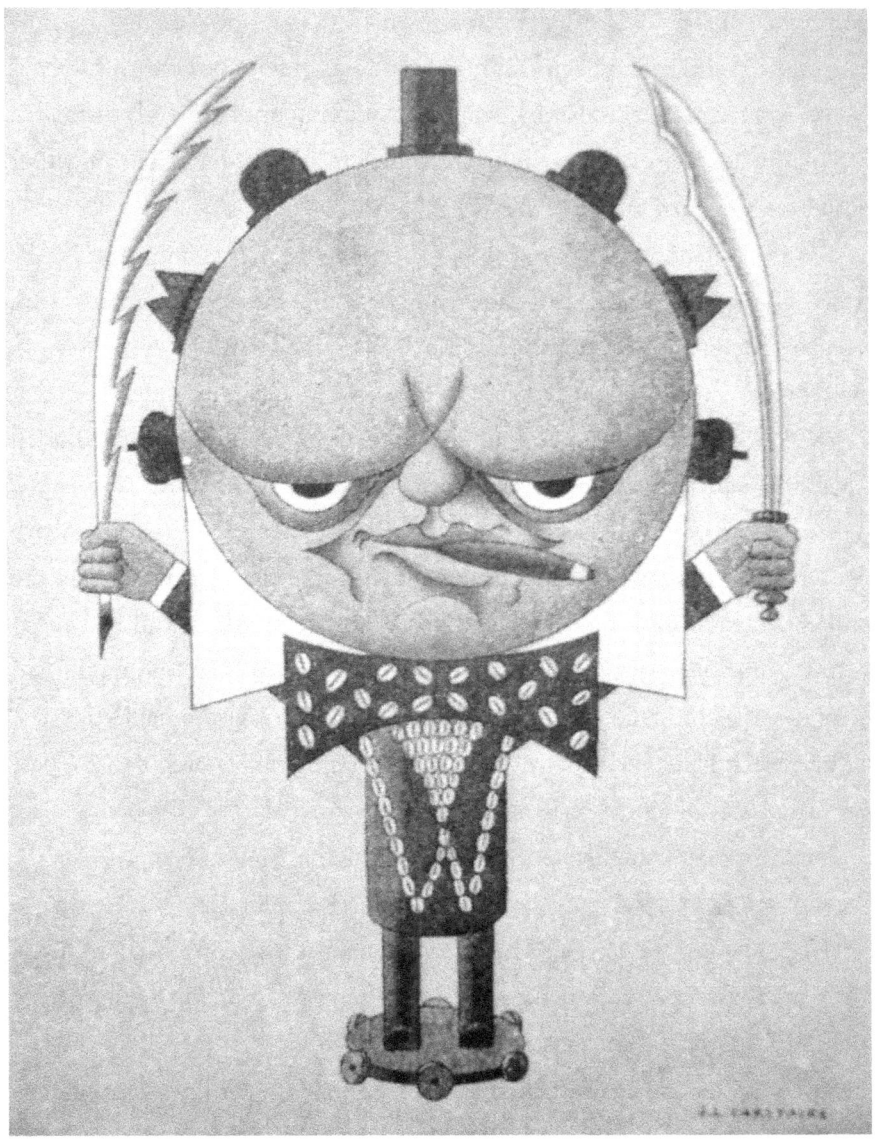

FIGURE 4.5 J. L. Carstairs, 'The Wood Carvings of M'Bongo M'Bongo. No V – A Struethsayer or Prophet of Doom', Punch, *13 September 1934.*

power in January 1933.[34] On the whole, his call did not receive a friendly hearing – pacifism had been embraced by thousands of ordinary Britons as well as by many influential individuals and Churchill was frequently dismissed as a marginalised, isolated warmonger[35] willing to advocate any cause, however desperate, to return him to high office.[36]

The essay Kennington contributed to *Sermons by Artists* indicates that he was well-disposed to some of the trends within contemporary mainstream pacifist thought. However, by the time *God of War* went on display in an exhibition organised by the Artists' International Association, entitled 'Against Fascism and War', in London in October 1935, Mussolini had invaded Abyssinia, and Kennington found himself agreeing with Churchill that the Italian dictator must be stopped and the nation urgently needed to embark upon a major programme of re-armament. Two months later he wrote to the military theorist Basil Liddell Hart that the Oxford students who had voted against war in February 1933[37] had been 'noble' but 'misguided'. The nation 'had to follow Winston'.[38] Indeed, if war in the near future was unavoidable, then the nation certainly needed its own 'War God'; Kennington believed that, on past performance, Churchill was by far the best candidate.[39]

Four years later, in November 1939, Kennington would be approached to become an official war artist working for Sir Kenneth Clark's War Artists Advisory Committee. He readily agreed and almost immediately submitted a novel proposal for him to make miniature figures of Churchill, by now once more First Lord of the Admiralty, from 'polished brass' to distribute among members of the public who had performed acts of heroism. Kennington already identified Churchill as 'one of the men who will pull us through this war ...'. He thought some of his brass Churchills might even be dropped onto Germany. They could be hollowed out to contain propaganda leaflets, or even delayed action explosives.[40] Replying early in December 1939, Clark was amused by Kennington's ingenuity and commended his patriotism but had to point out the scheme would be prohibitively expensive, especially when his

War Artists Committee was fighting for every penny from the Ministry of Information. There is a hint that Clark has yet to determine whether, in these early days of the Phony War, Churchill will be more of an asset than liability. He light-heartedly concluded that perhaps a few small versions could be produced to be dropped 'over Berlin and Josef Goebbels!'[41]

Churchill was more present in the news than usual in 1936, perhaps for the wrong reasons, as he emerged as one of the most outspoken champions of Edward VIII marrying Wallis Simpson, making her his queen and keeping his throne.[42] Rumours flew that Churchill was contemplating ousting Baldwin as Prime Minister as the head of motley collections of malcontents comprising a so-called 'King's Party'.[43] Churchill's inability to detect the King's undoubted and major character flaws on this occasion did not add lustre to his own reputation.[44]

Clarice Cliff's Toby jug (Figure 4.6) shows Churchill resplendent in an Admiral's hat trimmed with fur; firmly grasping a miniature Royal Navy ship, he sits on a suitably determined-looking British bulldog draped with the Union flag. Despite the fact he had been in the political wilderness for much of the decade, estranged from mainstream opinion within his own party on foreign policy, by the late 1930s he was once again regarded as a man to watch. In the spring of 1939 a number of newspapers, led by Lord Camrose's *Daily Telegraph*, campaigned for Churchill to be taken into Chamberlain's government as First Lord of the Admiralty.[45]

It is interesting how this image of Churchill will shortly evolve into Churchill as a bulldog – see Chapter 5 – from a John Bull figure of the type imagined by James Gillray and Isaac Cruikshank in the late eighteenth and early nineteenth centuries, to a corpulent and truculent ruddy-cheeked English rustic, into the British bulldog.[46] This animal, from the mid-nineteenth century onwards, was increasingly depicted as the inseparable companion of a stocky John Bull wearing a top hat, a waistcoat with a Union Jack design and tight riding breeches. Bull was now identified as a middle-class man of property – a

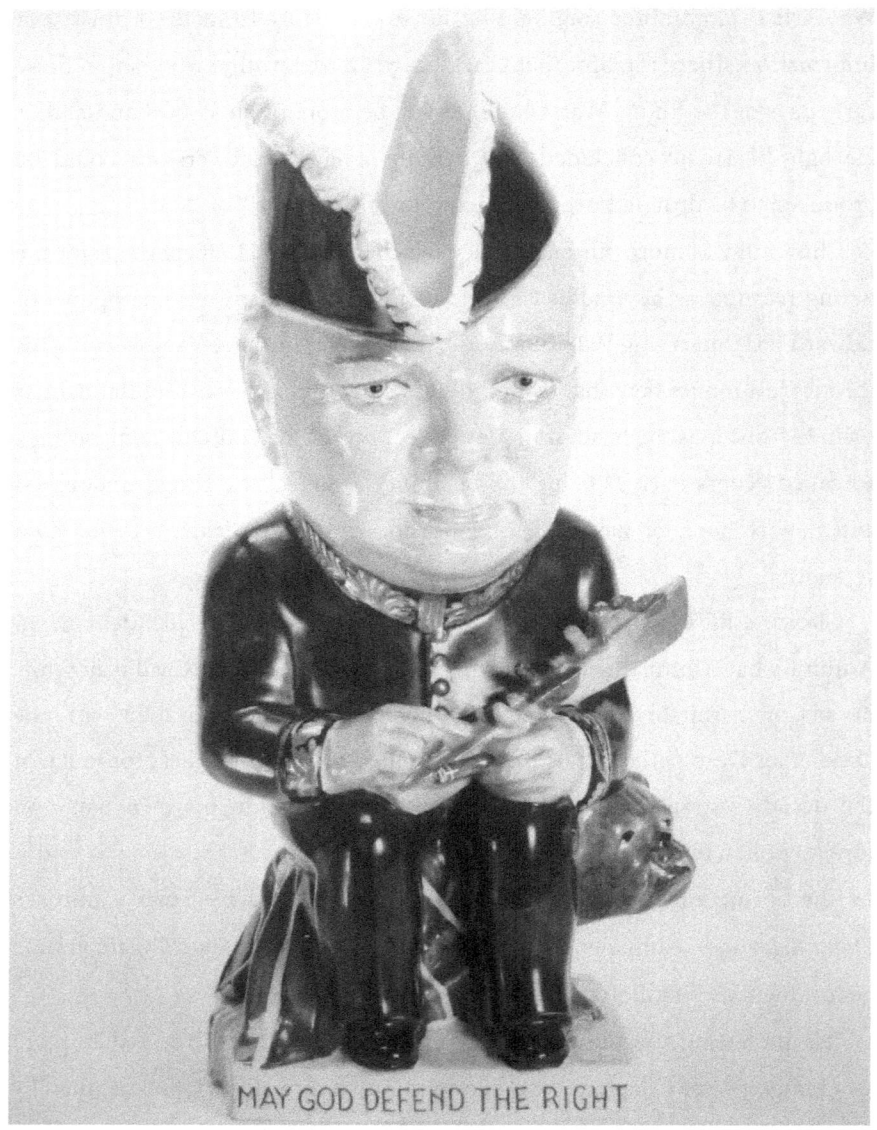

FIGURE 4.6 *Clarice Cliff (1899–1972)*, Toby Jug of Churchill as First Lord of the Admiralty, *c. 1938–1939, ceramic, 31 cm high, Private Collection.*

landowner.⁴⁷ The association with Churchill was merited in that, despite his often straitened finances during the 1930s, he spent a great deal of time and money developing the 80 or so acres he owned around Chartwell – constructing lakes and ponds and building a woodshed and a miniature cottage for his two youngest daughters.⁴⁸

5

Finest Hour? Churchill and the Second World War, 1939–1945

On the afternoon of the day Britain declared war on Germany, 3 September 1939, Prime Minister Neville Chamberlain invited Churchill to join his war cabinet as First Lord of the Admiralty and he readily accepted.[1] However, in the first few months the Royal Navy suffered some embarrassing setbacks – the loss of thousands of tons of merchant shipping to magnetic mines laid in the English Channel, the North Sea and in the mouth of the Thames, and the sinking in Scapa Flow of the battleship *Royal Oak* by an enterprising U-boat in mid-October 1939.[2]

At this early stage in the war, Hitler sometimes gave the impression he respected Churchill as though he was akin to some of the hard-drinking bruisers who had been early members of the Nazi Party.[3] As for Churchill, he had been presented with an opportunity to meet Hitler in August 1932 while visiting Bavaria on a research trip for his planned book on his celebrated military ancestor, the first Duke of Marlborough. He had displayed a mild interest in the proposal but then fell seriously ill with typhoid.[4] From the early days of the war Churchill invariably referred to the Führer as 'that man' or, when especially angry, 'that wretched man'.[5]

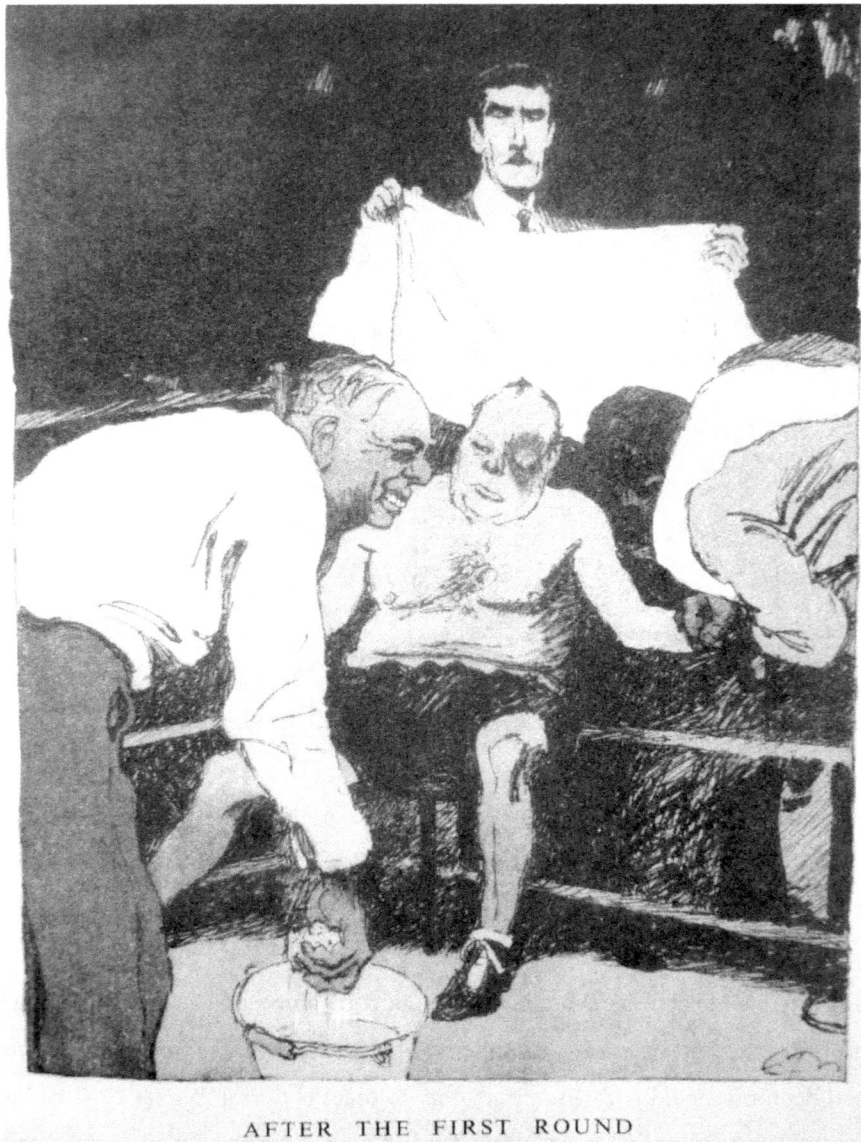

FIGURE 5.1 After The First Round, Simplicissimus *(Munich)*, 5 November 1939.

Given *Simplicissimus*' vivid image of Churchill as battered and bruised pugilist (Figure 5.1), it is intriguing that in 1942 Hitler declared to his circle over tea: 'The English will have got nothing out of this affair [the war] but a bitter lesson and a black eye... they owe all that's happening to them to one man, Churchill.'⁶ In 1939, however, he placed equal emphasis on the, to him, immensely sinister figure of the

FIGURE 5.2 *'Vicky' [Victor Weisz (1913–1966)], 'Mr. Churchill on the Platform as Vicky Sees Him',* Daily Telegraph, *29 January 1940, Cartoon Archive, Kent University.*

Jewish Secretary of State for War, Leslie Hore-Belisha (1893–1957). In this cartoon, Hore-Belisha hovers over a punch-drunk and disorientated Churchill as his solicitous trainer.[7] Hore-Belisha was a reforming Secretary of State for War (1936–1940), had quietly opposed appeasement in Cabinet and had been well-disposed towards Churchill while he was in the political wilderness.[8] He was abruptly sacked from his post after losing the confidence of Chamberlain on 4 January 1940.[9]

Victor Weisz, born in Berlin to Hungarian-Jewish parents, fled to the UK in 1935 and was soon working as a cartoonist for the *Daily Mirror* and the *Evening Standard*.[10] By the early 1940s, he had emerged as the UK's leading left-wing cartoonist along with Philip Zec (1909–1983) of the *Daily Mirror*.[11] In January 1940, Churchill gave a series of morale-boosting speeches around the UK (see Figure 5.2) intended to wrench the public from the widespread malaise of torpor and apathy from the so-called 'Phoney War'.[12] Towards the end of the

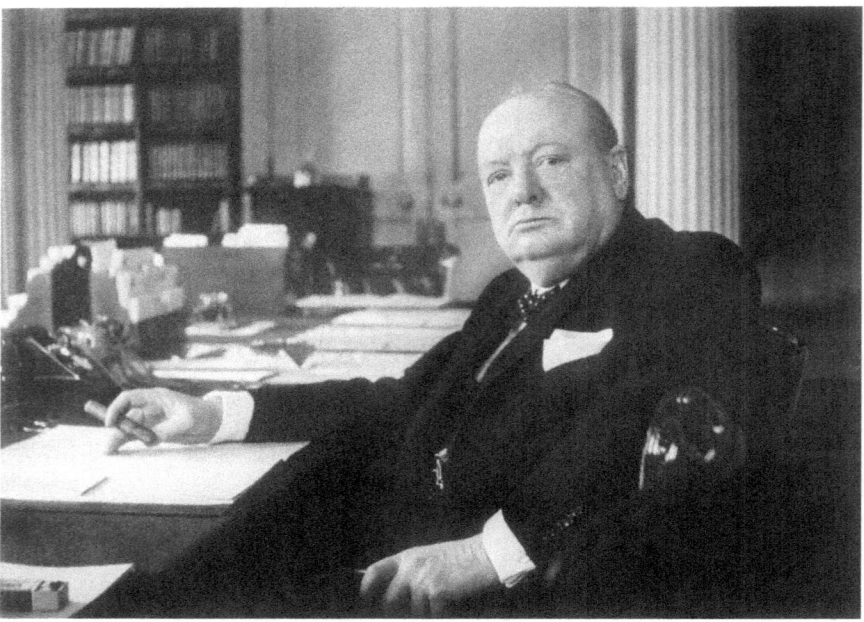

FIGURE 5.3 *Cecil Beaton (1904–1980),* **Winston Churchill As Prime Minister 1940–1945, Prime Minister Winston Churchill at his Desk in the Cabinet Room, No 10 Downing Street,** *early September 1940.*

FIGURE 5.4 *Leslie Gilbert Illingworth (1902–1979), 'Two-Gun Winston',* Daily Mail, *13 May 1940, Private Collection.*

month, civil servant John 'Jock' Colville, at the time rather more well-disposed to Prime Minister Chamberlain, wrote in his diary: 'Churchill's stock is rising ... He is indeed an orator – perhaps the only one in the country today and he does not read his speeches tamely like [Lord] Halifax [at the time Foreign Secretary] ... Nevertheless he is a dangerous person unless kept well under control.'[13]

Cecil Beaton's celebrated image of a defiant, even grumpy, Churchill at his desk in the Cabinet Office at 10 Downing Street (Figure 5.3) was taken just days before the Luftwaffe's blitz on London began on 7 September 1940.[14] In all, over 450 Germans bombers attacked from 5 pm onwards that evening; eight hours later, 436 Londoners had been killed with over 1,600 injured.[15]

Figure 5.4 shows a rather double-edged image from Leslie Gilbert Illingworth,[16] simultaneously referring to Churchill's part-American heritage and to his reputation for unthinking aggressiveness. Those within the Conservative Party who bemoaned the fall of Chamberlain, such as MPs R.A.B. Butler and Henry 'Chips' Channon, often at the time of Chamberlain's fall from and Churchill's rise to the Prime Ministership on the evening of 10 May 1940 referred to Churchill contemptuously as 'the greatest adventurer of modern political history' and a 'half-breed American'.[17]

The unanimity behind Churchill so compellingly evoked by Low (Figure 5.5) was actually more apparent than real. He did indeed have the backing of major figures within the Labour Party and a few old allies within the Conservative Party, such as Anthony Eden and Duff Cooper, but the majority of senior figures within the party and most MPs regarded him with a great degree of wariness, even hostility, until he proved his mettle at the time of the Dunkirk crisis in June 1940.[18] Conservative MPs appear to have been even more impressed by his steely ruthlessness in ordering the Royal Navy to fire on the French fleet at anchor at Oran and Mers-el-Kebir on 3 July 1940 to prevent it from ever falling into German hands: 1,299 French sailors were killed and a further 350 wounded. For the first time Churchill was cheered by the majority of Conservative MPs in the Commons.[19]

FIGURE 5.5 *Sir David Low, 'All Behind You Winston',* Evening Standard, *14 May 1940, Cartoon Archive, Kent University.*

Leslie Gilbert Illingworth's *Daily Mail* cartoon 'Westfront Hurricane' (Figure 5.6) presents Churchill as a benign old sea dog and Thames waterman, licensed by the Port of London Authority in his cap and well-worn jacket.[20] The message was clearly that he could be trusted to steer the battered British ship of state to safety despite the German onslaught in the West. Only five days after this cartoon was published Lord Gort, Commander-in-Chief of the British Expeditionary Force in France, ordered his troops to retreat towards Calais and Dunkirk.[21] Between 26 and 28 May 1940 a series of tense meetings took place within the British War Cabinet, chaired by Churchill, during which Lord Halifax suggested Britain seek peace with Germany with the help of Mussolini.[22] Churchill would not agree and effectively stalled for time until the evening of 28 May when the proposal was set aside, never to be revived. Churchill had

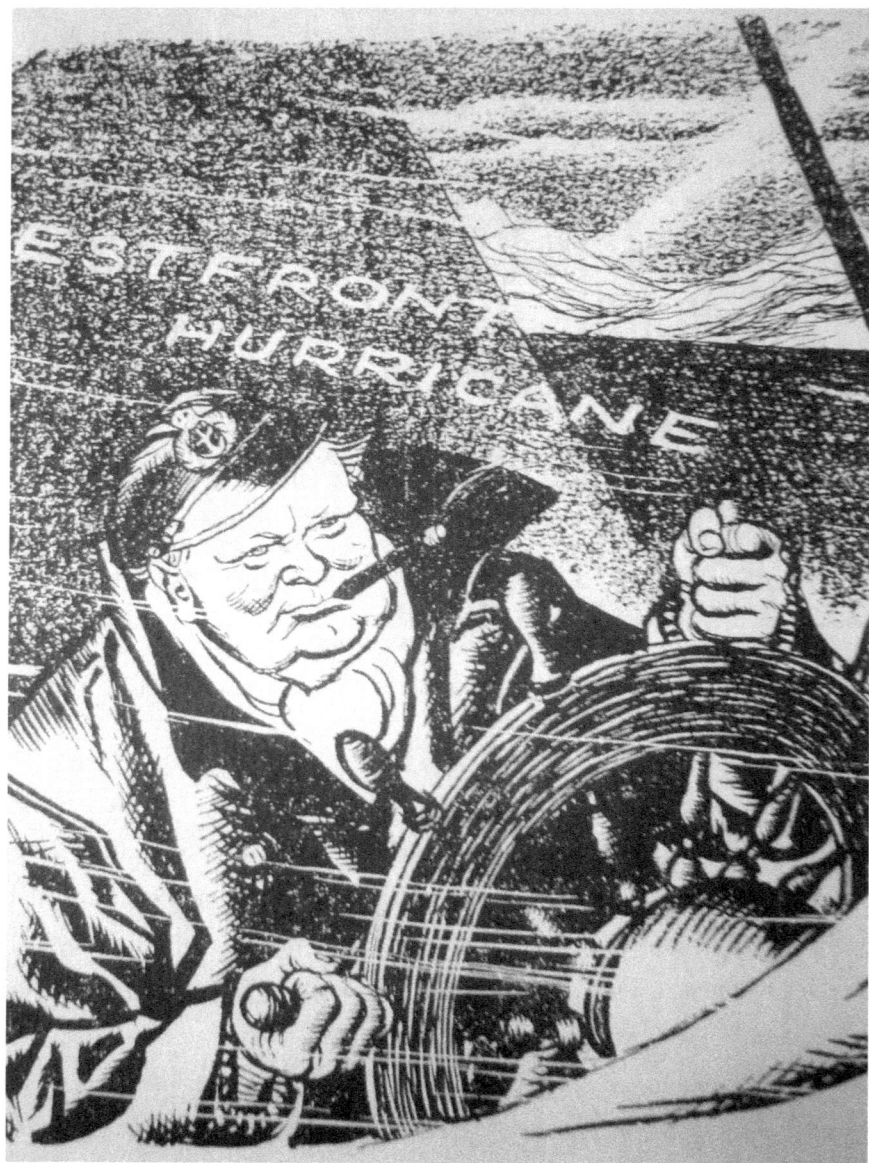

FIGURE 5.6 *Leslie Gilbert Illingworth, 'Westfront Hurricane, Mr. Churchill last night: "We are ready to face it"',* Daily Mail, *20 May 1940, Private Collection.*

skilfully strengthened his hand by winning the backing of ministers outside the Cabinet. One of them, Hugh Dalton (Minister of Economic Warfare) recalls Churchill stating he had been asked to consider asking: 'That Man [Hitler] to negotiate terms ... [However] "I am convinced that every one of you would rise up and tear me down from my place if I were for one moment to contemplate parley or surrender. If this long island story of ours is to end at last, let it end only when each one of us lies choking in his own blood upon the ground".[23]

Figure 5.7 shows one of the first images by a cartoonist to present Churchill as a bulldog, in this case wearing a British Army issue steel helmet rather than the distinctively shaped French *Casque Adrian* Churchill had actually more commonly worn at the front in France in 1915–1916. From the earliest days of his marriage to Clementine Hozier in 1908, Churchill referred to himself in letters to her as her 'pug dog' and often included simple pen drawings of himself as a scowling, happy or contrite pug, depending on the circumstances, beneath his signature. Strube may have been aware that two foreign political figures he had admitted between the wars, French statesman Georges Clemenceau[24] and the German President between 1925 and 1934, Field Marshal Hindenburg, had often been presented as bulldogs in cartoon form.[25]

Four days before this cartoon was published, Churchill made his celebrated speech in the House of Commons in which he declared:

> We shall go on to the end. We shall fight in France, we shall fight on the seas and oceans, we shall fight with growing confidence and growing strength in the air, we shall defend our island whatever the cost may be. We shall fight on the beaches, we shall fight on the landing grounds, we shall fight in the fields and in the streets, we shall fight in the hills, we shall never surrender....[26]

On the same day, Operation Dynamo, the evacuation from Dunkirk, was brought to a close: 224,000 British and 110,000 French troops had been saved

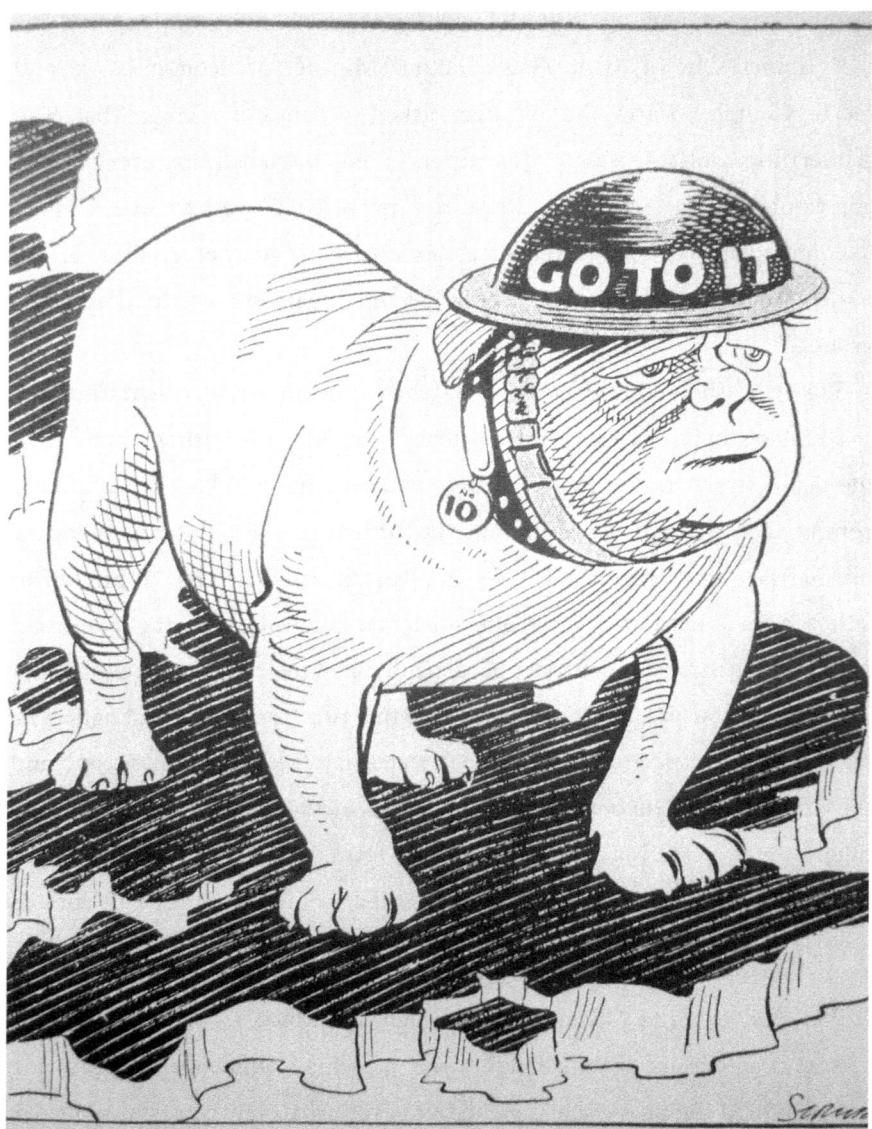

FIGURE 5.7 *Sidney George Strube, 'Go To It', Daily Express, 8 June 1940, Private Collection.*

from the beaches.²⁷ Three days after this cartoon appeared, Mussolini declared war on Britain and on 17 June, France asked for an armistice from the Germans. Britain now seemed truly alone – if one sets aside the fact it had at its disposal the resources of an immense empire.²⁸

Churchill was much given to sending out signed photographs of himself as gifts; one of those taken by Walter Stoneman in April 1941 was given to Josef Stalin in December 1941 by the then British Foreign Secretary Anthony Eden (see Figure 5.8). While Churchill was visiting Stalin for the second time, in October 1944, it was noted that the Soviet leader had the Stoneman photograph of Churchill framed on his desk in his bare, austere office in the Kremlin. Another Stoneman photograph was given to Stalin during this second visit, inscribed: 'From his friend Winston S. Churchill, September 1944 to Marshal and Premier Stalin who, at the head of the Russian Armies and of the Soviet Government broke the main strength of the German military machine and helped us all to open paths to Peace, Justice and Freedom.'²⁹ Despite the high-flown optimistic rhetoric, only a few months previously, as the Red Army advanced deep into Poland, Churchill had minuted his Foreign Secretary, Anthony Eden: 'I fear that a very great evil may come upon the world ... The Russians are drunk with victory and there is no length they may not go.'³⁰

Perhaps it is revealing that Churchill chose in October 1944 to give Stalin the photograph in which he appears at his grimmest, lower lip protruding balefully, whereas in others he is seen smiling and with a twinkle of amusement in his eyes. Lord Moran noted the day after Churchill had met Stalin and the second photograph had been handed over, Churchill told him the two of them had discussed the Russian Civil War and his steadfast support for the White cause: 'He talked about my private war with Russia in 1919, all in a friendly way. I said: "I am glad now that I did not kill you. I hope you are glad that you did not kill me?" Stalin agreed readily, quoting a Russian proverb: "A man's eyes should be torn out if he can only see the past".'³¹

FIGURE 5.8 *Walter Stoneman (1876–1948)*, Prime Minister Winston Churchill in No 10 Downing St, *3pm, 1 April 1941, photograph, 27.5 × 20.9 cm.*

The same photograph, often signed, was also sold to raise funds for the Red Cross Aid to Russia Fund, which from October 1941 was chaired by Clementine Churchill.[32] One from the set of Stoneman photographs (see Figure 5.9), issued in their thousands by the Ministry of Information during the war, was

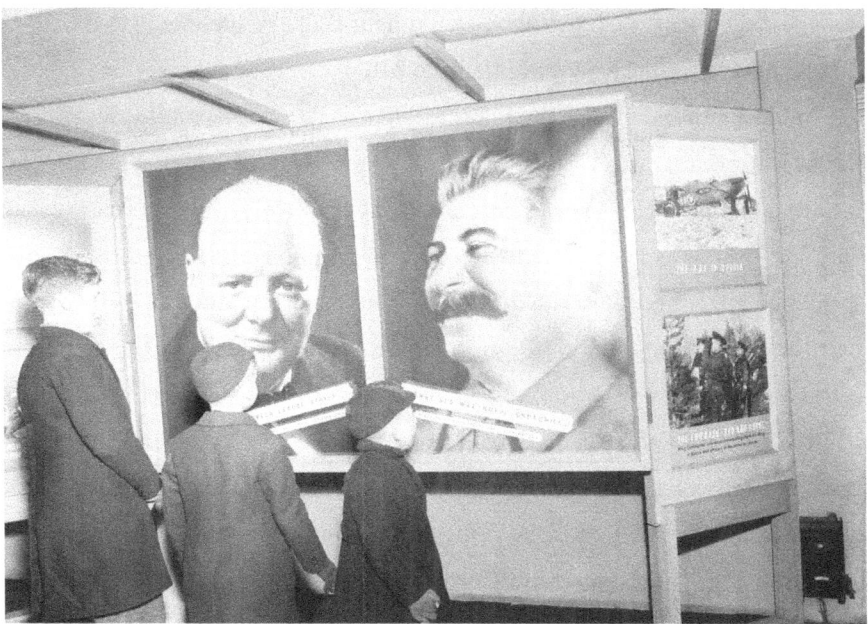

FIGURE 5.9 *A photograph from the series Stoneman took of Churchill in April 1941 was used during the summer of 1942 to promote the exhibition 'Comrades in Arms: Pictures of the Soviet People at War', held at Charing Cross Underground Station.*

used to promote Churchill as 'The Voice of Britain' in the General Election campaign of February 1950: Churchill outside his constituency office at Wanstead and Woodford (his old seat at Epping, West Essex had been divided into two and renamed)[33] alongside 'Barley Mow' the bulldog, Churchill's constituency mascot for the campaign (I shall leave it to the reader to judge the extent to which Churchill's physiognomy resembled that of a bulldog). Later in the 1950s thousands of photographs from the Stoneman series were reused by the Colonial Office and distributed among primary and secondary schools throughout the Commonwealth. The journalist, author and commentator, Yasmin Alibhai-Brown, has recently described how her Pakistani history teacher, Mr Amin, had a framed photograph of Churchill on display in a place of honour in his classroom of her secondary school in Kampala, Uganda in the early 1960s.

Mr Amin so admired Churchill he would light sticks of incense placed before the photograph as one would normally do before a devotional object.[34]

Churchill's thunderous expression in Figure 5.10 was produced by Yousuf Karsh, the photographer who had been given a few minutes with him in Ottawa in December 1941, suddenly snatching the Prime Minister's cigar away from his mouth: 'he looked so belligerent he could have devoured me'.[35] This image has justly been described as 'one of the most photographed images in the history of photography'.[36] Prominent are the polka-dot bow tie, the black jacket, and waistcoat with gold watchchain – already somewhat old-fashioned. Churchill has his left hand on his hip and slightly leans to his right, giving the impression of contained will and that he might soon spring forwards at the impudent photographer. Despite its undoubted popularity, not just in Canada but throughout the Empire and in the United States, Clementine Churchill later expressed reservations about the lingering impact of the photograph. In December 1958 she described it to the sculptor David McFall as a 'ferocious representation' of her husband which she believed to be quite out of character. Yes, her husband did have a temper, but the 'furious expression' the photograph had captured was entirely 'a manufactured expression and not a natural one'. However, she had to accept the image perfectly suited the times in which it had been taken and the 'demands of our war effort'.[37]

According to his autobiography, *Portrait and Pageant* (published in 1944), Salisbury had wanted to paint Churchill's portrait ever since he had heard his 'Blood, sweat and tears' speech of 13 May 1940. Salisbury wanted to honour the Prime Minister's 'invincible gallantry' and 'paint his portrait as a personal expression of my sincere admiration'.[38] He was unable to secure formal sittings with Churchill, but was allowed by John 'Jock' Colville, Churchill's personal parliamentary secretary, to study the Prime Minister 'from behind the Speaker's Chair in the House of Lords' (the Chamber of the Commons had been destroyed in bombing of 10–11 May 1941 and MPs had temporarily moved next door to the Lords). The artist painted two portraits in oils from a series of

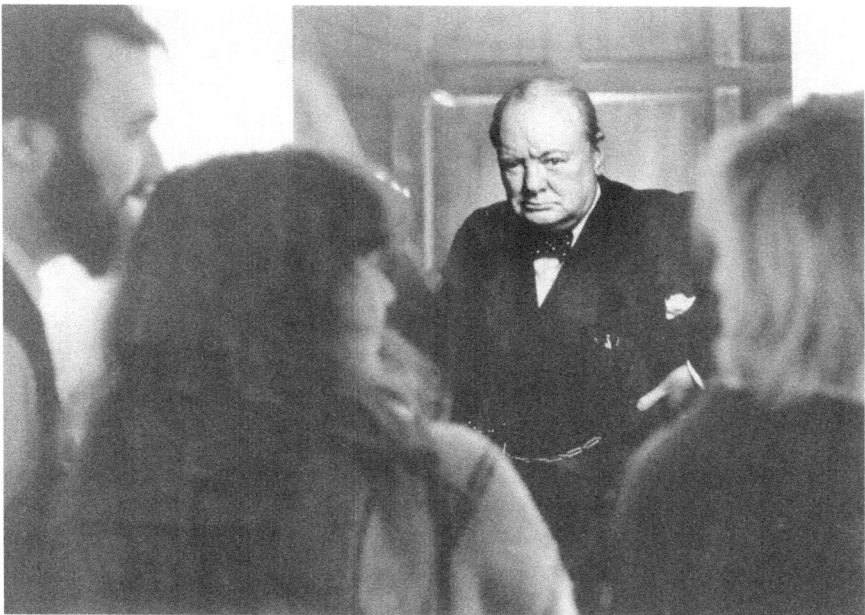

FIGURE 5.10 *Visitors in front of* Prime Minister Winston Churchill MP *by Yousuf Karsh (1908–2002), completed in 1941; photograph, 1989.*

quick studies he had made during the spring and summer of 1942. The first depicted 'the great Parliamentarian in the conventional morning dress of the grave statesman, our foremost Commoner . . .'. This portrait was purchased by Sir Frederick Heaton and presented to Churchill's old school, Harrow.[39]

The second portrait (Figure 5.11) was described by the artist as 'symbolic. It shows the Prime Minister in his siren suit, habitually immersed in the vital administration of worldwide strategy and the balancing of conflicting elements, as an exemplar of actual toil and physical effort'.[40] This was initially acquired by the Devonshire Club, of St James's. However, when its members heard that 'Mrs. Churchill especially liked it and pronounced it an exact likeness of her husband in those tremendous days', they decided to present it to Churchill in June 1943.[41] The club then asked Salisbury to paint a copy of it to hang in its main dining room.

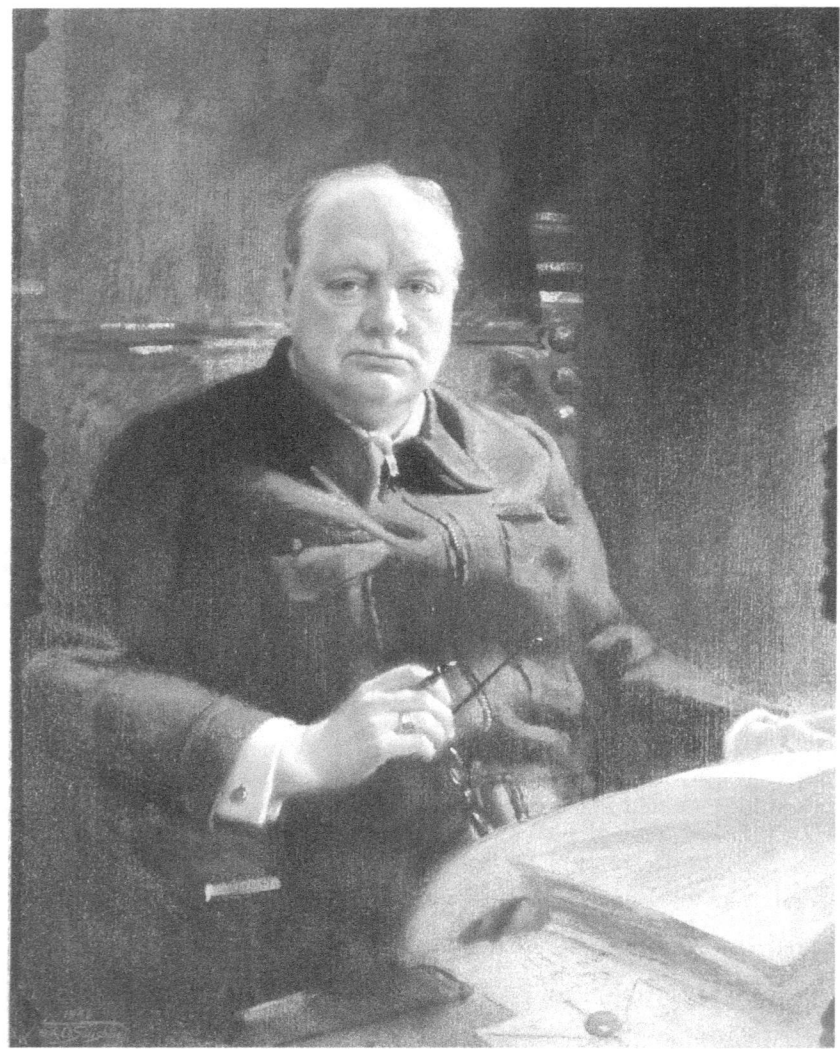

FIGURE 5.11 *Sir Frank Owen Salisbury (1874–1962)*, Prime Minister Winston Churchill, *1942, oil on canvas, 110.5 × 85.1 cm, Chartwell Manor, Kent.*

This would appear to be the first portrait of Churchill as wartime Prime Minister wearing his famous siren suit. His daughter Mary later revealed he owned a number of such suits which were known to his family and staff as his 'blue rompers' (see Figure 5.12). For the daytime he preferred to wear one in 'air force blue' whereas in the evenings 'he had luscious velvet ones ... usually dark green, or deep red ... with matching slippers'.[42] John Colville noted first encountering the Prime Minister at Number 10 in a 'blue denim siren suit' in October 1940.[43] Two years later, in August 1942, the British ambassador to Moscow, Sir Archibald Clark Kerr, was rather dismayed when the Prime Minister wore his 'blue siren suit' at a gala dinner held in the Kremlin. Clark Kerr described it as 'a dreadful garment that he claimed to have designed himself to wear during air raids'. Churchill looked as if he was wearing 'mechanics' overalls or more still ... a child's rompers ...' whereas Stalin and all Soviet officials present were either in uniform or in suits. As representatives of the world's foremost workers' state, they felt decidedly upstaged.[44]

Early in 1942 Sir William Reid Dick, then Sculptor in Ordinary to King George VI in Scotland, was commissioned to make a bronze portrait head of the Prime Minister by Sir Edwin Lutyens in the latter's capacity at President of the Royal Academy (see Figure 5.13). Reid Dick recalled that initially Churchill was very reluctant to provide any time at all for sittings, referring to how the demands of the war effort, which was not going well, cut into his time. Reid Dick indicated Churchill's reluctance to King George VI, who made it known that the Prime Minister should really make more of an effort to accommodate a sculptor with royal approval. Churchill made himself available for a series of short sittings, about half an hour each, in August and September 1942. Reid Dick recalled that his sitter was grumpy, taciturn and understandably preoccupied with the direction of the war. Messages arrived and the news was invariably bad or discouraging: retreat against the Japanese advancing through Burma to the frontier with Burma and doubts as to whether British and Dominion troops would hold Rommel and the Afrika Korps at El Alamein in

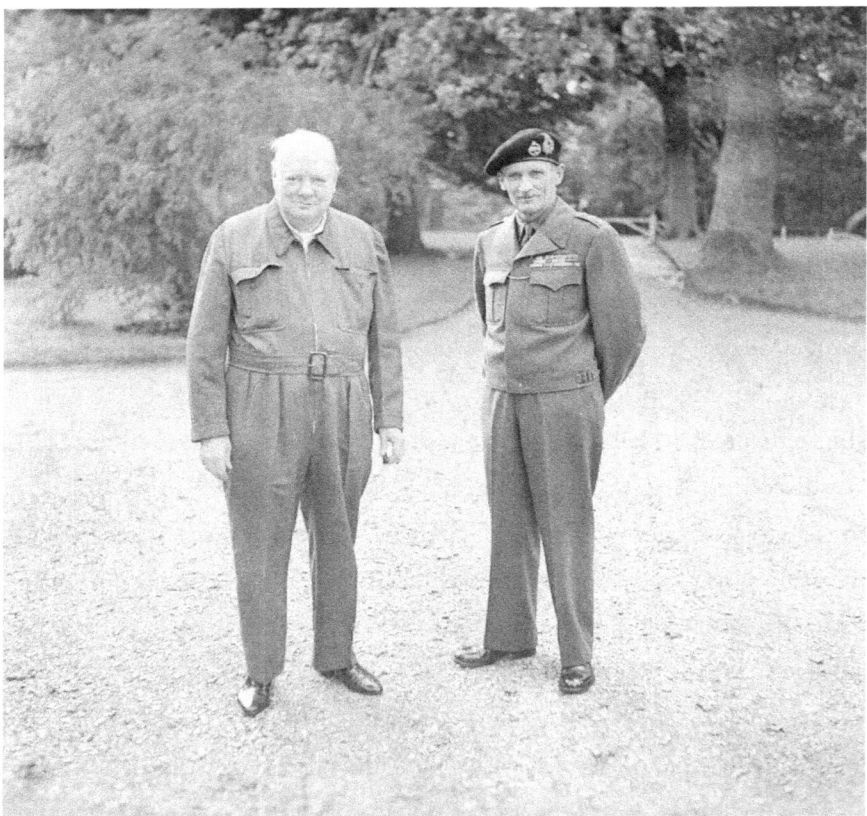

FIGURE 5.12 *Photograph of Churchill wearing a siren suit with Field Marshal Bernard Montgomery, southern Britain, 19 May 1944, Imperial War Museum, H 38661.*

Egypt.[45] The sculptor saw Churchill as a 'weary giant' with shoulders bowed beneath a crushing weight of responsibility which his sitter refused to shirk though the pressure might overwhelm him.[46]

For one sitting, at 10 Downing Street on 22 September, Reid Dick succeeded in passing off his friend, the portraitist Alfred Egerton Cooper, as his assistant, to set out the clay and position the modelling stand. Cooper made a swift sketch of Churchill in profile in pastel. The Prime Minister noticed this, even though he seemed to be thoroughly absorbed in a sheaf of incoming messages laid before him. At the end of the sitting he signalled to Cooper he wanted to inspect what had been drawn. The artist later described how: 'After some small

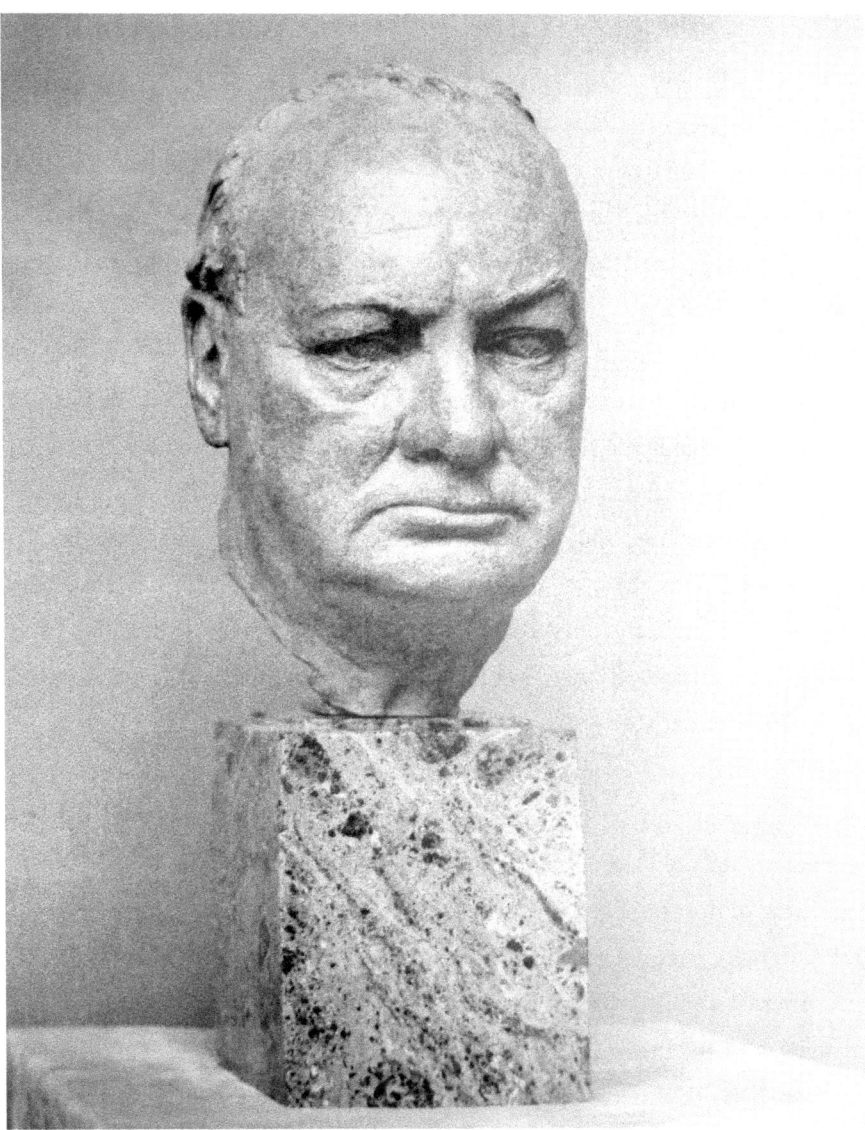

FIGURE 5.13 *Sir William Reid Dick (1879–1961),* Head of the Prime Minister, Winston S. Churchill, *1942, bronze, 47 cm high, Imperial War Museum, ART 16789.*

talk ... I asked if I might paint a portrait of him in that pose. Churchill grumbled and puffed, remarking that I was not a sculptor and must have therefore come under false pretences to make this request. Nevertheless he soon calmed down and must have admired the sketch for he did indeed consent to sit for me.' The resulting oil portrait, to which Cooper gave the title *Profile for Victory* (Figure 5.14), was first exhibited at the Royal Academy in May 1943, where it was widely praised as a 'morale-booster'.[47]

Cooper, while not a dazzling portraitist, was a thoroughly competent draughtsman. On this occasion he wisely drew upon the superb profile portrait of Condottiere Federigo da Montefeltro, Duke of Urbino (painted 1465–1472) by Piero della Francesca (1415/20–1492) which Cooper had seen in the Uffizi during a trip to Florence in the 1920s and had never forgotten. Thereafter, this work was for him the very essence of portraiture – the quintessence of a powerful personality captured even though only one side of their face was visible.[48] This oil proved such a success with the public that the profile was used as the basis for a poster issued in the autumn of 1943 by the Ministry of Information. Printed beneath Churchill's profile was a lengthy quotation from the speech he had given at the Mansion House on 10 November 1942 in which he had memorably declared: 'Now this is not the end. It is not even the beginning of the end. But it is, perhaps, the end of the beginning.'[49]

Reid Dick's portrait head was finished by the end of September 1942. On 7 October Churchill wrote to thank Sir Edwin Lutyens and the Royal Academy for the gift of the bronze head.[50] The Prime Minister described the head as 'a fine piece of work' suitably fitting as the first sculpture of himself commissioned by an official body. Six years later the Academy elected Churchill as an Honorary Academician Extraordinary.[51]

Clare Sheridan and Churchill had remained in touch for much of the interwar period. In the early 1930s, when she was particularly short of money, Churchill did his best to steer commissions her way from his wealthy friends such as press barons Lord Beaverbrook[52] and Lord Rothermere.[53] In June 1938

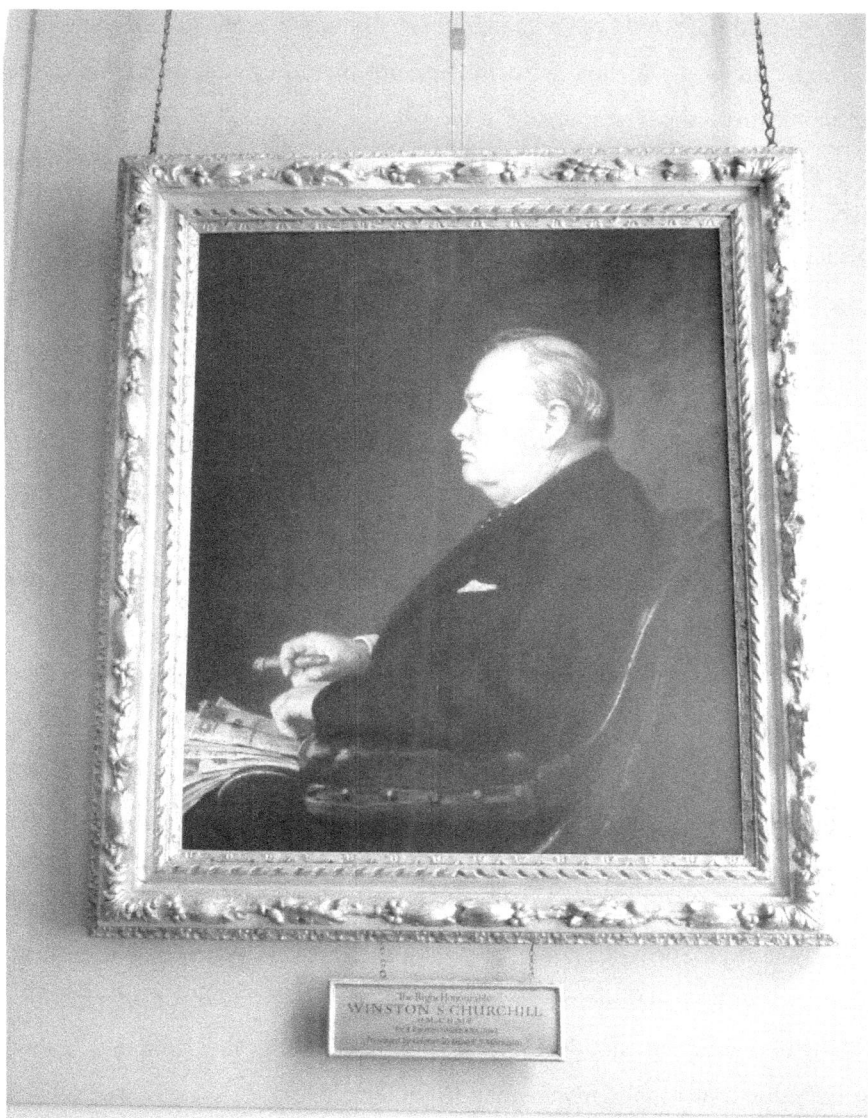

FIGURE 5.14 *Alfred Egerton Cooper (1883–1974)*, Profile for Victory: Sir Winston Churchill, *September 1942, oil on canvas, 50.8 × 40.6 cm, Carlton Club, London.*

she asked him if would open an exhibition of her work. He replied she would be better off asking a fellow artist, but he would certainly attend and give a vote of thanks to whomever opened the show.[54]

Three years later, in October 1941, Sheridan wrote to Churchill enquiring whether he knew the whereabouts of the portrait she had made of him in 1919. As far as she knew it had last been owned by Freddie Guest MP.[55] Mention of this early portrait may have planted the idea that Churchill should sit for her once more. In April 1942 Sheridan asked her cousin directly whether he would sit for her once again for a bust. She also suggested he sit for Oswald Birley, still painting in the Home Guard even though he had lost the sight in one eye during the First World War to poison gas.[56] Churchill quickly agreed to Sheridan's proposal, perhaps too quickly, for a few days later he was reminded by one of his secretaries that he had already agreed to sit for Reid Dick at the behest of Lutyens and the Royal Academy.[57]

Sheridan was not at all pleased to be informed by the Prime Minister's office that he could only spare the time for someone else to model him. She wrote to Churchill that she found the fact he could sit for Reid Dick 'deeply wounding', especially when in the past he had urged her to do heads of such leading political figures as Herbert Asquith and Philip Snowden. It was, she maintained, 'almost her right' to do his bust – he had been happy enough to sit for her all those years ago. She had a good reputation as a portraitist; why not sit for her? Churchill annotated the letter for Brenden Bracken, as Minister of Information, asking him about her standing as a sculptor and adding: 'she could have a shot at the same time as the Lutyens man [Reid Dick]'.[58]

Bracken replied that Sheridan was a 'dashing but rather erratic sculptor', not as highly regarded as Reid Dick who had, after all, been commissioned to do a portrait of Churchill for the Royal Academy. Joint sittings would be 'impossible. Perhaps he could give her a few sittings after Reid Dick had finished his portrait?'[59] (Churchill wrote to her at the beginning of June that he would do his very best to find time to sit to her over the summer.[60] Early in November

1942, just as the Second Battle of El Alamein was reaching a crisis point,[61] Churchill wrote to Sheridan asking whether could she 'do him' while he was working in bed; otherwise, she could try to model him while at work at his desk 'one or two mornings the week after next'.)[62]

She did manage to gain access to him in his bedroom at Number 10 once late in November 1942 and also on 1 December. She later recalled, in her 1957 autobiography, that she arrived at the Annexe of 10 Downing Street at 9 am on the morning of her first sitting with the Prime Minister to find 'Winston … in bed reading a newspaper. When I lowered it I saw a Hogarthian figure with cigar and spectacles. The light was bad, each side of his bed encumbered by tables laden with papers … Then he raised his newspaper and disappeared from view.' A secretary sat close by, pencil in hand, ready for any dictation required.[63]

After a few minutes Churchill looked up from his newspaper and asked: '"How are you getting on?" Sheridan replied: "'I can't even start unless you let me see you." "Oh, my dear, Sorry." He removed his cigar and gave me his unblinking attention for five minutes.' Cabinet ministers would start to arrive promptly at noon and Sheridan departed.[64] This routine continued during the second sitting when her arrival coincided with that of Churchill's breakfast tray. She was then able 'to study him for a while without his cigar, or his glasses … At the risk of upsetting the tray, Winston would waggle his feet about beneath the bedclothes and [his] mystified black cat would extend a paw. He seemed very attached to the animal, addressing it fondly as: "A most delectable cat. With a brain – not to be measured by ours, but a first class brain of its kind".'[65]

Finishing off his toast, Churchill inspected the head and complained: 'You don't seem to have worked on the mouth.' Sheridan replied sharply: 'You are always rolling that cigar around so I am leaving the mouth till last.' He seemed somewhat chastened by her reply and then mentioned an abortive sitting with Benito Mussolini in November 1922 (when Il Duce made a clumsy attempt to

seduce Sheridan which was derisively rebuffed by the sculptor).[66] Then silence for a while. He suddenly looked up at her: 'Forget Mussolini. Remember you are portraying the servant of the House of Commons.' She teased him that she thought he 'rather admired Il Duce'. She was surprised when he gravely nodded: 'I did, a very able man. He should have never come in against us... this whole war could have been prevented if it had not been for so many bungling statesmen.' Churchill took a long parting look at the head and declared: 'I think the head is a fine piece of work. We shall call it "Prime Minister by Obstreperous Anarchist".'[67]

A few days later Sheridan wrote to an old friend and her future biographer, Anita Leslie, that she thought she was making excellent progress with her portrait of the Prime Minister: 'I think the bust is going to be good. He [Churchill] is interested in it and wants it to be a success – but it's uphill work and very exhausting because he never gives me a chance. Always that blasted cigar in his mouth which twists his face. He's promised to "be good" next week and give me a whole half hour's full attention...'[68]

However, owing to the pressure of work, Churchill had to postpone their next two sittings. A week passed without word from Number 10. Sheridan felt that she needed just one more sitting with Churchill and wrote to his Secretary, Miss Layton, to ask whether the Prime Minister could not 'spare 10 or 15 minutes [to sit] without a cigar'. Otherwise she threatened she would 'commit suicide on the steps of 10 Downing Street, so all the world will know' he had refused her request.[69] The following day Churchill indicated he could spare her a quarter of an hour and his cousin would not need to break the law by ending her life.[70] Sheridan realised she had gone too far and wrote a few days later to apologise for her 'emotional and distraught outburst'.[71]

Sheridan reappeared at Number 10 at 9 am the next Monday to find Churchill propped up in bed but much preoccupied and on the telephone concerning a crisis that had just arisen in French North Africa – the until recently pro-Pétain High Commissioner Admiral François Darlan had just

been assassinated (24 December 1942). Winston had no time for the dead collaborationist, but the Americans were hopping mad as they – probably rightly – suspected the Free French and de Gaulle were responsible for Darlan's demise.[72]

The Prime Minister suddenly looked up guiltily from the telephone as he remembered the existence of his sculptor cousin. He asked her how the head was proceeding. She replied pointedly: 'I wish I could die in my sleep and then I would not have to keep trying to catch you expression.' Churchill was most contrite and promised: 'I'll be good.' He then, leaning back in bed, put aside his cigar and picked up a volume of John Buchan over which he chuckled as he read. Sheridan was able to work uninterrupted until noon whereupon Winston threw back the bedclothes and put on a dressing gown embroidered with a golden Chinese-style dragon. He had an imminent cabinet meeting and he had to get dressed. Sheridan was able to declare the head finished. Winston looked at the work admiringly and murmured 'good girl'. He patted her on the shoulder, beaming that he had not smoked 'for two hours … I keep my promises'. A group of Royal Marines carried the clay down to a van to drive both it and the artist to her studio.[73]

By the end of December 1942 the head was finished (see Figure 5.15). Churchill congratulated her on the bust, calling it 'a very fine piece of work'; he would like to buy one of the bronze casts planned and hoped £100 would help – the most he would ever pay for a portrait of himself and for a work of art. He added that he had a great fondness for Sheridan's portrait of his mother Lady Randolph (who had been Sheridan's aunt), which he 'always kept' by his bedside.[74] On Boxing Day she thanked Churchill for the prompt despatch of a cheque, adding that he had not been easy to model but not nearly as difficult as Gandhi, who had insisted upon sitting on the floor with a spinning wheel! She knew this would have needled her cousin, who could not abide Gandhi.[75]

A week later she wrote to Churchill that the plaster cast of the head was now at the foundry. She suspected he would no doubt approve that, to ensure there was enough bronze available for the task, she had melted down two of her

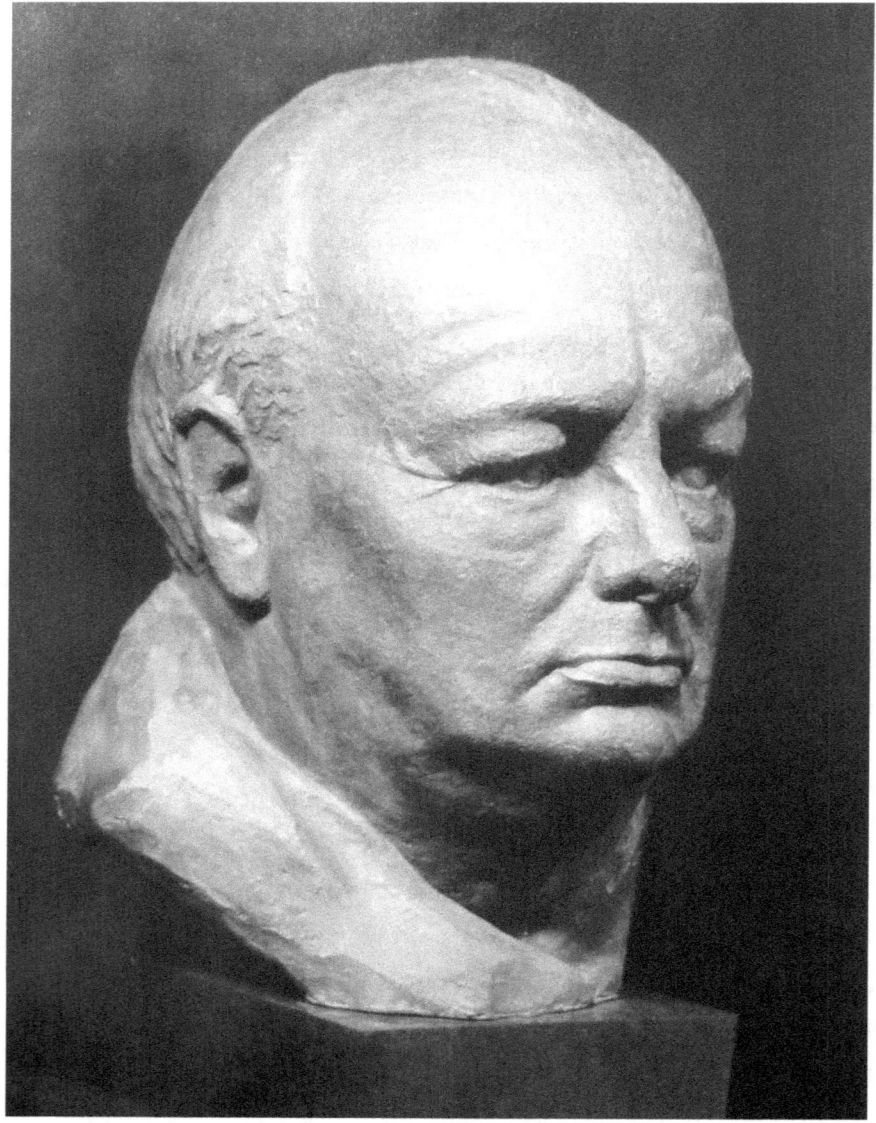

FIGURE 5.15 *Clare Sheridan (1885–1970),* Sir Winston Churchill, KG, DL, OM, CH, PC, MP, *1942, bronze, Chartwell Manor, Kent.*

earlier portrait heads – one of which had been of the former Soviet ambassador to the UK, Christian Rakovski.[76]

Four months later Sheridan wrote to Churchill, evidently very angry that the Royal Academy had rejected her head of Churchill for inclusion in that year's Summer Exhibition. She should have known the Academy would favour their man (Reid Dick); Eric Kennington had advised her that would be the case and so it had come to pass. This rejection would 'mean little' in the British art world as she was in good company with Jacob Epstein and Birley as 'outcasts and cast-outs'. However, exhibiting at the Royal Academy meant a great deal to 'the uninitiated' and always helped to sell other casts. Would Churchill consider presenting one of hers to the City of Edinburgh, or to Sir Kenneth Clark's War Artists Committee?[77]

Churchill passed on the letter to Brendan Bracken, who replied with a prompt minute in which he commented that 'Mrs Sheridan has an impressive capacity for raising awkward controversies!' He suggested a cast of the head should indeed be donated to Clark's WAAC; Bracken would arrange for her to have a 'soothing meeting' with Sir Kenneth. Churchill annotated the minute: 'Brendan – please look after this for me. Relatives!'[78] There is evidence that in the meantime Clementine Churchill weighed in on Sheridan's behalf; early in May 1943 she wrote to thank the sculptor for the 'bust of my husband', adding that she thought it was 'terrible' that the Royal Academy would not exhibit it.[79]

In June and then September 1943, Churchill readily agreed to Sheridan's suggestion that further casts of the head she had modelled in December 1942 be made for Victor Warrender, Lord Bruntisfield (who had proposed a cast be presented to the City of Edinburgh)[80] and for the prestigious clothing firm of Yaeger & Co, who proposed to display it in their main London store on Oxford Street to raise funds for the British Red Cross Aid to Russia Fund – the patron of which was Clementine Churchill.[81]

After the war Sheridan converted to Roman Catholicism. In August 1947 Churchill helped her to get into Italy to visit Rome and to see the Pope.

She informed him breathlessly: 'Winston, your name has worked miracles. It got me into the Catholic Church.' Churchill replied: 'Well, my dear Clare, don't expect my name to get you into the Kingdom of Heaven.'[82] In June the following year she spent a day with him at Chartwell. She thought her wartime portrait had stood up well. Her cousin, however, was in his 'dreadful boiler suit ... he rants about the inefficient, ignorant, crowd in power who are ... throwing the British Empire away. He is almost heartbroken. All his life he has been such a great Imperialist ... He tried so hard, bless him, to be interested in my concerns, but he can't sustain interest outside himself for more than a few minutes. However, he was very affectionate and I believe he is fonder of me than I know. When we parted he called to me from the top of the stairs: "Write whenever you want me to do something for you – remember our relationship is eternal..."'[83]

* * *

The poster *Our Heritage: Winston Churchill* by Robert Sargent Austin (Plate 7) was released onto the London Underground network early in May 1943 in time for a major Allied success in North Africa. On 7 May 1943, 150,000 German and Italian troops surrendered in Tunis to Anglo-American armies.[84] Two months later Mussolini would be toppled from power and placed under house arrest (although in September 1943, German commandos would free him from captivity to be placed at the head of a puppet pro-German government in northern Italy – the Republic of Salo). In September 1943, the Italians would break their alliance with Nazi Germany and Allied forces would land on Italian soil.[85]

Austin had been asked by the Publicity Committee of the London Passenger Transport Board to devise a series of uplifting posters on the theme 'Our Heritage'. Doubtless Churchill would have been delighted to see himself included alongside such British heroes at a time of national emergency as Admiral Lord Horatio Nelson, Sir Francis Drake and Pitt the Elder (Prime Minister at the time of the Seven Years' War of 1756–1763, when Britain had

been threatened with invasion). Intriguingly, Field Marshal Sir Douglas Haig, of whom Churchill had never thought much, was initially proposed by Austin for the series. However, after a month's debate the Committee decided Haig might be perceived as a divisive figure by contemporary audiences and it was decided to drop him from the campaign.[86]

Austin implied that Churchill had been the first figure to come into his mind as embodying the nation's heritage and this concept is an integral part of the poster's composition. The poster was designed in five parts: the artist began with a study in pencil derived from a photograph of Churchill combined with a sketch, now in a private collection. Austin made it from memory after catching sight of the Prime Minister walking one day from 10 Downing Street to the Palace of Westminster accompanied by only a single bodyguard.[87] A monochrome proof followed, then a first and a second colour were added and below part of the text of Churchill's celebrated speech of 4 June 1940, referred to earlier in this chapter.[88]

Austin was prescient in his conviction that Churchill's speech of 4 June 1940 had already become an indelible part of the national story, and indeed served as the foundation stone for the developing 'myth' of Britain at bay in 1940 and threatened with destruction. Churchill's body dominated the composition; he seems to be shielding St Stephen's Tower, representing the Palace of Westminster and the cradle of British democracy, from possible harm. Anyone taking the time to look at this poster presumably would have concluded that Britain's position in May 1943 was immeasurably better than it had been in the fraught days of May–June 1940. However, the expression on Churchill's face, reinforced by half of his features being cast in enigmatic shadow, is not at all jubilant or triumphalist but contemplative and musing. The poster implies that in the three years since Churchill made the speech quoted, success had been achieved on the battlefield. However, ultimate victory had still to be won. Although he is presented as seated at his desk in Downing Street he is symbolically still alert and standing guard over Britain and the

democratic system which so many had already given their lives to defend. The aura of grim determination and resolute purpose radiating from the Prime Minister encourages anyone scrutinising this poster while awaiting a Tube train to feel the same about his or her country.

Austin provides an interesting contrast with Walter Sickert as to how to evolve a new portrait of Churchill from a photograph taken by someone else. Austin came to the Underground Commission after a spell as an official war artist for the WAAC of the Ministry of Information sketching nurses of the Queen Alexandra's Imperial Nursing Service at their demanding duties tending the seriously wounded in the Astley Hall Military Hospital, Chorley, Lancashire. Austin noted signs of war weariness, of irritation at inadequate rations, but was struck by how many photographs he spotted around the hospital of the King and of Churchill. The latter resembled an unusually sombre yet dignified Renaissance military man as painted by Piero della Francesca. A trace of the presence of that master of the Quattrocento may be detected in the sobriety and dignity with which Churchill is presented in Austin's poster design.[89]

After his work for London Underground, Austin was despatched by the WAAC to draw munitions workers at the massive Woolwich Arsenal in southeast London. There he saw hardly any patriotic imagery inside its many buildings and workshops, and many of the workers he sketched made it clear that while Winston was just the man one wanted in charge in a time of war, he might not be in peacetime. One man brandished a copy of Sir Willliam Beveridge's famous report, published in December 1942, declaring that Winston was still a 'diehard Tory' as was clear from his lack of enthusiasm when it came to discussing in the Commons how to implement the recommendations of the report after the war.[90]

* * *

Lance-Corporal J. Leigh had apparently carried the mascot he had made, a scowling bulldog smoking a large cigar called 'Winston', since his unit landed on Sicily early in July 1943 (see Figure 5.16). The Seaforths then landed on the

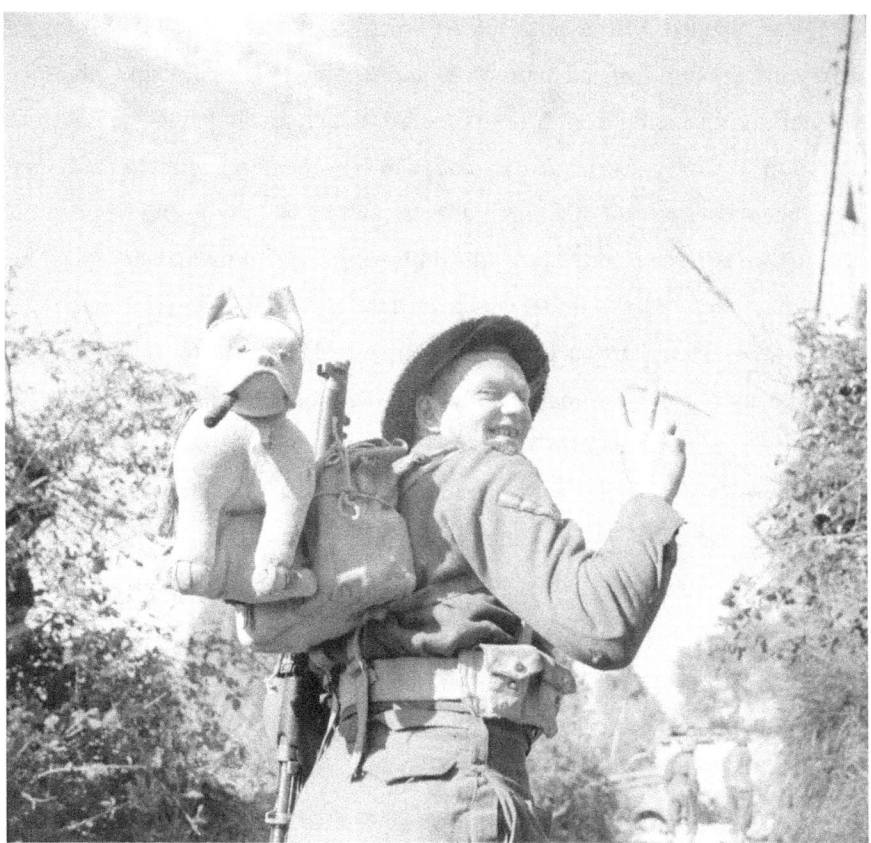

FIGURE 5.16 *Sergeant Johnson of the 2nd Army Film and Photographic Unit, with Lance-Corporal J. Leigh of the 6th Seaforth Highlanders and his mascot 'Churchill', 7 February 1944.*

mainland on 3 September 1943 and were involved in heavy fighting in Ortona early in January 1944. A month later they were sent to cross the Garigliano river line against an ever-determined German resistance.[91] The unit was allowed a short rest and towards the end of February 1944 it was sent to reinforce the Anzio bridgehead, which had been under such intense German pressure between 4 and 20 February 1944 that it almost collapsed and its defenders driven into the sea. However, the reinforcements allowed the Anglo-American defensive line to stabilise and the last major German attack, of 29–30 February

1944, was repelled.[92] Both sides settled down to stalemate until Allied forces broke out of the bridgehead between 23 and 30 May 1944 to link up with other Allied units advancing from Monte Cassino (which finally fell to the Polish II Corps on 18 May 1944).[93] Anzio, codenamed Operation Shingle, had very much been a pet project of Churchill's – though he had not been in a position to influence command of Allied units on the ground.[94] If he had, doubtless he would have ordered the units, which on landing found they had taken the Germans completely by surprise, to advance and not wait for a slow three-day build-up of men and material. By the time the American commander on the spot, Major-General John Lucas, was ready to advance towards Rome with his VI Corps, the Germans with characteristic speed and efficiency had moved elements of five divisions to contain his two. Famously Churchill commented at the time: 'I had hoped that we were hurling a wild cat onto the shore, but all we got was a stranded whale.'[95]

The jaunty Lance-Corporal Leigh seems to have survived the war; the fate of 'Churchill' the mascot is unknown. It was hardly an object that could be expected to intimidate the enemy, more one to amuse the infantrymen of the 6th Seaforths who, by February 1944, had seen a good seven months of near-continuous fighting. The mascot looks home-made and its appearance suggests Churchill inspired affection and amusement in equal parts. It is rare to see such a mascot carried by a front line infantryman.

Kimon Evan Marnego (Kem) had been born in Alexandria, the son of an anglophile Greek cotton merchant. In 1929 he moved to Paris and then, in 1940, to London where he went on to be employed by the French section of the Political Warfare Executive.[96] There he devised often surreal images of Churchill to be featured in French newspapers printed in London and then dropped by air over France.[97] At the time *Hitler's Nightmare* (Figure 5.17) was published in *Le Petit Parisien*, it was still an anti-British, pro-Collaborationist Vichy publication.[98] This was certainly one of the stranger conceptions of the British Prime Minister which put his rounded features to good effect while the

FIGURE 5.17 *Kem (1904–1988)*, Hitler's Nightmare, *reproduced in* Le Petit Parisien, *6 April 1944, Private Collection.*

quivering figure of Hitler seems to be menaced on all sides by the accusatory horizontal of Churchill's cigar.

In his *Evening Standard* cartoon of 31 July 1945 (Figure 5.18), Low presents Churchill, the siren-suited 'man of the people', co-existing with Churchill the upper-crust class warrior and leader of the Conservative Party since October 1940. He implies that while Churchill the wartime legend will continue to be remembered and cherished by the country, his incarnation as leader of the Conservative Party was indelibly associated with the deprivation of the 1930s and led to him being unambiguously rejected as leader of the country in the General Election of July 1945. The results of that election were released on the morning of 26 July 1945.[99] The Labour Party under Clement Attlee won a 146-seat majority with 48 per cent of the vote. The Conservative vote did not collapse, remaining a creditable 40 per cent. However, this only translated into 198 seats, as opposed to the 320 won by Labour.[100]

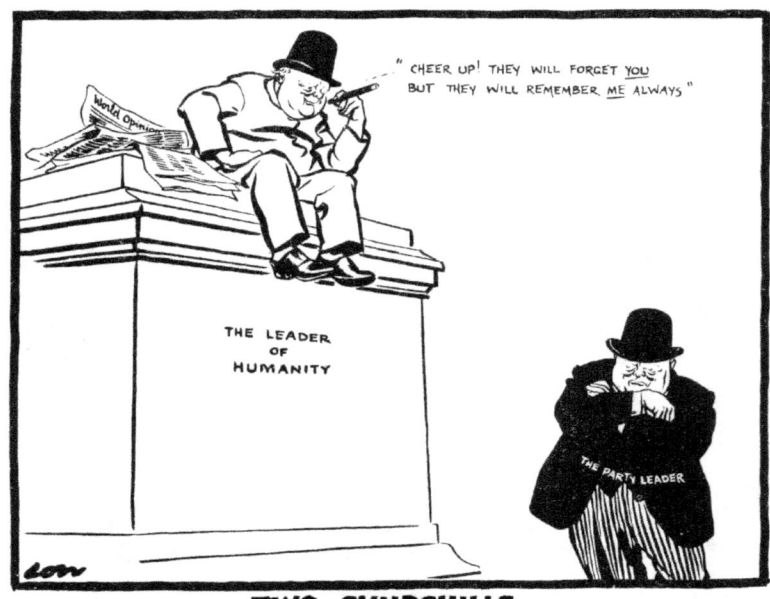

FIGURE 5.18 *Sir David Low, 'Cheer Up. They Will Forget You but They Will Remember Me Always',* Evening Standard, *31 July 1945, British Cartoon Archive, Kent University, LSE 1253.*

Attempting to cheer her husband up, Clementine told Churchill that the election results were 'a blessing in disguise', to which Churchill dryly replied: 'at the moment it's certainly very well disguised'.[101]

6

Churchill as Cold War Leader of the Opposition and as Prime Minister, 1945–1955

A proposal for Sir Oswald Birley to paint Churchill was first raised early in 1945 (see Plate 8). In January 1945 Clare Sheridan wrote to her cousin that she was 'delighted to hear you will be sitting to Oswald ... for a portrait'. He was 'one of our greatest contemporary portrait painters ... a lovely person and a gallant man'. With his fine record of bravery in the First World War she was certain they would have a great deal to talk about 'warhorse to warhorse'.[1] Such was Churchill's workload, however, that he could not find time for sittings. The 5th Lord Clanwilliam then suggested Birley paint one portrait of the Prime Minister for himself and a copy for the Carlton Club in London.[2] However, Churchill was still far too busy for sittings with Birley. The project languished until after Churchill's defeat in the General Election of July 1945. He now had the time, but felt too depressed to sit.

Birley finally secured sittings with Churchill in June and July 1946 and painted an introspective, pensive and preoccupied ex-Prime Minister – lost in thought and brooding on his lot as Leader of the Opposition. He had made himself relevant by

giving his famous 'Iron Curtain' speech at Fulton in March 1946[3] and in September the same year calling for a united Europe in Zurich.[4] However, he was often bested at the despatch box by Attlee and other Labour ministers in 1946, giving rise to mutterings within the Conservative Party that Winston was past it and should stand down to make way for Anthony Eden.[5] Birley's oil was a commission from the Speaker of the House of Commons; the portrait was intended for the Speaker's House. Mary Soames, Churchill's youngest daughter, later noted that initially her father was not at all keen on sitting for Birley. This was to be the first portrait of him since he had lost the July 1945 General Election and Churchill was still bruised by the event. He felt depressed and fretful. Soames noted in an occasional diary she kept at the time: '14 June 1946: "I spent the day chasing Papa to sit for Mr. B . . . later found Mr. B and Papa well-pleased with each other and the portrait." 15 June 1946: "Papa sat goodly all day."' Each sitting lasted about two hours, with Churchill dictating to a secretary throughout. Soames noted that her father greatly appreciated the artist's '"quiet charm", beautiful manners and impressive First World War record.'[6]

During the First World War, in March/April 1918, Jacob Epstein had looked to Lady Randolph Churchill and Lord Beaverbrook to help him become an official war artist and keep him from being posted overseas with the Royal Fusiliers. Both tried their best but were unable to secure his release from the army. Epstein received orders to go with a draft to Palestine but just before he was supposed to embark he was found wandering on Dartmoor in a confused and distracted state. He was sent to hospital to recover.[7]

Epstein was commissioned to make a portrait head of Churchill in August 1945 by the Ministry of Information's WAAC, at the suggestion of its chairman, Sir Kenneth Clark (see Figure 6.1). Epstein was initially reluctant to accept as he had a lot of other work to occupy him at the time. As it transpired, by the autumn of 1945 Churchill was Epstein's neighbour – the latter had been living at 18 Hyde Park Gate since the spring of 1928[8] while Churchill moved into 28 Hyde Park Gate in October 1945.[9] Epstein's initial tepid reaction to the offer of

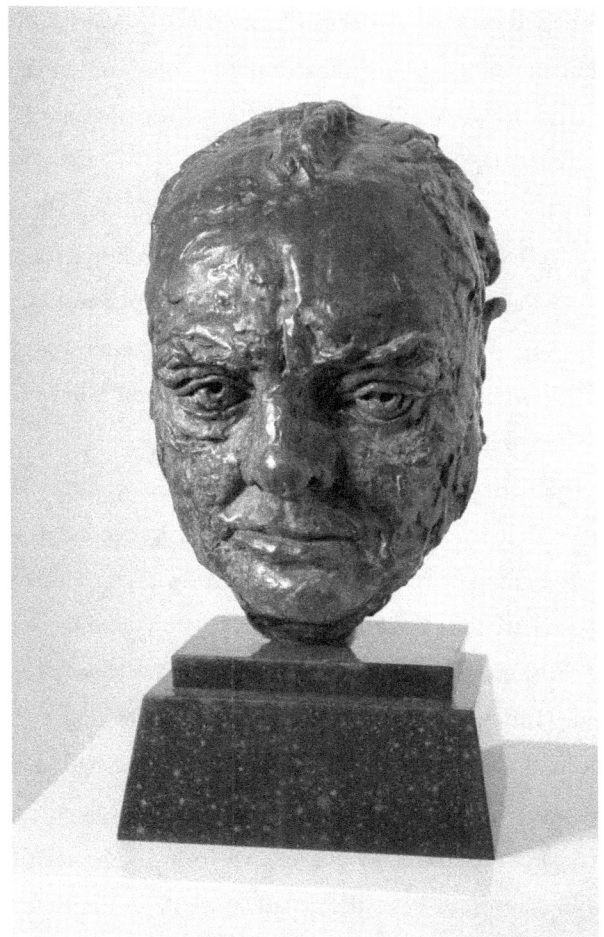

FIGURE 6.1 *Jacob Epstein (1880–1959), Head of His Majesty's Opposition, Winston Churchill, 1946, bronze, 31 × 19 × 24.5 cm, Government Art Collection, London.*

the commission may lie in him being very much a man of the Left at heart; he had presented himself as a dedicated anti-Fascist and anti-Colonialist and was well-disposed to the Soviet Union from 1933.[10] John Finch, Epstein's secretary in 1946, noted that he was 'unashamedly left wing in his politics. He had no time at all for... King George VI.' He had voted for Attlee in July 1945, though feeling the Labour leader was insufficiently radical in his socialism. However,

Finch was surprised by how respectful Epstein was towards Churchill when they first met in November 1946 – though the sculptor could become irritated by the press attention 'that man' attracted. Churchill was always self-deprecating about his own painting, which appealed to Epstein.[11]

Epstein was thus certainly not a fan of Churchill's politics. However, he does seem to have admired Churchill the war leader. Churchill arrived for his first sitting at 18 Hyde Park Gate in November 1946 with a plain-clothes policeman and a secretary. Apparently, after first looking over Epstein's studio and casts of women's heads Churchill ungraciously grunted to Finch: 'You wouldn't want to go to bed with any of his women, would you?'[12]

Epstein was nettled when he offered the policeman a chair as he stood at the door but Churchill curtly dismissed him. Churchill proceeded to smoke a huge cigar and dictated to the secretary for an hour. The secretary left to be replaced by another and Churchill smoked a second cigar for another hour. Churchill gave the artist three more sittings at Chartwell. The result, with furrowed brow and pugnacious chin, was judged a success when it was first exhibited at the Leicester Galleries in February 1947.[13] David McFall, who had been the nearest person that Epstein had to a regular and trusted studio assistant from the early 1930s, helped Epstein to make the plaster cast from the head of Churchill he had modelled in clay. McFall recalled that Churchill had objected strongly to the presence of a prominent dewlap of skin beneath his chin which Epstein had faithfully and accurately reproduced, claiming that it made him appear 'old and decrepit'. McFall was surprised when Epstein removed the offending detail; when he asked him why he had capitulated to the vanity of the sitter, Epstein shrugged and said that McFall would one day get old and find all-too-plentiful evidence in the mirror for waning powers; then he would understand.[14]

Epstein evidently enjoyed the time he had spent with Churchill, much more than he had anticipated. He was pleased with the portrait, despite the compromise concerning the area beneath Churchill's chin. He believed that he and Churchill had 'got on . . . if not entirely like a house on fire' (Churchill had

his reservations as to the sculptor's enthusiasm for an independent Jewish state of Israel – whose creation was barely two years in the future)[15] well enough that when Epstein was knighted in January 1954 he was convinced that Churchill (Prime Minister since October 1951) had been responsible for the recommendation.[16]

Henry Mayo Bateman's portrait (c. 1949; Figure 6.2) entertainingly imagines how a cigar-wielding Churchill might have been depicted by Picasso if he had sat for the Spaniard in the late 1940s, after Sir Alfred Munnings had referred so dismissively and crudely to Picasso during his Presidential Address at the Royal Academy Dinner in April 1949. Sir Alfred had also given the distinct impression in his remarks, broadcast by BBC radio, that his negative view of Picasso and of Modernism in general was heartily shared by the Prime Minister.[17] Indeed, he claimed that if he and Churchill happened to ever encounter Picasso, Matisse and Henry Moore in the street they would gladly give them a swift kick in the pants.[18] In March 1950, Churchill told Sir John Rothenstein, then Director of the Tate Gallery, that what Munnings had claimed was 'quite untrue ... besides, I never walk in the street'.[19] Churchill never gave any indication that he had much time for Cubism or thought much of Picasso, although in his 1921 essay 'Painting as a Pastime', he singled out Manet, Monet, Cézanne and Matisse for praise.[20] In October 1955 he would inspect with great interest and respect the murals Matisse had produced the chapel at Vence in the south of France.[21]

Bateman had admired the efforts of the wartime Churchill; in the image after Picasso he is clearly giving the 'V for Victory' sign he had adopted from August 1941 onwards, after signing the Atlantic Charter with President Roosevelt.[22] It took Churchill a while to familiarise himself with the gesture and not making it palm inwards, which would have been recognised by the vast majority of the British people as an offensive gesture

The pseudo-portrait could also be regarded as Bateman taking the opportunity to pay belated homage to Picasso's searing *Guernica*, which the cartoonist had seen and greatly admired when the vast canvas was exhibited for the first time in

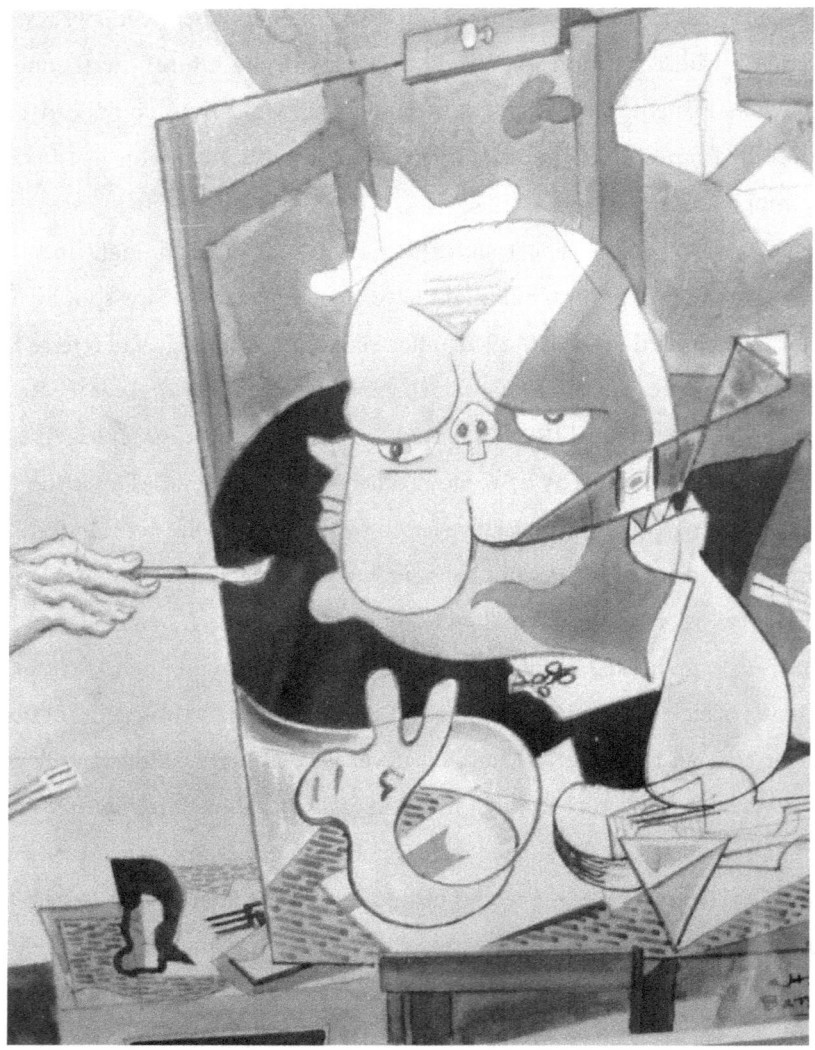

FIGURE 6.2 *Henry Mayo Bateman (1887–1970),* **Winston Churchill à la Picasso,** *c.1949, pen-and-ink and watercolour on paper, 25.5 × 22.3 cm, Private Collection.*

Britain at the New Burlington Galleries, London, in October 1938.[23] Bateman may well have had in mind the detail from *Guernica* used to promote the painting in October 1938 – the weeping and screaming woman – though his Churchill in contrast has his mouth firmly shut, chin defiantly jutting upwards in determination while his cigar is securely grasped in an unwavering left hand.[24]

Churchill might imply he did not care to be depicted as a female impersonator but cartoonists such as Low and Strube did it often between the wars, imagining him as an impressively well-built nursemaid,[25] an unlikely alluring tubby temptress of an Arabian harem,[26] or as an impressively helmeted Wagnerian heroine.[27] Gabriel effectively continued the tradition by presenting Churchill in the guise of a powerfully built, cigar-smoking symbolic female figure dressed as though for the frieze of a Classical Greek temple (Figure 6.3).[28] In the recent General Election of February 1950, which he had narrowly lost,[29] Churchill had frequently voiced his concern over the possible catastrophic outcome of the current nuclear arms race between the Soviet Union (which had tested its first atom bomb in August 1949) and the United States. He argued that by far the best policy for the future was for the UK to have its own nuclear capability while at the same time striving to achieve an agreement between the nuclear powers in which they radically limited their production of atomic weapons.[30]

Kukrinikzi's cartoon of Churchill, published in *Iskustvo* in 1951 (Figure 6.4), is useful for the reader to see how Churchill was perceived from an even more left-wing perspective. Indeed, there is evidence that Stalin rather appreciated this cartoon, and personally gave the order for it to be reproduced in the Soviet press. For though Churchill is here undoubtedly presented in grotesque form, there is something that is still commanding and menacing about him. It would seem that the Soviet leader regarded Churchill as by far the most formidable of the Allied leaders he encountered during the Second World War. In late March 1945, Stalin's senior general, Zhukov, wondered whether the Western Allies could be believed when they declared they had no desire to take Berlin before the Red Army. Stalin reflected for a moment and then stated he believed in Roosevelt's good faith but that Churchill was 'capable of anything'. This was said with a wry, even admiring, chuckle. Stalin always admired daring and cunning in equal measure.[31] Perhaps he warmed, just a little, to that hint of the gangster boss in Churchill – who blithely acknowledged without any apology, when they met in Moscow in October 1944, that he had once contemplated Stalin's

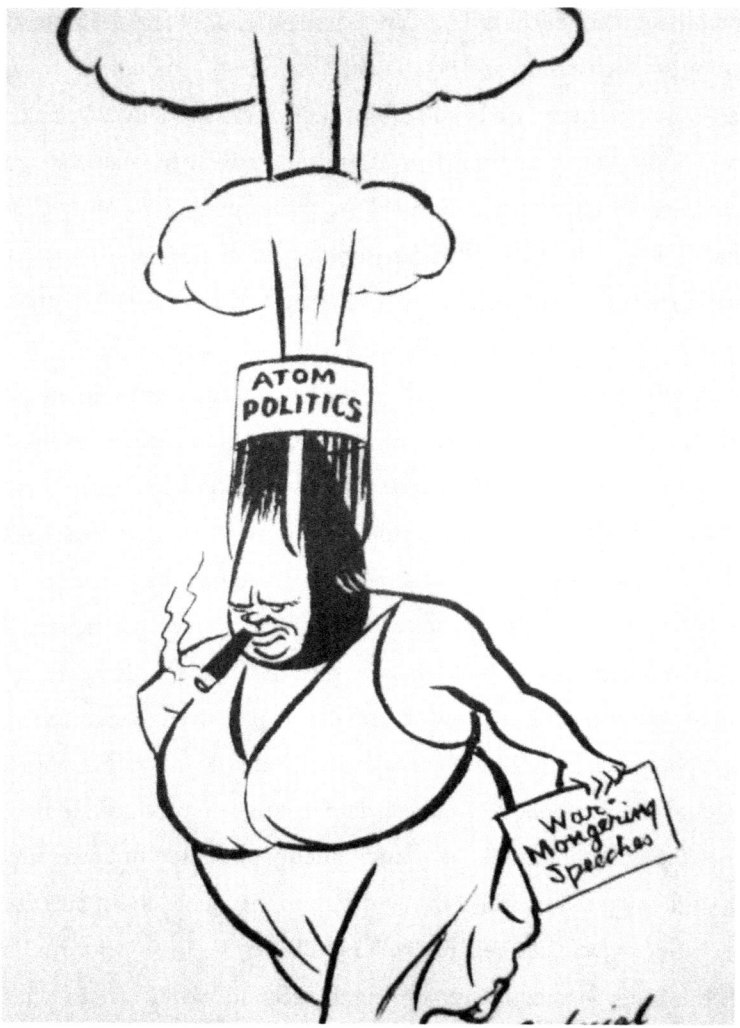

FIGURE 6.3 *Gabriel (1912–1997)*, Daily Worker, *2 March 1950, Private Collection.*

assassination during the Intervention period of 1919–1920 when he had been Secretary of State for War. Given how events had unfolded since then he was now rather glad he had not gone through with the plan.[32]

Stalin did appear genuinely surprised and put out that Churchill did not return to the Potsdam Conference in late July 1945 after losing that month's

FIGURE 6.4 *Kukrinikzi,* Iskustvo *(Moscow), 1951, Private Collection.*

General Election; in true Soviet style he assumed the result would be a foregone conclusion in favour of the sitting Prime Minister.[33]

The atmosphere was becoming distinctly frosty for Churchill's reputation as the temperature of the Cold War plunged post-1947. In 1949, Molotov, something of a patron to Kukrinikzi, had fallen out of favour with Stalin; one reason given was that Molotov had allowed a selection of Churchill's most rousing wartime speeches to be published in Moscow in December 1945, graced with quite a flattering portrait drawing of the former British Prime Minister by another artist to whom Molotov had given patronage.[34]

* * *

Attlee's government, having lost so many seats in February 1950, was mortally wounded, but there was much speculation in the summer of 1951 as to whether Churchill had the energy and was fit enough to lead the Conservatives into the next General Election.[35] The fact that Churchill was perceived as such an enthusiastic believer in the British Empire was thought to be reactionary and increasingly unpopular with the electorate. Churchill liked to emphasise that British military power, the lion's roar, still counted in the balance between the two superpowers: the United States and the Soviet Union.[36] Low wished Churchill would at least partly acknowledge the reality of British weakness; it no longer possessed the Empire of 1945 and the military muscle that went with it – with Indian independence in August 1947, the huge Indian Army had melted away. Empire had given way to Commonwealth (a word Churchill could rarely bring himself to say – preferring Empire, much to the irritation of his advisers).[37] By now Low admitted he was becoming bored with drawing Churchill – he had presented him in nearly every guise and, over the years, as most members of the animal kingdom (see Figure 6.5).[38]

The Jewish-Croatian Oscar Nemon had moved to the UK in 1938 to escape anti-Semitic prejudice in his native Yugoslavia and then in Brussels where he had established himself in the early 1930s. He developed a tremendous admiration for Churchill as wartime leader while living in Oxford during the war. He took British citizenship in 1947 and first encountered Churchill in December 1950 at the La Mamounia Hotel in Marrakesh, Morocco. Nemon later recalled in his unpublished memoirs that he had been invited at the last minute by 'a friend of mine, the French psychoanalyst René Laforgue', who thought a run-down and depressed Nemon would be re-energised by the opportunity to sketch his hero at close quarters (see Figure 6.6).[39]

Laforgue managed to reserve Nemon a table not far from Churchill's. He urged Nemon to make 'a few sketches' of him. The sculptor replied that he would make 'some mental notes . . . this I did and after lunch, when I was alone in my room, I started making a sculpture of the head of Churchill . . . Afterwards at meal times, my prolonged glances towards Churchill must have given

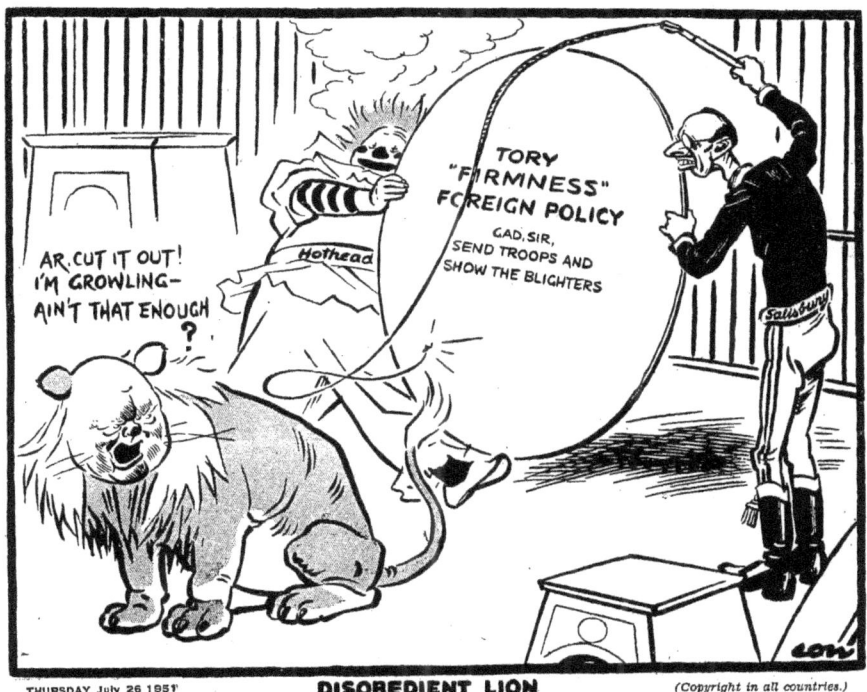

FIGURE 6.5 David Low, 'Arh, Cut It Out, I'm Growling. Ain't That Enough?' *Daily Herald, 26 July 1951*, Cartoon Archive, Kent University.

the impression of rather rude attention ... I became aware of Churchill's studied return of my gaze'. Nemon worried that 'such activity might be noticed by the Scotland Yard bodyguard'. However, the policeman told Nemon not to worry: 'Mr. Churchill's used to being looked at ... he never notices anyone outside the circle of his personal guests. Look at him as long as you like – everyone else does!' Nemon did so, 'but I quickly became aware that Churchill certainly did notice my attention and I felt that he was not very pleased by it.' The sculptor even feared he might be hit by 'a well-aimed dinner plate'.[40]

Then Churchill's party was joined by a cousin of Clementine's, Sylvia Henley,[41] whom Nemon had met in London during the Blitz. Nemon showed her the small head of Churchill he had just modelled. Henley was 'most enthusiastic about it and insisted on Lady Clementine seeing it'. Only a few hours later, Nemon received a note from her – she wanted to buy the terracotta. Nemon promised

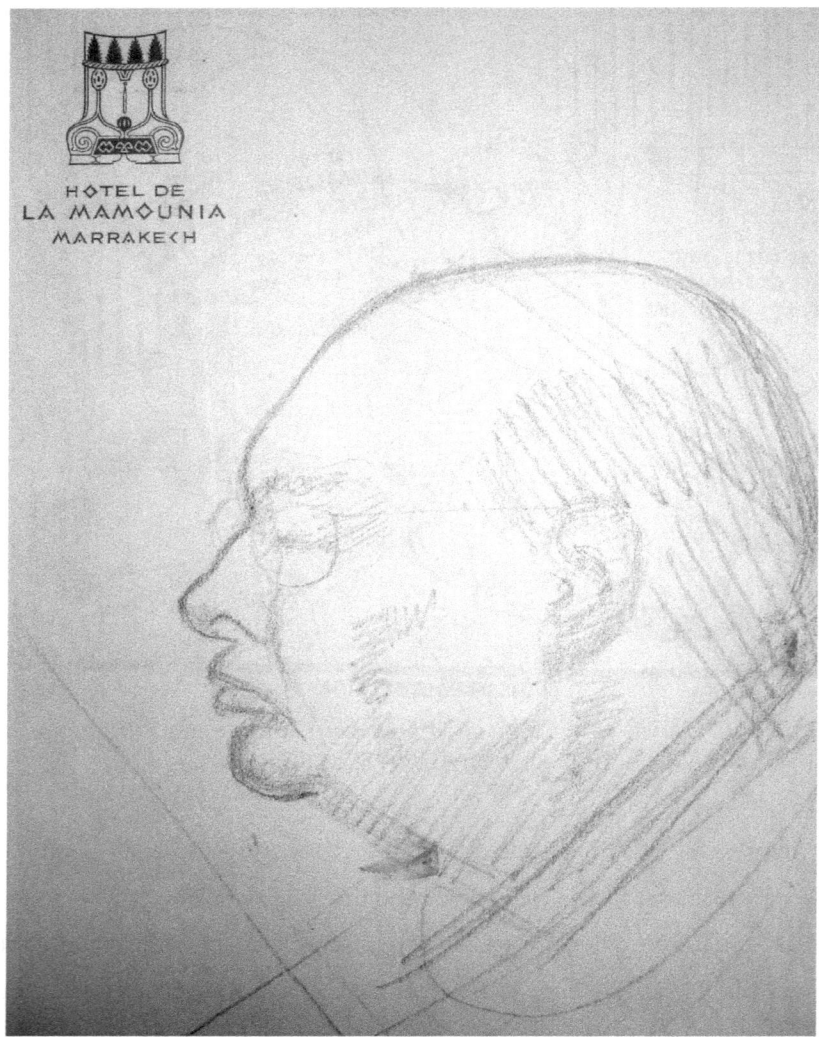

FIGURE 6.6 Sketch of Sir Winston Churchill *by Oscar Nemon (1906–1985), undertaken during the course of their first meetings at La Mamounia Hotel. This sketch was donated to Churchill College by the Nemon Estate. Plaster studies of Churchill by Oscar Nemon may be viewed by appointment at the Nemon Studio Museum and Archive on Boars Hill, near Oxford, to be booked via www.oscarnemon.org.uk.*

not to change this head and asked 'that I might be given the opportunity to do other studies of her husband – possibly while he was busy painting. She agreed and so I was able to make further sketches of him ...'.[42]

In February 1952, King George VI died, to be succeeded by Queen Elizabeth II. In November of that year she decided to commission 'a marble bust of Churchill for Windsor Castle to be placed in the Armoury alongside his illustrious ancestor, the Duke of Marlborough'.[43] The Queen had admired Churchill as her father's indomitable wartime Prime Minister and, since October 1951, he had been her Prime Minister. It would not be an exaggeration to say that Churchill was very taken indeed with the new and very young Queen. Roy Jenkins has described him as 'quite openly gaga' over her.[44]

Nemon later recalled that he was strongly recommended for the commission by 'Sir Carl Barker, Keeper of the Ashmolean Museum and [also] at Churchill's express wish . . .' Churchill's secretary John Colville told the sculptor that many among the Queen's advisers thought the commission should go 'to a member of the Royal Academy'. However, 'Churchill resolutely stuck to his choice . . .'.[45]

Nemon tried hard but usually failed to secure sittings with the elusive Churchill during early 1953. Finally, Colville brought pressure to bear from the Queen for her Prime Minister to make himself available to the sculptor late in March 1953.[46] Nemon was later to write that the portrait he finally coaxed from Churchill was

> the result of informal meetings at Chequers and at No 10 Downing Street where a room was put at my disposal. At No 10 I worked on three heads at the same time, each showing a different aspect of Churchill . . . I always dreaded the after-lunch sessions with my sitter as he was liable to be bellicose, challenging and deliberately provocative . . . Churchill rarely made appointments with me but one day he did so and he was obviously in a tense mood. My heart sank as he entered the room and strode over to the three shrouded heads. He pointed to the nearest and roared: 'Show it to me.' It was the most dramatic of the three. I could see his anger rising and I waited for the outburst . . . 'You think I look like a crafty, shifty, war-monger, do you? Is that what you think?' I hurriedly said that I had not intended to give that

impression but had tried to bring out his determination and purpose. He gave further vent to his wrath with some remarks about his 'bulldog' image, an attitude he struck for the morale of the nation, saying that he was not just a ferocious watchdog but a man compounded of many qualities including about fifty percent humour.[47]

Then Churchill looked at the second head. This satisfied him no better. He found the expression 'too intimate' for his taste and said he wanted a portrait that would convey his features but make no statement, in short a 'well-mannered and civilised portrait in the style of the Old Masters'. The third head was judged satisfactory and that 'is the one I carved; it stands in Windsor Castle today'. At one point though, Churchill stormed out and Nemon was left feeling 'thoroughly depressed' and wondering whether 'to destroy the three models' when Churchill returned. His temper had evaporated completely and he apologised at once: 'Why man you are a genius ...'. The readiness to apologise after a display of temper was as characteristic of him as his attitude to the Queen's desire for this sculpture of him. 'He told me later that he felt it a greater honour that she should want to have this bust in Windsor Castle than that she should confer on him the Order of the Garter. It was a "civilised way" of granting him some immortality....'[48]

In an interview Nemon gave to the *Daily Telegraph* in February 1954, he admitted that Churchill had been 'one of the most difficult subjects I have ever had'. Few of the sittings he had been given at 10 Downing Street had lasted more than 15 minutes. 'The Prime Minister has many moods, all clearly defined because he is a man of such powerful character. And he will not surrender his personality to the artist....' To sum up, Churchill was a 'very complex character and ... one of the most remarkable personalities of all time.'[49]

In late March 1953, Nemon was surreptitiously invited by the then President of the Royal Academy, Sir Gerald Kelly, to submit a bronze cast of his Churchill portrait head for Windsor Castle for that year's exhibition. However, much to

Kelly's embarrassment and Nemon's anger, the work was rejected by the sculptors who were Academicians on that year's selection jury.[50] Nemon was greatly touched to receive sympathetic letters from both Churchill and John Colville regarding the Academy's hostile reaction. The latter wrote:

> I cannot understand the RA; but there action outs you in the same category as John and Sickert! Anyhow, if I were you, I should not be greatly upset and the bust will earn greater fame on a permanent pedestal in Windsor Castle than on a sixpenny one at the RA Summer Exhibition! I ... look forward to seeing the busts tomorrow ... and I know that both the PM and Mrs. Churchill are very anxious to see them too.[51]

Being spurned by the Royal Academy actually brought Nemon and Churchill closer together; Nemon was often invited to Churchill family meals and gatherings. Churchill found the sculptor lively and engaging company. On one occasion, shortly before Churchill was made a Knight of the Garter by the Queen early in June 1953, Nemon recalled Churchill's daughter Diana asking her father whether 'he intended to keep the Knight's traditional vigil. Looking down at his plate he answered "no. I am not going to keep the vigil. I have sent the Queen a medical certificate to be exempt from that". Diana declared that not to keep the Vigil was 'a gross breech of tradition, a disregard of religion and above all a denial of Divine Soveriegnty'. Churchill was hurt:

> 'If I should die this very day and arrive at the Gates of Heaven to find St. Peter there he would ask me who I am. When I say Winston Churchill, I'm certain St. Peter will say "Ah Winston Churchill, To hell you go immediately!".
>
> 'I should ask St. Peter why and he will answer: "You murderer. You killed 25,000 people in the City of Dresden alone ... defenceless women and children and then and then there was Hiroshima."' At that point Churchill loosened his jacket: 'I should stand my ground against St Peter, Yes, I'd fight

him ... because I defended my country and my children against a madman, yes a madman! A creation of the Almighty too! ... I have known well the intrigues and the quarrels within the churches. It was I who nominated those bishops, those archbishops ... and those grave rabbis as well. I've been the arbiter in their disputes and you expect that I, knowing as I do their behaviour, can have any respect for the God they pray to?'

For about an hour Churchill held forth on comparative religion:

I do not feel guilty for what I have done. I don't feel at all guilty. But if Heavenly Law demands punishment for a crime you have wanted to commit and did not, then I confess to my guilt. I was determined not to let that Monster [Hitler] invade my country. I was ready to prevent that – even by means banned by the Treaty of Versailles. For that, if needs be, I'd willingly go to hell.[52]

Further sittings with Churchill were arranged but then were abruptly postponed as the Prime Minister suffered a major stroke on the evening of 23 June 1953.[53] News of this event had to be kept from the outside world and that included the sculptor. Nemon did not succeed in arranging access again to Churchill until the early autumn of 1953 and then he had to entice the Prime Minister with the prospect that Nemon would allow himself to be modelled in clay by his sitter.[54]

The sculptor later recalled: 'Churchill ... was tempted by me to try his hand at sculpture ... we should model each other at work. He felt that he was getting his own back at me in this way and so our duel began. We had not been at work long when he became excited about the difficulties in which he found himself. His cigar began to come to pieces and soon he was roaring like a lion over its prey. He shouted at me: "How on earth can I work when you keep moving?" I kept still after that and by doing so lost an opportunity of making a real study of him – a sad loss but almost inevitable as he was a restless and a most unwilling sitter.'[55]

Churchill, and just as importantly Lady Churchill, pronounced themselves content with the bust Nemon was carving in January 1954.[56] He was, however, a slow and meticulous worker; progress on the bust was further retarded by the fact that some of those involved in the commission, such as John Colville and Sir Owen Morshead, were keen to sit for their own portraits.[57] The marble was not delivered to Windsor Castle until late in June 1956 (see Figure 6.7). However, Sir Owen thought it well worth the wait, writing to the sculptor:

> ... my dear Nemon, let me say that I like the bust. It is to my eye, a penetrating and noble representation. It is a little too big ... But the ingenious idea of placing it in the East Window largely counteracts its being out of scale and, for my part, I am content. What I wish chiefly to see is whether its present position will satisfy the Queen. If so, all is well. I am very happy indeed that this great feat has been accomplished and, let me repeat, I am really pleased with the bust itself.[58]

Three weeks later, Sir Owen was pleased to report to Nemon: 'I asked the Queen today whether she was satisfied with your bust of Sir Winston and Her Majesty instantly exclaimed "But I think it is excellent, don't you? And it looks well there too, the only thing being that it shows the wrong side of his face." But when I pointed out that placed on one flank of the room it was immediately seen by the public she was quite contented. It was evident that she really does regard it as a success and a desirable acquisition.'[59]

In November 1953, Churchill – still recovering from the stroke he had experienced in June 1953 – gave a bravura performance in the House of Commons at the expense of the Labour Party leader Attlee.[60] Within a matter of days he would be attending the high-profile Three Power Bermuda Conference with the leaders of France and the United States. There he would argue passionately that after Stalin's death an agreement could be reached with the new Soviet leadership to seriously limit the production of nuclear weapons.[61] However, despite all the tributes paid to the great man on Churchill's seventy-ninth birthday,

FIGURE 6.7 *Oscar Nemon,* Prime Minister Sir Winston Churchill, *1952–1956, marble, 56 cm high, Royal Collection, Windsor Castle.*

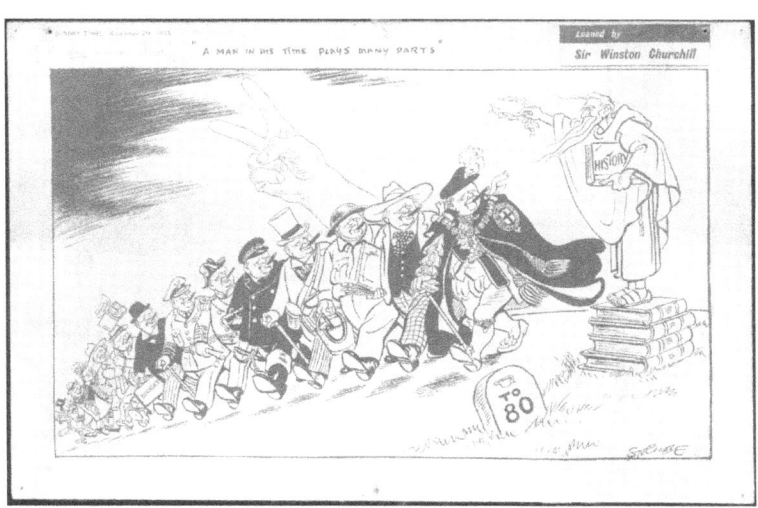

FIGURE 6.8 *Sidney George Strube, 'A Man in His Time Plays Many Parts',* Daily Express, *29 November 1953, Cartoon Archive, Kent University.*

Strube marks the many roles Churchill had performed and uniforms he had worn in over half a century in British politics while the subject of the cartoonist's admiration and affection had been an admirer and collector of Strube's cartoons since before the First World War. He had appreciated Strube's 'genial spirit' and was ever moved by the 'careworn face of his Little Man . . .'.[62]

by the end of the year the Chief Cabinet Secretary, Sir Norman Brook, judged that appearances had been cruelly deceptive: 'he [Churchill] no longer had the necessary energy, mental or physical to give to papers, or to people the full attention which they deserved'. He felt it would have been better for all and the country that Churchill had stepped down after his stroke in June 1953.[63]

Low recalled of his February 1954 cartoon 'Grand Old Evergreen' (Figure 6.9) that 'Sir Winston was so amused at this cartoon that he asked the artist for the original drawing'.[64] Churchill, evidently, still saw himself as a warrior. He may have felt himself under siege as later that month Malcolm Muggeridge

FIGURE 6.9 *Sir David Low, 'Grand Old Evergreen', Manchester Guardian, February 1954, Private Collection.*

declared in *Punch* that he was far too old, almost senile, to be left in charge of the country.[65] Two months later, on 5 April 1954, Churchill started well in a Commons debate about nuclear weapons and then completely lost his train of thought. Conservative backbenchers muttered that their leader was now 'gaga', and the government was only saved from an embarrassing defeat on the motion by a closing speech from Churchill's ever-more-frustrated heir apparent, Anthony Eden.[66] Perhaps much of the attraction of this cartoon lay in visualising how Churchill would have preferred to end his life – a few years later General Sir Alan Brooke reflected, preparing his *War Diaries* for publication, that in March 1945 it had been difficult to keep the Prime Minister away from the fighting along the River Rhine: 'I knew that he longed to get into the most exposed position possible. I honestly believe that he would really have liked to be killed on the front at this moment of success. He had often told me that the way to die was to pass out fighting, when your blood is up and you feel nothing.'[67]

* * *

The principle inscription on Nemon's sculpture *Seated Sir Winston Churchill* (Figure 6.10) reads: 'This Statue was commissioned by the Corporation of London in 1955 as a tribute to the Greatest Statesmen of his Age and the Nation's Leader in the Great War of 1939–1945.' Beneath that is written: 'The Rt Hon. Sir Winston Spencer-Churchill KG, OM CH, MP. Statesman.'

The statue had its genesis in Nemon reading in the London *Evening Standard*, early in December 1953, of a proposal by Sir George Elliston for a statue of Churchill to be erected inside the Guildhall. The next day, 2 December, the sculptor wrote to Sir George:

> Her Majesty the Queen recently commissioned me to make a bust of the Prime Minister for Windsor Castle. On such a command Sir Winston made a special effort to help me carry out this task. As a result, I made many studies of this most evasive and restless sitter and the thought has occurred to me that this material, which was collected only after a great struggle, may be useful for the purpose you have in mind.

He was still working on the bust for the Queen, and it was 'in my studio with the other studies of the Prime Minister and I should be very much pleased if you could spare a moment to some and see them. Lord Bracken ... or Sir Owen Morshead at Windsor Castle will be able to tell you about this work. I trust you will forgive my troubling you but I am sure you will appreciate the unique opportunity I have had of studying one of the most remarkable personalities of all time'.[68]

By late January 1954, the Corporation of London's Court of Common Council felt able to commission Nemon to 'execute a three-quarter length statue of Sir Winston Churchill in bronze at a fee of 1,000 guineas'.[69] A few days later the London *Evening Standard* was aware of the commission. On 5 February 1954, in 'the Londoners Diary' the paper reported that Nemon's statue for the Guildhall would take the form of a 'standing Churchill presented as if giving a speech ... It would be a larger than life study, three quarters length of the Prime Minister ... The final statue will show Sir Winston wearing his City robes'.[70]

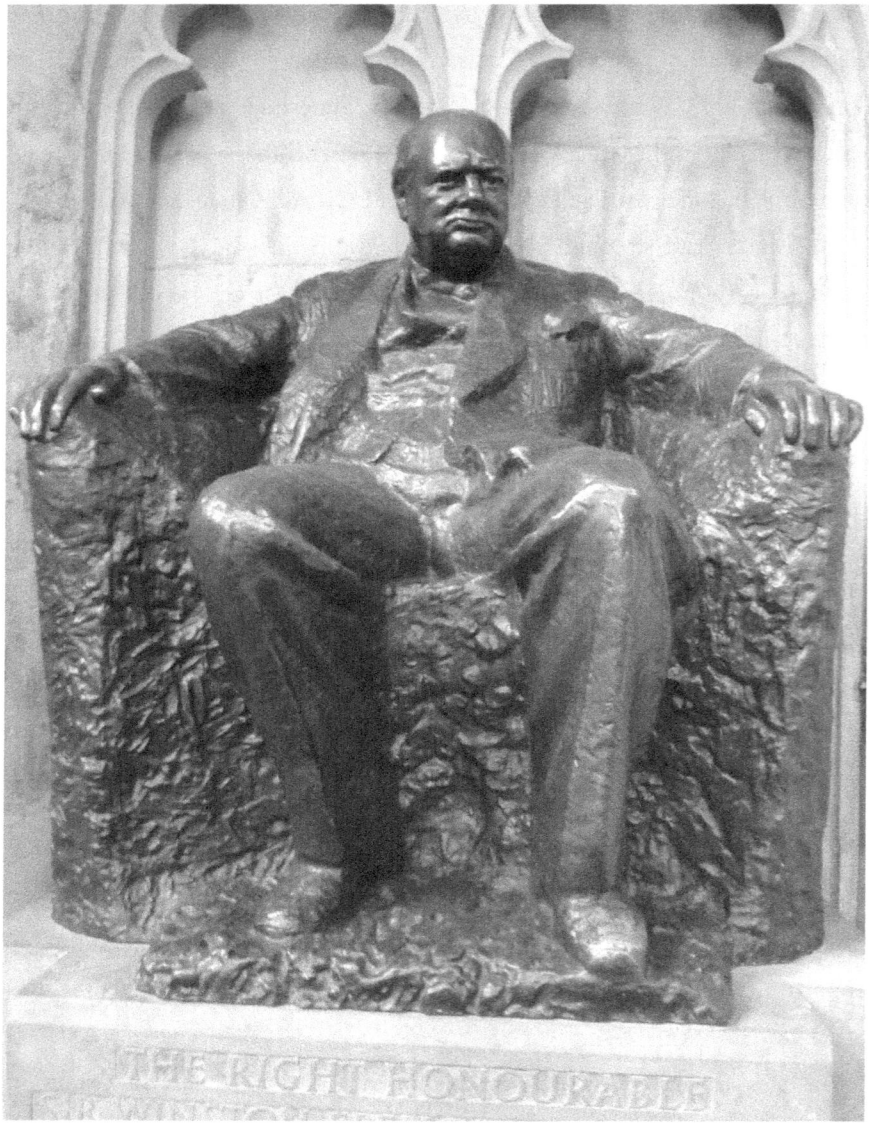

FIGURE 6.10 *Oscar Nemon,* Seated Sir Winston Churchill, *1954–1959, bronze, 141 × 110 × 86 cm, the Guildhall, London (in a niche at the west end of the North Wall), unveiled February 1959.*

In his unpublished autobiography, Nemon later recalled that he tried several times during the spring of 1954 to persuade Churchill to sit for the new commission. However, the Prime Minister was 'depressed because his political colleagues wanted him to retire. It was practically impossible to get him to come to my Studio but he finally came a few weeks before it was finished and he seemed satisfied with it'.[71]

Nemon also remembered how Churchill, during these occasional sittings with him for the Guildhall statue, often talked about 'his own feelings and attitudes ... "Don't let anyone else do for you what you can do for yourself"... Even in extreme old age he strongly resisted any attempts to help him up from his chair, sometimes using his last reserves of strength to maintain his independence'.[72] Later in 1954 Churchill would return from Cabinet meetings, sit at the table and 'gazing into space, mumble half-aloud "those hungry eyes. Those hungry eyes. I really should resign. One cannot expect Anthony to live for ever"'.[73]

By the early autumn of 1954 Nemon had decided, in consultation with Churchill and his family and the Corporation of London, that the Guildhall statue would now take the form of a magisterially seated Churchill. It is likely that Nemon's conception of a seated Churchill was informed by study of Daniel Chester French's (1850–1931) mighty 1920 statue of an Olympian seated Abraham Lincoln, 19 feet (5.9 metres) high, carved in dazzling white Georgia marble for the centre of the Lincoln Memorial (inaugurated by President Harding on 30 May 1922). Lady Churchill had first admired this sculpture during a visit to Washington DC in February 1931.[74]

Early in November 1954, the *Daily Telegraph* reported that Nemon had 'nearly completed in clay the statue of Sir Winston Churchill commissioned for the Guildhall by the City of London Common Council ... the statue rather bigger than life-size depicts the Prime Minister sitting in an armchair leaning slightly forward with an intent, listening air as though about to speak. He wears a frock coat and bowtie. His hands grip the chair arms and he seems to be on the point of rising. Mr Nemon said yesterday: "I met the PM socially on

several occasions ... I hope to get a mental picture of him to bring back to the studio, to represent to the world the idea of a man who was majestic and magnanimous'".[75]

Later that month the Corporation's statue committee approved Nemon's clay model; they were so pleased with the sculpture that they agreed to pay him an additional £2,000.[76] The Corporation was keen to have the full-sized plaster cast of the statue unveiled by its sitter in the Guildhall in June 1955 (see Figure 6.11). The sculptor in March 1955 thought this was achievable, but that the

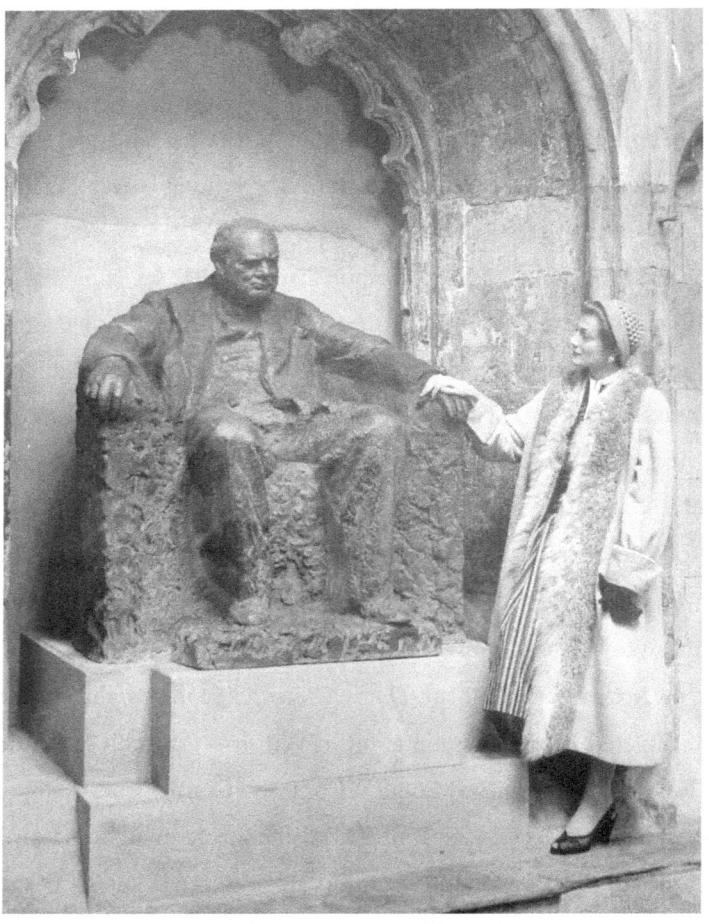

FIGURE 6.11 *Oscar Nemon,* Seated Sir Winston Churchill, *1954–1955, plaster cast, unveiled at the Guildhall, London, 21 June 1955.*

full-sized final bronze cast would take at least another six months to complete.[77] Later that March, Nemon indicated that Churchill and his family (particularly Lady Churchill) wanted him to undertake further work on the hands of the statue. The sculptor thought the chair in which Churchill is sitting required a certain amount of alteration.[78]

Nemon later recalled that, while working in the spring of 1955 on the full-sized plaster cast for the Guildhall, the Prime Minister had been 'so busy and hard-pressed that he had been unable to give me any more sittings and when it got to within three weeks of the unveiling, I began to grow desperate'. The only thing the sculptor thought he could do was to 'search for a model of the same massive build and do the preliminary work that way. My studio was in Chelsea at that time and reckoned the local pubs would be my happiest hunting ground'. He ventured into the pub nearest his studio and happened to bump into the daughter of the current Russian ambassador Krassin: 'she promised to send someone along'. The man appeared the next day – complete with his own armchair: 'he appeared to be a journalist who know a great deal about many prominent people ... however he eventually proved an embarrassment'.[79]

The full-sized plaster was completed, more or less to the sculptor's satisfaction, and on the day before the unveiling (21 June 1955) a reporter from the *Daily Express* called. He asked Nemon whether he was aware that the man who modelled for the statue, who was called Hamilton, was 'a notorious Fascist? ... Was I aware he had been jailed twice by Churchill in two World Wars?' Nemon was mortified by this untimely revelation and begged the reporter not to release the story on the day of the unveiling. 'However, the story was splashed on the front page of the Express the next day.' Several weeks later the sculptor lunched with Churchill and told him the full story. Churchill replied with a chuckle: 'If I'd known this would happen, I'd have sat for you even at midnight.'[80]

Lord Moran was present for the unveiling ceremony in the Guildhall on 21 June 1955 and noted that evening in his diary: 'He [Churchill] liked it as

much as he had disliked Graham Sutherland's portrait.' Churchill very much liked the fact that immediately to the left of his statue was the stupendous monument to Admiral Lord Nelson and next in line was the equally impressive one to the Duke of Wellington.[81]

Shortly after the unveiling ceremony, Kingsley Collett, Chief Commoner for the Corporation of London, wrote to thank Nemon for his efforts: 'I feel quite confident that all members of the Committee feel, as I do, that the statue will be one of the City's treasures. For Sir Winston to say that he: "greatly admired the art of Mr Oscar Nemon" and to go onto to say "I also admire, if I may say so, this particular example which the Lord Mayor has just unveiled because it seems to be such a very good likeness" must have pleased you as it does us. It was also particularly gratifying for me to hear from Sir Winston and members of his family personally how much they admired the statue and how moved they were with the ceremony.'[82]

However, it would be Churchill, and in particular Lady Clementine, whose insistence that further alterations be made to the statue ensured its casting into bronze would be repeatedly delayed.[83] The artist would not be rushed either. He felt he had to continue working on the statue in order to improve the hands according to the express wish of the sitter.[84] The finished bronze would not be installed inside the Guildhall until 12 February 1959. However, it was very favourably received by the press.[85] Nemon, usually his own harshest critic, was for once satisfied with his labours. He felt that he had created a truly iconic image of the man in his mature years who had 'saved Britain' in its hour of gravest danger. He thought this might be the last opportunity to create a memorial statue of Churchill derived from sittings with the man and which could be admired by the sitter.[86]

* * *

Graham Sutherland's controversial painting, *Study of Churchill in Garter Robes* (Plate 9) would be commissioned in the summer of 1954 by a committee containing members from both Houses of Parliament as a gift to be presented

to Churchill on the occasion of his eightieth birthday on 30 November that year. The idea of Churchill's gift taking the form of a painting depicting him as a 'man of the Commons' for over half a century was proposed by the Committee's chairman, Labour MP Frank McLeavy. He hoped the portrait, while remaining Sir Winston's property, would then be placed on permanent display within the Palace of Westminster.[87]

At the time, speculation in the Commons that Churchill should step down after this birthday was growing ever louder. That June he authorised an invitation to the Soviet leader Malenkov to a three-power summit (with the UK and USA) which would discuss agreement on a possible slow down, if not complete cessation, of nuclear weapon production and the testing of future hydrogen bombs. However, the invitation was issued without President Eisenhower being consulted on the precise wording of the text. The President made his displeasure clear and Churchill was even more discomfited when Malenkov promptly and dismissively replied that he could see no need for the summit the Prime Minister had proposed.[88] Behind the scenes tensions increased between Churchill and Eden when the former went back on his suggestion that he would step down in September. Churchill now decided he would wait at least a further six months, after his birthday celebrations had taken place.[89]

During June 1954 the Churchill Joint Houses of Parliament Gift Committee discussed which painter it should approach to undertake the commission. McLeavy, and one faction within the committee suggested the established portraitist Sir Hebert James Gunn (1893–1964), who had recently painted a well-received portrait of the Royal Family. Gunn, however, was judged to be too expensive. Then Labour MP Jennie Lee, backed by the committee's secretary, the Conservative MP Charles Doughty, proposed the younger, recently fashionable and cheaper Graham Sutherland, who had come to prominence for his portraits from 1949 onwards of Somerset Maugham and Churchill's old friend Lord Beaverbrook (1951). Lee sounded out Sutherland informally and the artist agreed though he had reservations about undertaking such a high-

profile commission. Ominously, given future unhappy developments, neither Churchill nor his wife were sounded out beforehand whether a portrait by such a modern artist would meet with their approval. A few days later, on 14 July 1954, Charles Doughty wrote to Sutherland, formally inviting him to paint the portrait. The portrait was to be 'full-length' and had to be finished in time for a presentation to Churchill on his birthday. Sutherland was to arrange sittings with Sir Winston and was to decide with him what Churchill was to be depicted wearing. The fee would be a hefty 1,000 guineas.[90]

Many years later Sutherland wrote to Lady Mary Soames that he promptly replied to the letter of 14 July agreeing to undertake the commission with a certain amount of 'foreboding.' He recalled that in the days that followed his acceptance he had further discussions concerning the painting with the committee secretary (Doughty): 'My memory is perfectly clear on two points raised: 1/ I was instructed to paint your father in his normal parliamentary clothes; 2/ The portrait was to be given to your father by both Houses on his 80th birthday *for his lifetime* and that after his death *it would revert to the House of Commons*. I was even shown places where it might hang.'[91]

A few weeks after accepting the commission, Sutherland was in contact with Lord Beaverbrook, who apparently in 1951 had suggested he tackle Churchill as a sitter. He wrote hinting at feeling a certain trepidation: 'I remember, when I was painting you, that you mentioned that I ought to do it. Now I am going to have a try . . . it won't be an easy thing at all, especially in the very short time they are allowing me.'[92]

By mid-August Sutherland had established contact with Churchill and the Prime Minister wrote to the painter that he thought his studio at Chartwell would be a good place for sittings: 'All the lights can be cut off and there is also a movable platform for me to put my chair on. Oswald Birley found it very convenient to paint his picture of me here [the 1946 one rather than the half-length from 1951].' After lunch Sutherland could make himself read and then Churchill proposed to sit for him 'for an hour or so'.[93]

Sutherland later recalled, in an interview with the *Sunday Telegraph* in 1965, that he first met Churchill at Chartwell shortly after noon on 26 August 1954. He was shown into Churchill's study and waited for about five minutes: 'Suddenly, I saw a nose appear around the corner of the door ... and it was Churchill. With that slightly sort of bent, peering look which he put on ... I suppose partly to intimidate the person he was meeting ... he shook hands ... [he] showed me his hands ... which he had modelled.' Churchill was very proud of his delicate hands which he was convinced he had inherited from his mother – Lady Randolph.[94]

They discussed the number of sittings that would be required. Sutherland recalled that, ominously, Churchill assumed from the beginning he would be depicted wearing the robes of a Garter Knight. The painter responded that he was sure he had been asked to paint the Prime Minister as he would normally appear in the House of Commons: wearing a black coat, waistcoat, striped trousers and a spotted bow-tie.[95]

Sutherland later told the *Sunday Telegraph*, in 1965, that Churchill had asked him: 'How are you going to paint me? As a cherub, or the Bulldog?' The artist replied: 'It entirely depends what you show me, sir.'[96] Four years previously, however, he wrote to Lord Beaverbrook that from the very beginning, 'he [Churchill] showed me the Bull Dog. For better, or for worse, I am the kind of painter who is governed entirely by what he sees. I am at the mercy of my sitter. What he feels, or shows at the time, I try to record.'[97]

Three sittings then took place at Chartwell on 26, 29 and 31 August 1954. At the first sitting Sutherland nervously informed his sitter that he would not show Churchill any day-to-day progress. Churchill protested: 'Don't forget I'm a fellow artist.' Sutherland decided he would have to be 'a bit dishonest'; he would show his subject 'some drawings but not others'. Churchill would look at a drawing one day and declare: 'This is going to be by far the best portrait I have ever had done – by far.' Then the next day he would look at the same drawing and say: 'Oh no, this won't do at all. I haven't got a neckline like that – you must

take an inch, nay, an inch and a half off.' Churchill did not like to see any hint of a double chin – Sutherland was to make him look 'noble'. Churchill was particularly proud of his supposedly smooth and unlined face, whereas, at close quarters, Sutherland could not help but notice a network of lines around the Prime Minister's eyes, wrinkles on his cheeks, a scar on his forehead, creases from nose to mouth and bags under his eyes. The painter had also registered that Churchill's mouth unmistakably drooped at one corner – evidence of the stroke the Prime Minister had suffered in June 1953 which remained a strict secret. Sutherland did not find about the stroke until after Churchill's death but at the time sensed something had gone amiss.[98]

From their first sitting Churchill proved to be an extremely restless sitter, smoking cigars and dictating letters rather than relaxing. After lunch he became 'torpid', unresponsive and slumped in his seat. He would sometimes even doze off. Churchill suggested at one point they paint each other – they should think of themselves engaged in a sort of duel. He seemed to enjoy Sutherland's company, suggesting they go on a sketching trip together to the south of France. Churchill also asked Sutherland for a signed copy of Robert Melville's monograph on the artist and, after studying its illustrations for a while, pronounced himself impressed by his 'mysterious and sinister' natural still lives.[99]

Clementine Churchill was impressed by Sutherland, both as an artist and as a person. She wrote to her daughter Mary in late August 1954 that she thought the painter was 'really ... a most attractive man and one can hardly believe that the savage cruel designs which he exhibits come from his brush'. After three sittings her husband was very much 'struck by the power of his drawing'.[100]

Sutherland later wrote to Lord Beaverbrook that it was towards the end of the August sittings that he first became aware of tensions at Chartwell caused by manoeuvrings behind the scenes; senior Conservatives were urging the Prime Minister to step down when he turned eighty.[101] Churchill 'repeatedly' told Sutherland 'they want me out ... But I am a rock' and at that 'the face would set in furious lines and the hands [would] clutch the arms of the chair'.[102]

Early in September 1954, Sutherland 'to humour the old man' borrowed Churchill's Garter Robes and persuaded a friend of similar build and height (about 5ft 7ins) as the Prime Minister to model them. This evolved into a quite finished oil sketch which Sutherland was prepared to show Churchill – who was very taken with it.[103] The following year the sketch was bought by Lord Beaverbrook who thought it was by far the most convincing of all the studies Sutherland produced of Churchill and should have been enlarged to become the gift presented to the Prime Minister in November 1954, rather than the seated Churchill Sutherland preferred.[104]

Churchill sat again on 2, 4, 9 and 17 September 1954. In all, over a two-month period (late August to mid-October 1954) Sutherland produced six oil sketches of Churchill from life and at least a dozen charcoal studies and pencil from life (see Figures 6.12–6.18). These were supplemented by numerous sketches of Churchill's hands, eyes, nose, mouth and even shoes.[105] As time passed, however, Sutherland found that his most pressing problem was deciding on Churchill's facial expression. He was particularly pleased with two oil studies he painted during the afternoon of 9 September when Churchill sat by a window dictating a letter and one side of his face was lit by the setting sun, giving him a 'most becoming rosy-pink glow'. At that moment, as he wrote a few days later to Lord Beaverbrook, the Prime Minister had resembled a 'sweetly melancholic and reflective cherub'.[106]

At the time Sutherland remarked wistfully to Churchill's doctor, Lord Moran: 'There are so many Churchills ... I have to find the real one.' Moran warned the painter: 'Winston is always acting. Try to see him when he has got the greasepaint off his face.' The doctor feared Sutherland would prefer to paint the legend and not what he saw before him.[107] The painter acknowledged in a newspaper interview that with the slightest movement and change in the light, the Prime Minister could easily look years younger, no longer an old man burdened with responsibility but recognisable as the subaltern who had fought at Omdurman in September 1898 – 56 years in the past.[108]

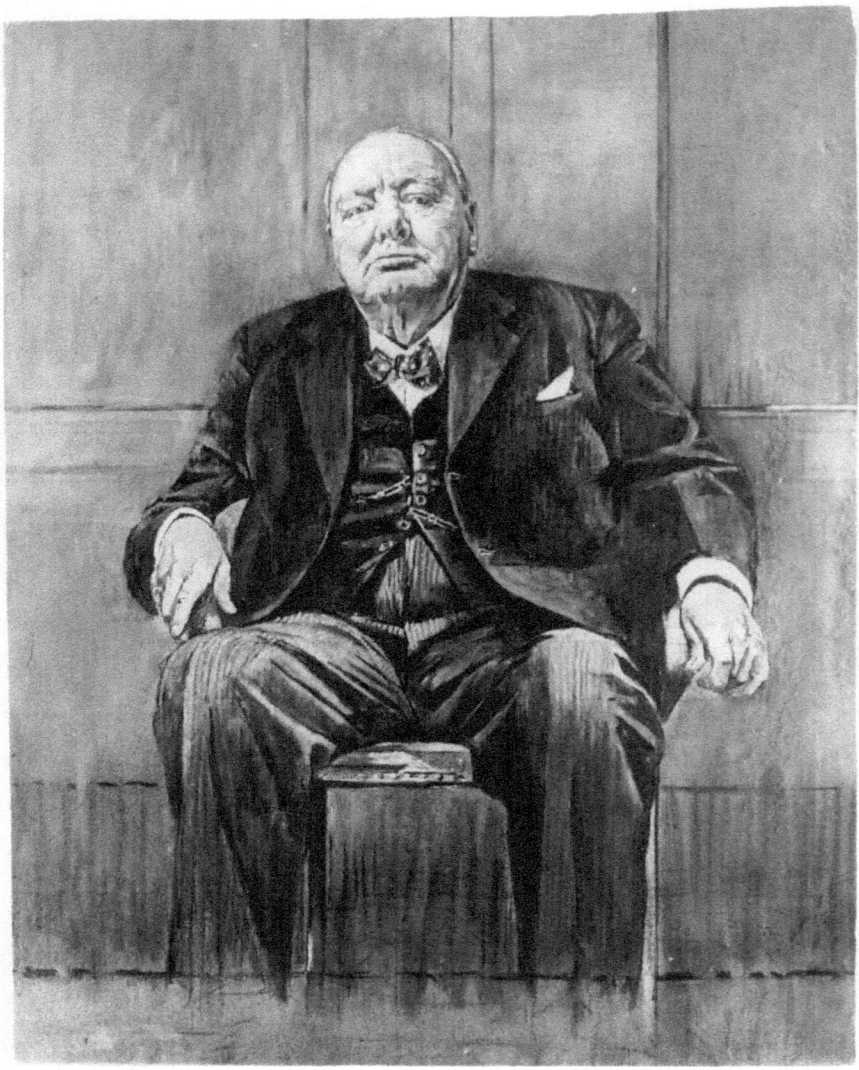

FIGURE 6.12 *Graham Sutherland (1903–1980)*, Portrait of Sir Winston Churchill, *1954, oil on canvas, 147.3 × 121.9 cm, destroyed by Lady Clementine Churchill, 1955–1956.*

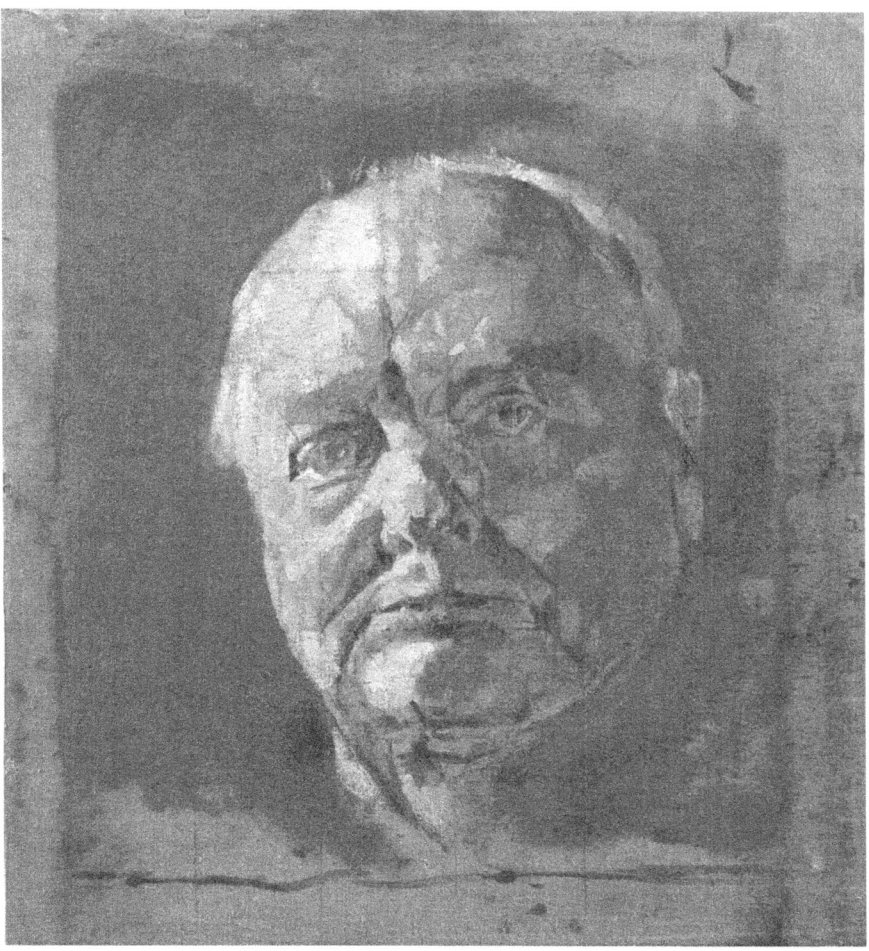

FIGURE 6.13 *Graham Sutherland,* Head Study of Winston Churchill, *1954, oil on canvas, 40.3 × 30.5 cm, National Portrait Gallery, London.*

By the middle of September 1954 Sutherland felt preliminary sittings were now finished. He selected a square-shaped canvas measuring 5 feet high by 4 feet wide. He felt that the shape of the canvas would help him by dictating the portrait's composition. As he explained in December 1954 to Honour Balfour of the BBC Home Service Radio: 'I wanted to paint him with a kind of four-square look – Churchill as a rock.'[109] He had decided on a seated Winston wearing his usual parliamentary clothes but the final facial expression still

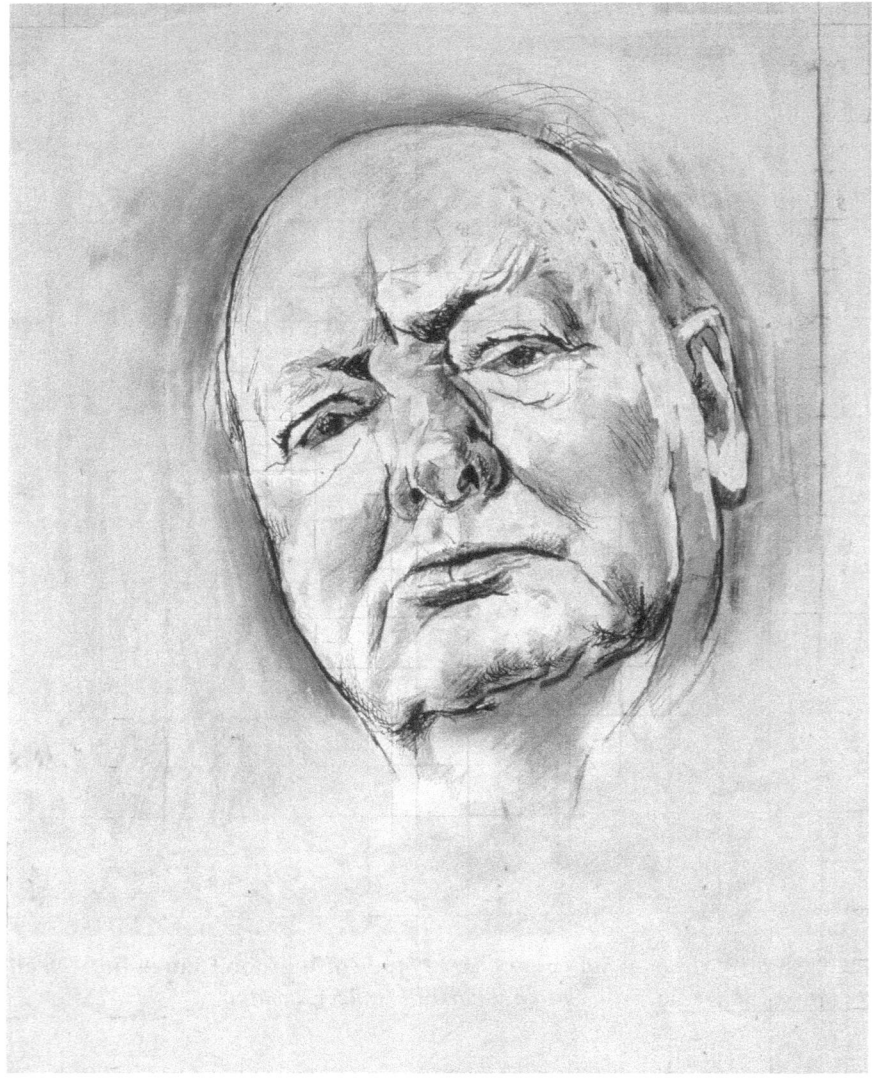

FIGURE 6.14 Graham Sutherland, Study of the Head of Churchill, *1954*, *pencil, pen-and-ink, black chalk and watercolour on paper, 37.5 × 30.5 cm, The Beaverbrook Art Gallery, Canada.*

proved elusive. He tried one, decided it did not work, and then painted it over. With feeling he told the *Daily Express* in November 1954: 'In painting you have to destroy in order to gain ... you have to sacrifice something you are quite pleased with in order to get something better ... It is risky.'[110]

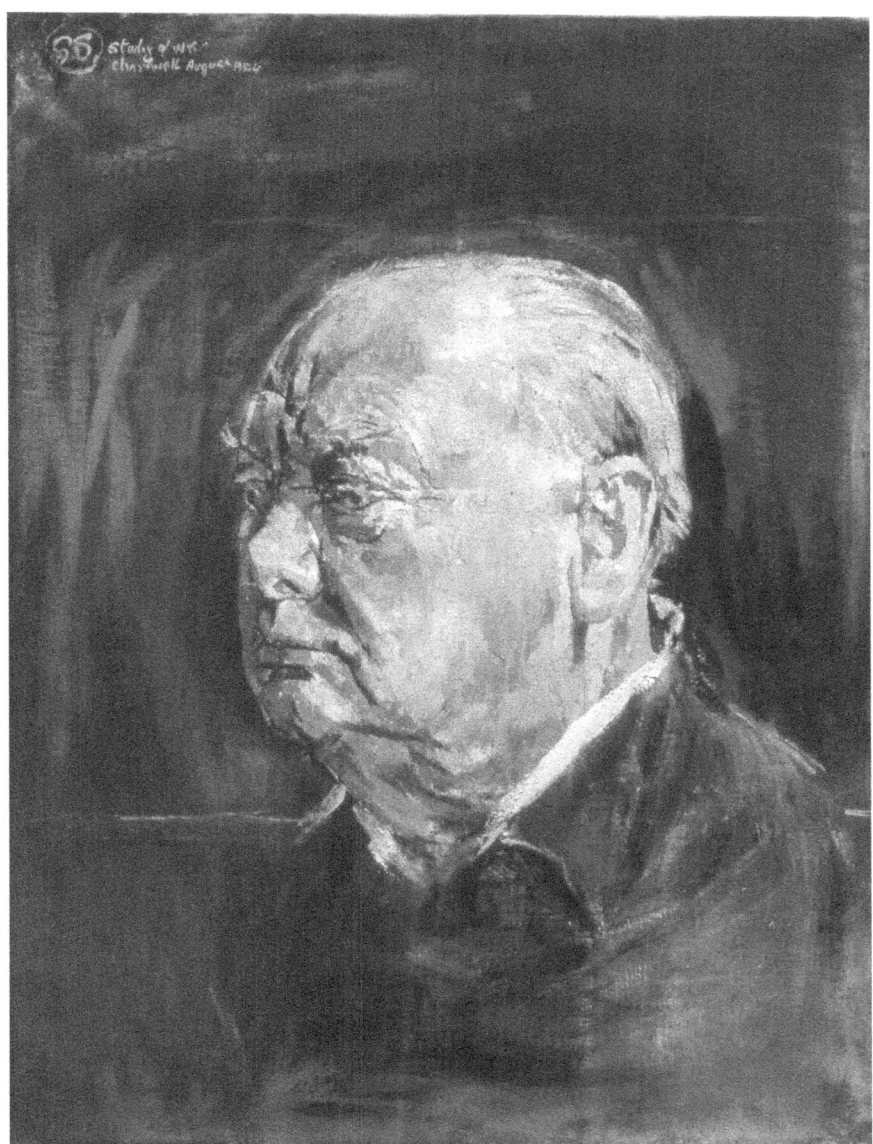

FIGURE 6.15 *Graham Sutherland,* Study of Churchill – Grey Background, *1954, oil on canvas, 61 × 45.7 cm, Beaverbrook Art Gallery, New Brunswick, Canada.*

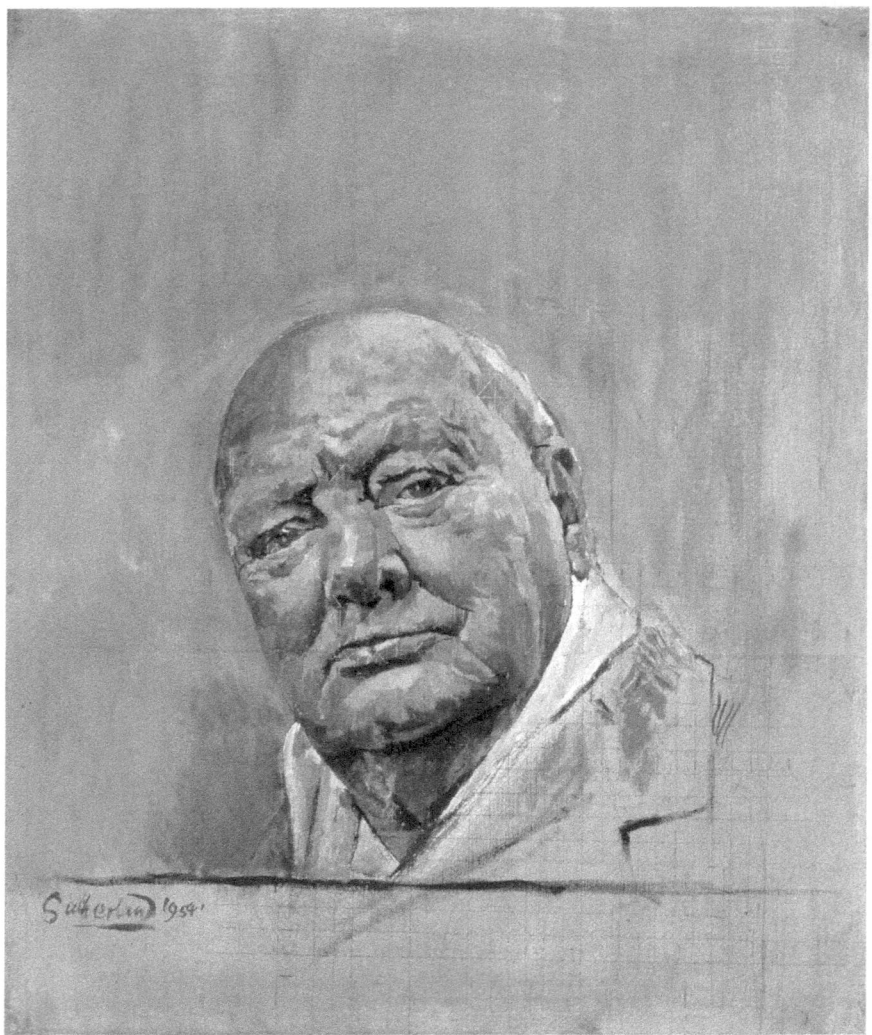

FIGURE 6.16 *Graham Sutherland,* Study of Churchill – Pink Background, *1954, oil on canvas, 61 × 50.8 cm, Beaverbrook Art Gallery, New Brunswick, Canada.*

Early in October 1954 he showed the partially completed portrait to Churchill's son Randolph and his wife June. Randolph declared that he rather liked the portrait, but suspected his father would not because Clementine would not like it. After the visit, June wrote to Sutherland that she thought the

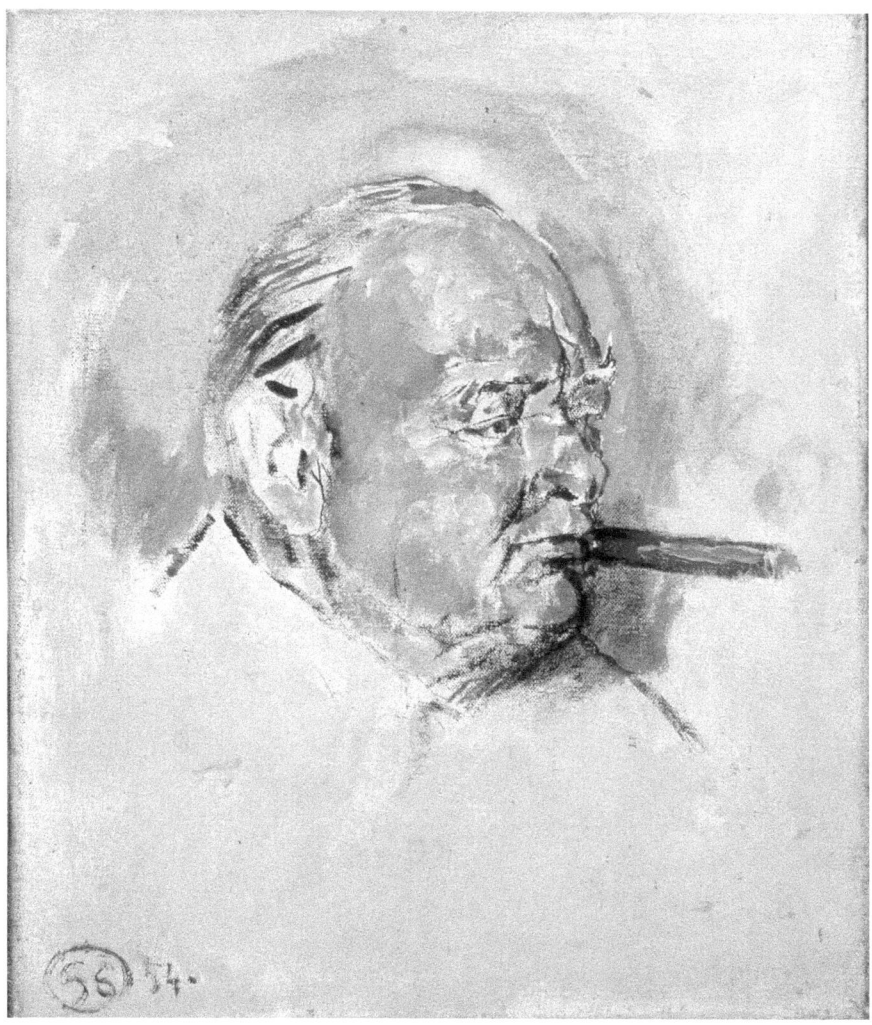

FIGURE 6.17 *Graham Sutherland,* Study of Churchill Smoking a Cigar, *1954, oil on canvas, 30.2 × 25.1 cm, Beaverbrook Art Gallery, New Brunswick, Canada.*

portrait was 'Brilliant, really quite alarmingly like him and so alive one feels he might suddenly change position and say something ... something pretty beastly I should think ... I wish he didn't have to look quite so cross, although I know he quite often does ... please don't change this anyway ... I think it is wonderful. I never imagined it could be so good.'[111]

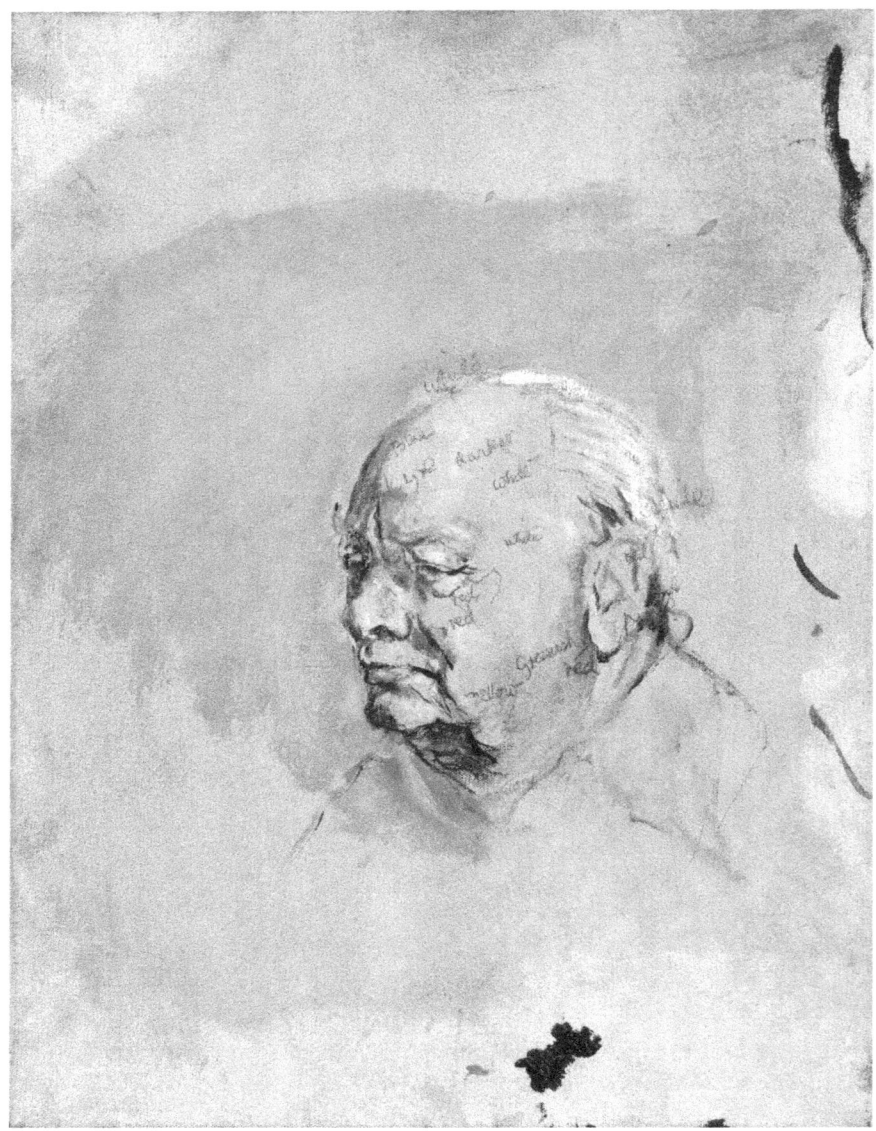

FIGURE 6.18 *Graham Sutherland,* Head Study of Winston Churchill, *1954, oil on canvas, 34.5 × 31.1 cm, National Portrait Gallery, London, 5331.*

Perhaps this reaction from Randolph and his wife unnerved Sutherland, as he asked Churchill for another sitting which took place on 17 October 1954. Sutherland took with him his wife Kathleen and an old friend, the photographer Elsbeth Juda, to take a series of reference photographs of the Prime Minister. Ever-appreciative of feminine beauty, Churchill was very taken with Kathleen and asked Juda to take photographs of her for a portrait he was keen to paint.[112] Juda later recalled that pre-lunch, Churchill was 'lively, puckish, cheeky and benevolent'. After hefty consumption of food and wine the Prime Minister became 'torpid and grumpy'. He often dozed off and Sutherland gently but firmly asked him not to slump and to give 'a little more of the old lion please, sir'.[113]

It was during this period that Sutherland experimented with depicting Churchill holding a lighted cigar; he produced one oil sketch of the Prime Minister smoking a cigar – which Churchill protested made him resemble a toffee apple. Within a few days Sutherland excluded the cigar on the basis that it would be too casual for a formal portrait.[114] He later told the *Sunday Telegraph* that he had strictly rationed the number of cigars Churchill was allowed to smoke during sittings, otherwise he might disappear for minutes at a time within a cloud of richly aromatic cigar smoke that made his eyes water (and Sutherland was a heavy cigarette smoker).[115] Sutherland did wonder later whether the cigar smoke was a way of evading the gaze of the artist, but decided his sitter could not help himself as a confirmed cigar-smoker for almost 60 years.[116]

By the end of October 1954, Sutherland thought the portrait was ready to be framed; he told his wife that he thought he was 'almost there' with the 'quicksilver expression' for Churchill's face he was trying to 'nail down'.[117] On 6 November, he showed the portrait to Sir Kenneth Clark and his wife, Jane. She was very impressed and complimentary. However, Clark was much less forthcoming. Sutherland experienced another attack of nerves – did the portrait need to be completely repainted? Should he lighten or darken the background, or leave it

unchanged?[118] Should he start again and paint a new portrait based upon his earlier sketch of Churchill in his garter robes – which was what Lord Beaverbrook urged him to do.[119]

Sutherland and his wife lunched with Churchill at Chequers on 13 November 1954; the painter had not brought the portrait with him but he was 'questioned at length' about it. Also present was Oscar Nemon, then working on his statue for the Guildhall, whom Sutherland had not met before. The painter later recalled that they had readily agreed that 'seated figures were so much easier [to do] than standing ones'. Nemon seemed pleasant enough, but Sutherland could not bring himself to like the man; the sculptor seemed just a little too keen to present himself as the official artist to the Churchill family. Coming from someone who looked and sounded 'like a foreigner', Sutherland found this hard to stomach.[120]

During and after lunch Churchill kept pressing Sutherland for more information about the portrait. When the artist admitted he had painted him seated, Churchill was worried that the loose skin beneath his chin would be exposed.[121] Later that afternoon Sutherland seized the opportunity to sketch Churchill's eyes as he was absorbed playing bezique. In 1965 Sutherland remarked to the *Sunday Telegraph* that it had been clear the Prime Minister wanted to 'win . . . he was determined to win . . . I caught the look, the expression I wanted . . . a combative look'.[122]

A week later, on 20 November, Clementine Churchill came to Sutherland's home in Kent to view the portrait. Also present were two of Sutherland's friends, the writer Somerset Maugham and the art dealer Alfred Hecht. Maugham had agreed beforehand to make a signal that Lady Churchill liked the portrait and duly did. Sutherland later told the *Daily Telegraph* that she had 'liked the portrait very much . . . she was very moved and full of praise for it . . .'.[123] Maugham, writing in 1963, recalled that Lady Churchill 'could not thank Graham enough . . . I liked it [the portrait] and so at the time did she.' Lady Churchill left at 3.30 pm with a black and white photograph of the portrait to

take to show her husband. Sutherland was relieved that everything seemed to have gone so well.[124]

However, the following morning an official car drew up and a letter was delivered to Sutherland containing a bombshell from the Prime Minister. Churchill wrote that he was

> quite content that any impression of me by you should be on record. I feel however that there will be an acute difference of opinion about this portrait and that it will bring an element of controversy into a function that was intended to be a matter of general agreement between the Members of the House of Commons where I have lived my life ... I am of the opinion that the painting, however masterly in execution, is not suitable as a Presentation from both Houses of Parliament ... About the ceremony in Westminster Hall. This can go forward although it is sad there will be no portrait. They have a beautiful book which they have nearly all signed, to present to me, so that the ceremony will be complete in itself. It has been a great pleasure to me to make your acquaintance and to meet your wife. When the present pressure has abated I should like to talk over the portrait with you as I have some suggestions to make if you invite them.[125]

Sutherland relayed this dismaying news to a shocked Charles Doughty – he and his wife Adelaide (later Dame Adelaide Doughty) were determined the portrait be presented and accepted. They visited Chartwell; Doughty spoke with the Prime Minister, his wife to Lady Clementine. Clementine told Mrs Doughty that she thought the portrait was 'very fine'. She pointed to Orpen's 1916 portrait of her husband and declared: 'When I first saw it, I didn't think I could bear it, he looked so defeated and sad. Now it is one of my most treasured possessions.' Then Doughty and Churchill appeared, the latter grumpy in his siren suit. Churchill spoke to Mrs Doughty: 'Your husband says I have got to accept this portrait.' This was said in a gruff, yet resigned, fashion.

Doughty later told his wife that he had explained to Churchill that 'people would be very upset and hurt if he rejected it'. The portrait had been paid for by MPs who had 'contributed out of their own pockets ... not all of them willingly'. In Churchill's study the Prime Minister had pointed to a print of the young Napoleon on his desk (possibly after Antoine-Jean Gros's portrait of Napoleon on the Bridge at Arcola, 1798)[126] and declared: 'Now that is what I call art. In this other thing [the photo of Sutherland's portrait] ... they paint one ... as if sitting on a lavatory!'[127]

The Prime Minister appears to have been calmed by Doughty, who was able to phone Sutherland that evening with the cheering news that the portrait would be accepted; the presentation on 30 November would take place as planned.

On 22 November, Sutherland despatched the portrait to 10 Downing Street. Churchill's secretary, John Colville, recalled the Prime Minister looking 'long and hard at the picture ... He then remarked petulantly: "It makes me look half-witted, which I am not ... Here sits an old man on his stool, pressing and pressing." Colville enigmatically replied: "The portrait of Dorian Gray?" (evoking the portrait by Oscar Wilde's fictional painter, Basil Hallwood, depicting the eponymous Gray and bearing the disfiguring marks of all the sins he has committed). Churchill snorted, did not reply, smiled and then "turned his back on it".'[128]

Lady Soames later recalled her mother was deeply upset by the prospect of the portrait being formally presented: 'It's too awful. I don't know if your father is going to turn up. He is so upset about it.' She reflected to Sutherland's biographer, Roger Berthoud, that they both 'deeply felt that they ought to have been able to see the picture sooner than they did ... they did feel a fast one had been pulled on them and that they had been taken for a ride'.[129] A few days before the official presentation Clementine Churchill wrote to Lord Beaverbrook, not realising the degree to which he had been privy to the development of the portrait from the artist, that her husband was 'very hurt'

that this 'brilliant painter with whom he had made friends ... should see him as a gross and cruel monster'.[130]

Sutherland always categorically denied he had ever in any regard felt hostile towards Churchill. Indeed, he wrote to Lord Beaverbrook in March 1961 the Prime Minister 'often showed me the greatest charm and could not have been kinder. Nevertheless, he was self-conscious and ill at ease during the actual time of the sittings. I was seduced by his charm at other times and wanted so much to please him. But I draw what I see and 90 percent of the time I recorded precisely what I was shown ... I would not like to go down ... as being a person who obliterated, or unconsciously malformed, a face at the dictate of another'.[131]

Sutherland wondered whether he had been all too true to his enduring conception of Churchill as a 'rock' and not as an avuncular charmer. He recalled the young soldier who had displayed such steel and courage under fire facing Dervish and Boer alike; the man he had seen with a competitive streak – who wanted to win whether at politics (securing a summit with the post-Stalin Soviet leadership and President Eisenhower) or at bezique. There was something larger than life about Churchill, a 'giant who did not fully know his own strength', who could be intimidating as well as genial.[132]

The presentation ceremony for the portrait took place in Westminster Hall on Churchill's eightieth birthday, 30 November 1954. With his back to the portrait, covered in a cloth, Churchill declared: 'This is the most memorable occasion of my life ... I doubt whether any of the modern democracies abroad has shown such a degree of kindness and generosity to a party politician who has not yet retired and may at any time be involved in a controversy [which brought laughter from the some in the audience] ... the portrait [turning back to glance at it as the cloth fell away] is a striking example of *modern* [emphasis] art [much laughter]. It certainly combines force and candour. These are qualities which no active member of either House can do without, or should fear to meet.'[133]

Sutherland was quite aware he had been the target for the Prime Minister's ill-concealed barb concerning modern art. Within his hearing some members of the audience stated loudly that he had made Churchill resemble 'a dirty old man ... what a terrible tribute to our greatest man ...'. The Conservative peer, Lord Hailsham, was heard to fulminate: 'If I had my way, I'd throw Mr. Graham Sutherland into the Thames. The portrait is a complete disgrace ... I have wasted my money – we have all wasted our money ... It is bad-mannered [and] a filthy colour' However, the majority of the members of the committee who had commissioned him came up to Sutherland to warmly congratulate him on the portrait. The Labour MP Anuerin Bevan (admittedly no fan of Churchill's) told Sutherland it was 'beautiful ... wonderful ... a real work of art that would last.'[134]

Lord Moran was present in the audience for the ceremony. That evening he noted in his diary that the Prime Minister had been 'in a mood to speak well of all men. Even Graham Sutherland was forgiven ... He [Churchill] described the portrait as "a remarkable example of modern art" (It certainly combines force and candour ...) There was a little pause [after the remark] and then a gust of laughter swept the hall.' Churchill concluded with: 'I have always earned my living by my pen and by my tongue. It was the nation and the race dwelling all round the globe that had the lion's heart. I had the luck to be called upon to give the roar.'[135]

Moran then reflected that Churchill had earlier mentioned to him that he rather admired the early sketch Sutherland had made of the Prime Minister wearing his Garter Robes. However, the Prime Minister could not bring himself to admire the final portrait he had been given, considering it to be 'filthy and malignant'. Moran recalled that Sutherland had earlier told him that he had wanted to paint Churchill 'with a kind of four-square look, to picture him as rock'. Moran had feared from the outset that the painter 'worshipped him [Churchill] too blindly. He felt Sutherland had painted Churchill "as he pictured himself in his own favourite part".' The painter,

unfortunately but understandably, had been too quick to accept 'the legend for the truth'.[136]

Moran further pondered that, if anything, the formidable public image associated with Churchill had been all too successful in establishing itself. For years the nation had pictured Churchill 'defying the overwhelming strength of a warrior race. He liked the part, it was the role he had dreamed would fall to him and he was soon playing it for all he was worth'. It was probably not a good idea to paint such a national hero in their lifetime. Sutherland had successfully offered a 'surface impression' but had quite 'missed the story that lies hidden beneath that fierce façade'.[137]

In his final thoughts on the subject Moran felt Sutherland had captured a great deal of Churchill's 'power and vigour and defiance ... and yet in coarse features'. Moran had always thought Churchill's features were 'delicate, almost feminine ... the lips too, though they often pout, are delicately moulded ... the coarseness of the face in the portrait is [really] only a part of the artist's romantic conception of a man of wrath struggling with destiny. It is not, however, Winston'.[138]

The day after the presentation readers of the *Daily Express* and *Daily Telegraph* begged for the portrait to be 'thrown away' and that 'it must be burned'.[139] Alfred Hecht wrote in its defence while Francis Bacon, somewhat tipsy, threatened to punch anyone on the nose who denigrated the portrait in his hearing.[140]

That evening, 1 December 1954, Sutherland and his wife attended a reception at 10 Downing Street. Sutherland recalled that Churchill went out of his way to be charming to Kathleen and amiable and friendly to the painter. Churchill came up to the artist and chuckled: 'Well, Sutherland, although we may not agree on artistic matters, we can still remain friends.' However, the painter could not help feeling hurt that his portrait was conspicuously not on display, on the grounds, so he was told by John Colville, it 'might spoil the occasion'.[141]

Two days later, on 3 December 1954, a small band of art critics, art school principals and gallery directors were invited at short notice to inspect the portrait at 28 Hyde Park Gate. One of those present, William Coldstream (Principal of the Slade and a fine portrait painter in his own right), approved of Sutherland's work as the antithesis to yet another predictable, slick, superficial boardroom portrait; this one had something searing to say about those who have wielded power and its impact upon them in old age. Another participant, the critic H.H. Middleton, wrote a week later in the *Spectator* that Sutherland's portrait was by far the best that had ever been painted of the Prime Minister, better than Orpen, Guthrie or Birley, and deserved to be 'bequeathed to posterity' and find a permanent home in the National Portrait Gallery.[142]

That same day Sutherland was interviewed on BBC Home Service radio about his experience of painting the Prime Minister. The painter readily conceded that 'painting a national hero' was rather 'a thankless task'. Perhaps it should only be done after the subject's death, from photographs, perhaps as much as three years after their demise. By then, one could see the subject with a 'truer perspective'.[143]

Sutherland was not to know that time was already running out for his portrait of Churchill. From 10 Downing Street it had been moved to 28 Hyde Park Gate. The painting remained there for two to three weeks and then was crated and sent to Chartwell. On arrival there it was unpacked but never placed on display. It would now seem that within a year of the portrait arriving at Chartwell Lady Clementine had ordered it to be destroyed.[144] Sutherland was understandably shocked when Mary Soames wrote to inform him of the portrait's unhappy fate – only revealed in January 1978, a month after Lady Clementine's death. He replied more in sadness in anger that 'My own feelings about the affair are not important. So much time has passed since I delivered the work that the whole undignified affair is for me past history ... for whatever reason the portrait was destroyed, it was an act of vandalism perhaps

not without precedent, but rare in history ... except in wartime'. He added that she had to believe he had not been part of any plot to force her father to leave Number 10: 'I had far too much respect and affection for him to lend myself in such a manner ... To me your father was invariably kind and civilised ...'.[145]

In the weeks following the announcement as to the fate of the portrait Sutherland briefly turned over in his mind whether he should try to paint it again, before deciding that only a 'Thomas Lawrence, or a Velazquez or a Goya' could have really done Churchill justice in 1954, and nearly a quarter of a century later he did not feel at all equal to the task.[146]

In late 1954 or early 1955, Sir John Rothenstein, Director of the Tate Gallery, was consulted by a representative of the House of Commons Press Gallery 'about a proposed presentation to Winston of a drawing of the House of Commons in session, in which he was to figure speaking ... as if seen from the press gallery'. He was asked to suggest an artist. 'I proposed that the commission should be given to Edward Ardizzone whose work as a war artist he had greatly admired'.[147] Rothenstein believed that Ardizzone was just the artist to create a convincing yet informal image of a dignified Churchill in command of the Commons as Prime Minister.[148] Rothenstein's suggestion was accepted and the artist was given access to the Press Gallery in February 1955, by which time Churchill had finally agreed that he would soon go as Prime Minister – which he finally did on 5 April 1955.[149]

Ardizzone may have been present in the Chamber on 1 March 1955 when Churchill made his last major speech, presenting the Defence White Paper in which he announced the government's intention to develop a British hydrogen bomb. He concluded plaintively and memorably with these words: 'Which way shall we turn to save our lives and the future of the world? It does not matter so much to old people; they are going soon anyway ... The dawn may come when fair play, love for one's fellow man, respect for justice and freedom, will enable tormented generations to march forth serene and triumphant from the

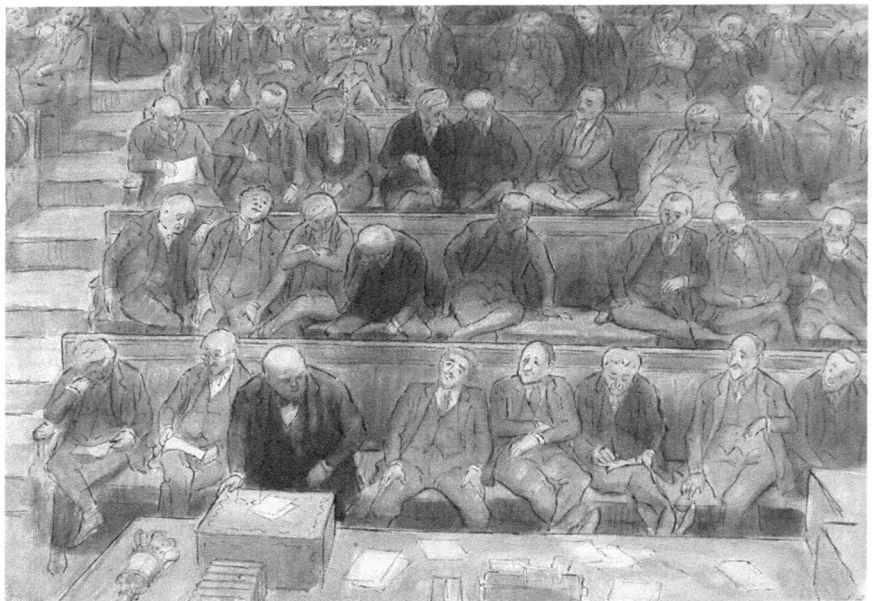

FIGURE 6.19 *Edward Ardizzone (1900–1979)*, Sir Winston Churchill Speaking in the House of Commons, *1955, pen-and-ink and watercolour on paper, Chartwell Manor, Kent.*

hideous epoch in which we dwell. Meanwhile, never flinch, never weary, never despair.' Journalists in the press gallery noted that both sides of the House were profoundly moved.[150]

In the drawing (Figure 6.19) Churchill appears every inch the stately, dignified statesman, firmly in control of proceedings. In 1953, a long-time observer of Churchill in the Commons, Labour MP Emanuel Shinwell, noted that even in his more mature years, his behaviour in the Chamber could be anything but grave, stately or pompous: 'Churchill's mood can change with lightning speed … One moment bristling with anger, real, or simulated, the next passing the incident off with a boyish grin, hugely delighted at being permitted to share in the fun … I have witnessed the clownish spectacle of Churchill putting out his tongue at the Opposition benches … nor has he

refrained from occasionally thumbing his nose at his assailants with a disdainful gesture that has convulsed the whole House in laughter.' Shinwell added that Churchill was still able in the Commons to 'command the whole gamut of emotions ... malicious, provocative and persuasive in turn, majestic one moment, the next displaying a capacity for rudeness which dismays even his friends, resilient and stubborn, yet ... ready to show a kindliness to an opponent that leave some, at least momentarily, disarmed. Truly, with all his faults, a man of rare quality.'[151]

During a visit Rothenstein made to Chartwell, on 18 July 1955, he noted: 'On my way out he [Churchill] expressed his admiration for the Ardizzone *House of Commons in Session*, which he had recently seen'[152] Rothenstein was present at the lunch at the Savoy on 28 February 1956 where the drawing was formally presented to Churchill. The recipient and the lobby journalists who had clubbed together to pay for it; all seemed delighted. The grim spectre of the Sutherland portrait was for a moment laid to rest.[153]

* * *

In April 1955, Churchill left office. He had dinner with the Queen at 10 Downing Street on the evening of 4 April and held his last Cabinet meeting the following morning. On the afternoon of 6 April he left 10 Downing Street for the last time and drove to Chartwell as Anthony Eden became Prime Minister and Leader of the Conservative Party.[154] Already the question was in the air as to how Churchill might be commemorated in public sculpture. Despite Michael Cummings's playful speculation (see Figure 6.20),[155] Henry Moore would never have been in the running for such a commission even if he had wanted it – which, as a confirmed Labour Party supporter, would have been most unlikely.[156] According to his daughter Mary, Churchill was profoundly depressed on leaving office. As has been indicated elsewhere he avoided sittings with Oscar Nemon for his statue in the Guildhall. Churchill then experienced an 'arterial spasm' on 2 June which noticeably affected his balance and handwriting and deepened his gloom. However, he was considerably revived

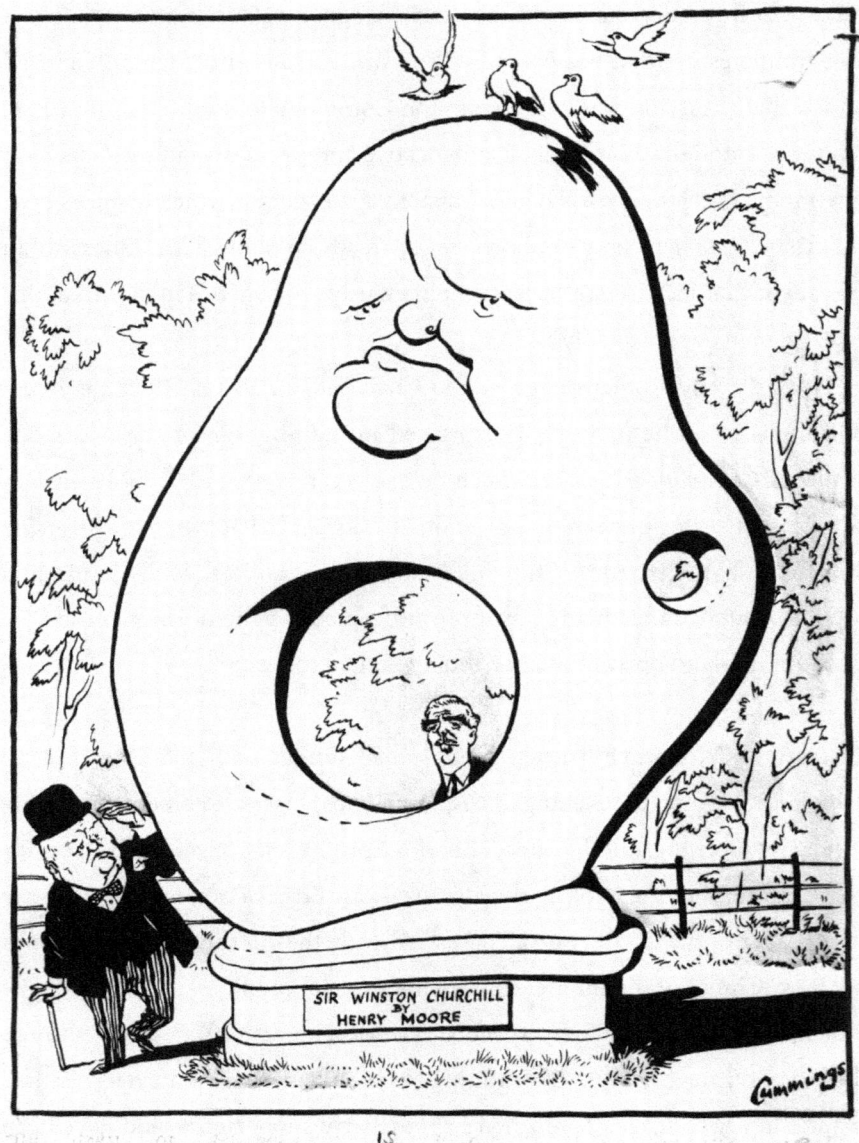

FIGURE 6.20 *Michael Cummings (1919–1997)*, Daily Express, *2 March 1955, Cartoon Archive, Kent University.*

and cheered on 21 June by the stimulus provided by 'going to the Guildhall to witness the unveiling of the statue of himself sculpted by [Oscar] Nemon'. After that event, and satisfied with Nemon's impressive efforts, he looked upon proposals to commemorate him in sculpture with much more enthusiasm than previously.[157]

7

Churchill's Twilight Years: Retirement to Finis, 1955–1965

During the London Blitz, Bernard Hailstone had served as a fireman with the Auxiliary Fire Service in London. His unfussy and sincere realism was praised in September 1942 when he exhibited as a 'fireman artist' at the RA in aid of the London Fire Service Benevolent Fund.[1] Early in 1955 he was approached to paint a portrait of Churchill as Warden of the Cinque Ports. When Churchill was asked if he would provide sittings for the portrait he was undoubtedly wary, still bruised by his experience with the Sutherland commission the previous year. However, Hailstone's wartime service commended him to Churchill, who was also reassured by Sir John Rothenstein that the artist was a solid draughtsman in the mould of Oswald Birley and not at all likely to paint in the manner of Sutherland.[2] The Director of the National Portrait Gallery, David Piper, later judged Hailstone to be 'a reasonably well-known and quite competent academic painter ... but more than that I cannot say'.[3]

Sittings took place during the early summer of 1956. Hailstone initially found Churchill 'heavy going', surly and unresponsive. However, as they talked, Churchill's habitual courtesy and curiosity reasserted themselves – he was keen to hear more of Hailstone's experiences as a fireman in the docks during

the Blitz of 1940–1941[4] and then, later in the war, as an official portraitist for the War Artists Advisory Committee (1941–1945) attached to the Ministry of Supply (1941), Ministry of War Transport (1943–1945) and finally South East Asian Command (1945).[5] Churchill admired Hailstone's 1945 portrait of Admiral Lord Mountbatten, Supreme Allied Commander in South East Asia and one of his favourites among his military commanders. For some, Churchill's faith in Mountbatten was puzzling, as the dashing Mountbatten's self-confidence invariably appeared to outmatch his competence as a strategist. Indeed, one of his most persuasive detractors has characterised him as 'no great strategist but . . . a genius when it came to public relations'.[6]

Hailstone may not have been as talented as Sutherland but could be relied upon to produce a less disturbing and more reassuring image of the old war horse. He was cheerful, calm and polite, exuding an unruffled, quiet self-confidence that Churchill had detected and greatly approved of in the elder and more patrician Oswald Birley. Sutherland's portrait seemed to weigh on his mind; more than once he protested indignantly to Hailstone: 'Sutherland made me look like some half-dead thing . . . it made me look half-witted, which I ain't!'[7]

Hailstone's oil portrait of Churchill as Lord Warden of the Cinque Ports (Figure 7.1) was formally presented to the Court of Brotherhood in Hastings on 7 September 1955.[8] The oil is rather bland and commonplace. The preparatory drawings, however, are more impressive and revealing of the sitter's mood and state of mind (see Figure 7.2): preoccupied, a little sad, resigned to the loss of office and power to shape the world's affairs. The artist noticed how often Winston's thoughts turned to the threat of nuclear war in the near future; he pondered out loud whether he had done enough while in office to avert what would surely sound the death knell for mankind.[9] Hailstone was touched by how his sitter seemed genuinely relieved by the artist's assurance he had done more than most during the last years of his Prime Ministership to persuade the United States and Soviet Union to adopt a sensible attitude towards the bomb and its possible deployment.[10]

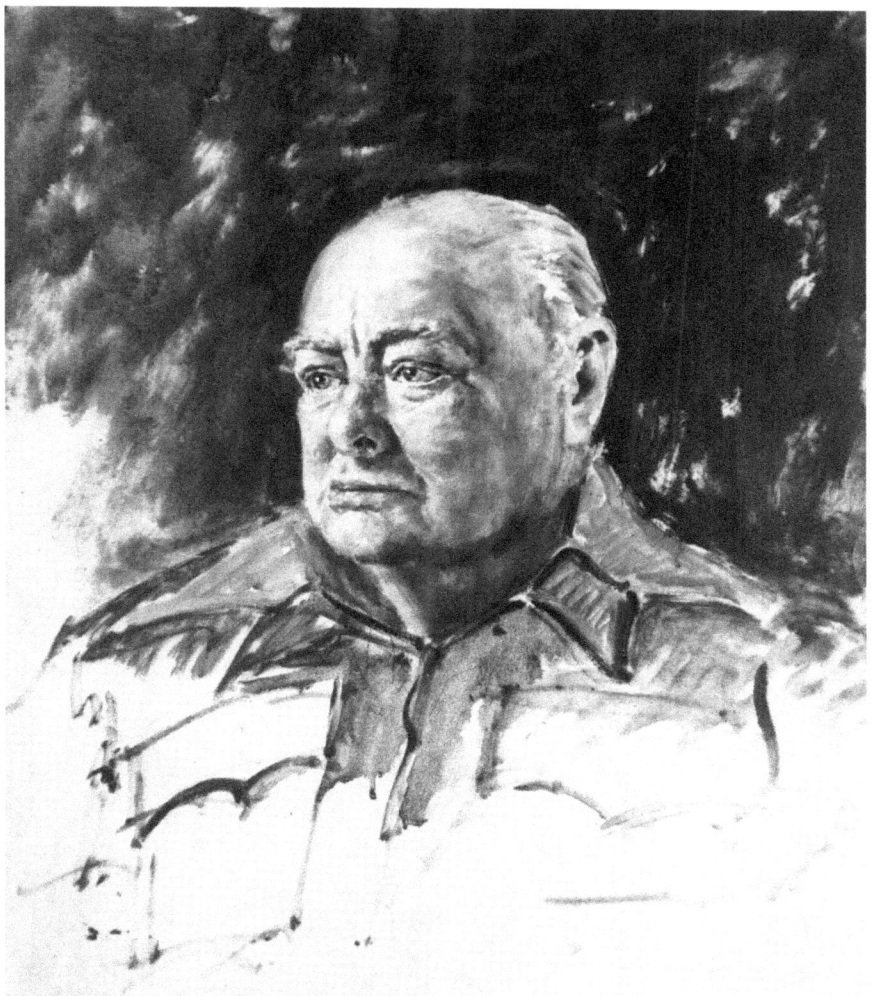

FIGURE 7.1 *Bernard Hailstone (1910–1987)*, **Study of the Head and Shoulders of Sir Winston Churchill**, *1955, oil on canvas.*

Ruskin Spear's striking 1956 portrait (Plate 10) could be interpreted as Churchill viewed balefully by an artist of the 'kitchen sink',[11] 'look back in anger'[12] generation which, ironically, held Walter Richard Sickert in high regard – as did Churchill. Sir John Rothenstein noted during the Royal Academy Dinner of April 1957 that Churchill 'began to speak about his portrait by Ruskin Spear hanging in the exhibition which he obviously

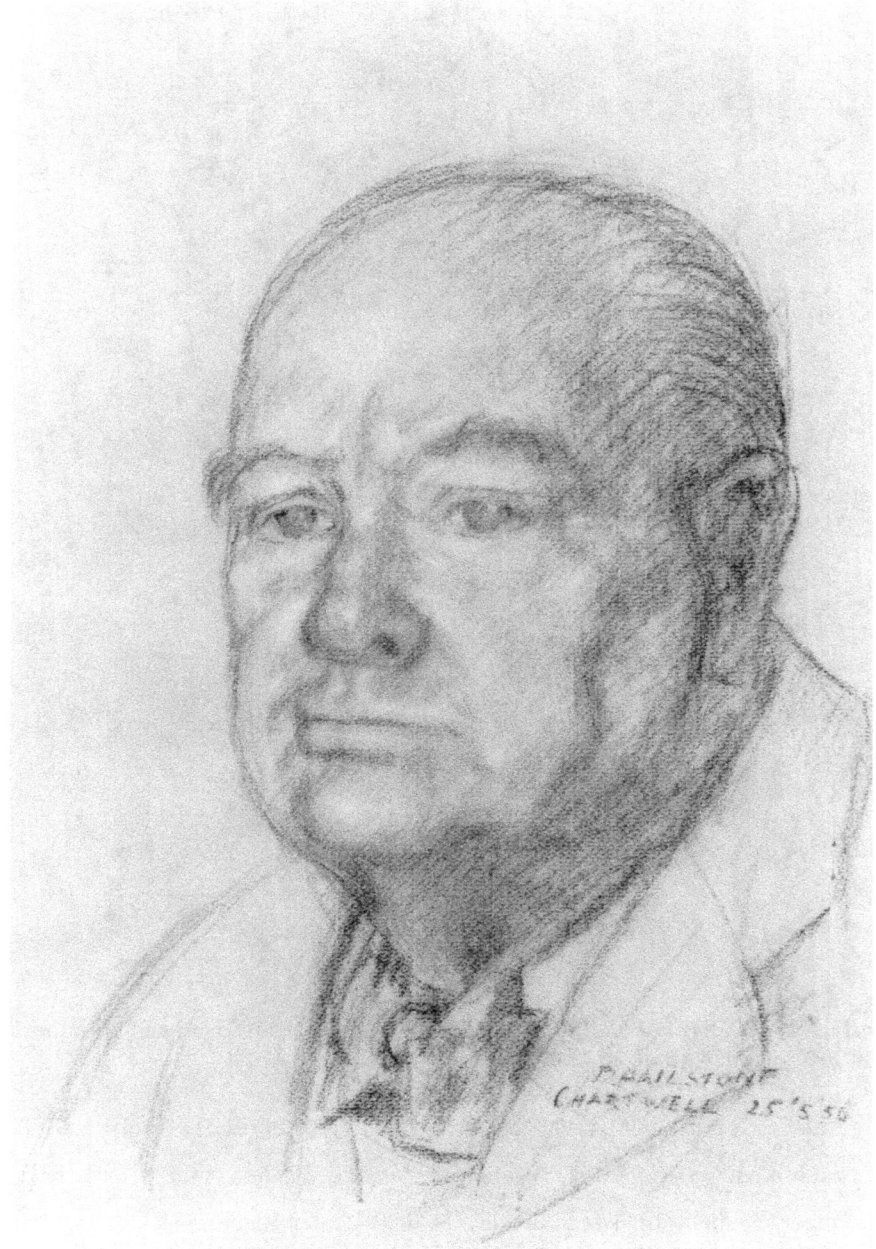

FIGURE 7.2 *Bernard Hailstone*, Head Study of Sir Winston Churchill, *1956, chalk on paper, 44.5 × 30.5 cm, National Portrait Gallery, London.*

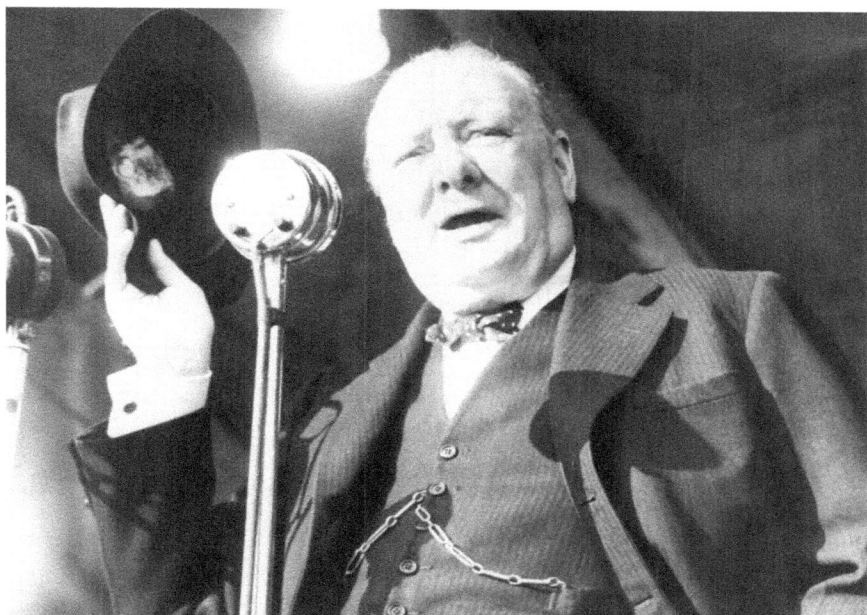

FIGURE 7.3 *Anon*, Winston Churchill Speaking at Walthamstow Stadium, General Election Address, July 1945, *photograph, Imperial War Museum, London*.

disliked ... later on I saw him refuse to shake hands with Spear' which Rothenstein thought most out of character.[13]

In May 1957 Brendan Bracken seemed to refer damningly to the Spear portrait in a letter to the sculptor Oscar Nemon: 'That absurd Royal Academy, which treated you so badly, has now insulted Sir Winston by including in its latest exhibition a grotesque portrait of their only living honorary academician. I lunched with Sir Winston yesterday and he told me that at the banquet they gave last Wednesday night the "artist" responsible for this vile painting tried to introduce himself to his victim. Sir Winston was much disappointed that the choice remarks made by him to his fellow academician escaped the notice of the newspaper reporters.'[14]

It is evident that many art critics regarded Spear as leading the way in the production of a new kind of challenging and unsparing form of semi-official

portraiture; some examples he had exhibited at the RA since the mid-1950s were even described as 'social satires' calling to mind the work of Thomas Rowlandson, bringing the exalted down to size.[15] It is also clear that Spear's portrait of Churchill did cause a particular stir. Veteran portraitist R.O. Dunlop wrote to defend Spear against the accusation that his portrait of Winston was 'cheap sensationalism' and 'an act of defilement'. He suggested, probably tongue in cheek, that perhaps it would be a good idea for some enterprising official body to commission John Bratby or Francis Bacon to paint the great man.[16]

Spear's less than hagiographical image of Churchill had touched a nerve – providing tangible evidence for a lack of deference from the younger generation to that which had led the country during the war. Some younger artists exhibiting at the Academy by the mid-1950s thought the portraiture invariably seen there needed a good shaking up. Spear was even accused of having behaved like a 'teddy boy with a brush' in his assault on Churchill's reputation, presenting him as one more mendacious politician using the wireless to bewitch his audience.[17] Of course in his younger days as an MP, Churchill had sometimes been described as something of a pushy, verbally aggressive, ambitious aristocratic 'swell' or 'knut'.[18]

Those venting such spleen on Spear do not seem to have been aware that he had served in the war and had received official commissions from Clark's War Artists Advisory Committee in 1943–1944.[19] Intriguingly, only a few months after Spears's controversial portrait had been exhibited, there was much debate in many of the country's broadsheet newspapers as to whether British society was stifled by an officially-imposed oppressive deference towards those in authority, even if they were manifestly undeserving of such a view.[20]

Of course Spear's portrait of Churchill had been exhibited in the first Royal Academy summer exhibition to be held after the debacle of Suez; the British failure to take and hold the Canal in November 1956 had proved a profound national humiliation for Britain and any lingering imperial pretensions.[21] To some extent, perhaps, Spear was pushing against an open door; as the 1957 RA

show was about to close, Neville Wallis welcomed the fact that Spear's 'controversial Churchill portrait' had been purchased for a very respectable £750.[22] He interpreted this as an encouraging sign that not all collectors were still in thrall to the portrait style of Sir Gerald Kelly, Sir Herbert James Gunn and Sir Alfred Munnings.[23] A month later, critic and art historian Alan Bowness also took heart from Spear's success; still in his mid-forties, he was to be commended for the refreshing, direct appeal of his portraiture, 'vulgar in the best sense … carrying on with considerable success the anecdotal part of the Sickert tradition'. He was also critical of the 'sensitive, tentative … and rather precious realism' evident in much of British portraiture that had recently been on display'.[24]

By the end of the decade an editorial in *The Times* took it for granted that British sculpture was dominated by sculptors, such as Henry Moore, Reg Butler, Bernard Meadows, Lyn Chadwick, Kenneth Armitage and Eduardo Paolozzi, who produced work the British public found neither 'agreeable' or 'reassuring' nor which 'lent itself to ready comprehension'.[25] The editorial wondered (since Sir Jacob Epstein was now in his twilight years – he would die in August 1959) who a more traditionally minded memorial committee could approach for a 'satisfying memorial'. One sculptor in whom it had faith was Epstein's long-standing assistant, David McFall.[26]

Early in 1958 the Wanstead and Woodford Conservative Constituency Association approached McFall to make a full-length statue of Churchill to commemorate his 33 years as their MP[27] – for the current seat and its earlier incarnations.[28] It would appear that the key figures within the 'Sir Winston Churchill Commemoration Fund Committee' – Alderman Charles H. Moss (then then Mayor of Woodford), Sir Dennis Allen and Churchill's agent, Colonel Sir Stuart Mallinson – had been referred to McFall by the sculptor Sir Charles Wheeler, who was elected President of the Royal Academy in 1956 with a brief to promote the continuing viability of more traditional forms of sculpture.[29]

Since October 1924, Churchill's relations with his Constituency Association had been relatively harmonious over the years apart from a period in

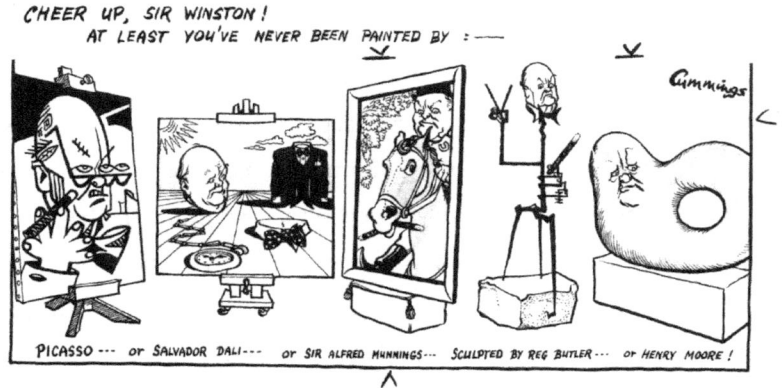

FIGURE 7.4 Michael Cummings, 'Cheer Up Winston. At least you've never been painted by Picasso, or Salvador Dali, or Sir Alfred Munnings or sculpted by Reg Butler or Henry Moore', Daily Express, 4 May 1957, Cartoon Archive, Kent University.

By the time this image was published there was a definite general suspicion, in the popular press especially, that contemporary sculptors were not equal to the task of producing convincing and effective public portraiture. The public carvings Moore had produced for the 'new towns' of the late 1940s, such as *Family Group* (1954–1955) for Harlow and a similar composition for Stevenage, had been much criticised[30] while the work associated with the so-called 'Geometry of Fear' sculptors – so dubbed by the critic Herbert Read in response to the work exhibited in the British Pavilion at the 1952 Venice Biennale – was perceived as even more alien and alienating.[31]

Reg Butler (1913–1981) had become notorious early in 1952 for the radical nature of his winning tubular design for the competition of a Memorial to the Unknown Political Prisoner held by the Institute of Contemporary Art.[32] Indeed, the winning maquette had been attacked when it was exhibited at the Tate Gallery in March 1953 by a Hungarian political refugee living in London.[33]

October–November 1938, during his 'wilderness years', when his prominent public opposition to the Munich Agreement and criticism of Chamberlain's appeasement policy towards Hitler's Germany was deemed by some in the Association as flagrant disloyalty. Early in November 1938, the Association voted whether or not to de-select Churchill as its future parliamentary candidate. Churchill won by 100 votes to 44. Even so, he later indicated he thought it had been a close call.[34]

McFall, born into a working-class family in Glasgow (his father was a postman)[35] began the commission by travelling early in February 1958 to the villa La Pausa at Rocquebrune in the south of France, where Churchill was then staying.[36] La Pausa was owned by the Hungarian-American Emery Reves and his Texas-born wife Wendy.[37] McFall arrived at the Villa to discover that Churchill was unwell and in bed; indeed he had recently suffered a stroke. However, Churchill sat for the sculptor between 3 and 6 February. McFall returned to London with the head in clay and took a plaster cast from it on 13 February 1958. A cast in bronze was made from it on 28 February 1958 (see Figure 7.5).[38]

Four days later McFall received the following letter from Wendy Reves:

Lady Churchill ... [is] very anxious to know you and will, on her return to London, make a point to meet you and discuss you work with you ... she would greatly prefer a 'seated statue' ... to put the face of Sir Winston of today onto a body of Sir Winston during the war days would, of course, be most peculiar looking and if the entire statue is done after the manner of him today – then it should be seated ... she feels Roosevelt's statue (standing) is very unattractive[39] and fears the results might be similar. She's very interested indeed in your statue-to-be and I feel she will be of great help to you ... Of course you can realise how frantic we have all been over Sir Winston's illness – but thank the dear God above ... he has come out of it and seems even more fit than before[40]

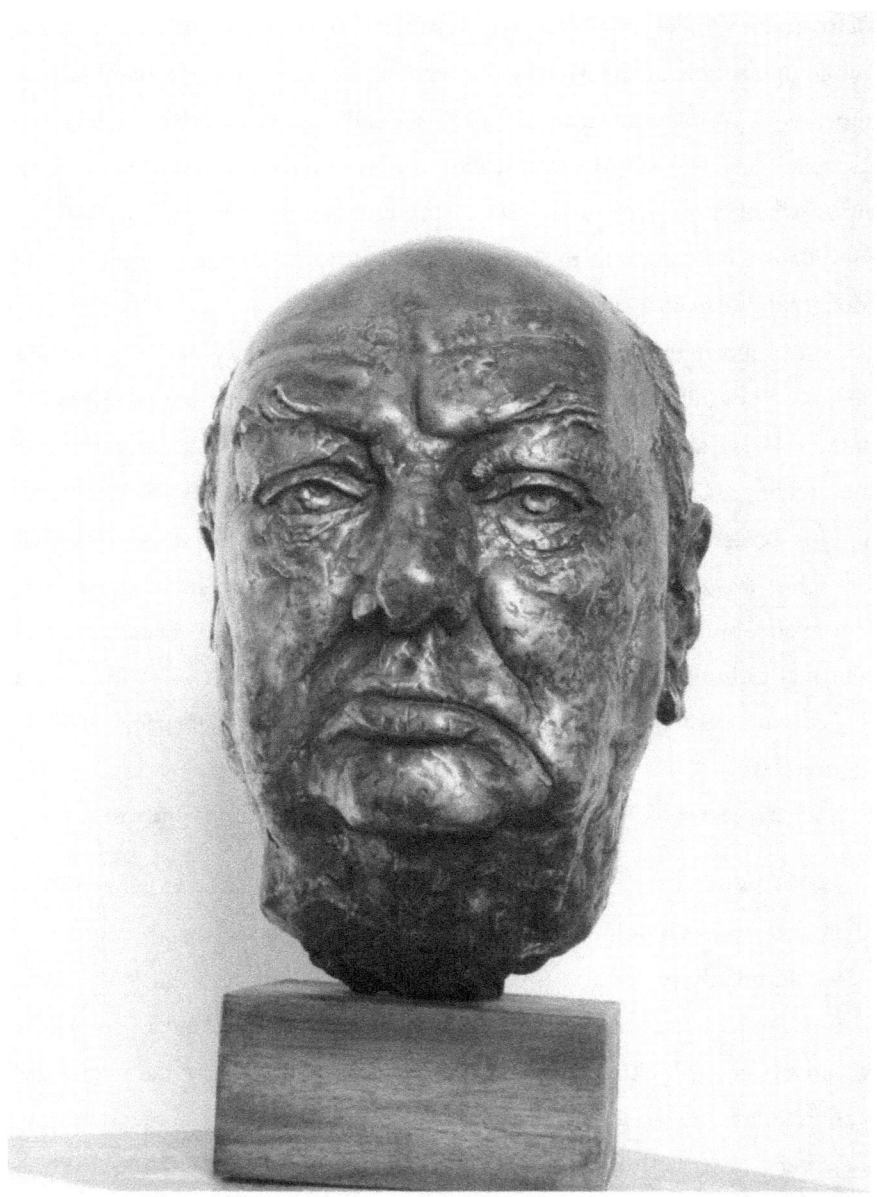

FIGURE 7.5 *David McFall (1919–1988), Sir Winston Churchill (known as* The Rocquebrune Head*), 1958, bronze, 31 cm high, Private Collection.*

The sculptor sent Mrs Reves a photograph of the plaster cast of his head of Churchill and promptly received the following letter from her:

> I found the photo of the plaster Churchill most imposing and powerful ... the eyes are too closed ... is my only criticism ... as you explained you wanted to capture him as you saw him and, indeed, he was rather sleepy during those days ... it was the beginning of his illness and his health was not at its best when you were here! I am so happy that you came when you did as it may be a very long time before he can undertake a 'sitting' again....[41]

McFall later recalled that, looking at the Rocquebrune Head, 'Sir Winston remarked to a friend that he realised for the first time that he really was an old man. The friend asked me later, could I not cheat a little? I could not. This was a human document and I was not going to alter it ... the sculptor must have the concentration to dismiss the sitter's advice as work proceeds. Sir Winston repeatedly demonstrated with flattened hand what he believed to be the exceptional height of his forehead ... Epstein told me [in 1946] that Churchill had made the same observation to him but Sir Jacob mischievously pointed out that we all look lofty as seen in the shaving mirror. More poignantly Sir Winston asked Epstein to leave out all "the scraggy skin under my chin". I well remember that he did so, because I cast his original clay model immediately after the third sitting.'[42]

Towards the end of March 1958, the *Daily Herald* newspaper reproduced a photograph of the initial Churchill plaster cast. Its art critic was extremely impressed, writing alongside the photograph: 'We have seen Churchill stubborn. Churchill grave. Churchill triumphant ... surely this is a Churchill we have not seen before – the man of deep sorrow.' In the accompanying interview McFall declared that when he first met Churchill he was 'struck by something in him I had not expected to see. Tragedy. His age is a matter of great sorrow to him and I caught him at a very tragic moment of his life. I felt I had to do this intimate, unhappy head of him. I shall not use this head for the

statue [for Woodford]. That should be of Churchill the Legend. But this is just the head of a man. In his glory and disappointment.'[43]

McFall was to take his 'strange, sad head ... to the Royal Academy today where it will be exhibited in the summer exhibition.' The sculptor was asked how he had caught that 'haunting' look on Churchill's face. He replied: 'I know he [Churchill] does not like pompous, self-important artists, so I made myself as invisible as possible ... I put him on an ordinary chair instead of a rostrum which meant I had to work on my knees. And I used the minimum of equipment. By persuading him I was hardly there at all, I caught his private instead of public expression.'[44]

Sir John Rothenstein was so impressed by the portrait when he saw it at the Royal Academy that he proposed the head be bought for the nation from the funds of the Chantry Bequest. However, even though his proposal was supported by such luminaries as the Academy's President, Sir Charles Wheeler, Sir William Coldstream (Principal of the Slade School of Art) and the eminent art historian Lawrence Gowing, it transpired this could not be done as the head had not actually been modelled in the UK.[45]

Meanwhile, McFall began another series of sittings with Churchill, this time at Chartwell, on 11, 16 and 30 May 1958, and 2 and 6 June 1958. McFall modelled Churchill's right hand on 6 June and cast it in plaster three days later. On 9 June, a plaster cast was made from what would become known as McFall's 'Chartwell Bust' of Churchill (see Figure 7.6).[46] This would be the last portrait of Churchill ever to be derived from face-to-face sittings; he was now too frail and too deaf to have the strength or the patience to submit to the process again.[47] McFall would present a cast of the Chartwell bust to the Royal Academy in 1963 as his diploma work on election as a full Academician.[48]

Twenty years later McFall was to reveal to the *Daily Telegraph* that Churchill's family had not been happy about the evidence of his stroke in the slightly distorted, down-turned mouth evident on the head of the 'Rocquebrune bronze'; the sculptor was prevailed upon to make a second portrait, the 'Chartwell bust' which 'while less accurate was more flattering'.[49] When he

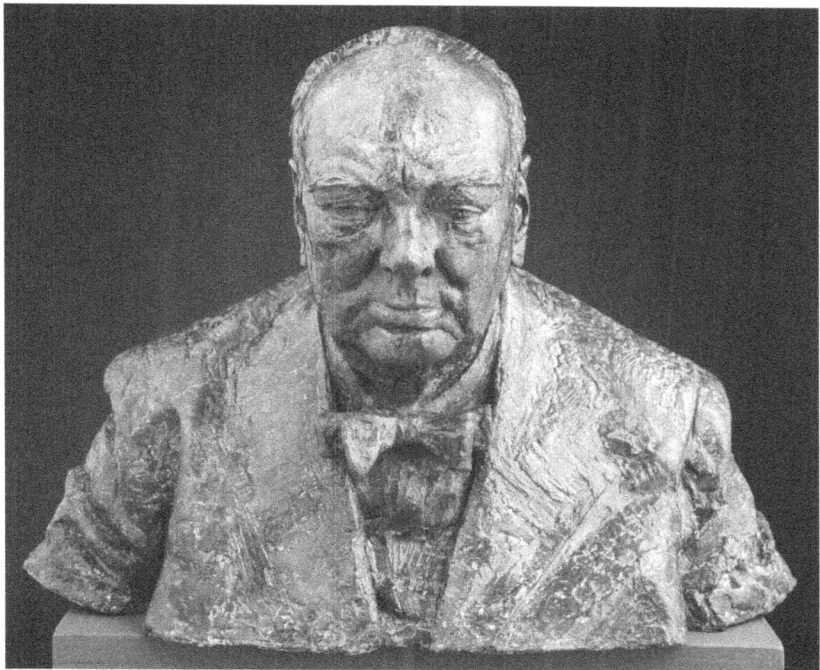

FIGURE 7.6 *David McFall*, Bust of the Rt Hon. Winston Churchill, *1958* © *Royal Academy of Arts, London; Photo: Paul Highnam.*

visited Chartwell in May–June 1958: 'Lady Churchill was the perfect hostess ... But on the subject of portraits of Winston she became ... a screaming dervish ... She had taken him on a tour of "acceptable portraits" of Winston at Chartwell ... She announced to me: "the Sutherland picture will never be seen again ... accidents can happen to sculpture as well ...".'[50]

He had also agreed by June 1958 with the Woodford Statue Committee that he should 'portray Churchill as he was in 1944' and the Chartwell bust was to 'represent this time fourteen years previously'.[51] This latter version thus served as the model for the head on the final statue, which would be unveiled by Field Marshal Montgomery in October 1959 (see Figure 7.7).

The 'Chartwell Bust' of Churchill was first exhibited with the Society of Portrait Sculptors in London in November 1958. On the whole its critical

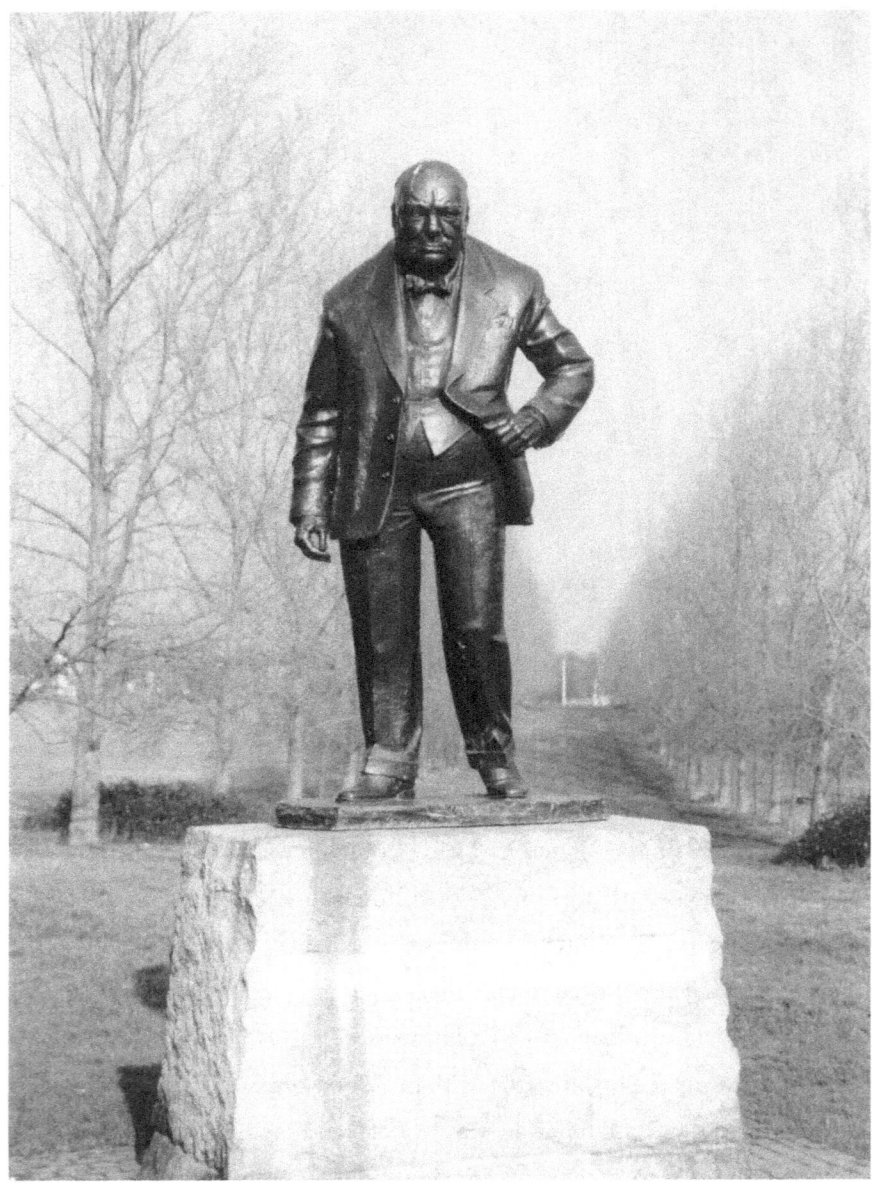

FIGURE 7.7 *David McFall*, Sir Winston Churchill, *1958–1959, 2.59 m high, bronze figure, Salway Hill and Broomhill Walk, Woodford Green, Essex.*

reception was more tepid, less enthusiastic than that given the earlier head. For example, Neville Wallis, in *The Observer*, was impressed by the work's 'robust qualities', though he took issue with the 'exaggeration of the lower jaw ... underlining a morose mood at variance with the unruffled and reflective gaze' of the sitter'.[52]

Early in December 1958, photographs of McFall working on the full-sized plaster model of his Churchill statue for Woodford were reproduced in a number of newspapers and swiftly caused a stir. One appalled observer described his model as a 'two-ton shocker':

> I saw an aggressive, scowling Churchill statue yesterday ... And I was shocked ... this two ton 8 foot high work by Chelsea sculptor Davd McFall is going to raise eyebrows at Woodford ... the Woodford folk are already worried by the pictures of the towering, menacing figure.

The commissioning committee were due to see it shortly. However, the nonchalant sculptor claimed declared he was not in the least worried: 'I'm not interested in anybody's opinion but that of the man in the street. I am pleased with my work and I think the common man will be too. My milkman and postman approve of it ... and it their opinion I respect. They have no reason to be dishonest about it ... Sir Winston gave me eleven sittings in the South of France and in Chartwell. ... He told me to try to show his intellect and that is what I have tried to do. I am determined not to give Woodford one of those terrible "toby jug" Churchills.'[53]

Another newspaper report described McFall's Churchill as 'the elder statesman, grim, severe, forbidding. The sculptor depicts Sir Winston pulling back the flap of his jacket as if reaching for his watch. But already there are complaints, locally and nationally, that the effect is "gorilla-like" and a "caricature".'[54]

Representing the statue committee, Colonel Sir Stuart Mallinson was quoted stoutly defending the statue: 'I am very pleased with it ... Lady Churchill will be asked to see it before it is completed. You had better say I am satisfied

subject to the final finishing, Lady Churchill's opinion and that of the other members of the committee. As it's going to be rather high up, I suppose certain features must be emphasised.' Colonel Mallinson was confident that the £5,000 required to pay for the statue would be raised; £3,200 had already been subscribed by the public.

The architect Sir Albert Richardson, Churchill's friend and a past President of the Royal Academy, was asked for his opinion of the maquette. He had not seen the sculpture but said: 'Sir Winston doesn't care for distortion of any sort; he likes the reasonable Englishman's point of view. Some portrayals of him in the past have been too brutal and Sir Winston has rightfully complained "I am not like that ...".' Lord Hailsham had stated that Sutherland's portrait of Churchill had made him 'resemble a turtle'. Hailsham had threatened to throw that portrait in the Thames. Today he refused to deny he would try to do the same to McFall's statue if erected.'[55]

The five-man statue committee viewed the full-sized plaster on 6 December 1958 and 'took less than an hour to decide they were delighted with it'. They did not consider it in the slightest as 'Gorilla-like; a caricature [or], a disgrace ...'. Sir Stuart Mallinson announced to the press: 'The longer we regarded it, the more we realised that it hit us as Sir Winston hits the world and emphasises his determination to see a task through to the end.'[56]

McFall expressed how relieved he was by the decision: 'I wasn't really worried that my judgement was wrong but I was upset at first by the spurious criticisms of people who had not even seen the statue.' The sculptor said that criticism of the model had been 'terribly unfair. It is meant to be big and to hit and think it does. The gesture of reaching of his pocket watch is one Sir Winston used to end each of the eleven sittings ... I had with him in the South of France and at Chartwell.'[57]

Two days later the then Mayor of Woodford, Councillor Roy Dalton, announced in the *Times* newspaper that 'the final design for a bronze statue of Sir Winston Churchill has been approved by the commemoration committee ...

It shows Sir Winston as he was in about 1944–1945. Mr. McFall's preliminary study in bronze came in for some criticism on the grounds that it depicted an old man.'[58] The new model, approved by the committee, 'shows a much younger-looking Sir Winston. We want on our monument the Sir Winston who was at the height of his power.' Alderman Dalton told the newspaper: 'The new head portrays Sir Winston as he was about 1945. It is Sir Winston in the prime of his wartime triumph, the determined man whom the world knows.'[59]

It is intriguing that the Committee was so keen to evoke 1944–1945, over 14 years in the past – a period when Churchill had often felt unequal to the tasks before him – as opposed to 1940–1942, widely judged today as his 'finest hour'.[60] In January 1945, for example, he had been justly taken to task by his Deputy Prime Minister, Clement Attlee, for the chaotic way in which the government was being run.[61] By that point the defeat of Hitler's Germany was assured and yet it was now clear that the Soviet Union would dominate central and eastern Europe. As early as 12 May 1945, Churchill had warned the new President, Harry Truman, that an 'iron curtain' was descending all along the Soviet front.[62] The Prime Minister felt powerless to arrest what he perceived to be the precipitate decline of British power.[63] Of course, by the end of July 1945 he had been unceremoniously voted out of office – given the 'order of the boot', as he put it by the British people.[64]

On 8 December, MacFall was interviewed by the *Daily Telegraph*, which stated that: 'for the latest design [of the statue] he went to Chartwell six times to see Sir Winston: "I have seen his personal greatness and I have given less of the legend and more of the man. He looks resolute and full of virility. I have borne in mind three things in this work: fortitude; gravity and purpose. These I think are his salient characteristics and I think I have finally got them in this new model. When it is set up on Salway Hill, I want the site left as it is, with the figure standing on a great, crude block of granite with just Sir Winston's name on it, stark and bold. I do not want any rockeries, crazy paving or York stone walls round it."'[65]

However, a few days later McFall received a letter of some concern from Lady Clementine Churchill. She was anxious to talk with the sculptor about the statue: 'I think it is a remarkable achievement; but I am disturbed at what to me seems an exaggeration – indeed almost a caricature of Winston ... Take, for instance, two photographs of him taken during the war ... In both we have the projecting lower lip, but not as swollen as it appears to be in the statue. I think he looks quite fierce enough in the second photograph! I have lived with him now for fifty years and I can never remember him looking in the least like the ferocious representation ... I am afraid it is too late for anything to be done? ... I think angry and brutal expressions are particularly out of place because during the War, whenever there was a bad crisis, my husband was always calm and serene. Please forgive me. But I do feel just a touch might make the statue live.'[66]

The degree to which McFall reacted to Lady Churchill's reservations is not clear. However, towards the end of January 1959 Sir Stuart Mallinson wrote to the *Times* to reassure its readers, and possibly Lady Churchill as well, that the photographs of McFall's plaster model which had prompted such uproar early in the previous month had been taken when the work was poorly lit. They would 'in no way represent the final effect in bronze ... The sponsors [of the memorial] feel that while it would have been possible to produce a statue of Sir Winston in more cherubic aspect, this statue will convey what they wished: the Prime Minister whose voice held the nation together, brought hope to those in darkness and defied the power of Hitler ... in the opinion of many who have seen it even at this stage, this work of Mr. David McFall is a masterpiece.'[67]

McFall's full-sized plaster model of the statue went to the foundry on 10 February 1959 and was cast to the sculptor's satisfaction by 2 September 1959. It is evident that the head of the final statue owed much more to the 'Chartwell Bust' he had created in May–June 1958 than to the earlier, more accurate and unforgiving 'Rocquebrune Head'. It is likely that he had taken

Lady Churchill's comments into consideration, but had also tried to remain true to the image he had formed of Churchill when he had last seen him at close quarters at Chartwell.

A month before the unofficial unveiling the statue was discussed by critic Louis Stanley in *The Sketch*. He described it as 'a work of unusual strength with a mass of subtle detail in its making'. He predicted McFall's Churchill would establish him as one of the UK's four leading public sculptors, alongside Charles Wheeler, Henry Moore and William Reid Dick. Stanley quoted an anonymous RA who had claimed earlier in the year that McFall had 'aimed consciously at ugliness. That is absurd ... the basis of the Churchill likeness lies in the shape of the skull and in the bony structure of the face. It brings out his fierce, almost demonic, energy.'[68]

The statue was finally unveiled on the afternoon of 31 October 1959. Field Marshal Montgomery pulled the cord to remove the sheet covering the figure and then Sir Winston walked slowly all the way round the base. He pronounced it 'very nice'[69] and then spoke into a waiting microphone: 'I am most grateful for the people of Wanstead and Woodford for the signal honour you now do me. You have sustained and supported me throughout the 35 years I have had the privilege of representing you in Parliament.' He then glanced up the statue for a few seconds before adding: 'It is not easy to speak of a work of art portraying oneself. I should like nevertheless to congratulate the Trustees on their choice of such a distinguished young sculptor and I should like to offer Mr. David McFall my sincerest compliments on his work.'[70]

A week after the unveiling one of the local newspapers noted that, in addition to attracting a crowd of over 4,000 people on the day of the ceremony, since then it had been visited by hundreds: 'housewives, businessmen, travelling salesmen, school children, people from all walks of life ... A lot of people still do not like the work ... but from chatting to people visiting the site it is clear the compliments outnumbered the condemnations.'[71] Residents of Broomhill Walk, facing the statue, were quoted as saying they were 'rather flattered' it

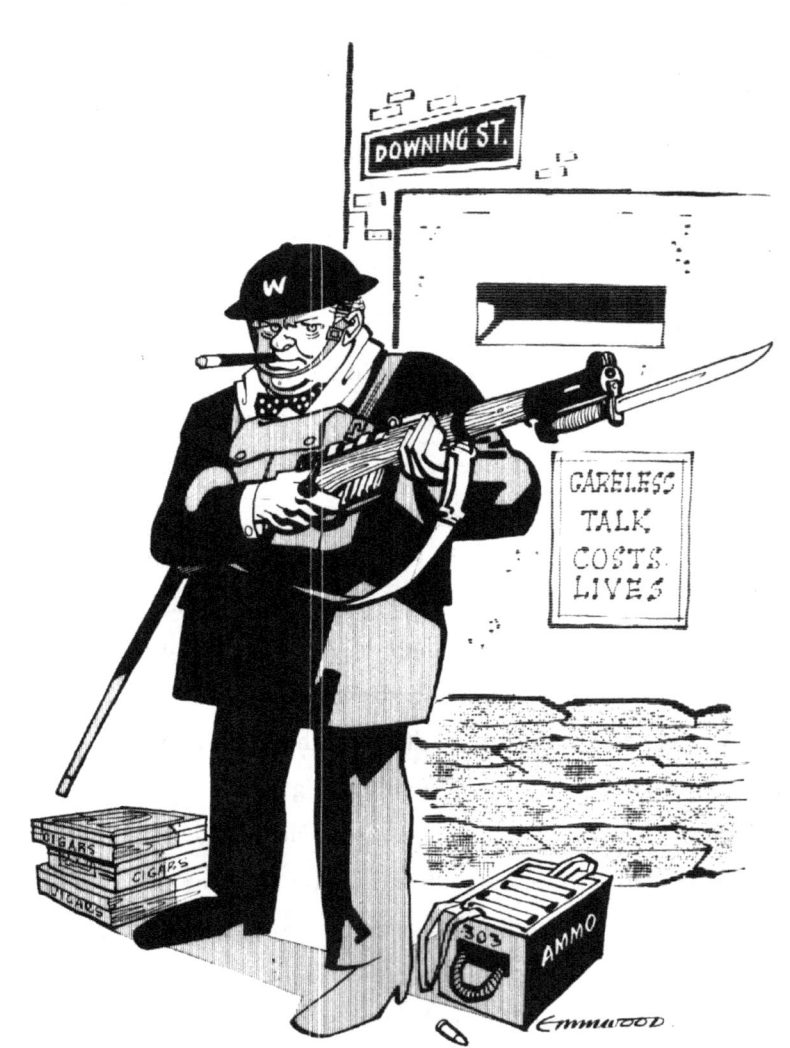

FIGURE 7.8 *John Musgrave Wood (1915–1999) (known as 'Emmwood'), 'If They Come Back to London I shall take a Rifle and put myself in a Pill Box and Shoot 'till I have no more ammunition'*, Daily Mail, 12 September 1960, Cartoon Archive, Kent University MW 0752.

Emmwood presents the Churchill who gave the ringing speech of 4 June 1940 which contain these celebrated lines: 'We shall go on to the end. We shall fight in France, we shall fight on the seas and oceans, we shall fight with growing confidence and growing strength in the air, we shall defend

our island whatever the cost may be. We shall fight on the beaches, we shall fight on the landing grounds, we shall fight in the fields and in the streets, we shall fight in the hills, we shall never surrender ...'[72] However, the Churchill he presents with rifle and fixed bayonet in hand looks much younger and less careworn than the Prime Minister of 1940. Indeed, he has become a veritable superhero, removed from any acquaintance with earthly reality into the realm of myth – the myth of 1940 focused on the person of Churchill behind which, supposedly, the entire British nation rallied to defy Hitler.[73]

Just a year previously, in November 1958, Churchill's wartime colleague, Harold Macmillan, had been satirically transformed by Vicky into 'Supermac'.[74] Far from finding this label a disadvantage, Macmillan had revelled in the appellation as well as never failing to remind the public of his duties as Churchill's wartime representative. In the ensuing General Election of October 1959 Macmillan mobilised both the wartime image of Churchill, the 'bulldog at bay' of 1940 and the mantle of 'Supermac', trading at one remove on the mantle of the American comic character of Superman who first became known in the UK during the Second World War.[75] Macmillan won the election comfortably with a large majority.[76] He could only wonder at the continuing potency of the image of the wartime Churchill when the actual man had largely faded from public view.[77]

should be sited where it was. One visitor to the statue did 'regret there was little sign of the gentleness and the kindness which he [Churchill] has'. A 'local housewife from Epping' agreed that Churchill did indeed 'look ruthless ... But he had to be ruthless to achieve what he did'. He husband, lurking behind, piped up: 'He looks like a real bulldog.' Another housewife 'from Woodford Green' declared: 'It is £5,000 well spent to have a statue honouring a man who helped to save Britain.'[78]

Given Churchill's sometimes strained relations during the war with the Church of England, with Bishop Bell of Chichester[79] over the area bombing of Germany, for example, he will not have been entirely surprised to learn that one of the few dissenters on the afternoon of the reporters' visit was 'an Anglican

clergyman ... who stated the money for the statue should have been spent on cancer research'. This was not a view popular with those standing nearby.[80]

* * *

After retiring as Prime Minister in April 1955, Churchill was re-elected as MP for Wanstead and Woodford in the General Election of the following month. In June 1955 he took his old place in the Commons Chamber on the corner seat on the front bench below the gangway. He did not speak in the Chamber again, although he did contemplate contributing in July 1958 to a debate concerning the recent revolution in Iraq, during which the young King, Feisal II, had been murdered and the general unravelling of British influence in the Middle East.[81]

In their respective portraits (Figures 7.9 and 7.10), Juliet Pannett and Gerald Scarfe, in their own way, address the reality of Churchill's physical decline and the ravages of time. Pannett is somewhat gentler and more affectionate in her presentation of an undeniably decrepit 'Father of the House'. She had been a 'Special Artist' for the *The Illustrated London News* (from 1957 to September 1964) and the only woman allowed to make sketches from the Press Gallery by the Commons Serjeant of Arms.[82] There is more bite, even venom, in the image of the younger artist – not quite so under the spell of the wartime Churchill[83] which Pannett admitted still had resonance for her as someone who had worked in London throughout the Blitz as a journalist.[84] Scarfe's image is symptomatic of a less forgiving and, perhaps, more cynical generation. Two years previously he had begun to contribute to the satirical magazine *Private Eye* – very much in the vanguard of a boom in anti-Establishment satire on the cusp of the 'Swinging Sixties'.[85]

Churchill suffered a serious stroke on 12 January 1965 and died on the morning of Sunday 24 January at 27 Hyde Park Gate. His coffin lay in state in Westminster Hall from 27 to 29 January 1965. His funeral took place in St Paul's Cathedral on 30 January.[86] For many observers his passing constituted the end of an era: the irrevocable end for imperial greatness and self-confidence.[87]

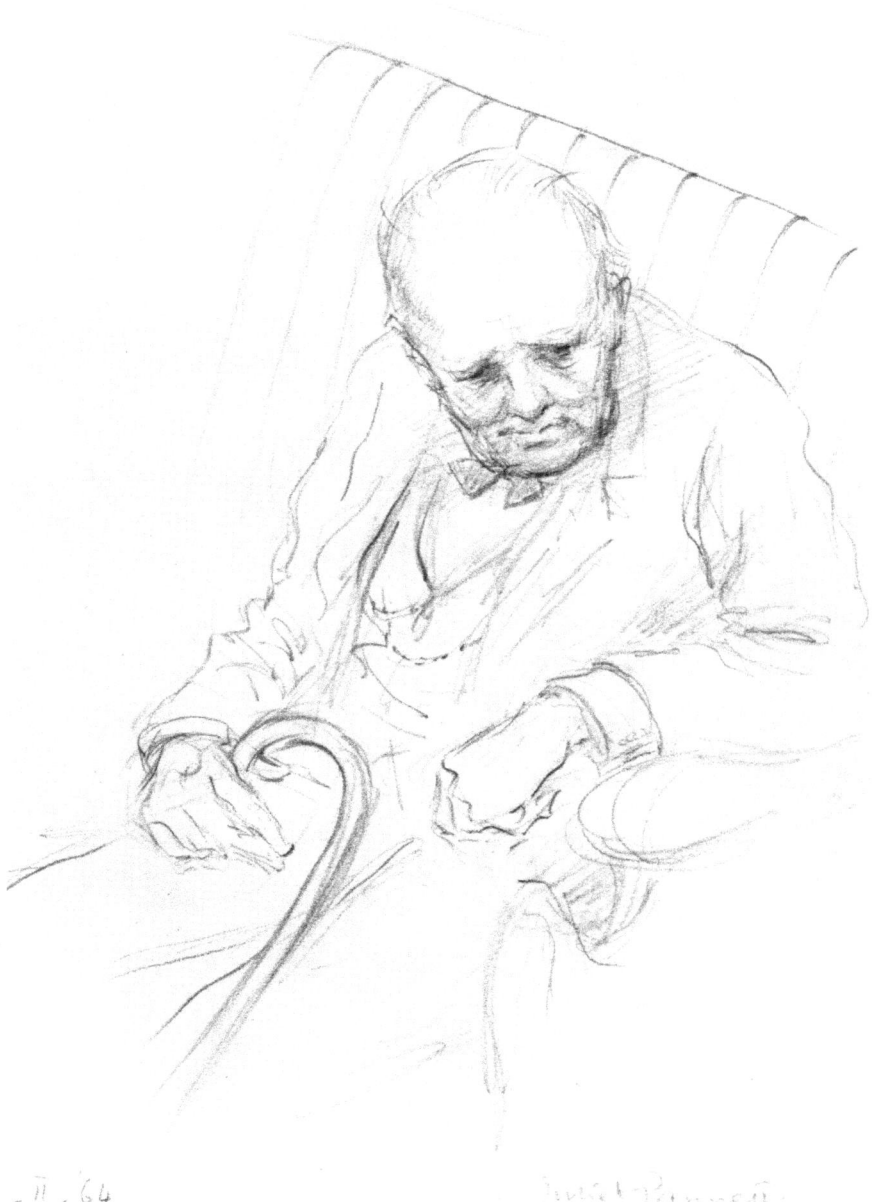

FIGURE 7.9 *Juliet Pannett (1911–2005)*, Sir Winston Churchill Seated in the House of Commons, *6 February 1964, pencil on paper, 22.9 × 15.2 cm, National Portrait Gallery, London.*

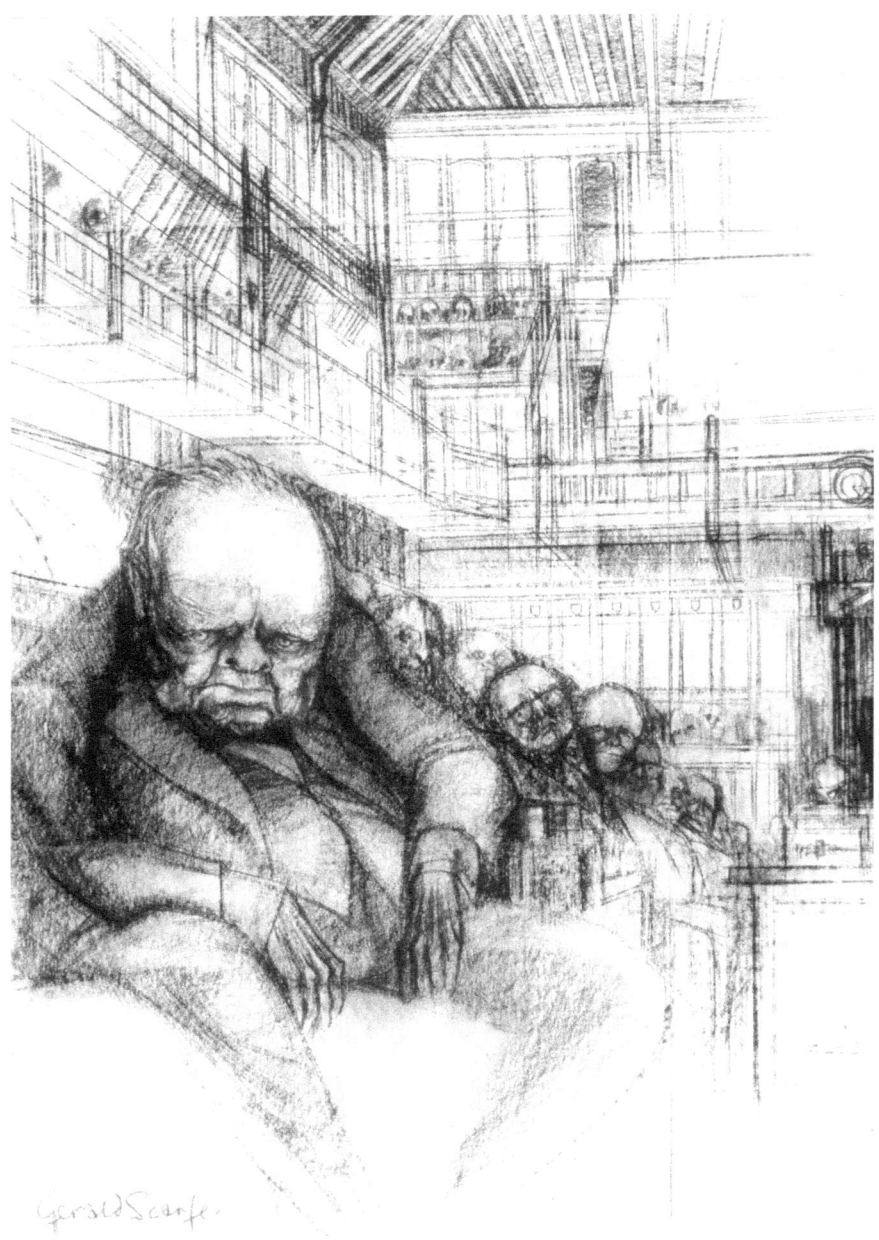

FIGURE 7.10 *Gerald Scarfe (1936–)*, Sir Winston Churchill on his Last Day in the House of Commons, 27 July 1964, *pencil on paper, Private Collection.*

Scarfe's haunting portrait was reproduced on the front cover of *Private Eye* six days after the funeral, on 5 February 1965, and predictably caused outrage.[88] At the dawn of a new age of self-consciously edgy and transgressive satire, little mercy could be shown to old heroes, however respected by the public at large.

8

Churchill's Visual Legacy: Memorials, 1965–1999

Within a fortnight of Churchill's state funeral, Conservative MP Sir John Tilney proposed in the Commons in mid-February 1965 that it temporarily set aside the accepted rule that no memorial be erected to one of its members within its precincts before ten years had elapsed. Tilney wished to set in train a memorial to Churchill to stand in the Members Lobby of the Commons. His motion was approved by a huge majority and a committee of MPs was rapidly constituted to select a sculptor which was chaired by the Labour MP and one of Churchill's old verbal sparring partners in the Commons, Emanuel Shinwell.[1]

Discussion ensued for some time within the memorial committee as to whether there should be a competition to select a design and which sculptors should be approached to participate. After six months, the Churchill family were sounded out as to whether they had any preferences regarding a sculptor. Lady Clementine Churchill, her daughter Sarah and former son-in-law Duncan Sandys (1908–1987) all indicated the only sculptor who could be considered for the task was Oscar Nemon.[2] He was the sculptor who had spent the most face-to-face time with Churchill, had sketched him extensively between late 1950 to 1956 and, perhaps just as importantly, got on well with the Churchill family – especially the flinty Lady Clementine who, as we have seen, gave David McFall quite a difficult time in 1958.

By early autumn Nemon had been formally approached to submit a selection of sketch maquettes for the proposed statue. The one that had most immediate appeal with the family and the commission committee depicted a Churchill from the late 1930s or early 1940s in a pose he had adopted so often in the Chamber: poised as he if he was about to deliver a winning point in a debate. There is a hint of humour in the expressive head Nemon modelled for the body derived from a combination of his own sketches from life and from his own memories of his many meetings with Churchill (they last appear to have met at the time of Churchill's eighty-sixth birthday in November 1960). Most of the MPs on the Committee, including Shinwell, felt that Nemon had effectively captured the Churchill who relished, indeed wallowed, in good debate and the cut and thrust of argument leavened by the occasional barbed witticism, or memorably deflating aphorism.[3]

Nemon was offered the commission early in 1966, promptly accepted and – for him – worked with unusual speed so the full-sized statue was ready to be unveiled by Lady Clementine Churchill inside the Members Lobby on 1 December 1969 (see Figure 8.1).[4]

The following day, the unveiling of the statue was covered by the *Guardian* newspaper. Nemon's conception of Churchill was described as 'truculent'. It was claimed 'Lady Clementine Spencer-Churchill was clearly shaken' as her husband emerged from beneath the sheet covering the figure: 'It was for all the world as though Churchill had himself thrown off his coverings by taking a sudden, thrustful, step forward. There he stood once more in the Members Lobby, hands on hips, the hint of a pugnacious smile, a pair of broad shoulders avid for new burdens.' The statue was described as projecting an 'impish' Churchill who had undoubtedly 'thrilled and inspired the House and also made it angry'.[5]

The figure was judged a great success by the small group of art critics from the art world able to gain access to it, such as Sir John Rothenstein.[6] Nemon was already well on the way to becoming the one sculptor Churchill memorial statue committees would approach for a figure – helped by the fact his designs

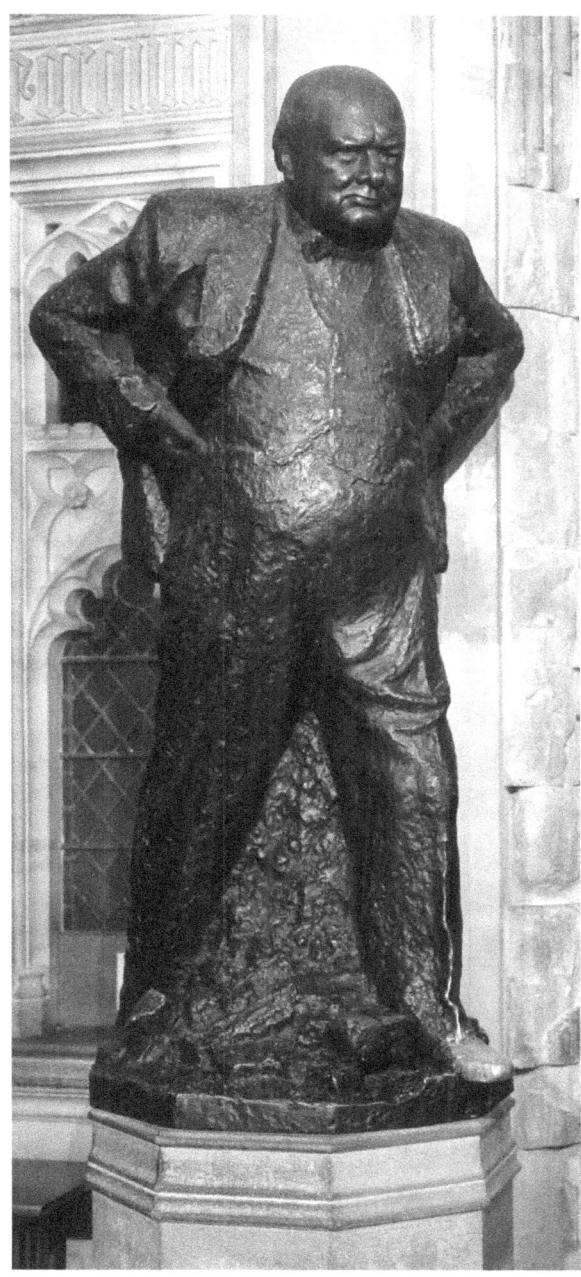

FIGURE 8.1 *Oscar Nemon, Sir Winston Churchill, 1966–1969, 2.1 m high, bronze, Members Lobby of the House of Commons, London.*

would invariably be approved by the Churchill family. Between 1965 and 1977 he produced a bronze seated Churchill for Westerham Borough Council (unveiled in July 1969 by the former Australian Prime Minister Robert Menzies)[7] – commemorating the time Churchill had spent at nearby Chartwell Manor, which he had bought in 1922;[8] a bronze over-life-sized full-length figure of Churchill striding forward wearing a British Army overcoat for central Brussels (unveiled October 1967)[9] as well as other bronze variations of Churchill walking in an overcoat for St. Margaret's Bay near Dover (unveiled in December 1972 by Churchill's grandson Winston); Luxembourg City (unveiled in October 1973);[10] Mexico City (unveiled in 1976) and Toronto (unveiled in October 1977).[11]

Despite his best efforts, Nemon did not succeed in hypnotising all memorial committees in search of a statue of Churchill. In the spring of 1969 Westminster College at Fulton, Missouri commissioned the Czech-born, British-based sculptor Franta Belsky (1921–2000) to make an over-life-sized bronze figure of a vigorous-looking Churchill to commemorate the famous speech he gave there in March 1946, during which he not only used the phrase 'Iron Curtain' but also 'special relationship' to define that which he asserted without doubt existed between Britain, weakened by war, and the now dominant United States with superpower might.[12] The memorial committee had been especially impressed by the liveliness of a sketch model head of Churchill which Belsky produced to clinch the commission. The statue was unveiled on 16 May 1971 (Figure 8.2).[13]

Though Churchill never formally sat for him, Belsky later recalled how the Prime Minister's features were imprinted on his mind when he was able to study Churchill at close quarters during a review the Prime Minister made in the spring of 1941 of the Free Czech Brigade in which the sculptor was serving at the time as a gunnery officer.[14] He also sketched Churchill 'on the stump', campaigning on platforms in London during the General Elections of June–July 1945, February 1950 and October 1951. Belsky thought Churchill had been a fascinating subject to observe; as his emotional mood changed, his

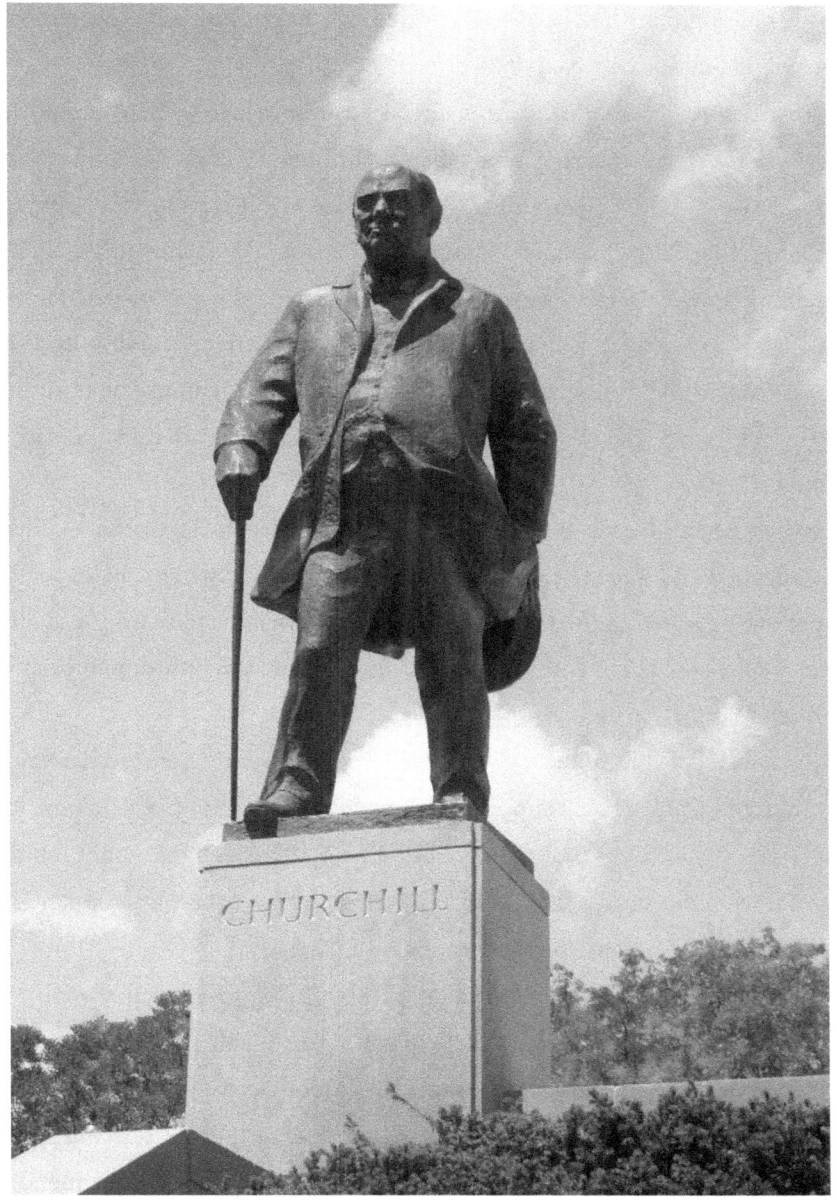

FIGURE 8.2 *Franta Belsky (1921–2000)*, Sir Winston Churchill, *1969–1971, 2.43 m high bronze, Westminster College, Fulton, Missouri; unveiled 16 May 1971.*

whole physiognomy had been transformed – from grumpy baby, to cherub, to a scowling bulldog deprived of its dinner.[15]

The idea of a statue of an over-life-sized bronze figure of Churchill for Parliament Square was first mooted in December 1967 by Sir John Tilney, Conservative MP for Liverpool Wavertree.[16] Once he had secured the support of Churchill's widow, and that of over 150 MPs, in July 1969 the proposal for a Churchill memorial was accepted by the Labour Prime Minister, Harold Wilson, who directed Tilney and his chief supporter, Sir John Rodgers (Conservative MP for Sevenoaks), to form an all-party committee to decide who would sculpt the memorial, and precisely where in Parliament Square it should stand.[17]

By late September 1969 a 'Sir Winston Churchill Memorial Committee' had been formed and quickly came to the conclusion that any statue of Churchill ought to be erected in the north-east corner of Parliament Square – a site the great man had once identified as a fitting spot for any future memorial to himself.[18]

A minority of committee members were keen to commission another figure of Churchill from Oscar Nemon, but the majority had not been that greatly impressed by Nemon's statue of Churchill for the Members Lobby of the Commons – the head was thought to be 'superb' but there was much less enthusiasm for Nemon's stylised treatment of the body.[19]

In February 1970, the Winston Churchill Statue Appeal was launched in *The Times* with the aim of raising £30,000 to pay for a suitable statue of Churchill in Parliament Square. Meanwhile, that same month, a panel of experts from the Royal Fine Art Commission inspected the maquette of a Churchill statue Nemon had proposed for Parliament Square and rejected it. They recommended that the Statue Committee hold a restricted competition among a number of invited sculptors.[20]

A month later, in mid-March 1970, advised by the President of the Royal Society of British Sculptors and the Director of the Victoria and Albert Museum,

the Statue Committee invited Nemon and eight other sculptors, including Ivor Roberts-Jones, to submit a maquette of a Churchill figure by the end of June.[21] The selection sub-committee viewed the eight submitted maquettes early in July 1970. They were most impressed by those submitted by Nemon and by Roberts-Jones, who presented the Prime Minister as he had been around 1953–1954, swathed in the capacious robes of a Knight of the Garter – an honour to which he had been appointed by the Queen in April 1953.[22] The sub-committee asked the two artists to go away, think again and resubmit a new maquette by the end of October. Roberts-Jones was specifically requested to think of Churchill as a 'younger man', the statesman who had so inspired the country in 1940.[23]

Roberts-Jones later recalled that he had been an admirer of Churchill's since the late 1930s without being blind to the man's 'many shortcomings'.[24] He had served as an Artillery Captain and commander of a battery of 25-pounder guns fighting the Japanese in Burma (1944–1945)[25] and liked to think of himself as a soldier of 'Churchill's Army' as the warrior of ancient times had served in Pharaoh's Army.[26] He had seen Churchill on the campaign trail in either February 1950 or October 1951, but on neither occasion voted for his party (he was not to vote Conservative for the first time until October 1959 – for Harold Macmillan).[27] The sculptor duly submitted his second maquette just before the specified deadline (see Figure 8.3). This time he presented a Churchill who was much younger, less frail and more vigorous, standing wearing a snug-fitting British Army officers greatcoat (of the type known as a 'British Warm'), left foot slightly advanced with him leaning on his elegant walking cane with his right hand. The defiant and contemplative pose was derived from a well-known photograph taken of a sorrowful Churchill inspecting the still-smoking ruins of his beloved Chamber of the House of Commons after it was bombed during the night of 10–11 May 1941.[28]

The conception of this second maquette also owes a great deal to an example of Ancient Egyptian funerary sculpture in the British Museum; Rodin's dynamic statue of the writer Honoré de Balzac, immersed in a dressing gown (1897–1898);[29] a statue of Oliver Cromwell by Hamo Thornycroft

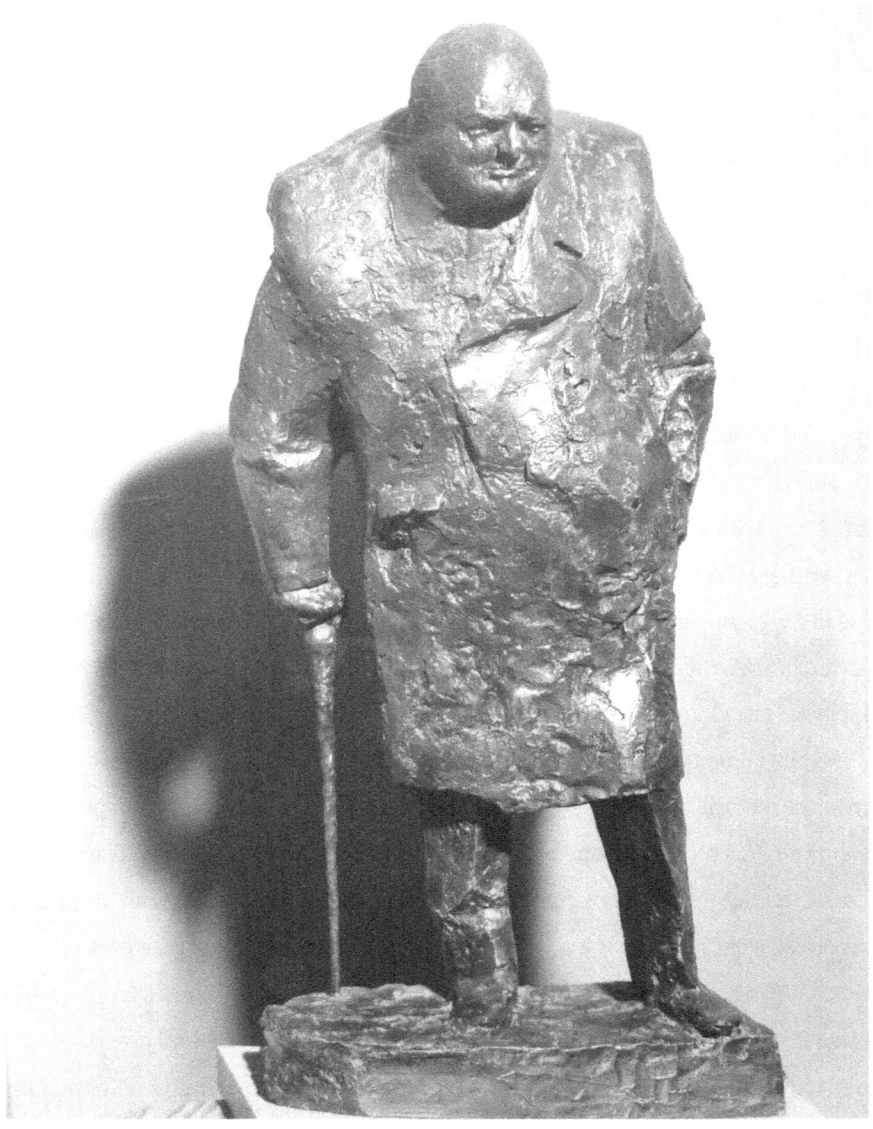

FIGURE 8.3 *Ivor Roberts-Jones (1913–1996)*, Second Maquette for the Parliament Square Churchill Statue, *1970, bronze, 80 cm high, Private Collection.*

(unveiled in November 1899) that still stands immediately outside the House of Commons; and a statue of the French First World War Prime Minister, Georges 'Le Tigre' Clemenceau, by a student of Rodin's, François Cogné, sited in Paris, appropriately enough in the Place Clemenceau at the north end of the Avenue Winston Churchill, and unveiled in 1932.[30] (In every visit Churchill made to Paris after its liberation from the Germans in August 1944, he always made time to lay a wreath at the foot of Cogné's characterful statue.)[31]

When the selection sub-committee viewed the two new maquettes early in November 1970, it unanimously selected the one submitted by Roberts-Jones.[32] A fortnight later this decision was approved by a panel from the Royal Fine Arts Commission.[33] However, a number of members on the larger Churchill Statue Committee – led by Duncan Sandys – still preferred Nemon's maquette. Roberts-Jones was asked to undertake further work on his maquette, particularly to add 'definition and clarity' to his conception of Churchill's head.[34]

By February 1971, Roberts-Jones's latest version of his maquette for the Churchill project – essentially as the statue stands today in Parliament Square (see Plate 11) – had been closely inspected and approved of by members of the WCSC, a panel from the RFAC and the Minister of Works.[35] However, a few members of the wider Statue Committee, led by Sandys and supported by Churchill's widow, his daughter Sarah, and grandson, Winston Churchill junior, still argued that Nemon should continue to be seriously considered for the commission.[36]

Despite this rearguard action from Nemon's supporters, Roberts-Jones was officially confirmed as the sculptor for the commission in mid-March 1971.[37] The sculptor bought a new home on the outskirts of Cratfield, in rural Suffolk, which had a large barn attached. Roberts-Jones thought this building would serve as an excellent studio in which to construct the armature of the huge figure of Churchill – which would finally stand over three metres high.[38]

Roberts-Jones began work on the statue in earnest early in 1972. By April that year the WCSC's Secretary could report after a visit to the studio-barn in Cratfield that the sculptor was making excellent progress on Churchill's body and on the head. On a previous visit he thought Churchill bore rather too close a resemblance to the fascist dictator Benito Mussolini.[39] Oddly enough, Lord Moran had noted after scrutinising Churchill on a platform during a General Election rally in Huddersfield in October 1951: 'he sat apart on the platform ... as if he were by himself; his head had sunk into his shoulders and, in the hard light of the hall his face and scalp appeared devoid of hair; the monolithic lines of the great skull and jowl were somehow familiar; yes, he was like Mussolini.'[40]

The full-sized clay model of the figure was viewed and approved by a deputation from the WCSC and the RFAC in mid-October 1972;[41] six weeks later the entire figure was cast in plaster. Roberts-Jones then carefully divided the figure into eleven sections which were cast separately by the Meridian Foundry in Peckham.[42] The sculptor then painstakingly reassembled the sections to create the full-sized bronze figure.[43]

The statue was cast and reassembled to Roberts-Jones exacting standards on schedule, and installed upon its plinth in Parliament Square about a month before the work was unveiled, on 1 November 1973, by Lady Clementine Churchill, in the presence of the Queen.[44]

The chairman of the WCSC, Sir John Tilney told *The Times* that he was delighted with Roberts-Jones's efforts:

> not every facet of such an historic character can be captured in bronze. [Churchill] lived so many lives anyone of which any of us would have been proud to have lived. But his grit and greatness are here for all to see ... this heroic statue of the man who walked with destiny has arrived in its proper home in the heart of London, in the precincts of Westminster, where it will become an emblem and a spectacle for generations not yet born....[45]

Sculptor Sir Charles Wheeler was fulsome in his praise for the work in *The Times*, describing it as 'a fine statue of a great man. At the time of its inception I thought his task impossible of solution and said so. I must now eat my words. As a character study the sculpture is admirable, its monumentality is very impressive and it is altogether worthy of the historic plot it will occupy for many generations yet to come. Sir John Tilney, through his persistence, and the sculptor by his skill, has rendered a service to us and to posterity.'[46]

However, Roberts-Jones was criticised for having made Churchill resemble a 'hunchback' while the head of the figure appeared to have been subjected to a 'facelift'.[47] Later, in 1987, the figure would be described as looking decidedly 'wobbly on his legs' and 'wearing what might be a badly creased mackintosh ...' Churchill looked 'dyspeptic rather than defiant'.[48]

Interviewed over twenty years later about the commission, Roberts-Jones acknowledged his conception had never been welcomed by the Churchill family, particularly Lady Clementine, whom he suspected would have liked to do to the statue 'what she did to the Sutherland picture'. He mused that if Lady Churchill could have 'turned artillery on it' she would have. It had been in many ways his most challenging commission – how to make heroic a man who so often could resemble a 'petulant baby'. However, he had persevered. 'The best monuments mix dignity and caricature, to get a kind of irony ... They must have an edge and suggest an inner life.' He had, however, 'chanced on the work the other day and I suddenly thought: "that looks rather good".'[49]

The statue, often a focal point for demonstrations in Parliament Square, is widely considered one of London's best-loved and most photographed statues.[50] One admirer of the statue is the film-maker Danny Boyle, who gave it a cameo appearance in his film *Isles of Wonder* as part of the opening ceremony of the London Olympics in July 2012.[51]

The idea for another commission originated early in 1976 with anglophile James J. Coleman Jr, at the time the Honorary British Consul for Louisiana and managing director of the International River Centre in downtown New

Orleans. He imagined an inspiring figure of Churchill by Roberts-Jones, after the manner of his Churchill in Parliament Square, standing in a small park in front of a new 1,200-room, 30-storey-high Hilton Hotel that was soon to be built on the site.[52] Coleman approached the sculptor in the late spring of 1976 and they met in London in the summer of that year. Roberts-Jones quite quickly conceived a figure of Churchill wearing the wearing the distinctive cap and coat of an 'Elder Brother' of the Trinity House Corporation of Watermen, Lighthousemen and River Pilots.[53] He had been wearing these same clothes for his first meeting with President Franklin Roosevelt at Placentia Bay, Newfoundland on 8–11 August 1941.[54] This maritime-themed apparel also recalled the pseudonym Churchill had adopted when writing to Roosevelt shortly after becoming Prime Minister, in May 1940, describing himself coyly as a 'former naval person'.[55]

To give the figure a touch of added animation, Roberts-Jones suggested he present Churchill giving what was to become his trademark 'V for Victory' sign with the fingers of his left hand, which he had begun making in public from June–July 1941 onwards.[56] The sculptor had been struck by a series of photographs of Churchill returning from Placentia Bay wearing his 'Elder Brother' garb and giving the 'V for Victory' sign on arrival at the Royal Navy base at Scapa Flow to British sailors on passing ships. The gesture had come as a novelty to Churchill, who before 1941 seems to have been oblivious to its existence as a tradition sign of British working-class derision and defiance. Indeed, his secretary John Colville noted that on returning from Placentia Bay, the Prime Minister had still not learned to make the Victory sign the correct way, palm facing his audience rather than offensively with the back of the hand facing outwards. Churchill was extremely contrite to be told he just had to give the traditional V-sign to the entire company of a passing British battleship – including the Admiral of the Home Fleet based in Scapa Flow.[57]

Coleman was very taken with depicting Churchill as 'a tough old sea dog', but also requested the sculptor to slightly re-work his initial conception of

the head of the Prime Minister, to make him look 'unmistakably ... like a great leader of the Western World'.[58] Coleman and his statue committee (drawn from the partners of the International River Centre of New Orleans) approved Roberts-Jones's scale maquette for the figure which they inspected in the autumn of 1976. The full-sized figure (see Figure 8.4) was cast in the spring of 1977 and unveiled by Churchill's daughter, Lady Mary Soames, on 19 November 1977.[59]

Apparently, Lady Soames very much approved of the figure; the sculptor noted she seemed to be much more enthusiastic about it than that he had made of her father for Parliament Square four years previously.[60] A few months later the sculptor heard from Louisiana's honorary vice-consul that his statue still enjoyed 'wide acclaim. Everyone agrees it portrays Sir Winston as the sturdy, indomitable character he was and which gave us all such hope during those trying days ... those of us who lived through his inspirational leadership realise how badly the world today needs someone of his stature.'[61]

It is worthy of note that after the end of the Second World War the 'V for Victory' gesture rather dropped out of popular use, as did the offensive V-sign. However, it reappeared in the United States and Western Europe in the late 1960s, oddly enough among left-wing, counter-culture activists as an anti-establishment, anti-'powers that be', peace sign.[62] The association between Churchill and the gesture was widely recalled and then cemented in the mid-1990s, at the time of the fiftieth anniversaries in June 1994 and May 1995 of respectively D-Day and then of VE Day.[63] Nowadays the gesture is ubiquitous among film stars celebrating the launch of a new film and supermodels marking the launch of yet another stupendously expensive collection of designer clothes.[64]

* * *

Of the many statues of Churchill by Nemon, *Married Love* (Figure 8.5) is one of his most human and appealing conceptions – in large part because it acknowledges the vital importance to Churchill's well-being of his 50-year marriage to Clementine Hozier (September 1908–January 1965). One had to be a special kind of woman to survive such a long marriage to a man as

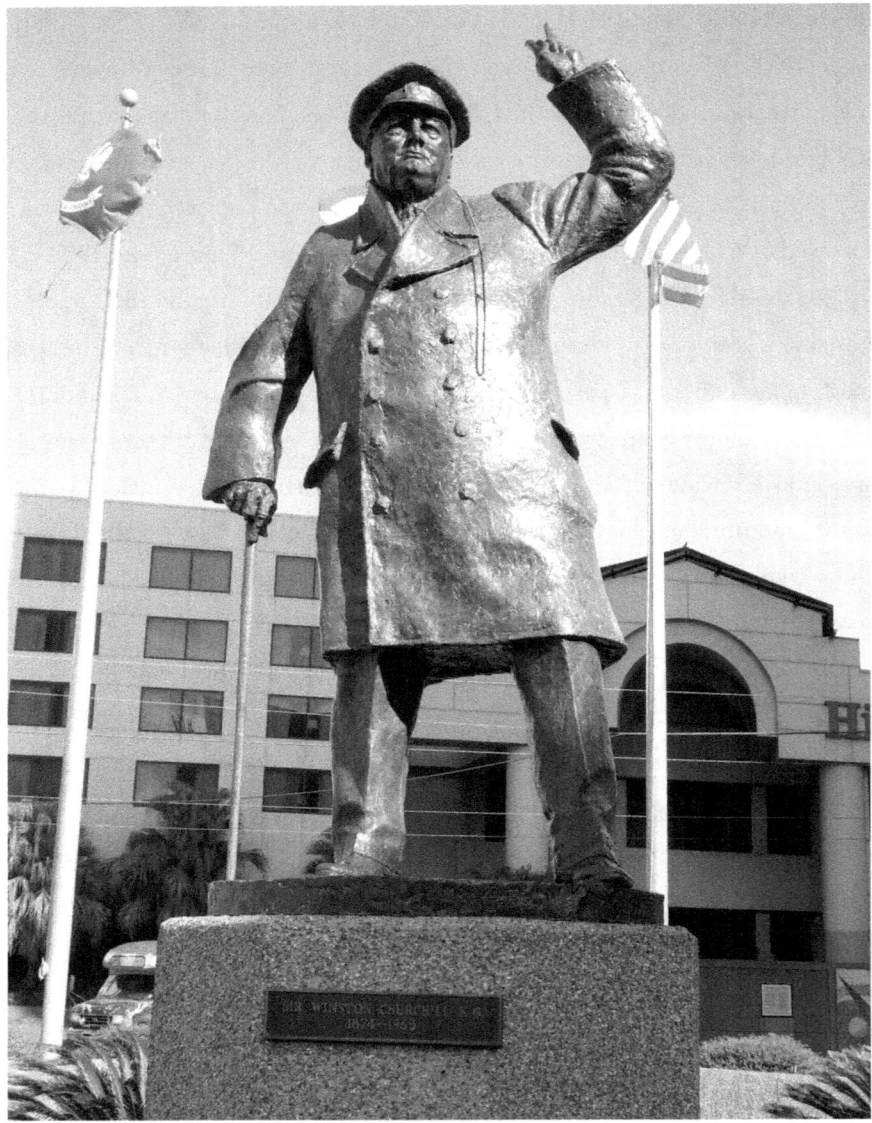

FIGURE 8.4 *Ivor Roberts-Jones,* Sir Winston Churchill KG, OM, CH, *1976–1977, 2.74 m high, bronze, British Place, New Orleans, USA.*

mercurial, moody and demanding as Churchill. 'Clemmie' was such a woman. It was remarked by many of their contemporaries, such as Asquith's formidable wife Margot, how much Churchill seemed to depend on his wife, and seemed to find even her brief absences from his side almost physically

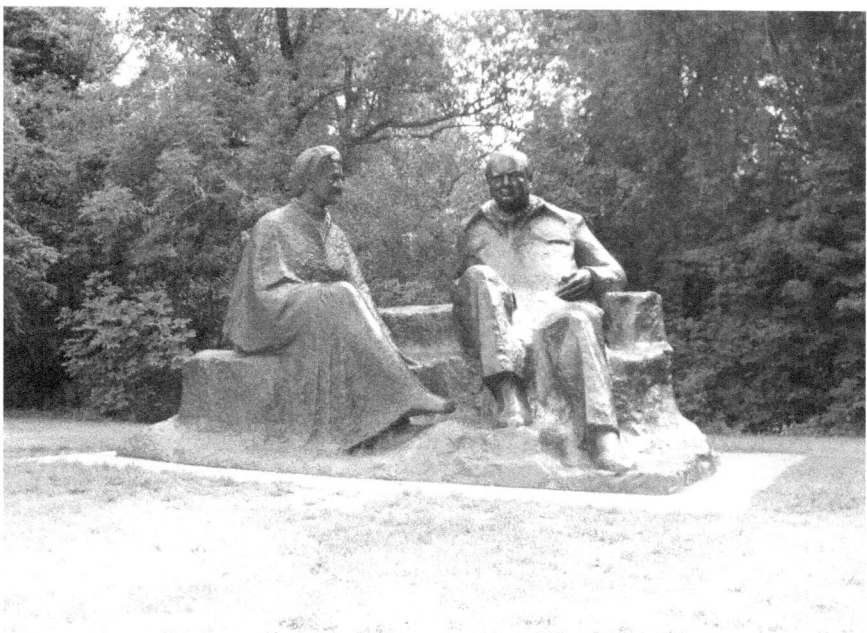

FIGURE 8.5 *Oscar Nemon*, Married Love: Winston and Clementine Churchill, *1976–1990, bronze, Garden of Chartwell Manor, Kent; unveiled in November 1990 by the Queen Mother.*

painful.[65] Churchill had flashes of self-awareness of how trying to his wife he could be, especially when out of office in the wake of the Gallipoli debacle. In January 1916, for example, he wrote to her while serving in France: 'It is splendid having you home to think about me and love me and share my inmost fancies. What should I find to hold on without you. . . .'[66] Churchill most cruelly felt her absence when she left Chartwell in December 1934 for a four-month long cruise of the South Pacific on the yacht of their mutual friend Walter Moyne, Lord Guinness. The following month Churchill wrote to her that he was struggling hard not to give into 'melancholy' without her healing presence: 'It makes me gasp to look at the map and see what enormous distances you have covered since I saw the last of your dear waving hand at Victoria Station and it depresses me to feel the weight of all that space pressing down upon us both. How glad I shall be when you turn homewards.'[67]

Later Churchill's secretary, John 'Jock' Colville, estimated that during the critical years of the Second World War, 'Lady Churchill ... was, perhaps, the only human being who, on matters which were not political, could influence his decisions in a sense contrary to his own judgement and volition. She was indeed the only person who was never, in any circumstances, even the slightest bit over-awed or afraid ... of him.'[68]

Nemon initially had the idea for a sculpture featuring a seated Churchill alongside Lady Clementine in 1975. Nemon had wanted Lady Churchill to sit for a portrait for him but she had been very resistant. However, her objections weakened when the sculptor initially suggested making a small sculpture of her seated alongside her husband as Nemon had presented him in his memorial for Westerham. This had been unveiled in 1969 and was one of Lady Churchill's absolute favourite statues of her husband, looking authoritative, in command, but 'benignant' – one of Churchill's favourite adjectives to describe himself.[69]

The small statuette had been completed and cast by March 1978 (three months after Lady Churchill had passed away). The *Daily Telegraph* announced that month: 'Oscar Nemon has just completed [a] double sculpture of Sir Winston and Lady Churchill ... The figure of Churchill is similar to the one he produced for Westerham Green, near Chartwell ... It prompted Lady Churchill to tell Mr. Nemon: "That is how I see him and that is how I love him."' Her own likeness, however, was caught by Nemon only after much resistance on her part. She did not like sitting for portraits. However, shortly before her death, 'she allowed the sculptor to model her in her flat in Princes Gate. Obeying what he knew to be Churchill's preference, he strove to capture her smile, rather than the "Scottish Eagle" as Churchill called her face in repose.'[70] The sculptor now hoped that a much-enlarged version of the maquette could be commissioned for 'Hyde Park, surrounded by trees, ducks and children ... or in Connaught Place where Lady Clementine often took the air in old age.'[71]

This larger statue would not find a site in central London but, in 1983, Nemon was asked by the English-Speaking Union of the United States to

produce a life-sized cast of the composition. This was unveiled in Kansas City, USA, on 12 May 1984 and was the sculptor's last conception of Churchill he saw realised and unveiled before his death in April 1985. A second, posthumous, cast of the statue was unveiled in the grounds of Chartwell Manor by the Queen Mother in November 1990.[72]

Noël Coward, often a welcome visitor to Chartwell during the Second World War and during Churchill's second term as Prime Minister,[73] once remarked on the potency of cheap music. Lawrence Holofcener's sculpture, *Allies* (Figure 8.6), unveiled on New Bond Street in May 1995, perhaps demonstrates the sheer power of vapidly meretricious figurative sculpture if competently executed. Roosevelt's likeness is not too hapless. However, the figure supposedly of Churchill is more reminiscent of the late, great Yorkshire character actor and ex-wrestler Brian Glover (1934–1997) unsuccessfully attempting to impersonate the late Soviet Premier Nikita Khrushchev.

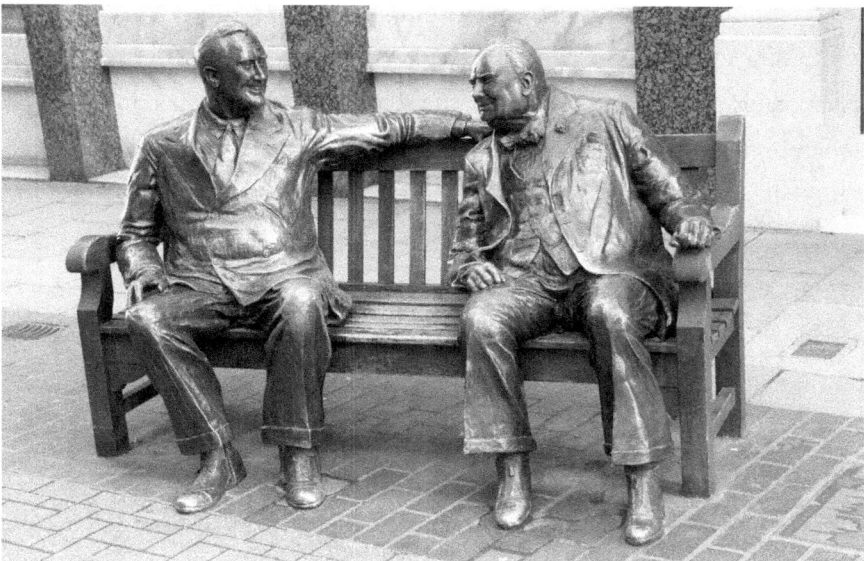

FIGURE 8.6 *Lawrence Holofcener (1926–),* Allies *(Double Portrait of President Franklin Delano Roosevelt and Winston Churchill), 1995, bronze, 137 × 183 cm, corner of New Bond Street and Grafton Street, London.*

The sculpture was commissioned in 1994 by the Bond Street Association to commemorate the fiftieth anniversary of Victory in Europe Day on 8 May 1995[74] – although, of course, by 8 May 1945, Roosevelt was dead and had been succeeded as President by Harry S. Truman. However, the composition was apparently inspired by the sculptor noticing a photograph of Roosevelt and Churchill sitting side-by-side on a bench in the early days of the Yalta Conference (3–11 February 1945).[75]

Along with Roberts-Jones's statue in Parliament Square, this is by far the most photographed Churchill in the UK (over 2,500 times a month according to the Borough of Westminster).[76] Indeed, the composition invited visitors to be photographed occupying the space on the bench between the President and Prime Minister. I have observed it is quite possible for people to sit on their laps, be photographed and photograph themselves with their heads next to one of the statesmen.[77]

* * *

In the summer of 1995, Roberts-Jones, by now 81 years old, was approached by the cultural attaché at the Czech Embassy in London with a proposal to devise a new statue of Churchill to stand in the recently renamed 'Winston Churchill Square' in Prague's Third District. The sculptor jumped at this opportunity to make 'one last grand Churchill' as he had never been fully satisfied with the head of the Prime Minister he had created for the figure in Parliament Square. By the early autumn of 1996 he had made a monumental head and shoulders of Churchill in clay, photographs of which were much admired by the memorial committee in Prague. The sculptor at the time implied he had been aiming for a portrait of a Winston who was a little older than the one he had made for Parliament Square and one more scarred by experience, surviving a heart attack in December 1941, almost dying from pneumonia in February 1943 and narrowly avoiding sniper fire in Athens in December 1944, but who had endured to acknowledge the cheers of the crowds and make the radio broadcast announcing the end of war in Europe. The sculptor had done his research and was aware of how deflated and depressed Churchill had been after VE Day:

FIGURE 8.7 *Ivor Roberts-Jones,* Head of Sir Winston Churchill KG, OM, CH, *1995–1996, bronze, 53 × 84.5 cm, Zizkov Town Hall, Prague Third District, Czech Republic.*

Communist forces dominated central and eastern Europe (including Prague) and the war against Japan had still to be won at a time when British military and financial resources where stretched to their absolute limit. He had tried very hard to suggest these conflicting emotions in the massive clay head, which was sent away to be cast in plaster only about a fortnight before Roberts-Jones died in his studio from a massive heart attack.

With the sculptor now dead, the Prague committee was to give permission to have a cast of the Parliament Square Churchill. This was supervised by Nigel Boonham, the then President of the Society of Portrait Sculptors, and the statue was unveiled in Sir Winston Churchill Square by Lady Thatcher in November 1999. Six months later, on 9 May 2000 (the fifty-fifth anniversary of the liberation of Prague by the Soviet Red Army), a bronze cast of the monumental head was unveiled inside the Town Hall of Prague's Third District (see Figure 8.7).[78]

Epilogue
Churchill for the Twenty-first Century

Just over a week before Roberts-Jones's last portrait of Churchill was unveiled with great ceremony and appreciation in Prague, Parliament Square was the scene of a huge left-wing 'anti-capitalist' demonstration. One group of 'guerrilla gardeners', also known as 'avant-gardeners' placed a strip of green turf on top on the head of Roberts-Jones's statue of Churchill, giving him the look of a rather long-in-the-tooth punk rocker (see Figure E.1).[1] Shortly afterwards a 25-year-old former soldier, one James Matthews, clambered onto the statue and dabbed red paint on the corners of Churchill's mouth as if he was drooling blood. Matthews was later quoted as declaring he felt justified in painting the head of the statue because Churchill was 'an irrational, sometimes vainglorious leader whose impetuosity, egotism and bigotry on occasion cost many lives, unnecessarily and caused much suffering that was needless and unjustified'.[2] It is uncanny how the image of Churchill with the turf Mohican is reminiscent of Strube's 1920 image of Churchill, the then War Secretary, as a Native American chief on the war path.

The vandalising of the Roberts-Jones statue was one of those watershed moments when one generation, those who could recall the war and Churchill's two terms as Prime Minister, looked at a younger one (whose experience, growing up, of contemporary history had been watching the Falklands War

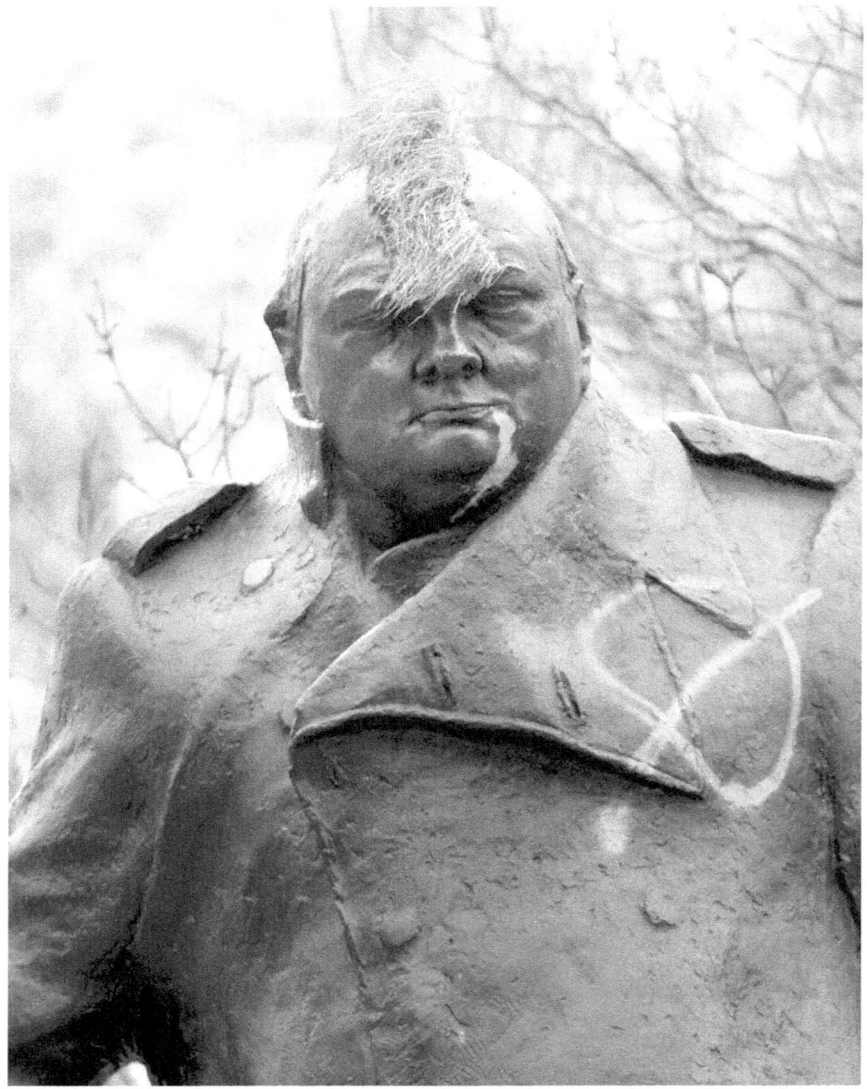

FIGURE E.1 *Churchill in Parliament Square with a turf Mohican, May 2000.*

and the battles of the miners' strike on television) with total incomprehension and a definite degree of dread for the future.[3] The reaction of cartoonist Nicholas Garland (Figure E.2)[4] was representative of many who believed the protestors' image of Churchill as a war criminal or warmonger was a travesty

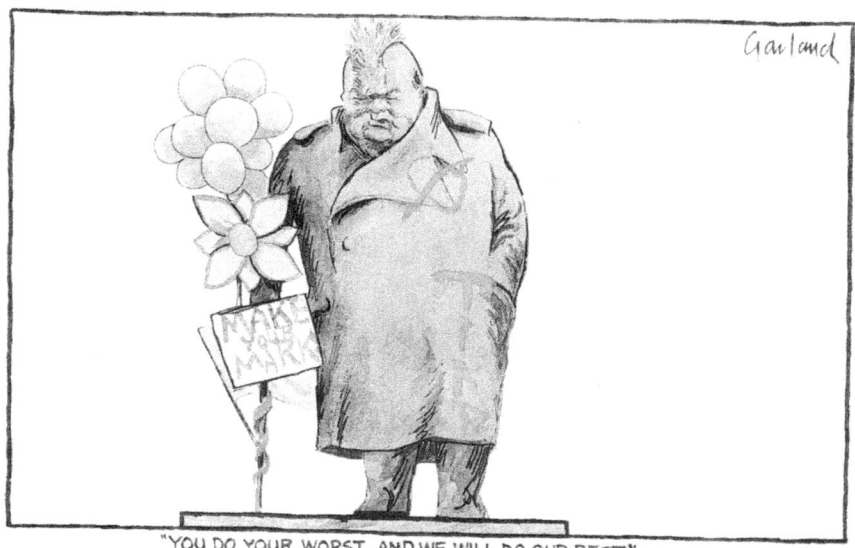

FIGURE E.2 Nicholas Garland (1935–), 'You do your worst and we will do our best', Daily Telegraph, 3 May 2000, Cartoon Archive, Kent University.

and that he embodied an old-fashioned civility and courage sadly lacking in contemporary British society.

The image of Roberts-Jones's Churchill sporting a vivid green Mohican caught the eye of 'guerrilla grafitti' artist Banksy, and in 2003 he produced the screenprint *Turf War* (Plate 12) – though the image of Churchill he 'adopted' was derived from the set of photographs Karsh took of the Prime Minister in Ottawa in December 1941.[5] In a similar way to Warhol's multi-coloured treatment of Chairman Mao in the same medium (1972–1977), Banksy's take on Churchill is ultimately less subversive and derisive and more affirmational and even affectionate. He may have been, according to the artist, an 'old codger who was ... drunk most of the time in the war', but Banksy had to admit 'Winston' had been shot at in his early seventies and had fought for his country on the Western Front when he was a bit too old to be there, which was more that could be said for the UK politicians in power in 2003.[6] He almost seemed to regard Churchill as a form of loveable rogue – all the more laudable for his

utter failure to meet contemporary codes of political correctness. However, he was banking on the image still retaining a degree of useful, publicity worthy shock value, as he titled the July 2003 exhibition in Hackney, in which the image first appeared, 'Turf War'. This exhibition duly proved to be his breakthrough show to a wider gallery-going audience.[7]

The image of the May 2000 'punk Churchill' and Bansky's 2003 'homage' to the same moment also resonated with Marcus Harvey. In 2008 he first made a small head of Churchill in silver sporting a much larger Mohican (see Figure E.3) than that placed by the protesters in May 2000. This was first exhibited at Pangolin King's Place in November 2008, Harvey stating in a contemporary newspaper interview that 'the vandalised statue ... has become as iconic as the original ... it has become a new icon, not a cartoon. I grew up as part of the punk generation and rather than serving to satirise Churchill, the Mohican gives ownership and underlines his own reputation as someone who stood aside [from] and sometimes up to the establishment.'[8] The artist has since indicated that his 're-imaging of a Punk Churchill' was as informed by memories of Simon Ward playing Churchill in Richard Attenborough's film *Young Winston* (released in the UK in July 1972 and rarely off the nation's television screens thereafter)[9] and of Churchill's participation in the dramatic cavalry charge on the Dervish at Battle of Omdurman on 2 September 1898 – cleverly edited in the film so that one minute the British lancers appear invincible and irresistible and the next they are suddenly, shockingly vulnerable, vastly outnumbered and surrounded by a ferocious enemy who do not run but hack and stab their attackers with gusto. The film was based on Churchill's 1930 autobiography *My Early Life*, which the artist re-read before producing his *Punk Churchill*. Harvey was very struck by Churchill's matter-of-fact and far from self-aggrandising description of his participation in the charge at Omdurman:

> On account of my shoulder [damaged while playing polo] I had always decided that if I were involved in hand-to-fighting I must use a pistol and

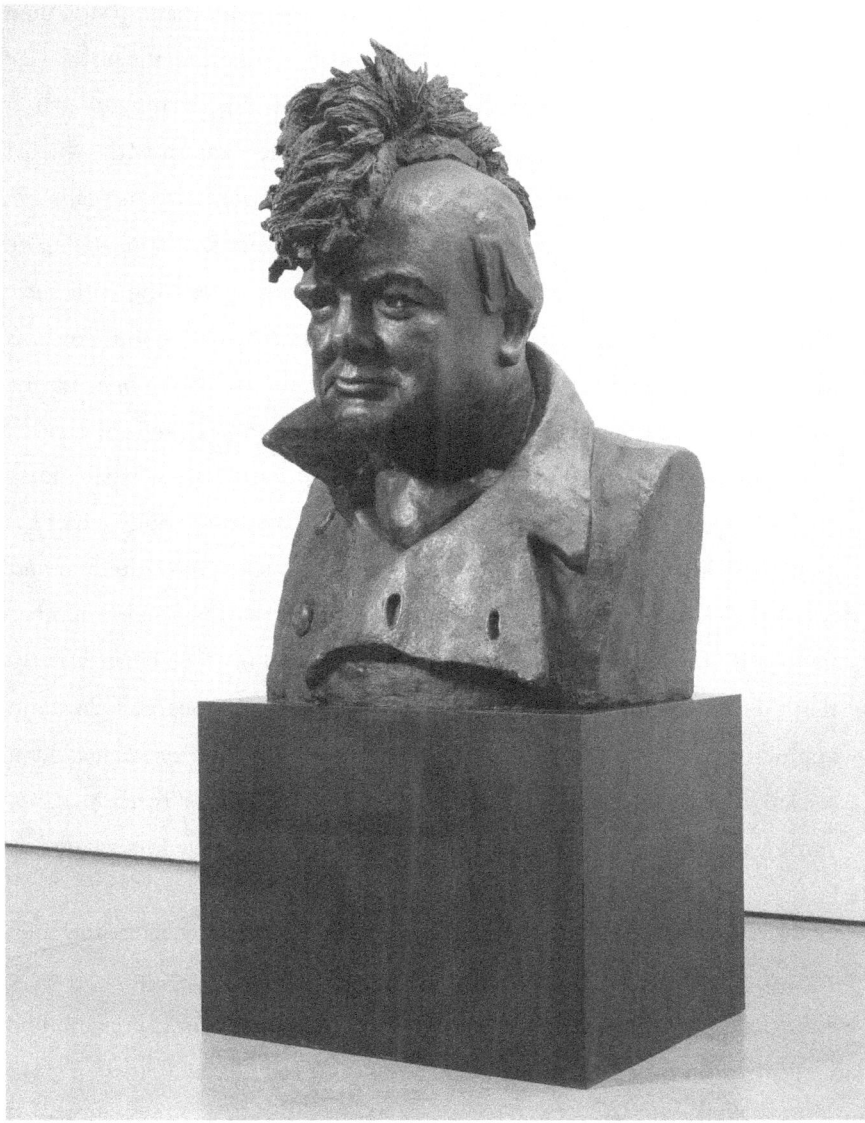

FIGURE E.3 *Marcus Harvey (1963–), Punk Churchill, 2008*, bronze, 2.5 × 1.3 × 1.5 m, Burger Collection, Hong Kong.

not as sword. I had purchased in London a Mauser automatic pistol, then the newest and latest design [a 7.53 1896 pattern semi-automatic pistol with a ten-round clip] ... I had practiced carefully with this during our march and journey up the river [Nile]. This then was the weapon with which I determined to fight. I had first of all to return my sword into its scabbard, which is not the easiest thing to do at a gallop. The Dervishes appeared to be ten or twelve deep at the thickest, a great grey mass gleaming with steel, filling the dry watercourse ... The trooper immediately behind me was killed ... I checked my pony as the ground began to fall away beneath my feet ... I found myself surrounded by what seemed to be dozens of men ... I saw the gleam of [a] curved sword as he [a Dervish] drew it back for a ham-stringing cut. I had room and time enough to turn my pony out of his reach and, leaning over on the offside, I fired two shots into him at about three yards. As I straightened myself in the saddle, I saw before me another figure with an uplifted sword. I raised my pistol and fired. So close were we that the pistol actually struck him. Man and sword disappeared below and behind me ... Then for the first time that morning I experienced a sudden sensation of fear. I felt myself absolutely alone ... Two or three hundred yards away I found my troop already faced about and partly formed up ...

Churchill wondered whether the lancers would be charging again and then noticed that he had lost 'three or four men from my troop. Six men ... were bleeding from spear-thrusts, or sword cuts ... I asked my second Sergeant if he had enjoyed himself. His answer was: "Well, I don't exactly say I enjoyed it Sir, but I think I'll get more used to it next time." At this the whole troop laughed.'[10]

Reading *My Early Life* made it clear to the artist that Churchill as the young man who had fought tribesmen from the North-west Frontier, Sudanese Dervish and Boer commandos would have made short work of the later punks of the King's Road, with their multi-hued Mohicans, festooned in safety pins for the tourists and representative of a pantomime, make-believe capacity for

imminent violence. Even in the early days of the phenomenon (1975–1976) punks often had to be protected by the police from being beaten up by skinheads, retro Teddy Boys and just ordinary members of the public outraged by their outlandish appearance and what that was taken as representing – hostility to the established mores of society.[11]

Harvey was aware that there was a gentler, much more sensitive side to Churchill's character; he had, after all, been awarded the Nobel Prize for Literature, a facet which was memorably caught and synthesised by cartoonist Ralph Steadman.

Steadman's feline Churchill (Figure E.4) is lovable, sorrowful and rather vulnerable – inviting a protective impulse, if anything. The artist was aware that for much of his life his subject had been stalked by a 'black dog' of depression.[12] In his later years Churchill had more usually depicted as a bulldog – especially after the popularity of Strube's June 1940 cartoon depicting him as one wearing a steel helmet standing guard over southern England – but on occasion as a tubby, hungry tom cat, for example in Low's 1928 *Tasty Morsels* in which he appears not as a well-fed, pampered house cat but a hungry opportunist of the streets, complete with the neckerchief of the Edwardian costermonger tough, about to take a swipe at the complaisant family goldfish (see Figure E.5). Low captures the Churchill who invites approval and yet was quite capable of a predatory feline move. In private he had referred to his wife Clementine from very early on in their marriage as his 'cat/kat'.[13] His cousin Clare Sheridan later recalled how during one dinner party before the First World War the 'shamelessly uxorious Winston' had said: 'She [Clemmie] is my golden puss cat and I like barking at her and seeing her climb up a tree and spit.' Sheridan's pet name for Churchill, by contrast, was 'black puss . . . a large and formidable beast . . . generally friendly but capable of lashing out with clawed paw'.[14]

Churchill, indeed, had numerous cats and dogs as pets throughout his life. During the London Blitz, when the bombing was at its worst Churchill's

secretary, John Colville, noted how the Prime Minister at dinner in Number 10 would reprove his black cat Nelson for being afraid of the sound of anti-aircraft gun fire and the detonations of nearby explosions, asking the cat to 'try and remember what those boys in the RAF are doing.'[15]

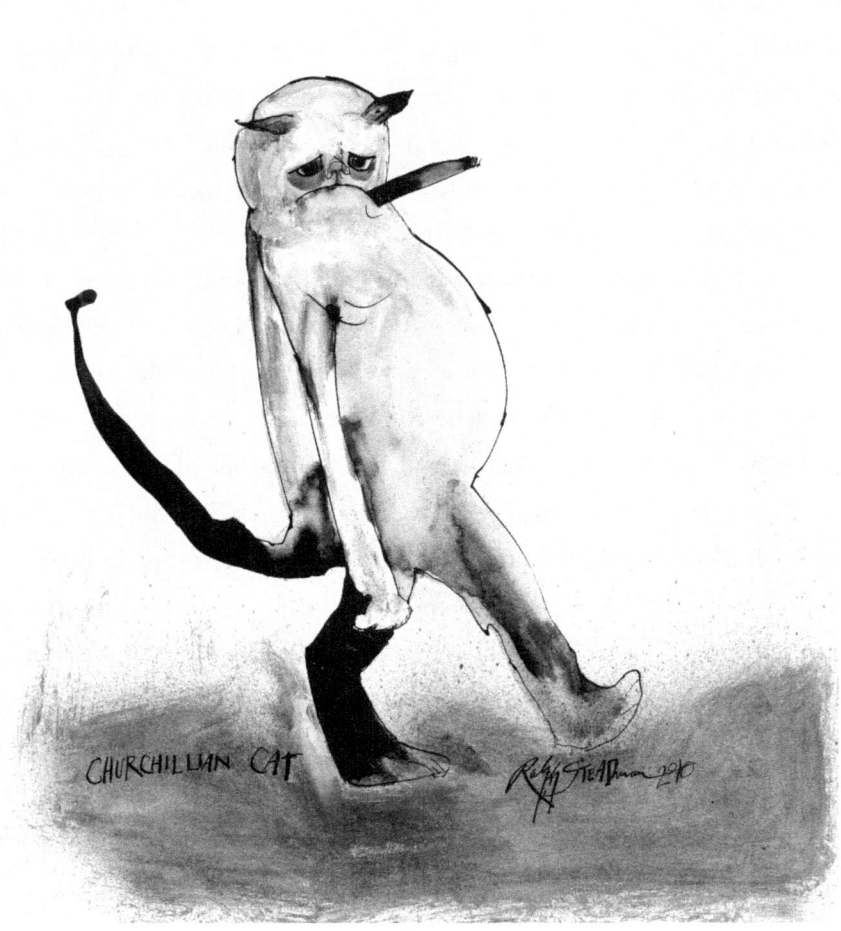

FIGURE E.4 *Ralph Steadman (1936–)*, Churchillian Cat, *2010, pen-and-ink and watercolour on paper, Private Collection.*

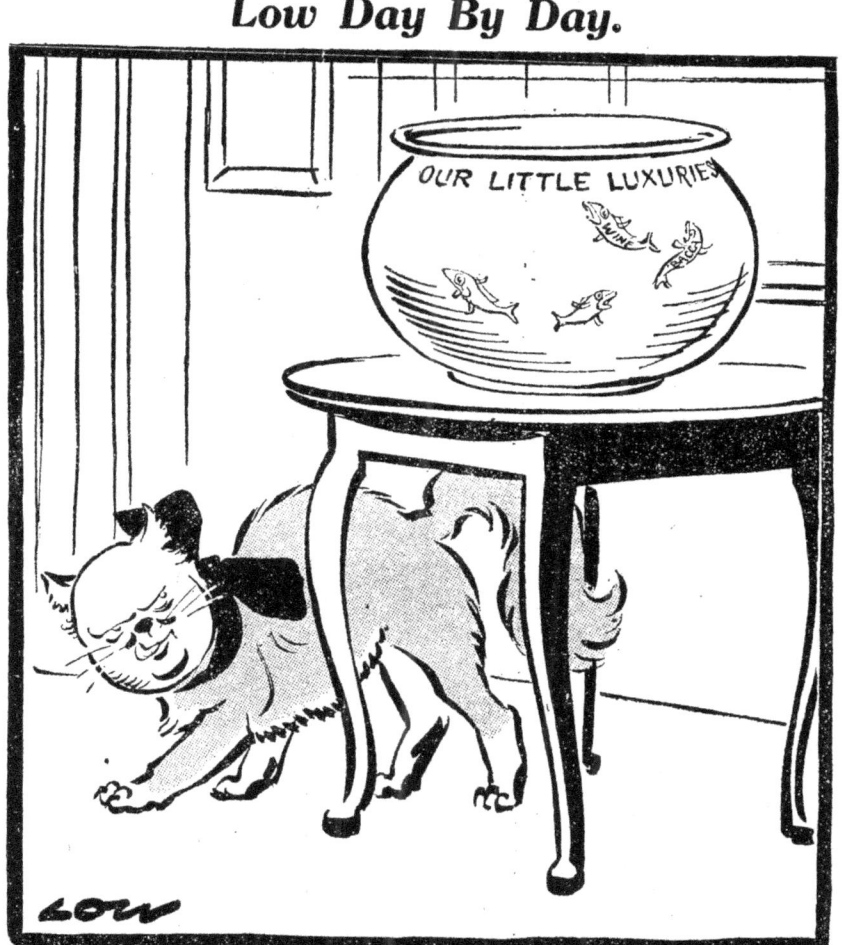

FIGURE E.5 David Low, 'Tasty Morsels', The Star, 22 March 1927, Cartoon Archive, Kent University.

One of the more recent images of Churchill I have found especially appealing was the work from a much younger artist than Steadman, with the perspective of a very different generation – a screen print by Sarah Haines also from 2010 (Figure E.6), inspired by a photograph of Churchill trying on a fez

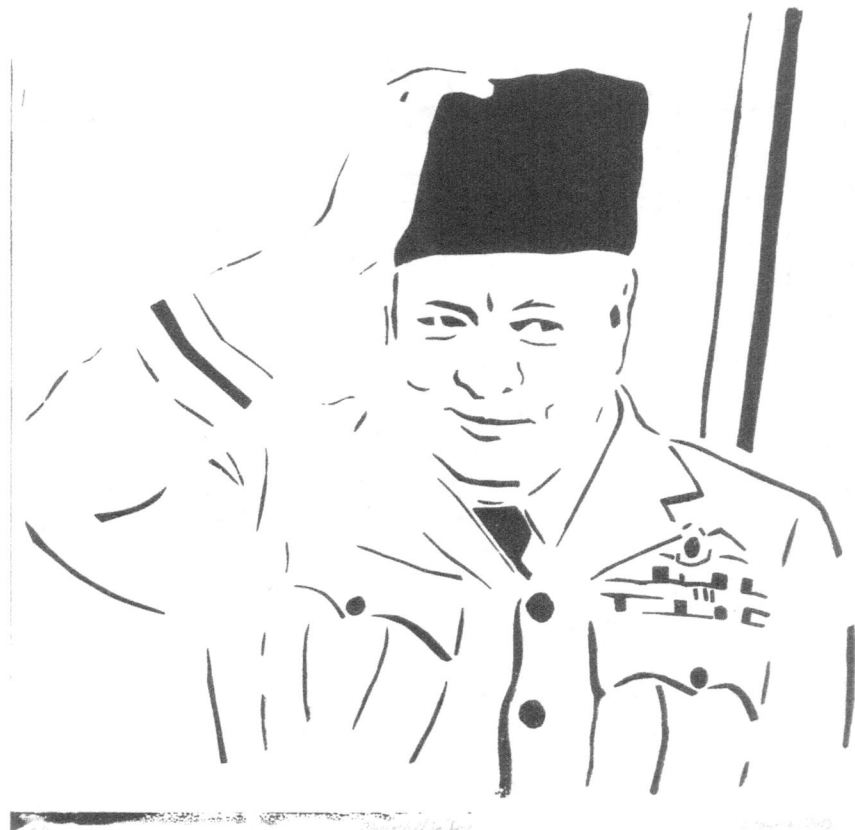

FIGURE E.6 *Sarah Haines (1979-)*, **Winston Churchill Trying On a Fez**, *2010, screen print, 29.7 × 29.7 cm, Private Collection.*

in Cairo during the Allied conference held in the city late in November 1943.[16] One can just make out he is also wearing one of his many uniforms – that of an Air Commodore in the RAF – which he would often be seen wearing at the Tehran Conference in December 1943 and at Yalta in February 1945. I find it a fitting and satisfying image on which to conclude in many respects, derived from a photograph taken when Churchill was at the absolute pinnacle of success in the Second World War and yet in private he was uneasily becoming aware that his power and that of the British Empire, which he so zealously cherished, could now only diminish. Indeed, just a few days later, during the

Teheran Conference, he had the terrible, heart-wrenching realisation that while it was billed as a gathering of the Big Three, in terms of military might and economic strength, he represented a Britain that was very much the half in the 'Big Two and Half'.[17]

The print also captures the charm of Churchill's boyish smile, often remarked upon by contemporaries throughout his career. In Cairo in November 1943 he had advised his daughter Sarah: 'War is a game played with a smiling face; but do you think there is laughter in my heart? ... I never forget the man at the front, the bitter struggles and the fact that men are dying in the air, on the land and at sea.'[18]

The image has also been executed with impressive technical subtlety – Churchill is present but equally gives an impression of fading away and one can readily imagine that soon all that will remain is a trace of that famously cheeky grin. For someone whose feline qualities Steadman caught so incisively, it seems only fitting that Churchill, stubbornly unknowable and ungraspable in an all-too easy recognisability in which he was partially complicit, should take his leave of us with the enigmatic, sometimes rather worrying, impish smile worthy of a Cheshire cat. I suspect we will only get as close to fully comprehending the totality of Churchill the man as we will from decoding the meaning of that most infuriatingly elusive of fictional felines. In September 1944, his long-suffering wartime Chief of the Imperial General Staff, General Sir Alan Brooke, thought of Churchill with mingled exasperation, wry affection and admiration. The General could not quite bring himself to see Churchill as a titan – that, he suspected, would have been far too close to the Prime Minister's own image of himself – but rather as a 'superhuman being' with 'feet of clay'. And yet: 'Without him England was lost for a certainty ... with him England has been on the verge of disaster time and again ... Never have I admired and despised a man simultaneously to the same extent. Never have such opposite extremes been combined in the same human being.'[19]

NOTES

Introduction: The Titan Emerges

1. Mary Soames, *Winston Churchill: His Life as a Painter* (London: Collins, 1990).
2. Fred Urquhart, *W.S.C: A Cartoon Biography* (London: 1955) which only covers images of Churchill from c. 1900–1954 and Timothy S. Benson, ed., *Churchill in Caricature* (London: The Political Cartoon Society, 2005) – which, as its title indicates, focuses on Churchill in cartoons and caricature but not on his image in other art forms.
3. Charles Eade, ed., *Churchill by His Contemporaries* (London: The Reprint Society, 1955 [first published in 1953]), pp. 76–77.
4. Andrew Roberts, *Hitler and Churchill: Secrets of Leadership* (London: Phoenix, 2004), p. 8.
5. Eade, *Churchill by His Contemporaries*, pp. 269–270.
6. Ibid. p. 270.
7. Ibid. p. 271.
8. Winston Churchill, 'Cartoons and Cartoonists', *The Strand Magazine*, June 1931. Reproduced in Winston Churchill, *Thoughts and Adventures* (Wilmington, Delaware: ISI Books, 2009), p. 30.
9. Churchill, *Thoughts and Adventures*, pp. 29–30.
10. Ibid. p. 22.
11. Evelyn Waugh, *Men at Arms* (London: Everyman's Library, 1994), pp. 166–167. Typically, though on one level Waugh is dismissive of Churchill through his character Crouchback, another character, Major Erskine, a professional soldier whose opinion Guy respects immensely, immediately interjects in the conversation: 'Churchill is about the only man who may save us from losing the war ... It was the first time that Guy had heard a Halbardier suggest that any result, other than complete victory, was possible'.
12. Eade, ed., *Churchill by His Contemporaries*, p. 273.
13. Churchill had first met Aitken around 1910 in London but they became friends in late December 1915 in France. Roy Jenkins, *Churchill* (London: Pan Books, 2002), p. 296.
14. Churchill became particularly friendly with Rothermere around 1917–1918 during his term as Minister for Munitions, though there is evidence for him being in touch with

the Press Baron after he resigned from the government in November 1915; see Winston Churchill to Clementine Churchill, 19 January 1916 in Mary Soames, *Speaking for Themselves: The Personal Letters of Winston and Clementine Churchill* (London: Black Swan, 1999), p. 156.

15 Churchill, *Thoughts and Adventures*, p. 24. In his June 1931 article 'Cartoons and Cartoonists', Churchill referred to Low as: 'the greatest of our modern cartoonists'.

16 Roger Berthoud, *Graham Sutherland: A Biography* (London: Faber & Faber, 1982), p. 225.

17 'Entry for 3 December 1918' in John Julius Norwich, ed., *The Duff Cooper Diaries* (London: Phoenix, 2006), p. 87. During the conversation that evening Beaverbrook admitted to the existence of a 'press gang', determined to promote Churchill, which included himself, Lord Rothermere and Edward Hulton – owner of the *Daily Sketch*; ibid. p. 88.

18 Mary Soames, *Winston Churchill: His Life as a Painter* (London: Collins, 1990), p. 95.

19 Ibid. pp. 101–102.

20 Ibid. p. 168.

21 Jenkins, *Churchill*, p. 316.

22 Ibid. p. 808.

23 Churchill's admiration for the 'Welsh Wizard' has been explored in revealing and engrossing detail in Richard Toye, *Lloyd George & Churchill: Rivals for Greatness* (London: Pan, 2008).

24 Jenkins, *Churchill*, p. 317.

25 Anita Leslie, *Clare Sheridan* (New York: Doubleday, 1977), p. 219.

26 Jenkins, *Churchill*, p. 438.

27 Winston Churchill, *Great Contemporaries* (London: Macmillan, 1943 [first published 1937]), p. 115.

28 Ibid. Now in the National Portrait Gallery, London; John did try to draw Churchill but it was late in his career, by which time alcohol and depression had undermined his considerable artistic gifts. The result in a private collection is far from being one of his most persuasive and accomplished likenesses.

29 Jonathan Black, *The Sculpture of Eric Kennington* (Aldershot: Lund Humphries, 2002), pp. 64–65.

30 In the early years of the First World War, 1914–1915, Hindenburg's image had first been carefully crafted by the press section of Ober Ost – the German High Command on the Eastern Front. This was then supplemented by the efforts of the press office of the Prussian War Ministry and also by Press and Publicity Section IIIB of the German

Supreme Command on his appointment as Chief of the German General Staff late in August 1916. Anna von der Goltz, *Hindenburg: Power, Myth and the Rise of the Nazis* (Oxford: Oxford University Press, 2011), pp. 20–22 and pp. 38–41.

31 Roberts, *Hitler and Churchill*, p. 47

32 Churchill, *Great Contemporaries*, p. 85.

33 Anna von der Goltz, *Hindenburg*, pp. 27–32.

34 Churchill, *Great Contemporaries*, p. 94.

35 Von der Goltz, *Hindenburg*, pp. 156–159

36 Eric Kennington letter to Clare Sheridan, c. March 1954, copy, Estate of the Artist.

37 Leslie, *Clare Sheridan*, p. 297.

Chapter 1: Young Winston: At War and in Politics, 1898–1914

1 Charles Eade, ed., *Churchill by His Contemporaries* (London: The Reprint Society, 1955 [first published in 1953]), p. 11.

2 Roy Jenkins, *Churchill* (London: Pan Books, 2002) p. 9.

3 'Entry for 30 November 1954' in Lord Moran, *Winston Churchill: The Struggle for Survival, 1940–1965* (London: Sphere Books, 1968), p. 653.

4 Jenkins, *Churchill*, pp. 14–15.

5 Ibid. p. 19.

6 Ibid. p. 32

7 Ibid. p. 41.

8 Ibid. p. 46.

9 Ibid. p. 52.

10 Ibid. p. 53.

11 Ibid. p. 62.

12 Ibid.

13 Ibid. p. 58.

14 Ibid.

15 Jenkins, *Churchill*, p. 87.

16 Earl Winterton in Eade, ed., *Churchill by His Contemporaries*, p. 50.

17 Partridge began work at *Punch* in 1899; he was appointed its chief cartoonist in 1910 and knighted in 1925. *The Times*, 11 August 1945, p. 6.

18 Jenkins, *Churchill*, p. 104.

19 Ibid, p. 121.

20 Winterton in Eade, ed., *Churchill by His Contemporaries*, pp. 52–53.

21 Jenkins, *Churchill*, p. 181.

22 Ibid, p. 185.

23 Ibid, pp. 198–199.

24 Jonathan Black and Sara Ayres, *Abstraction and Reality: The Sculpture of Ivor Roberts-Jones* (London: Philip Wilson Publishers, 2014) pp. 63–64.

25 Jenkins, *Churchill*, pp. 194–195.

26 Churchill, 'The Battle of Sidney Street', first published in *Nash's Magazine*, March 1924, reprinted in J.W. Muller, ed., *Churchill as Peacemaker* (Cambridge: Cambridge University Press 1997), p. 68.

27 Jenkins, *Churchill*, pp. 203–204.

28 Jenkins, *Churchill*, p. 139.

29 Ibid. p. 137.

30 Eade, ed., *Churchill by His Contemporaries*, p. 9.

31 Andrew Roberts, *Hitler and Churchill: Secrets of Leadership* (London: Phoenix, 2004), p. 61.

32 Ibid. p. 230.

33 Ibid. p. 137

34 Churchill, *Great Contemporaries*, p. 111.

35 Richard Toye, *Lloyd George and Churchill: Rivals for Greatness* (London: Pan, 2008), p. 169.

36 Jenkins, *Churchill*, pp. 251–253.

37 Strube was born in Bishopsgate the son of a German-born wine merchant who owned a pub on the Charing Cross Road; a protégé of John Hassell between 1910 and 1911, he started working for the *Daily Express* from September 1912. He volunteered for the Army in 1915, served in France as a bayonet instructor in 1916–1917 and saw front-line action in 1918. Early in the 1920s he created the character of 'the little man' and by 1931 was the highest-paid cartoonist in the UK. He was sacked by the *Express* in 1948 and worked as a freelance for the last eight years of his life. Obituaries in *The Times*, 5 March 1956, p. 13; *Hampstead and Highgate Express*, 9 March 1956, p. 5.

38 Jenkins, *Churchill*, p. 238.

39 Winston Churchill to Clementine Churchill, 28 July 1914 quoted in Mary Soames, ed., *Speaking for Themselves: The Personal Letters of Winston and Clementine Churchill* (London: Black Swan, 1999), p. 96.

40 Jenkins, *Churchill*, p. 230.

Chapter 2: Disaster and Rehabilitation in the First World War, 1914–1918

1 Roy Jenkins, *Churchill* (London: Pan Books, 2002), p. 76.

2 Ibid. p. 89.

3 Ibid. pp. 206–207.

4 Entry for 10 June 1915, Minutes of the Art and Library Committee of the National Liberal Club, London (NLC).

5 Entry for 21 July 1915, Minutes of the Art and Library Committee of the NLC.

6 Jenkins p. 269.

7 E-mail from Dr Seth Thévoz (Hon. Librarian, National Liberal Club, London) to Dr Jonathan Black, 3 July 2015.

8 Entry for 29 January 1918, Minutes of the Art and Library Committee, NLC.

9 I am indebted to Dr Seth Thévoz, Hon. Librarian of the NLC for this suggestion on 13 July 2015.

10 De Forest had been born in Paris the son of American circus performers who died in Istanbul from typhoid when he was only three years old. In 1887 he and his younger brother were adopted by Baroness Clara de Hirsch nee Bischoffsheim – wife of millionaire Franco-Jewish banker Maurice de Hirsch. There is one story that Maurice and his brother were, in fact, Baron de Hirsch's illegitimate sons. Now armed with the impressive surname of De Forest-Bishoffsheim, Maurice was educated at Eton and Christ Church Oxford as Baroness de Hirsch was determined that both her adopted sons became 'proper English gentlemen.' In March 1899 Maurice was awarded the title of Baron by the Austro-Hungarian Emperor Franz Joseph and now could call himself Baron von Forest. The following year his adopted mother died leaving him a fortune, estimated in the millions, in her will, and Maurice became a British subject. For the next six years he served as a junior officer first in a fashionable battery of Militia Artillery, whose patron was the Prince of Wales (who in 1901 became King Edward VII), and then in the Staffordshire Imperial Yeomanry. During this period he set aside the Jewish religion of his birth and converted to the Roman Catholic faith. He also threw himself into motoring and motor racing, competing in the Gordon Bennett race and holding the world land speed record between 1903 and 1905. He was also becoming increasingly interested in flight and in 1909 offered the Baron de Forest

prize of £2,000 to the first Englishman to fly the English channel in an English-made heavier-than-air machine (when Bleriot flew across the Channel in July 1909 de Forest doubled the prize to £4,000 – it would be won in 1910 by the pioneering English pilot and aircraft designer Thomas Sopwith). He found time before the First World War to enthusiastically take up a number of winter sports including skiing, bobsleigh and toboggan – competing in St Moritiz's famous Cresta Run several times. 'Count de Bendern', Obituary, *The Times*, 8 October 1968, p. 14.

11 Winston Churchill in 'Cartoons and Cartoonists' *Strand Magazine*, June 1931 in J.W. Muller, ed., *Churchill as Peacemaker* (Cambridge: Cambridge University Press, 1997), p. 30.

12 Jenkins, *Churchill*, p. 187.

13 Ibid. p. 188.

14 Trevor Wilson, *The Myriad Faces of War: Britain and the Great War, 1914–1918* (Cambridge UK: Polity Press, 1988), p. 160.

15 De Forest and Churchill saw much less of each other during the 1920s; de Forest gave up his Austro-Hungarian title in 1920 and called himself Maurice Arnold de Forest. In 1932 he became a naturalised citizen of the Principality of Lichtenstein and was granted the title of Count de Bendern. From 1936 he represented his new homeland as a diplomat. He owned a luxurious villa at Cap St Martin on the French Riviera where his path occasionally crossed with Churchill's when the latter was staying as a guest at the nearby villa of La Dragonniere, owned by Lord Rothermere. Mary Soames, *Winston Churchill: His Life as a Painter* (London: Collins, 1990), p. 95. De Forest died at another of his luxurious homes, in Biarritz, in 1968. 'Count de Bendern', Obituary, *The Times*, 8 October 1968, p. 14.

16 Peter Stansky, *Sassoon: The Worlds of Philip and Sybil* (New Haven and London: Yale University Press, 2003), pp. 141 and 158. In 1922, Sassoon would recommend the architect Philip Tilden to Churchill as someone who could remodel Chartwell Manor and make it habitable. Ibid. p. 138.

17 Entry for 20 October 1915, Minutes of the Art Committee, Library, NLC.

18 Churchill stepped down on 11 November 1915. Mary Soames, *Winston Churchill: His Life as a Painter* (London: Collins, 1990), p. 24.

19 From 20 November to the end of December 1915; Jenkins, *Churchill*, pp. 290–297.

20 Entry for 16 February 1916, Minutes, Art Committee, Library, NLC, London.

21 Entry for 21 June 1916, Minutes, Art Committee, Library, NLC, London.

22 Indeed, the same month the NLC took possession of the Townsend portrait was when Churchill started sitting for William Orpen for one of the most painfully revealing and moving portraits of the man ever created.

23 Entry for 5 December 1916, Minutes, Art Committee, Library, NLC, London.

24 Entry for 30 January 1917, Minutes, Art Committee, Library, NLC, London.

25 Jenkins, *Churchill,* p. 323.

26 Entry for 31 July 1917, Minutes, Art Committee, NLC, London.

27 Entry for 26 February 1918, Minutes, Art Committee, NLC, London; this approach to Churchill was made barely a month before the massive German offensive on the British Army in Picardy which began on 21 March 1918.

28 Entry for 7 December 1920, Minutes, Art Committee, NLC, London.

29 Entry for 22 February 1921, Minutes, Art Committee, Library, NLC, London.

30 Entry for 24 May 1921, Minutes, Art Committee, Library, NLC, London.

31 Jenkins, *Churchill*, p. 370.

32 Ibid. p. 384.

33 Ibid. p. 392.

34 Churchill tendered his resignation to the NLC on 26 November 1924; e-mail from Dr Seth Thevoz (Hon Librarian of the NLC, London) to Dr Jonathan Black, 3 July 2015.

35 The bomb blast fatally wounded Mr W. Moyse, the club's long-serving dining room superintendent then guarding the premises as a Private in the local Home Guard.

36 Entries for 21 April 1943 and 28 July 1943, Minutes of the Managing Committee, Library, NLC, London.

37 Entry for 22 July 1943, Visitors Book of the Dog and Duck Circle, Library, NLC, London.

38 Entry for 20 April 1915, in John Julius Norwich, ed., *The Duff Cooper Diaries* (London: Phoenix, 2006), p. 6.

39 Jeremy Black, *The Great War and the Making of the Modern World* (London: Continuum, 2011), p. 74.

40 Gary Sheffield, *A Short History of the First World War* (London: Oneworld, 2014), p. 60.

41 Dr Andrew Norman, *Winston Churchill: Portrait of an Unquiet Mind* (Barnsley, UK: Pen & Sword Military, 2012), p. 78.

42 Ibid. p. 78

43 Sir John Lavery, *The Life of a Painter* (London: Cassell, 1940), p. 177.

44 It would seem Churchill first experienced a serious bout of depression while Home Secretary during 1910–1911; Mary Soames, *Clementine Churchill: The Revised and Updated Biography* (London: Doubleday, 2002). He later discussed the condition at

greater length with his doctor, Lord Moran, in August 1944. Entry for 14 August 1944 in Lord Moran, *Winston Churchill: The Struggle for Survival, 1940–1965* (London: Sphere Books, 1968) pp. 187–188.

45 Jenkins, *Churchill*, p. 277.

46 Ibid. p. 279.

47 Muller, ed., *Winston Churchill*, p. 325.

48 Winston Churchill, 'Hobbies', first published in *Nash's Magazine*, December 1925, reprinted in Muller, ed., *Winston Churchill*, pp. 362–363.

49 Ibid. p. 333.

50 Mary Soames, ed., *Speaking for Themselves: The Personal Letters of Winston and Clementine Churchill* (London: Black Swan, 1999), p. 655.

51 Clementine Churchill to Winston Churchill, 6 August 1928 quoted in Soames, ed., *Speaking for Themselves*, p. 324.

52 Clementine Churchill to Winston Churchill, 5 January 1935 in Soames, ed., *Speaking for Themselves*, p. 367.

53 Eade, ed., *Churchill by His Contemporaries*, p. 288.

54 Oliver Locker-Lampson MP to Winston Churchill, 20 September 1915, CHAR 1/117/95, Churchill Archives Centre [CAC], Churchill College Cambridge [CCC].

55 Locker-Lampson, early in 1916, took command of a RNAS armoured car unit sent to serve alongside the Imperial Russian Army. His unit served with distinction in the Caucasus, Galicia and Romania during 1916–1917. The unit was withdrawn from Russia early in 1918; Locker-Lampson, largely because of what he witnessed in Russia and the collapse of the Imperial Russian Army, became a convinced anti-Bolshevik campaigner and stood out in the Commons in 1919–1920 for the ferocity of his support for Churchill in his crusade against Lenin and his colleagues. Later, as Conservative MP for Birmingham Handsworth (1922–1945), he was an early opponent of the Nazis and denounced Hitler for his appalling treatment of the Jews. He was one of a handful of Tory MP who backed Churchill's calls for rearmament and, in 1939, campaigned for Sigmund Freud to be given asylum in the UK. Obituary, *The Times*, 9 October 1954, p. 22.

56 Jenkins, *Churchill*, pp. 288–292.

57 The helmet was named after Captain Adrian of the French Army, who had designed it during the summer of 1915. Nigel Fountain, ed., *When the Lamps Went Out: From Home Front to Battle Front, Reporting The Great War, 1914–1918* (London: Guardian Books, 2014), p. 165.

58 Winston Churchill to Clementine Churchill, 8 December 1915 quoted in Soames, ed., *Speaking for Themselves,* p. 128.

59 Ibid. p. 132.

60 Ibid. p. 140.

61 Jenkins, *Churchill*, p. 298.

62 Soames, ed., *Speaking for Themselves*, p. 147.

63 Jenkins, *Churchill*, p. 301.

64 Ibid, pp. 299–300.

65 Jenkins, *Churchill*, p. 302.

66 Muller, ed., *Winston Churchill*, pp. 120–121.

67 Jenkins, *Churchill*, p. 301.

68 Winston Churchill to Clementine Churchill, 22 February 1916 in Soames, ed., *Speaking for Themselves*, p. 179.

69 Jenkins, *Churchill*, p. 309.

70 Winston Churchill to Clementine Churchill, 24 January 1916 in Soames, ed., *Speaking for Themselves*, p. 161.

71 Jenkins, *Churchill*, p. 311.

72 Geoffrey Robinson to Sir Philip Sassoon, 15 August 1916 quoted in Stansky, *Sassoon*, pp. 63–64.

73 Rothermere, (Harold Harmsworth), as owner of the *Sunday Pictorial*, had recently commissioned a series of articles about the war for the paper from Churchill for the impressive sum of £250 each. Jenkins, *Churchill*, p. 312.

74 Ibid. p. 316.

75 Ibid. p. 313.

76 Ibid. p. 312.

77 Norman, *Winston Churchill*, p. 82.

78 Esher to Sassoon, 30 May 1917, Stansky, *Sassoon*, p. 70.

79 Churchill, 'Painting as a Pastime', *The Strand* magazine, December 1921, reprinted in Muller, ed., *Winston Churchill*, p. 337

80 John Rothenstein, *Time's Thievish Progress. Autobiography* III (London: Cassell, 1970), p. 130.

81 Leslie, *Clare Sherdian*, pp. 304–305.

82 Jenkins, *Churchill*, p. 323.

83 Ibid. pp. 332–333.

84 Andrew Roberts, *Hitler and Churchill: Secrets of Leadership* (London: Phoenix, 2004), p. 118.

85 Jenkins, *Churchill*, p. 338.

86 Ibid. pp. 351–352.

Chapter 3: Churchill's Roaring Twenties: From Liberal to Conservative

1 Churchill, 'Cartoons and Cartoonists' (first published in the *Strand Magazine*, June 1931) in J.W. Muller, ed., *Churchill as Peacemaker* (Cambridge: Cambridge University Press, 1997), 27

2 Following his victory in the General Election of December 1918, Lloyd George had promoted Churchill to become Secretary of State for War. Roy Jenkins, *Churchill* (London: Pan Books, 2002), p. 338.

3 David Carlton, *Churchill and the Soviet Union* (Manchester UK: Manchester University Press, 2000), p. 16.

4 Christopher Dobson and John Miller, *The Day We Almost Bombed Moscow: The Allied War in Russia, 1918–1920* (London: Hodder and Stoughton, 1986), pp. 18–19.

5 Richard Toye, *Lloyd George & Churchill: Rivals for Greatness* (London: Pan Books, 2008), p. 200.

6 Carlton, *Churchill and the Soviet Union*, p. 18.

7 Ibid. p. 20.

8 Ibid. p. 22.

9 Leslie, *Clare Sheridan*, p. xiii.

10 Ibid. p. 42.

11 Ibid. p. 103.

12 Ibid. p. 95.

13 Between 1906 and 1909, Guest had also been Churchill's Parliamentary Private Secretary. In 1911, he was a founder member, with Churchill and F.E. Smith, of the Other Club. Until his death in 1937, Guest was the club secretary. John Colville, *The Churchillians* (London: Weidenfeld & Nicolson, 1981), pp. 10–13.

14 Clementine Churchill, for one, did not care for Guest at all. In 1913 she referred to him as a 'sheep in lion's clothing . . .', Clementine Churchill to Winston Churchill in Mary Soames, ed., *Speaking for Themselves: The Personal Letters of Winston and Clementine Churchill* (London: Black Swan, 1999), p. 71.

15 Anita Leslie, *Clare Sheridan* (New York: Doubleday, 1977), p. 113.

16 Ibid. pp. 113–114.
17 Ibid. p. 114.
18 Ibid. pp. 114–115.
19 Ibid. p. 115.
20 Ibid.
21 Ibid. p. 118.
22 Entry for 5 September 1920 in Leslie, *Clare Sheridan*, p. 119.
23 Ibid. pp. 120–121.
24 Ibid. pp. 139–140.
25 Ibid. p. 145.
26 Ibid. pp. 156–157.
27 Ibid. p. 273.
28 McEvoy File, Archives, National Portrait Gallery, London.
29 Jenkins, *Churchill*, p. 445.
30 Ibid. p. 808.
31 Lawrence James, *Churchill and Empire: Portrait of an Imperialist* (London: Weidenfeld & Nicholson, 2013), pp. 123–134.
32 Sir John Guthrie, notes, c. 1929–1930, Churchill File, Archives, Scottish National Portrait Gallery, Edinburgh.
33 Carlton, *Churchill and the Soviet Union*, pp. 16–17; see also Dobson and Miller, *The Day We Almost Bombed Moscow*, pp. 273–274.
34 Jenkins, *Churchill*, p. 361.
35 Carlton, *Churchill and the Soviet Union*, p. 12.
36 Soames, *Winston Churchill*, p. 76.
37 David Low, *Low's Autobiography* (London: Michael Joseph, 1955), p. 143.
38 Jenkins, *Churchill*, p. 5.
39 Charles Eade, ed., *Churchill by His Contemporaries* (London: The Reprint Society, 1955 (first published in 1953), p. 255.
40 Fred Urquhart, *W.S.C: A Cartoon Biography* (London: 1955), p. 43.
41 Leslie, *Clare Sheridan*, pp. 140–145.
42 Carlton, *Churchill and the Soviet Union*, p. 23.

43 Jenkins, *Churchill*, p. 351.

44 Adam Zamoyski, *Warsaw 1920: Lenin's Failed Conquest of Europe* (London: Harper Collins, 2008), pp. 97–110.

45 Low, *Low's Autobiography*, p. 93.

46 Entry for 22 June 1922 in Norwich, ed., *The Duff Cooper Diaries*, p. 164.

47 Charles Townsend, *The Republic: The Fight for Irish Independence* (London: Penguin/Allen Lane, 2013), pp. 404–405.

48 Jenkins, *Churchill*, p. 375.

49 Ibid. pp. 382–384.

50 Ibid. p. 389.

51 Ibid. p. 392.

52 Ibid. p. 393.

53 Eade, ed., *Churchill by His Contemporaries*, p. 259.

54 Jenkins, *Churchill*, p. 401.

55 Andrew Roberts, *Hitler and Churchill: Secrets of Leadership* (London: Phoenix, 2004), p. 206.

56 Peter Stansky, *Sassoon: The Worlds of Philip and Sybil* (New Haven and London: Yale University Press, 2003), p. 158.

57 Ibid. p. 44.

58 Ibid. p. 118.

59 Ibid. pp. 158–159.

60 Churchill to Clementine Churchill, 8 March 1925 in Soames, ed., *Speaking for Themselves*, p. 290.

61 Stansky, *Sassoon*, p. 70.

62 Ibid. p. 161.

63 Ibid. p. 168. Sassoon sent Churchill a pair of black swans to Chartwell from Trent Park in June 1927 followed by a quartet of Indian Comb ducks seven years later. Churchill was also a regular painting guest of Sassoon's at Trench Park and Port Lympne.

64 Eade, ed., *Churchill by His Contemporaries*, p. 70.

65 Jenkins, *Churchill*, p. 396.

66 Churchill himself referred to the effectiveness of Baldwin's pipe as a 'prop' to snag the imagination of the public in his 1931 essay on 'Cartoons and Cartoonists', Muller, ed., *Winston Churchill*, p. 29.

67 Low had first noticed the formidable nature of the Conservative Party's publicity machine, and how effectively Baldwin was being transformed from titan of industry into an avuncular and homely man of the people, during the General Election of October 1924. David Low, *Low's Autobiography* (London: Michael Joseph, p. 161).

68 Jenkins, *Churchill*, pp. 405–406.

69 Low, *Low's Autobiography*, p. 143.

70 Ibid. p. 146.

71 Ibid. p. 147.

72 Ibid. p. 148.

73 Ibid. p. 196.

74 Matthew Sturgis, *Walter Sickert: A Life* (London: Harper Perennial, 2005), p. 301.

75 Ibid. p. 560.

76 Ibid. p. 559.

77 Wendy Baron to Angela Lewi, NPG, 18 September 1970, Sickert File, Archives, NPG, London.

78 Hermione Lee, *Virginia Woolf* (London: Vintage, 1997), p. 642.

79 Frank Rutter in *The Sunday Times*, 19 February 1928; clipping Sickert File, Archives, NPG, London.

80 Ivor Churchill's mother was Consuelo née Vanderbilt, who had acrimoniously divorced the 9th Duke of Marlborough. In 1921 she married the French financier and patron of the arts Jacques Balsan. From the late 1920s onwards Churchill and his wife would often stay at her château in the south of France. Soames, ed., *Speaking for Themselves*, p. 649.

81 Richard Shone, *From Beardsley to Beaverbrook: Portraits by Walter Richard Sickert* (Bath: Victoria Art Gallery, 1990), p. 36.

82 Julian Symons, *Horatio Bottomley* (London: Cresset Press, 1955), pp. 289–290 and Matthew Parris, *Great Parliamentary Scandals* (London: Robson Books, 1996), pp. 81–83.

83 Roberts, *Hitler and Churchill*, p. 8.

84 For more on how the toxicity of Bottomley's reputation damaged belief in British patriotism in the minds of the Bloomsbury circle between the wars: Richard Overy, *The Morbid Age: Britain Between The Wars* (London: Penguin Allen Lane, 2009), pp. 22–24 and David Reynolds, *The Long Shadow: The Great War and the Twentieth Century* (London: Simon & Schuster, 2013), p. 56 and pp. 200–201.

85 Almost inevitably the figure of John Bull was not invented by an Englishman but by a Scot, Dr John Arbuthnot, and appears in a pamphlet Arbuthnot published in 1712

entitled *Law is a Bottomless Pitt*. Dr Andrew Norman, *Winston Churchill: Portrait of an Unquiet Mind* (Barnsley, UK: Pen & Sword Military, 2012), p. 149.

86 Roger Berthoud, *Graham Sutherland: A Biography* (London: Faber & Faber, 1982), p. 300.

87 Sturgis, *Walter Sickert*, p. 562.

88 Lilian Browse to David Piper, NPG, 17 March 1965, Sickert File, Archives, NPG, London.

89 Miss D.M. Phillips (Ministry of Works) to C.K. Adams (Director NPG), 7 September 1960, Sickert File, Archives, NPG, London.

90 Sir William Emrys Williams (Chairman NCF) to David Piper (Director, NPG), 3 March 1965, Sickert File, Archives, NPG, London.

91 Sturgis, *Walter Sickert*, pp. 616–617.

92 Jenkins, *Churchill*, p. 420.

93 A good example of such a photograph is reproduced in Mary Soames, *Clementine Churchill: The Revised and Updated Biography* (London: Doubleday, 2002), plate 52.

94 Eade, ed., *Churchill by His Contemporaries*, p. 262.

95 Andrew Roberts, among others, has cogently argued that the gusto with which Churchill sought to break the General Strike effectively alienated a whole generation of trade unionists and a large section of the British urban working class from him. They would not forget the zeal with which he had attacked organised labour in 1926 when it came to voting in the General Election of July 1945. Roberts, *Hitler and Churchill*, p. 206.

96 Eade, ed., *Churchill by His Contemporaries*, p. 262

97 Soames, *Clementine Churchill*, p. 242.

98 Soames, *Winston Churchill*, p. 76.

Chapter 4: Churchill's 'Wilderness Years' – the 1930s

1 Epstein's carvings *Night* and *Day* for the new headquarters of the London Underground Railways caused a furore when unveiled in April 1929; the reaction in the popular press to his large carving of a conspicuously heavily pregnant Asian woman, *Genesis*, exhibited at the Leicester Galleries in February 1930, was apoplectic. Epstein was widely denounced for inflicting this 'Mongolian moron' on the British public. June Rose, *Daemons and Angels: A Life of Jacob Epstein* (London: Constable, 2002), pp. 172–176.

2 Emanuel Shinwell noted Churchill's abuse of Ramsay MacDonald in the late 1920s, to the extent he believed Churchill was among the few opposition politicians the Labour

Prime Minister actually loathed. Charles Eade, ed., *Churchill by His Contemporaries* (London: The Reprint Society, 1955 [first published in 1953]), p.76.

3 Roy Jenkins, *Churchill* (London: Pan Books, 2002) p. 435.

4 Ibid. p. 474; Andrew Roberts, *Hitler and Churchill: Secrets of Leadership* (London: Phoenix, 2004), p. 206; Mary Soames, *A Daughter's Tale: The Memoir of Winston and Clementine Churchill's Youngest Child* (London: Doubleday, 2011), p. 107; Lawrence James, *Churchill and Empire: Portrait of an Imperialist* (London: Weidenfeld & Nicholson, 2013), p. 184.

5 Jenkins, *Churchill*, pp. 433–444.

6 Ibid. p. 434.

7 Entry for 4 November 1920 in John Julius Norwich, ed., *The Duff Cooper Diaries* (London: Phoenix, 2006), p. 133.

8 David Low, *Low's Autobiography* (London: Michael Joseph, 1955), p. 220.

9 Ibid. p. 221.

10 Ibid. p. 226.

11 James, *Churchill and Empire*, p. 298.

12 Ibid. pp. 304–305.

13 It would appear that as early as February 1934 Churchill had proposed Nicholson, along with the author H.G. Wells, for election to the Other Club. Freddie Guest (Hon. Secretary, The Other Club) to Churchill, 22 February 1934, 22 February 1934, CHAR 2/233/1, CAC, CCC.

14 Mary Soames, *Winston Churchill: His Life as a Painter* (London: Collins, 1990), p. 84.

15 Peter Stansky, *Sassoon: The Worlds of Philip and Sybil* (New Haven and London: Yale University Press, 2003), p. 196.

16 Ibid, p. 196

17 In September 1936 Clementine Churchill mentioned socialising with Nicholson and Sassoon – the latter sending his private aircraft to fly her to Port Lympne. Clementine Churchill to Winston Churchill, 8 September 1936 in Mary Soames, ed., *Speaking for Themselves: The Personal Letters of Winston and Clementine Churchill* (London: Black Swan, 1999), p. 416.

18 Mary Soames, *A Daughter's Tale: The Memoir of Winston and Clementine Churchill's Youngest Child* (London: Doubleday, 2011), p. 106.

19 Soames, *Winston Churchill*, p. 86.

20 Soames, *A Daughter's Tale*, p. 39.

21 Ibid. p. 262.

22 James R. Mellow, *Hemingway: A Life Without Consequences* (New York: Da Capo Press, 1992), pp. 308–309; Jeffrey Meyers, *Hemingway: A Biography* (London: Macmillan, 1986), p. 189.

23 David Boyd Haycock, *I Am Spain: The Spanish Civil War and the Men and Women who went to Fight Fascism* (Brecon: Old Street, 2012), pp. 32–42.

24 David Carlton, *Churchill and the Soviet Union* (Manchester, UK: Manchester University Press, 2000), p. 38.

25 Soames, *Winston Churchill*, pp. 84–85.

26 Ibid. p. 86.

27 Matthew Sturgis, *Walter Sickert: A Life* (London: Harper Perennial, 2005), p. 563. Today the painting is part of the collection at Corsham Court, Wiltshire.

28 Jeremy Wilson, *Lawrence of Arabia: The Authorised Biography of T.E. Lawrence* (London: Minerva, 1990), pp. 646–648.

29 In less happier circumstances Ironside would be Chief of the Imperial General Staff under Churchill (May–July 1940); they did not see eye-to-eye and Ironside was 'kicked upstairs' after two months and made a Field Marshal; Jonathan Black, *The Face of Courage: Eric Kennington, Portraiture and The Second World War* (London: Philip Wilson Publishers, 2011), p. 22.

30 P. G. Konody, *Daily Mail*, 8 October 1921, p. 4.

31 Nicholas Farrell, *Mussolini: A New Life* (London: Weidenfeld & Nicolson, 2003), p. 225.

32 Kennington to Basil Liddell-Hart, c. November 1937, LHA, KCL. Fourteen years later, Churchill's doctor, Lord Moran, would reflect that Churchill under the harsh lighting of a conference hall reminded him of someone: '. . . yes, he was like Mussolini . . .!' Entry for 15 October 1951, Lord Moran, *Winston Churchill: The Struggle for Survival, 1940–1965* (London: Sphere Books, 1968), p. 371.

33 Later in April 1934 Low's famous character 'Colonel Blimp', satirising the British military mind and ethos, made his first appearance in the London *Evening Standard*. Colin Seymour-Ure and Jim Schoff, *David Low* (London: Secker & Warburg, 1985), p. 93.

34 For example, in the House of Commons on 8 March 1934; Stansky, *Sassoon*, p. 219.

35 Clementine Churchill had first noted her husband being described as a 'War Monger' during the Dundee General Election campaign of November 1922: Clementine Churchill to Winston Churchill, 9 November 1922 in Mary Soames, *Clementine Churchill: The Revised and Updated Biography* (London: Doubleday, 2002), p. 236.

36 Between 1933 and 1936 Churchill was often accused in the Commons, usually by Labour MPs, of being an alarmist 'warmonger'. Jenkins, *Churchill*, pp. 474–476.

37 The Oxford Union passed the following resolution on 9 February 1933: 'That this house will in no circumstances fight for its King and Country.' Juliet Gardiner, *The Thirties: An Intimate History* (London: Harper Press, 2010), p. 498.

38 Eric Kennington to Basil Liddell Hart, c. December 1935, LHA, KCL.

39 Ibid.

40 Kennington to Clark, 29 November 1939, Clark Papers, 8812.1.4-441a, TGA, London.

41 Clark to Kennington, 1 December 1939, Clark Papers, 8812.1.4-441b, TGA, London.

42 Entry for 30 November 1936 in Norwich, ed., *The Duff Cooper Diaries*, p. 234.

43 Jenkins, *Churchill*, p. 500.

44 Ibid. p. 474.

45 Ibid. p. 541.

46 When the character of Bull first appeared in a pamphlet John Arbuthnott published in 1712 he had no animal accompaniment. Bull appears to have first been joined by a bulldog in British caricatures produced during the early years of the American War of Independence (1775–1783). Dr Andrew Norman, *Winston Churchill: Portrait of an Unquiet Mind* (Barnsley, UK: Pen & Sword Military, 2012), p. 149.

47 Tim Clayton and Sheila O'Connell, *Bonaparte and the British: Prints and Propaganda in the Age of Napoleon* (London: British Museum Press, 2015), p. 76 and p. 133 for Gillray's unflattering conception of John Bull in the mid-1790s; p. 69 for Isaac Cruikshank's version of Bull later in the decade, somewhat slimmer, a lover of home and hearth and accompanied by a cat curled up by a blazing fire rather than with the bulldog, or mastiff, more commonly associated with him.

48 Soames, *Clementine Churchill*, p. 256.

Chapter 5: Finest Hour? Churchill and the Second World War, 1939–1945

1 Mary Soames, *A Daughter's Tale: The Memoir of Winston and Clementine Churchill's Youngest Child* (London: Doubleday, 2011), p. 130.

2 Ibid. p. 138.

3 Quoted in Andrew Roberts, *Hitler and Churchill: Secrets of Leadership* (London: Phoenix, 2004), p. 138.

4 Soames, *A Daughter's Tale*, p. 92.

5 Roberts, *Hitler and Churchill*, p. 143.

6 Hitler on 2 February 1942 quoted in Roberts, *Hitler and Churchill*, p. 137.

7 Ian Kershaw, *The Hitler Myth: Image and Reality in the Third Reich* (Oxford: Oxford University Press, 2001), p. 240.

8 Entry for 24 September 1938 in John Julius Norwich, ed., *The Duff Cooper Diaries* (London: Phoenix, 2006), p. 264.

9 Entry for 5 January 1940, John Colville, *The Fringes of Power: Downing Street Diaries, 1939–1955* (London: Phoenix, 2005 [first edition, 1985]), p. 47. In 1953 Hore-Belisha was to contribute one of the most perceptive essays in Charles Eade, ed., *Churchill by His Contemporaries* (London: The Reprint Society, 1955 [first published in 1953]), pp. 269–275.

10 A depressive who suffered from insomnia, Vicky committed suicide in February 1966.

11 Zec had been born in North London to Russo-Jewish parents who originally came from Odessa.

12 Soames, *A Daughter's Tale*, p. 142.

13 Entry for 27 January 1940 in John Colville, *The Fringes of Power: Downing Street Diaries, 1939–1955* (London: Phoenix, 2005), p. 54.

14 Terence Pepper, Roy Strong and Peter Conrad, *Beaton Portraits* (London: National Portrait Gallery, 2004), p. 75.

15 Juliet Gardiner, *The Thirties: An Intimate History* (London: Harper Press, 2010), p. 23.

16 Illingworth began work for the *Daily Mail* in November 1939 and retired from it in 1969. Obituary, *The Guardian*, 22 December 1979, p. 24.

17 Entry for 10 May 1940, Colville, *The Fringes of Power*, pp. 96–97.

18 Ibid. Entry for 30 May 1940, p. 115.

19 Roy Jenkins, *Churchill* (London: Pan Books, 2002), pp. 623–624.

20 Churchill is not depicted wearing the rather smarter and more formal wear to which he was entitled as an Elder Brother of Trinity House – an honour which had been conferred upon him shortly after he was appointed First Lord of the Admiralty for the first time in October 1911. Jenkins, *Churchill*, p. 206.

21 Ibid. p. 596.

22 Ibid. p. 599.

23 Laurence Rees, *World War Two Behind Closed Doors: Stalin, the Nazis and the West* (London: BBC Books, 2008), p. 71.

24 Clemenceau had been commonly known as 'the tiger' since the 1870s. However, he was presented as a tenacious bulldog or mastiff by French cartoonists at the time he became French Prime Minister in November 1917, promising the introduction of implacable and remorseless 'total war'. Gregor Dallas, *At the Heart of a Tiger: Clemenceau and his World, 1841–1929* (London: Macmillan, 1993), p. 502.

25 Von der Goltz, *Hindenburg*, p. 258. Hindenburg had been depicted during the First World War, usually in the left-wing German press, as a bulldog wearing the spiked

Pickelhaube helmet. Such representations appeared again after he was elected Reich President in April 1925. However, in July 1926, his private office sued a cartoonist for defamation for drawing Hindenburg as a bulldog; the President won and the offending cartoonist had to pay a hefty fine.

26 Jenkins, *Churchill*, p. 611.

27 Ibid. p. 597.

28 Mark Connelly, *We Can Take It! Britain and the Memory of the Second World War* (London: Longman, 2004), p. 64.

29 Churchill Photographs File, Archives, NPG, London.

30 Minute, 8 May 1944 quoted in Carlton, *Churchill and the Soviet Union*, p. 214.

31 Entry for 18 October 1944, Lord Moran, *Winston Churchill: The Struggle for Survival, 1940–1965* (London: Sphere Books, 1968), pp. 227–228.

32 Soames, *A Daughter's Tale*, p. 212.

33 Ibid. p. 40.

34 According to Alibhai-Brown, her history-master, B.K. Amin, admired Churchill the painter and enthusiast for Morocco as much as Churchill the wartime statesman. Yasmin Alibhai-Brown, *Exotic England: The Making of a Curious Nation* (London: Portobello Books, 2015), pp. 67–68.

35 John Ramsden, *Man of the Century: Winston Churchill and his Legend since 1945* (London: Harper Collins, 2003), p. 56.

36 Paul Moorhouse, *The Great War in Portraits* (London: National Portrait Gallery, 2014), p. 25.

37 Lady Clementine Churchill to David McFall, letter, 13 December 1958, courtesy of the Estate of David McFall RA.

38 Salisbury File, Archives, NPG, London.

39 Salisbury painted a copy of this first version in 1943 for the Constitutional Club which sold it at auction at Sotheby's in November 1996; Churchill Portraits in Oils File, Archives, NPG, London.

40 Frank Owen Salisbury, *Portrait and Pageant – Kings Presidents and People* (London: John Murray, 1944), p. 188.

41 Ibid. p. 189.

42 Soames, *A Daughter's Tale*, p. 262.

43 Entry for 8 October 1940, Colville, *The Fringes of Power*, p. 218.

44 Rees, *World War Two behind Closed Doors*, p. 158.

45 Dennis Wardleworth, *William Reid Dick, Sculptor* (Farnham, Surrey: Ashgate, 2013), pp. 155–157.

46 Ibid. p. 157.

47 *The Tatler and Bystander*, 5 May 1943, clipping in Churchill Portraits Box, Archives, NPG, London.

48 Ibid.

49 Soames, *A Daughter's Tale*, p. 247.

50 Winston Churchill to Sir Edwin Lutyens, 7 October 1942, CHAR 20/54B/119, CAC, CCC.

51 Soames, *Winston Churchill*, p. 156.

52 Sheridan to Churchill, 12 April 1934, CHAR 2/204/28, CAC, CCC.

53 Churchill note, 11 May 1934, CHAR 2/204/34, CAC, CCC.

54 Sheridan to Churchill, 16 June 1938, CHAR 1/323/68-69, CAC, CCC.

55 Sheridan to Churchill, 29 October 1941, CHAR 1/361/64, CAC, CCC.

56 Sheridan to Churchill, 25 April 1942, CHAR 1/368/27-28, CAC, CCC.

57 Elizabeth Layton to Churchill, 28 April 1942, CHAR 1/368/32, CAC, CCC.

58 Sheridan to Churchill, 5 May 1942, CHAR 1/368/33-36, CAC, CCC.

59 Bracken to Churchill, 19 May 1942, CHAR 1/368/38, CAC, CCC.

60 Churchill to Sheridan, 1 June 1942, CHAR 1/368/39, CAC, CCC.

61 By 4 November 1942 General Montgomery's 8th Army had decisively beaten the Italo-German forces ranged against it at El Alamein. Soames, *A Daughter's Tale*, p. 247.

62 Churchill to Sheridan, 12 November 1942, CHAR 1/368/43, CAC, CCC.

63 Quoted in Anita Leslie, *Clare Sheridan,* (New York: Doubleday, 1977), p. 258.

64 Ibid. p. 286.

65 Ibid.

66 Ibid. p. 218.

67 Ibid. p. 286.

68 Ibid. p. 285.

69 Sheridan to Elizabeth Layton (at 10 Downing Street), 11 December 1942, CHAR 1/368/47, CAC, CCC.

70 Churchill to Sheridan, 12 December 1942, CHAR 1/368/48-49, CAC, CCC.

71 Sheridan to Churchill, c. 14 December 1942, CHAR 1/368/49, CAC, CCC.

72 The British SOE may have hand in the assassination. Colin Smith, *England's Last War against France: Fighting Vichy, 1940-1942* (London: Weidenfeld & Nicolson, 2009), pp. 425–427.

73 Leslie, *Clare Sheridan*, p. 287.

74 Churchill to Sheridan, 20 December 1942, CHAR 1/368/50, CAC, CCC.

75 Sheridan to Churchill, 26 December 1942, CHAR 1/368/51-53, CAC, CCC. Incensed by Gandhi's 'Quit India' campaign, launched in August 1942, Churchill promptly had him arrested and imprisoned: James, *Churchill and Empire*, p. 297.

76 Sheridan to Churchill, 7 January 1943, CHAR 1/374/2, CAC, CCC. Rakovsky, who during the Russian Civil War had acquired the cheerful nickname of 'the Butcher of Ukraine', sat for Sheridan during June and July 1924 and left London for Paris in November 1925: Leslie, *Clare Sheridan*, p. 232.

77 Sheridan to Churchill, 21 April 1943, CHAR 1/374/6-8, CAC. CCC.

78 Bracken minute to Churchill, 29 April 1943, CHAR 1/374/10-11, CAC, CCC.

79 Clementine Churchill to Sheridan, 5 May 1943, CHAR 1/374/16, CAC, CCC.

80 Sheridan to Churchill, 14 June 1943, CHAR 1/374/17-19, CAC, CCC.

81 Sheridan to Churchill, 27 September 1943, CHAR 1/374/21-25, CAC, CCC.

82 Leslie, *Clare Sheridan*, p. 295.

83 Ibid. pp. 295–296.

84 John Terraine, *The Right of the Line: The Role of the RAF in World War Two* (Barnsley, UK: Pen & Sword, 2010), p. 399.

85 Christopher Duggan, *Fascist Voices: An Intimate History of Mussolini's Italy* (London: Vintage, 2013), pp. 394–397.

86 Bex Lewis and David Bownes, 'Underground Posters in Wartime' in David Bownes and Oliver Green, eds., *London Transport Posters; A Century of Art and Design* (London: Lund Humphries and the London Transport Museum, 2008), p. 183.

87 Austin File, Archives, NPG, London.

88 Alan Powers, 'Artist and Printer: Poster Production, 1900–1970', in Bownes and Green, eds., *London Transport Posters*, p. 71.

89 Brian Foss, *War Paint: Art, War, State and Identity in Britain, 1939–1945* (New Haven and London: Yale University Press, 2007), pp. 85–86.

90 Ibid. p. 102.

91 War Diary of the 6th Seaforth Highlanders, WO-98, National Archives, Kew, London.

92 Ibid.

93 Max Hastings, *Finest Years: Churchill as Warlord, 1940–1945* (London: Harper Press, 2009), p. 442.

94 Ibid. p. 443.

95 Jenkins, *Churchill*, p. 729.

96 Established in August 1941 by Anthony Eden and Churchill's protégé Brendan Bracken (1901–1958), Minister of Information from July 1941 to May 1945. Ian McLaine, *Ministry of Morale: Home Front Morale and the Ministry of Information in World War II* (London: George Allen & Unwin, 1979), p. 3.

97 Robert and Isabelle Tombs, *That Sweet Enemy: The French and the British from the Sun King to the Present* (London: Pimlico, 2007), pp. 583–584.

98 Within days of the liberation of Paris, late in August 1944, the newspaper embraced the cause of Free France and moved sharply to the left in its opinions. Antony Beevor and Artemis Cooper, *Paris after the Liberation: 1944–1949* (London: Penguin, 1995), p. 155.

99 Maureen Waller, *London 1945: Life in the Debris of War* (London: John Murray, 2005), p. 320.

100 Peter Hennessy, *Never Again: Britain 1945–1951* (London: Vintage, 1993), p. 84.

101 Jenkins, *Churchill*, p. 798.

Chapter 6: Churchill as Cold War Leader of the Opposition and as Prime Minister, 1945–1955

1 Sheridan to Churchill, 15 January 1945, CHAR 1/1386/11-12, CAC, CCC.

2 John Colville to 5th Lord Clanwilliam, 17 May 1945, CHAR 20 196/68; John Colville to Captain Oswald Birley, 30 May 1945 CHAR 20/196/74, CAC, CCC.

3 Roy Jenkins, *Churchill* (London: Pan Books, 2002), pp. 809–810.

4 Mary Soames, *A Daughter's Tale: The Memoir of Winston and Clementine Churchill's Youngest Child* (London: Doubleday, 2011), p. 369.

5 Jenkins, *Churchill*, p. 807.

6 Mary Soames, *Winston Churchill: His Life as a Painter* (London: Collins, 1990), p. 152.

7 Epstein letters and telegrams to Lady Randolph Churchill, 2, 5 and 14 April, CHAR 28/130/12-17; Lord Beaverbrook to Lady Randolph regarding Epstein, 5 April 1918, CHAR 28/130/14, CAC, CCC.

8 Raquel Gilboa,... *Unto Heaven will I Ascend: Jacob Epstein's Inspired Years, 1930-1959* (London: Paul Holberton, 2013), p. 15.

9 Jenkins, *Churchill*, p. 803.

10 Gilboa, *Unto Heaven will I Ascend*, p. 76.

11 Ibid. p. 164.

12 June Rose, *Daemons and Angels: A Life of Jacob Epstein* (London: Constable, 2002), p. 230.

13 Gilboa, *Unto Heaven will I Ascend*, p. 172.

14 Ibid. p. 165.

15 Lawrence James, *Churchill and Empire: Portrait of an Imperialist* (London: Weidenfeld & Nicholson, 2013), p. 353.

16 Gilboa, *Unto Heaven will I Ascend*, p. 165.

17 Soames, *Winston Churchill*, p. 156.

18 David Kynaston, *Austerity Britain 1945-1951* (London: Bloomsbury, 2007), p. 334.

19 John Rothenstein, *Time's Thievish Progress. Autobiography III* (London: Cassell, 1970), p. 131.

20 J.W. Muller, ed., *Churchill as Peacemaker* (Cambridge: Cambridge University Press, 1997), p. 333.

21 Jenkins, *Churchill*, p. 904.

22 Ibid. p. 666.

23 Simon Martin, *Conscience and Conflict: British Artists and the Spanish Civil War* (Lund Humphries, Farnham, UK, 2014), p. 119.

24 Ibid. pp. 122-123.

25 See Low in the *Evening Standard*, 6 May 1931; Fred Urquhart, *W.S.C: A Cartoon Biography* (London, 1955), p. 83.

26 See Strube in the *Daily Express*, 7 November 1924 in Urquhart, *W.S.C. A Cartoon Biography*, p. 62.

27 See Strube in the *Daily Express* in November 1931 for Churchill in Wagnerian drag, ibid. p. 84

28 'Gabriel' was James 'Jimmy' Friell, born in Glasgow who worked as cartoonist for the left-wing *Daily Worker* from 1936 to 1956. He resigned from the paper in November 1956, over the Soviet invasion of Hungary, and went to work for Beaverbrook's *Evening Standard*. By the late 1960s he had given up political cartoons to work in television. Obituary, *The Guardian*, 12 February 1997, p. 18.

29 The Labour Party under Attlee won with a tiny minority of just six seats: Labour won 46 per cent of the popular vote; the Conservatives 44 per cent. Kynaston, *Austerity Britain 1945–1951*, pp. 391–392.

30 Jenkins, *Churchill*, p. 836.

31 Laurence Rees, *World War Two Behind Closed Doors: Stalin, the Nazis and the West* (London: BBC Books, 2008), p. 358.

32 Entry for 18 October 1944 in Lord Moran, *Winston Churchill: The Struggle for Survival, 1940–1965* (London: Sphere Books, 1968), p. 227.

33 Robert Service, *Stalin: A Biography* (London: Pan Books, 2005), p. 487.

34 Ibid. p. 524.

35 Jenkins, *Churchill*, p. 838.

36 Ibid. pp. 840–841.

37 In November 1949, at a United Europe rally, Churchill brought himself to say 'Empire and Commonwealth.' Jenkins, *Churchill*, p. 817.

38 David Low, *Low's Autobiography* (London: Michael Joseph, 1955), p. 356.

39 Nemon, *A Sculptor's Recollections*, unpublished autobiography, p. 59, Nemon 3/1, Nemon Papers, CAC, CCC.

40 Ibid. p. 60, Nemon Papers, CAC, CCC.

41 Sylvia Henley née Stanley was a first cousin to Clementine Churchill and a daughter of the 4th Baron Stanley of Alderley. She was one of Clementine's closest friends from the early 1930s. Soames, *A Daughter's Tale*, p. 72.

42 Nemon, *A Sculptor's Recollections*, p. 64, Nemon 3/1, Nemon Papers, CAC, CCC.

43 Sir Owen Morshead (Royal Librarian, Windsor Castle) letter to Oscar Nemon, 5 November 1952, Nemon 2/2, Nemon Papers, CAC, CCC.

44 Jenkins, *Churchill*, p. 845.

45 Nemon, *A Sculptor's Recollections*, p. 65, Nemon 3/1, Nemon Papers, CAC, CCC.

46 Colville to Nemon, 20 March 1953, Nemon 2/2, Nemon Papers, CAC, CCC.

47 Ibid. p. 66, Nemon 3/1, Nemon Papers, CAC, CCC.

48 Ibid. pp. 66–67, Nemon 3/1, Nemon Papers, CAC, CCC.

49 *Daily Telegraph*, 5 February 1954, Nemon 2/2, Nemon Papers, CAC, CCC.

50 Sir Gerald Kelly to Nemon, 27 March 1953, Nemon 2/2, Nemon Papers, CAC, CCC.

51 John Colville to Nemon, 30 March 1953, Nemon 2/2, Nemon Papers, CAC, CCC.

52 Nemon, *A Sculptor's Recollections*, p. 69, Nemon 3/1, Nemon Papers, CAC, CCC.

53 Soames, *Winston Churchill*, p. 187.

54 Clementine Churchill to Nemon, 26 August 1953, Nemon 2/2, Nemon Papers, CAC, CCC.

55 Nemon, *A Sculptor's Recollections*, pp. 69, Nemon 3/1, Nemon Papers, CAC, CCC.

56 John Colville to Nemon, 19 January 1954: 'The Prime Minister was indeed pleased with the bust and has several times told me how good he thought it.' Nemon 2/2, Nemon Papers, CAC, CCC.

57 Sir Owen Morshead to Nemon, 20 November 1954, Nemon 2/2, Nemon Papers, CAC, CCC.

58 Morshead to Nemon, 1 July 1956, Nemon 2/2, Nemon Papers, CAC, CCC.

59 Morshead to Nemon, 21 July 1956, Nemon 2/2, Nemon Papers, CAC, CCC.

60 Jenkins, *Churchill*, p. 870.

61 Ibid. p. 873.

62 Muller, ed., *Winston Churchill*, pp. 27–28.

63 Soames, *Winston Churchill*, p. 196. Lady Soames agreed with Sir Norman's analysis, as did Roy Jenkins who has argued that, after 1953, Churchill did very little to 'add lustre to his reputation'; he should have retired on a high note after seeming to have staged a full recovery from his stroke in August 1953. Jenkins, *Churchill*, p. 897.

64 Urqhuart, *W.S.C. A Cartoon Biography*, p. 234.

65 David Kynaston, *Family Britain: 1951–1957* (London: Bloomsbury, 2009), p. 356.

66 Jenkins, *Churchill*, p. 876.

67 Alex Danchev and Daniel Todman, eds., *War Diaries, 1939–1945. Field Marshal Lord Alanbrooke* (London: Phoenix, 2002), p. 678.

68 Nemon, to Sir George Elliston, 2 December 1953, Nemon 2/3, Nemon Papers, CAC, CCC.

69 E.H. Nichols (Town Clerk, Corporation of London) to Nemon, 27 January 1954, Nemon 2/9, Nemon Papers, CAC, CCC

70 London *Evening Standard*, 5 February 1954, clipping in Nemon 2/9, Nemon Papers, CAC, CCC.

71 Nemon, *A Sculptor's Recollections*, Nemon 3/1, Nemon Papers, CAC, CCC

72 Ibid.

73 Ibid.

74 Mary Soames, *Clementine Churchill: The Revised and Updated Biography* (London: Doubleday, 2002), p. 272. Clementine admiringly inspected French's statue of Lincoln again during a wartime visit to Washington DC in September 1943: ibid. p. 375.

75 *Daily Telegraph*, November 1954, clipping in Nemon 2/9, Nemon Papers, CAC, CCC.

76 Town Clerk (Corporation of London) to Nemon, 19 November 1954, Nemon 2/9, Nemon Papers, CAC, CCC.

77 Ibid. 17 February 1955, Nemon 2/9, Nemon Papers, CAC, CCC.

78 Ibid. 1 April 1955, Nemon 2/9, Nemon Papers, CAC, CCC.

79 Nemon, *A Sculptor's Recollections*, p. 75, Nemon 3/1, Nemon Papers, CAC, CCC.

80 Ibid.

81 Entry for 21 June 1955, Moran, *Winston Churchill*, p. 703.

82 Collett (Chief Commonor, Corporation of London) to Nemon, 30 June 1955, Nemon 2/9, Nemon Papers, CAC, CCC.

83 Nemon to the Town Clerk (Corporation of London), 1 July 1956, Nemon 2/9, Nemon Papers, CAC, CCC.

84 Town Clerk (Corporation of London) to Nemon, 10 April 1957 and Nemon to the Town Clerk, 14 June 1957, Nemon 2/9, Nemon Papers, CAC, CCC.

85 *The Times*, 13 February 1959, Churchill Sculpture Box, Archives, NPG, London

86 Ibid.

87 Frank McLeavy interviewed on Radio 4, 28 November 1974, quoted in Roger Berthoud, *Graham Sutherland: A Biography* (London: Faber & Faber, 1982), p. 183.

88 Jenkins, *Churchill*, pp. 883–884.

89 Ibid. p. 884.

90 Berthoud, *Sutherland*, p. 183.

91 Sutherland to Lady Mary Soames, 1 January 1978, Berthoud, *Sutherland*, p. 184.

92 Sutherland to Lord Beaverbrook, 3 August 1954, Archives, Beaverbrook Art Gallery, Fredericton New Brunswick, Canada.

93 Churchill to Sutherland, 14 August 1954, quoted in Berthoud, *Sutherland*, p. 185.

94 Sutherland in the *Sunday Telegraph*, 20 January 1965, clipping in Churchill Sutherland Subject Box, Archives, NPG, London.

95 Berthoud, *Sutherland*, p. 185.

96 Sutherland in the *Sunday Telegraph*, 20 January 1965, clipping in Churchill Sutherland Subject Box, Archives, NPG, London.

97 Sutherland to Lord Beaverbrook, 21 March 1961, Archives, Beaverbrook Art Gallery, Fredericton New Brunswick, Canada.

98 Sutherland in the *Sunday Telegraph*, 20 January 1965, clipping in Churchill Sutherland Subject Box, Archives, NPG, London.

99 Berthoud, *Sutherland*, p. 187.

100 Jenkins, *Churchill*, p. 890.

101 During July 1954 Churchill rebuffed various attempts by senior Conservatives to persuade him to state when he would definitely go. By the end of the month he made it clear he would not step down until after his eightieth birthday and then probably not until March 1955. Jenkins, *Churchill*, pp. 878–888. It would not be until mid-January 1955 that he finally accepted he would have to retire early in April of the same year. Jenkins, *Churchill*, p. 892.

102 Sutherland to Lord Beaverbrook, 21 March 1961, Archives, Beaverbrook Art Gallery, Fredericton New Brunswick, Canada [BAG].

103 Berthoud, *Sutherland*, p. 188.

104 Sutherland to Beaverbrook, 9 September 1955, Archives, BAG, Canada.

105 Berthoud, *Sutherland*, p. 188.

106 Sutherland to Lord Beaverbrook, 12 September 1954, Archives, BAG, Canada.

107 Berthoud, *Sutherland*, p. 189.

108 Sutherland quoted in the *Daily Express*, 3 September 1954, clipping, Churchill Sutherland Box, Archives, NPG, London.

109 Sutherland to Honour Balfour, 3 December 1954, BBC Written Archives, Caversham, Berkshire.

110 Sutherland quoted in the *Daily Express*, 30 November 1954, clipping, Churchill Sutherland Box, Archives, NPG, London.

111 Berthoud, *Sutherland*, p. 190.

112 Ibid.

113 *The Times Magazine*, 9 May 2009, p. 14.

114 Berthoud, *Sutherland*, p. 190.

115 Sutherland in the *Sunday Telegraph*, 20 January 1965, clipping in Churchill Sutherland Subject Box, Archives, NPG, London.

116 Berthoud, *Sutherland*, p. 190.

117 Ibid. p. 191.

118 Ibid.

119 Sutherland to Lord Beaverbrook, 10 November 1954, Archives, BAG, Canada.

120 Berthoud, *Sutherland*, p. 192.

121 Ibid. p. 191.

122 Sutherland in the *Sunday Telegraph*, 20 January 1965, clipping in Churchill Sutherland Subject Box, Archives, NPG, London.

123 Sutherland quoted in the *Daily Telegraph*, 13 January 1978, clipping in Churchill Sutherland Subject Box, Archives, NPG, London.

124 Berthoud, *Sutherland*, p. 193.

125 Ibid. p. 194.

126 The final full-sized version is currently in the Musée du Chateau de Versailles though it could have been the more characterful preparatory sketch in the Musée du Louvre.

127 Berthoud, *Sutherland*, p. 195.

128 Colville quoted in the *Sunday Telegraph*, 12 February 1978, clipping in Churchill Sutherland Subject Box, Archives, NPG, London.

129 Berthoud, *Sutherland*, p. 195.

130 Lady Clementine Churchill to Lord Beaverbrook, 28 November 1954, Archives, BAG, Canada.

131 Sutherland to Lord Beaverbrook, 21 March 1961, Archives, BAG, Canada.

132 Sutherland quoted in *The Radio Times*, 28 November 1974, clipping in Churchill Sutherland Subject Box, Archives, NPG, London.

133 Berthoud, *Sutherland*, p. 197.

134 Ibid. p. 198.

135 Entry for 30 November 1954, Moran, *Winston Churchill*, p. 647.

136 Ibid. p. 652.

137 Ibid. p. 653.

138 Ibid. pp. 653–654.

139 Berthoud, *Sutherland*, p. 198.

140 *Daily Sketch*, 1 December 1954, clipping in Churchill Sutherland Subject Box, Archives, NPG, London.

141 Sutherland in the *Sunday Telegraph*, 20 January 1965, clipping in Churchill Sutherland Subject Box, Archives, NPG, London.

142 Berthoud, *Sutherland*, p. 200.

143 Sutherland to Honour Balfour, 3 December 1954, BBC Home Service Radio, BBC Written Archives, Caversham, Berkshire.

144 Berthoud, *Sutherland*, p. 200.

145 Ibid, p. 300.

146 Ibid. p. 302.

147 Ardizzone was one of the few British artists to be an official war artist for almost the entire length of the war, sketching troops in France in 1940, on the Home Front in 1941-1942, in Egypt and North Africa in 1942, in Italy in 1943-1944 and in Germany shortly before the end of the war in Europe in May 1945. Brian Foss, *War Paint: Art, War, State and Identity in Britain, 1939-1945* (New Haven and London: Yale University Press, 2007), p. 196.

148 Rothenstein, *Time's Thievish Progress*, p. 135

149 Soames, *Winston Churchill*, p. 196.

150 Jenkins, *Churchill*, p. 893.

151 Emanuel Shinwell in Eade, ed., *Churchill by his Contemporaries*, p. 82.

152 Rothenstein, *Time's Thievish Progress*, p. 139.

153 Ibid. p. 135.

154 Jenkins, *Churchill*, p. 896.

155 Cummings first produced cartoons for the left-wing *Tribune* newspaper from 1939. In 1949 he was taken on by the *Daily Express* and moved to the right politically. He would be sacked in 1989; his fierce anti-Communism and anti-Irish nationalism did not make him at all popular with left-wing print unions, or with the National Union of Journalists. Obituaries in *The Times*, 11 October 1997 and the *Daily Express*, 10 October 1997, Churchill Cartoons File, Archives, NPG, London.

156 In the late 1930s Moore had been sympathetic towards Communism. He was an official war artist from 1940 to 1942. He voted for Labour in July 1945 but turned down an offer of a knighthood from Prime Minister Clement Attlee in December 1950 on the grounds he could not imagine being addressed as 'Sir Henry'. Alan Wilkinson, ed., *Henry Moore: Writings and Conversations* (Aldershot, UK: Lund Humphries, 2002, p. 68 and pp. 131-133.

157 Soames, *Winston Churchill*, p. 197.

Chapter 7: Churchill's Twilight Years: Retirement To Finis, 1955-1965

1 Jan Gordon, 'Art and Artists', *The Observer*, 6 September 1942, p. 2.

2 Memo from Maureen Hill (National Portrait Gallery) to Sir David Piper, reporting a telephone conversation with Bernard Hailstone, 28 July 1965, Hailstone File, Archives, NPG, London.

3 Sir David Piper (National Portrait Gallery) to Robert Cecil (Foreign Office), 30 July 1965, Hailstone File, Archives, NPG, London.

4 Memo from Maureen Hill (National Portrait Gallery) to Sir David Piper, reporting a telephone conversation with Bernard Hailstone, 22 April 1966, Hailstone File, Archives, NPG, London

5 Brian Foss, *War Paint: Art, War, State and Identity in Britain, 1939–1945* (New Haven and London: Yale University Press, 2007), p. 198.

6 Andrew Roberts, *Eminent Churchillians* (London: Phoenix, 1997), p. 73.

7 Hailstone to Sir David Piper, undated (c. March 1978), Hailstone File, Archives, NPG, London.

8 Hailstone to Churchill, 1 September 1955, CHUR 2/354, CAC, CCC. A later pencil drawing was commissioned from the artist in 1956 by the Borough of Hastings.

9 Hailstone to Sir David Piper, 9 August 1965, Hailstone File, Archives, NPG, London.

10 Roy Jenkins, *Churchill* (London: Pan Books, 2002), p. 883.

11 The term 'kitchen sink', applied to the 'grubby realism' of John Bratby, Edward Middleditch and Jack Smith, had been coined in December 1954 by the critic David Sylvester in *Encounter* magazine. David Kynaston, *Austerity Britain 1945–1951* (London: Bloomsbury, 2007), p. 438.

12 One cannot imagine Churchill having much time for the 'Angry Young Men' generation. John Osborne's controversial play *Look Back in Anger* debuted at the Royal Court Theatre in Sloane Square early in May 1956; Dominic Sandbrook, *Never Had It So Good: A History of Britain from Suez to the Beatles* (London: Little Brown, 2005), p. 27. By late July 1956 the *Daily Express* was referring to Osborne and novelist Kingsley Amis as 'angry young men'. At the end of the year, the *Daily Mail* announced that it had been 'the year of Angry Young Men'. Sandbrook, *Never Had It So Good*, p. 166.

13 John Rothenstein, *Time's Thievish Progress. Autobiography III* (London: Cassell, 1970) p. 142.

14 Brendan Bracken to Oscar Nemon, 3 May 1957, Nemon 2/6, Nemon Papers, CAC, CCC.

15 Neville Wallis on the Royal Academy Summer Exhibition, *The Observer*, 1 May 1955, p. 15.

16 *The Observer*, 12 May 1957, p. 13.

17 The disturbing behaviour of disaffected youth in the form of so-called 'Teddy Boys' had first been commented upon in the British press in July 1953: David Kynaston, *Family Britain: 1951–1957* (London: Bloomsbury, 2009) p. 316.

18 Indeed, between 1902 and 1904 Churchill was identified as an ally of the young Conservative firebrand Lord Hugh Cecil (1869–1956) whose followers were known as 'Hughligans'. Jenkins, *Churchill*, p. 76.

19 Foss, *War Paint*, p. 105.

20 Sandbrook, *Never Had It So Good*, p. 517.

21 Peter Hennessy, *Having It So Good: Britain In The Fifties* (London: Penguin-Allen Lane, 2006), pp. 443–458.

22 A second version of Spear's composition was purchased in 1959 by Lord Beaverbrook to hang in the art gallery he was establishing at Fredericton, New Brunswick in Canada.

23 *The Observer*, 11 August 1957, p. 10.

24 Alan Bowness, 'Critics Choice', *The Observer*, 15 September 1957, p. 13.

25 Garlake, *New Art, New World*, p. 227.

26 *The Times*, 20 July 1959, p. 8.

27 *Glasgow Herald*, 8 March 1958, clipping McFall File, Archives, Royal Academy, London.

28 Churchill had been elected to the seat of Epping (West Essex) on 30 October 1924 as a 'Constitutionalist' allied to the Conservative Party. At the next General Election, in May 1929, he stood in the seat as a Conservative. In June 1945 the seat was divided into two and in the General Election of the following month Churchill was elected MP for the portion of the old seat which had been renamed Wanstead and Woodford. Jenkins, *Churchill*, pp. 393 and 794.

29 Sarah Crellin, *The Sculpture of Charles Wheeler* (Farnham, UK: Lund Humphries, 2012), pp. 93–95.

30 Though Moore's figuration for Harlow was really not that challenging from the point of view of contemporary avant-garde critical opinion, its simplification proved too much for the local population. The sculpture was vandalised so often it eventually had to be moved to a much less accessible and public site. Margaret Garlake, *New Art, New World: British Art in Post-War Society* (New Haven and London: Yale University Press, 1998), pp. 235–236.

31 The British Pavilion at the 1952 Venice Biennale, which opened in June that year, was dominated by 30 abstract works produced by Henry Moore, Lynn Chadwick, Eduardo Paolozzi, Kenneth Armitage, Robert Adams and Reg Butler. *The Times*, 8 April 1952, p. 9.

32 *The Times*, 1 February 1952, p. 6.

33 'The Monumental in Sculpture', *The Times*, 2 October 1956, p. 3.

34 Jenkins, *Churchill*, p. 532.

35 McFall studied sculpture at the Royal College of Art and then at the City and Guilds School in London from 1940 to 1945. He had been elected an ARA in 1955 and then a full Academician in 1963. McFall File, Archives, Library of the Royal Academy, London.

36 Churchill had first stayed at La Pausa, situated between Menton and Monte Carlo, in January 1956. He referred to it fondly as 'Pausaland'. He would return frequently during the next five years. Mary Soames, *Winston Churchill: His Life as a Painter* (London: Collins, 1990), p. 201.

37 Reves, born Imre Revesz, had moved to the USA in 1940 and from then on was Churchill's literary agent in the country. In the 1950s he handled the literary rights for Churchill's *The Second World War*. Jenkins, *Churchill*, p. 518.

38 Information courtesy of the Estate of David McFall RA.

39 The bronze statue of a standing Franklin Delano Roosevelt in London's Grosvenor Square is the work of Sir William Reid Dick and was unveiled by Roosevelt's widow Eleanor in April 1948. Dennis Wardleworth, *William Reid Dick, Sculptor* (Farnham, Surrey: Ashgate, 2013), p. 167.

40 Wendy Reves to David McFall, 4 March 1958, courtesy of the Estate of David McFall RA.

41 Wendy Reves to David McFall, 20 March 1958, courtesy of the Estate of David McFall RA.

42 McFall quoted in the *Daily Telegraph*, 16 January 1978, clipping courtesy of the Estate of David McFall RA.

43 McFall interviewed in the *Daily Herald*, 31 March 1958, clipping courtesy of the Estate of David McFall RA.

44 Ibid.

45 Newspaper clipping, 12 May 1958, McFall File, Archives, RA, London.

46 Information courtesy of the Estate of David McFall RA.

47 Soames, *Winston Churchill*, p. 204.

48 McFall File, Archives, RA, London.

49 McFall to the *Daily Telegraph*, 10 January 1978, clipping courtesy of the Estate of David McFall RA.

50 McFall quoted in the *Daily Telegraph*, 16 January 1978, clipping courtesy of the Estate of David McFall RA.

51 Ibid.

52 Neville Wallis, 'At the Galleries: Things Old and New', *The Observer*, 23 November 1958, p. 16.

53 Clipping from an unidentified newspaper, dated 5 December 1958, courtesy of the Estate of David McFall RA.

54 Clipping from an unidentified newspaper, dated 5 December 1958, courtesy of the Estate of David McFall RA.

55 Ibid.

56 *London Evening Standard*, 6 December 1958, clipping courtesy of the Estate of David McFall RA

57 Ibid.

58 *The Times*, 8 December 1958, clipping courtesy of the Estate of David McFall RA.

59 Ibid.

60 See the verdict of Max Hastings, *Finest Hour: Churchill as Warlord* (London: HarperPress, 2009), p. 594 and Dr Andrew Norman, *Winston Churchill: Portrait of an Unquiet Mind* (Barnsley, UK: Pen & Sword Military, 2012), pp. 128–137.

61 Jenkins, *Churchill*, p. 775.

62 Ibid. p. 787.

63 Hastings, *Finest Hour: Churchill as Warlord*, p. 572.

64 Jenkins, *Churchill*, p. 798.

65 *Daily Telegraph*, 8 December 1958, clipping, McFall File, Archives, RA, London.

66 Lady Clementine Churchill to David McFall, 13 December 1958, courtesy of the Estate of David McFall RA.

67 *TheTimes*, 24 January 1959, clipping courtesy of the Estate of David McFall RA.

68 Louis Stanley, *The Sketch*, 10 September 1959, clipping courtesy of the Estate of David McFall RA.

69 *The Evening News*, Saturday, 31 October 1959, p. 1.

70 *The Woodford Times*, Friday, 6 November 1959, p. 1.

71 Ibid. p. 1.

72 Jenkins, *Churchill*, p. 611.

73 Malcolm Smith, *Britain and 1940. History, Myth and Popular Memory* (London: Routledge, 2007 [first published 2000]), pp. 4–6.

74 Sandbrook, *Never Had It So Good*, p. 92.

75 Kynaston, *Family Britain: 1951–1957*, p. 105.

76 Hennessy, *Having It So Good: Britain In The Fifties*, p. 520.

77 Ibid. p. 573.

78 Ibid. p. 2.

79 Bell, much to Churchill's displeasure, had denounced the RAF's policy of area bombing in the House of Lords in February 1944. The Prime Minister was even more furious when Bell was backed, behind the scenes, by a former Archbishop of Canterbury and the sitting Archbishop of York. Michael Burleigh, *Moral Combat: A History of World War II* (London: HarperPress, 2010), pp. 504–505.

80 *The Woodford Times*, Friday, 6 November 1959, p. 2.

81 Jenkins, *Churchill*, p. 900.

82 Julia Pannett to Miss Sloan (National Portrait Gallery), 11 November 1965, Pannett File, Archives, NPG, London.

83 Gerald Scarfe to Dr Jonathan Black, e-mail, June 2015.

84 Julia Pannett to Miss Sloan (National Portrait Gallery), 9 December 1965, Pannett File, Archives, NPG, London.

85 The first issue of *Private Eye* was published in October 1961. Sandbrook, *Never Had It So Good*, p. 543.

86 Jenkins, *Churchill*, p. 911.

87 Dominic Sandbrook, *White Heat: A History of Britain in the Swinging Sixties* (London: Little Brown, 2006), pp. xi–xiii.

88 Information courtesy of the Palace of Westminster Art Collection, November 2014.

Chapter 8: Churchill's Visual Legacy: Memorials, 1965–1999

1 Churchill House of Commons Statue Commission (1965–1969), PWO/2/34, House of Commons Archives, London.

2 Duncan Sandys MP to Emanuel Shinwell MP, 26 August 1965, DSND 13/8 (1965–1975) Duncan Sandys Papers, CAC, CCC.

3 Emanuel Shinwell MP to Duncan Sandys MP, 23 September 1965, DSND 13/8 (1965–1975) Duncan Sandys Papers, CAC, CCC.

4 Jonathan Black and Sara Ayres, *Abstraction and Reality: The Sculpture of Ivor Roberts-Jones* (London: Philip Wilson Publishers, 2014) p. 64.

5 *The Guardian*, 2 December 1969, clipping, Churchill in Sculpture File, Archives, NPG, London.

6 While the House of Commons is in session, the Members Lobby is out of bounds to those who elected them.

7 John Ramsden, *Man of the Century: Winston Churchill and his Legend since 1945* (London: Harper Collins, 2003) p. 111.

8 *The Times*, 24 July 1969, p. 1.

9 Churchill was hailed at the time as the 'Liberator of Brussels' in September 1944, while the statue also recalled his being awarded the freedom of the city on a visit he made there in November 1945. Mary Soames, *A Daughter's Tale: The Memoir of Winston and Clementine Churchill's Youngest Child* (London: Doubleday, 2011), p. 365.

10 This statue in part commemorated the fact Churchill had been awarded the freedom of Luxembourg City in 1946. Ramsden, *Man of the Century*, p. 290.

11 Press release for unveiling of a statue in Nathan Phillips Square, 23 October 1977, Nemon 2/6, Nemon Papers, CAC, CCC.

12 Roy Jenkins, *Churchill* (London: Pan Books, 2002), pp. 809–810.

13 Between 1972 and 1992 Belsky produced a portrait of Churchill in low-relief for the P&O Ferry, *The Spirit of London* (1972); a bronze head of Churchill for the Library of the Churchill Archive, Churchill College, Cambridge (1985) and a bronze head and shoulders of him to sit in a niche near the British Embassy in Prague (1991–1992).

14 Obituary, *The Guardian*, 5 July 2000, clipping, Belsky Papers, Archives, HMI, Leeds.

15 Obituary, *Daily Telegraph*, 7 July 2000, clipping, Belsky Papers, Archives, HMI, Leeds.

16 Black and Ayres, *Abstraction and Reality*, p. 64.

17 *Hansard*, 3 July 1969, p. 638.

18 *The Times*, 5 March 1970, p. 11.

19 Minutes of the Winston Churchill Statue Committee [WCSC], 17 December 1969, DSND 13/8, Sandys Papers, CAC, CCC.

20 Minutes of the WCSC, 25 February 1970, DSND 13/8, Sandys Papers, CAC, CCC

21 Minutes of the WCSC, 22 April 1970, DSND 13/8, Sandys Papers, CAC, CCC.

22 Entry for 24 April 1953, Lord Moran, *Winston Churchill: The Struggle for Survival, 1940–1965* (London: Sphere Books, 1968), p. 428.

23 Minutes of the Adjudicating Sub-Committee of the WCSC, 1 July 1970, DSND 13/8, Sandys Papers, CAC, CCC.

24 Roberts-Jones interviewed by Bryon Rogers, 'Churchill Rises in the Barn', *Daily Telegraph*, 12 January 1973, clipping, Department of the Environment, PWO 1/105 AD II, National Archives, Kew Gardens, London.

25 Roberts-Jones commanded the 5th Battery, 27th Field Artillery Regiment in Burma from 6 May 1944 to 28 July 1945. He spent much of November 1944 in a field hospital being treated for malaria. Roberts-Jones Army Service Record (Forms B199A; W 3149 and X214), Army Personnel Centre, Historical Disclosures, Kentigern House, Glasgow; accessed by Dr J. Black, September 2013.

26 Roberts-Jones to Dr Peter Cannon Brookes (Keeper of Art, National Museum of Wales, Cardiff), 29 December 1981, Roberts-Jones Papers, Archives, NMWC.

27 In 1970, Roberts-Jones could not raise much enthusiasm for either Conservative Prime Minister Edward Heath, or the Labour Leader of the Opposition, Harold Wilson. By the end of the decade, however, he had become rather an admirer of Margaret Thatcher. Roberts-Jones interviewed by Ian Collins, 'Sculptor Ivor Captures Fame and Fortune', *Eastern Daily Press*, 4 January 1994, p. 6.

28 Black and Ayres, *Abstraction and Reality*, p. 67.

29 Ibid. p. 66.

30 Ibid. p. 68.

31 Entry for 10 November 1944 in John Julius Norwich, ed., *The Duff Cooper Diaries* (London: Phoenix, 2006), p. 335.

32 Minutes of the Adjudicating Sub-Committee of the WCSC, 3 November 1970, DSND 13/8, Sandys Papers, CAC, CCC.

33 F. Fielden, (Secretary to the RFAC) to Sir John Tilney, Minutes of WCSC, 17 November 1970, DSND 13/8, Sandys Papers, CAC, CCC.

34 Sir John Tilney to Duncan Sandys, 10 December 1970, DSND 13/8, Sandys Papers, CAC, CCC.

35 Sir John Tilney to all members of the WCSC, 16 February 1971, copy, DSND 13/8, Sandys Papers, CAC, CCC.

36 Sarah Churchill to Lady Clementine Spencer-Churchill, 8 February 1971, Nemon 2/6, Nemon Papers, CAC, CCC.

37 Richard Crawfurd-Benson (Secretary of the WCSC), to Duncan Sandys, 11 March 1971, DSND 13/8, Sandys Papers, CAC, CCC.

38 Bryon Rogers, 'Churchill Rises in the Barn', *Daily Telegraph*, 12 January 1973, clipping, DSND 13/8, Sandys Papers, CAC, CCC.

39 Richard Crawfurd-Benson to Sir John Tilney, 7 April 1972, copy, DSND 13/8, Sandys Papers, CAC, CCC.

40 Entry for 15 October 1951, Moran, *Winston Churchill*, 1968, p. 371.

41 Sir John Tilney, progress report to members of the WCSC, 22 January 1972, DSND 13/8, Sandys Papers, CAC, CCC.

42 Richard Crawfurd-Benson to Winston Churchill MP, 10 March 1973, DSND 13/8, Sandys Papers, CAC, CCC.

43 Sir John Tilney to the members of the WCSC, 11 June 1973, DSND 13/8, Sandys Papers, CAC, CCC.

44 Black and Ayres, *Abstraction and Reality*, p. 81.

45 Sir John Tilney quoted in 'Resolute and Defiant as Ever, Churchill's Statue is Unveiled', *The Times*, 2 November 1973, p. 2.

46 Sir Charles Wheeler, letter to *The Times*, 6 November 1973, p. 21.

47 Mr H.A.H. Harris, letter to *The Times*, 6 November 1973, p. 21.

48 Loyd Grossman quoted in *The Times*, 3 August 1985, p. 13.

49 Roberts-Jones quoted in *The Sunday Telegraph*, 27 June 1993, p. 5, Press Clippings File, IRJ Papers, HMI, Leeds and *The Eastern Daily Press*, 4 January 1994, p. 6, Press Clippings, IRJ Papers, HMI, Leeds.

50 Peter Mathews, *London's Statues and Monuments* (Oxford: Shire Publications, 2012), p. 30 and Andrew Kershman, *London's Monuments: From Boudicca and Byron to Guy the Gorilla* (London: Metro Publications, 2013), p. 72.

51 Black and Ayres, *Abstraction and Reality*, p. 83.

52 James J. Coleman Jr, interviewed by Dr S. Ayres, 22 October 2012.

53 The corporation was established by King Henry VIII at Deptford in 1514. Churchill was made an Elder Brother of Trinity in 1913. Jenkins, *Churchill*, p. 206.

54 James J. Coleman interviewed by Dr S. Ayres, 22 October 2012.

55 Hastings, *Finest Years: Churchill as Warlord*, p. 15.

56 The 'V for Victory' gesture had first been suggested by Victor de Laveleye, the Belgian Minister of Justice in the Belgian Government-in-Exile in London in a broadcast he made to the Belgian people on 14 January 1941. On 19 July 1941, Churchill referred in a speech to the need to promote the 'V for Victory campaign' in occupied Europe and for the British people to show solidarity by adopting the gesture. Jenkins, *Churchill*, p. 666.

57 Entry for 26 September 1941, John Colville, *The Fringes of Power: Downing Street Diaries, 1939–1955* (London: Phoenix, 2005), p. 384: 'The PM will keep giving the "V" sign with the palm inwards which will offend the delicate.'

58 Roberts-Jones to Sir John Rothenstein, c. September 1985, Rothenstein Papers, Archives, Tate Britain, London.

59 *New Orleans Times Picayune*, 20 November 1977, p. 1.

60 Black and Ayres, *Abstraction and Reality*, p. 256.

61 Ray Samuel (Hon. British Vice-Consul to New Orleans), to Roberts-Jones, 10 February 1978, papers of James J. Coleman OBE (Hon. British Consul for Louisiana).

62 Gerard de Groot, *The 60's Unplugged: A Kaleidoscopic History of a Disorderly Decade* (London: Macmillan, 2008), p. 381.

63 Robert Hewison, *Culture and Consensus: England, Art and Politics Since 1940* (London: Methuen, 1997), p. 298 and Mark Connelly, *We Can Take It! Britain and the Memory of the Second World War*, London: Longman, 2004), pp. 285–290.

64 Fred Inglis, *A Short History of Celebrity* (Princeton, NJ: Princeton University Press, 2010), p. 245.

65 Margot Asquith observing Churchill and his wife during a trip in the Admiralty steam yacht to Greece in May 1913. Michael Shelden, *Young Titan: The Making of Winston Churchill* (London: Simon & Schuster, 2013), pp. 288–289.

66 Churchill to Clementine Churchill, 24 January 1916 in Mary Soames, ed., *Speaking for Themselves: The Personal Letters of Winston and Clementine Churchill* (London: Black Swan, 1999), p. 161.

67 Churchill to Clementine Churchill, 30 January 1935 in Soames, ed., *Speaking For Themselves*, p. 379. Before she left the UK in December 1934 their marriage had been under strain, mostly due to financial problems and Churchill's inability to cut his expenditure despite his ability to make considerable sums from articles. She was very taken with a fellow passenger on Lord Moyne's yacht, a wealthy art collector called Terence Philip. It was the one occasion when her otherwise steadfast faithfulness to her husband was seriously tested: Soames, *A Daughter's Tale*, p. 87.

68 Dr Andrew Norman, *Winston Churchill: Portrait of an Unquiet Mind* (Barnsley, UK: Pen & Sword Military, 2012), p. 155.

69 Ibid. p. 207.

70 On another occasion a clearly delighted Churchill recalled how 'Clemmie' had inflicted a verbal mauling on a heckler at public meeting in Dundee during the General Election campaign of November 1922: 'she dropped on him like a jaguar out of a tree'. Soames, *Clementine Churchill*, p. 261.

71 *Daily Telegraph*, 12 March 1978, clipping in Churchill Sculpture File, Archives, NPG, London.

72 *Daily Telegraph*, 30 November 1990, clipping in Churchill Sculpture File, Archives, NPG, London.

73 Coward first visited Chartwell in August 1939; then, and thereafter, Churchill enjoyed his renditions of 'Mad Dogs and Englishmen' and 'The Stately Homes of England.' Mary Soames, *A Daughter's Tale: The Memoir of Winston and Clementine Churchill's Youngest Child* (London: Doubleday, 2011), p. 129.

74 Holofcener quoted in *The Times*, 3 May 1995, clipping in Churchill Sculpture File, Archives, NPG, London.

75 Ibid.

76 Peter Matthews, *London's Statues and Monuments* (London: Bloomsbury, 2012), pp. 106–107.

77 Personal observation, noon to 1 pm, 4 August 2015, New Bond Street, London.

78 Black and Ayres, *Abstraction and Reality*, pp. 286–287.

Epilogue: Churchill for the Twenty-first Century

1 *The Independent*, 10 May 2000, p. 10 and 6 July 2000, p. 6.

2 Matthews at his trial expressed his sorrow for his act, particularly when he discovered the artist of the Churchill statue had himself been a veteran of two years fighting against the Japanese in Burma. He was found guilty and sentenced to one month in prison. He was also fined £250 by the Royal Parks Agency for criminal damage. Nathalie Curry, '1066 and All That', *The Independent*, 28 May 2000, p. 10.

3 Mark Garnett, *From Anger to Apathy: The Story of Politics, Society and Popular Culture in Britain since 1978* (London: Vintage Books, 2008), pp. 330–331.

4 Ironically, both Garland's parents had been convinced Communists; he broke with the party at the time of the Soviet invasion of Hungary in November 1956 and from 1966 to 1986 and 1991 to 2011 worked for the conservative newspaper the *Daily Telegraph*. Career outline: *The Spectator*, 26 March 2011, p. 11.

5 Will Ellsworth-Jones, *Banksy: The Man Behind the Wall* (London: Aurum, 2012), p. 126.

6 Banksy interview with Cosmo Landesman, *Sunday Times*, 20 July 2003, p. 9.

7 Ellsworth-Jones, *Banksy: The Man Behind the Wall*, pp. 126–127.

8 *The Independent*, 15 November 2008 – clipping, Churchill Sculpture File, Archives, NPG, London.

9 Harvey to Dr Jonathan Black, July 2015.

10 Winston Churchill, *My Early Life* (London: Eland, 2002 [1930]), pp. 188–192.

11 Dominic Sandbrook, *Seasons in the Sun: The Battle for Britain, 1974–1979* (London: Penguin Allen Lane, 2012), p. 563.

12 Churchill made a rare early reference to suffering from the depressive effects of his 'black dog' in a letter to his wife in July 1911. Mary Soames, ed., *Speaking for Themselves: The Personal Letters of Winston and Clementine Churchill* (London: Black Swan, 1990), p. 53.

13 Clementine Churchill at first referred to her husband as her 'pug', or 'pug-dog', but as time passed and he put on weight she would invariably draw him in her letters to him

as a diminutive, rotund and friendly pig. Dr Andrew Norman, *Winston Churchill: Portrait of an Unquiet Mind* (Barnsley, UK: Pen & Sword Military, 2012), p. 63.

14 Anita Leslie, *Clare Sheridan* (New York: Doubleday, 1977), p. 65

15 Entry for 8 October 1940 in John Colville, *The Fringes of Power: Downing Street Diaries, 1939–1955* (London: Phoenix, 2005), p. 218.

16 The image was very much admired in 2010 by Lady Soames; Haines to Dr. Jonathan Black, July 2015.

17 Andrew Roberts, *Hitler and Churchill: Secrets of Leadership* (London: Phoenix, 2004), p. 128 and Laurence Rees, *World War Two Behind Closed Doors: Stalin, the Nazis and the West* (London: BBC Books, 2008), p. 214.

18 Soames, *A Daughter's Tale*, p. 283. Many years earlier, in 1916, Churchill had described war 'as a game . . . played with a smile' to his wife: Winston Churchill to Clementine Churchill, 27 January 1916 in Mary Soames, *Clementine Churchill: The Revised and Updated Biography* (London: Doubleday, 2002), p. 186.

19 Entry for 10 September 1944 in Alex Danchev and Daniel Todman, eds., *War Diaries, 1939–1945. Field Marshal Lord Alanbrooke* (London: Phoenix, 2002), p. 590.

INDEX

Bold indicators signify a picture.

Air Commodore 234
Aitken, Max 5
Alibhai-Brown, Yasmin 105
Allen, Dennis 185
Allies (Holofcener, 1995) 221–2, **221**
Amalgamated Union of Building Trades Workers [AUBTW] 77–8
American heritage 59–60, 98
Amery, Leo 81
Anglo-Irish Treaty negotiations (1921) 37
animal figures 63, 136, **137**, 232–3 *see also* bulldog imagery
anti-Capitalist demonstrations 225
anti-socialist candidacy 63
Anzio 123–5
Ardizzone, Edward 173–5, **174**
armoured cars 29, 37–8
Army Major 30, 38
Arras 38
Artists' International Association 88
Asquith, H.H. 6, 21–3, 32, 35, 42, 49
Asquith, Margot 218
Asquith, Violet (Bonham-Carter) 21, 35
assassination, concerns over 63
Attlee, Clement 125, 128, 129, 136, 143, 195
Austin, Robert Sargent 120–2

Bacon, Francis 171, 184
Baldwin, Stanley 33, 64, **69**, 70, 78, 80, 89
Balfour, Honour 159
Balzac, Honoré de 211
Banksy 227–8
Barker, Carl 139
Barley Mow (bulldog mascot) 105
Bassano Ltd **20**
Bateman, Henry Mayo 131–2, **132**

Battenberg, Prince Louis of 29
BBC 159, 172
beach photograph 4
Beaton, Cecil 43, **96**, 98
Beaverbrook, Lord 5–6, 7, 73, 112, 128, 153, 154, 155, 157, 169
Bell, Bishop, of Chichester 199–200
Belsky, Franta 208, **209**
Bengal Famine 81
Bermuda Conference 143
Berry, Michael 6, 76
Berry, William (Lord Camrose) 5, 6, 55, 76, 89
Berthoud, Roger 168
Bevan, Aneurin 170
Beveridge, William 122
Birkenhead, Lord 50
Birley, Oswald 114, 119, 127–8, 154, 180
Black, Jeremy 35
black swans 67
Blitz, London 95, 179, 231–2
'Blood, sweat and tears' speech 106
Bodkin, Thomas 37
Boer War 14–16
boiler/siren suit 4, 76, 82–3, 107–9, **108**, **110**, 120, 125, 167
Bolsheviks 45, 47–9, 53–5, 57, 58, 72
Bonham-Carter, Violet (née Asquith) 21, 35
Boonham, Nigel 223
Boothby, Robert 'Bob' 33
Bottomley, Horatio 75
bow tie 3, 13, 77, 106, 155
Bowness, Alan 185
Boyle, Danny 215
Bracken, Brendan 119, 147, 183
brass miniatures 88

Bratby, John 184
bricklaying 76–8, 83
British Expeditionary Force 57, 99
Brook, Norman 145
Brooke, Alan 146, 235
Browne, Felicia 83
Brussels 208
bulldog imagery 89, 91, 101, **102**, 105, 123, 140, 155, 199, 231
bulldog mascot 122, **123**
Butler, R.A.B. 98
Butler, Reg 185, 186

Camrose, Lord (William Berry) 5, 6, 55, 76, 89
Canada 106, 208
Capa, Robert 83
Carstairs, J.L. 85, **87**
carte de visite 11
cartoons
 in 1930s 85–8
 animal figures 63, 101, **102**, 136, **137**, 232–3
 Carstairs **87**
 Cummings **176**, **186**
 Emmwood **198**
 Evans 67, **69**
 Gabriel 133, **134**
 Garland **227**
 hats in 4, 28
 Illingworth **97**, **100**
 Kem 124, **125**
 Kukrinikzi 133, **135**
 Low 58–9, **60**, **62**, **64**, **65**, **71**, **81**, **99**, **126**, 133, **137**, 145–6, **146**, 231
 Partridge **19**
 Ravenhill **22**
 Reed **18**
 Simplicissimus **94**
 Spi **77**
 Steadman 231–2, **232**
 Strube 24, **25**, **48**, **61**, **79**, **102**, 133, **145**, 225, 231
 Weisz **95**, 96

'Cartoons and Cartoonists' (Churchill, *Strand Magazine*, 1931) 4
Casque Adrian helmet 37, 38, 40, 101
cats 82, 116, 232
ceramics
 Cliff's Toby jug 89, **90**
 John-Bull style 76
Chamberlain, Neville 93, 96, 98, 187
Chancellor of the Duchy of Lancaster 28, 30, 35, 38, 75
Chancellor of the Exchequer 33, 64–5, 70, 78
Channon, Henry 'Chips' 98
Chantry Bequest 190
'Chartwell Bust' (McFall, 1958) 190–2, **191**, 196
Chartwell Manor
 bought for the nation 6, 55
 Churchill building walls at 76
 as location for Sutherland portrait sittings 154–5
 Married Love (Nemon, 1977–1990) **219**, 221
 reconstruction of 63, 66–7, 76, 91
 Sickert's visits to 73
 Study for Breakfast at Chartwell II (Nicholson, 1934–5) 82, **84**
 and the Sutherland portrait 172
cherub 155, 157, 196
Chief Ear-To-The-Ground Winston (Strube, 1920) **61**
Church of England 199–200
Churchill, Clementine (née Hozier)
 on 1945 General Election 125
 birth of Sarah 66
 and Clare Sheridan 119
 on Karsh photograph 106
 on Lincoln Memorial statue 149
 marriage to Winston Churchill 21, 28, 219–20
 Married Love (Nemon, 1977–1990) 217–20, **219**
 on McFall statue 187, 194, 196–7
 on memorial statues 205, 206, 213

INDEX

on Nemon's sculptures 137–8, 143, 151, 152
photographs of 4, 43
in portraits 82, **84**
presented with Salisbury portrait 107
Red Cross Aid to Russia 104, 119
on Robert-Jones' memorial statue 215
on Sickert portrait 75, 76
and the Sutherland portrait 154, 156, 162–3, 166–7, 168–9, 172, 191
unveiling of Parliament Square statue 214
and Walter Sickert 73
Winston Churchill as 'pug dog' of 101, 275 n.12
on Winston Churchill's depression 42
as Winston's 'cat/kat' 231
Churchill, Consuelo (née Vanderbilt) 249 n.80
Churchill, Cornelia 49
Churchill, Diana (daughter) 141
Churchill, Gwendoline 'Goonie' 35
Churchill, Ivor 75
Churchill, Jack (brother) 35, 42
Churchill, June (daughter-in-law) 162–4
Churchill, Lady Randolph/Jennie Jerome (mother) 49, 59–90, 118, 128, 155
Churchill, Mary (daughter) *see* Soames, Mary
Churchill, Randolph (father) 13, 49
Churchill, Randolph (son) 162–4
Churchill, Sarah (daughter) 66, 205, 213, 235
Churchill, Winston (grandson) 208, 213
Churchill by his Contemporaries (1953) 37
Churchill College, Cambridge **140**, 271 n.13
Churchillian Cat (Steadman, 2010) 232
cigars 22–3, 57, 106, 116, 117, 131, **163**, 165
Clanwilliam, Lord 127
Clark, Jane 165
Clark, Kenneth 88–9, 119, 165
Clark Kerr, Archibald 109

Clemenceau, Georges 101, 213
Cliff, Clarice 89, **90**
clothing *see* dress
coalition government 32, 35, 63
Cogné, François 213
Coldstream, William 172, 190
Coleman Jr, James J. 215–17
Collett, Kingsley 152
'Colonel Blimp' 252 n.33
Colonial Office 105
Colville, John 'Jock' 95, 109, 139, 141, 143, 168, 171, 216, 220, 232
'common man' 70, 72, 193
common touch 44
Commonwealth 105, 136
Communism 44, 45, 54–5
'Comrades in Arms: Pictures of the Soviet People at War' **105**
Conservative MP, Churchill as 13, 16, 27, 32, 64
Constituency Association 185, 187
'conversation pieces' 82
Cooper, Alfred Duff 6, 33, 80, 97, 112
Cooper, Alfred Egerton 110, **113**
Corporation of London 147, 149–50
Court of Brotherhood 180
Coward, Noël 221
Crewe, Marquess of 33
Cromwell Road, Kensington 35
Cruikshank, Isaac 89
Cummings, Michael 175, **176**, **186**

Daily Express 25, **48**, **61**, 79, **102**, **145**, 151, 160, 171, **176**
Daily Herald **137**, 189
Daily Mail 97, **100**, **198**
Daily Mirror 95
Daily Telegraph 14, 89, **95**, 149, 171, **227**
Daily Worker **134**
Dalton, Hugh 101
Dalton, Roy 194–5
damage to paintings 33
Dardanelles Expedition 23, 35, 36, 42–4
Darlan, François 116

De Forest, Baron Maurice Arnold 'Fruity Tuty' 28–30
death of Churchill 146, 200
defection from Conservatives to Liberal party 16, 27, 32
della Francesca, Piero 112, 122
depression ('black dog') 35, 42, 44, 127, 175, 231
Devonshire Club 107
Dobson, Frank 80
double chin 130, 156, 166, 189
Doughty, Adelaide 167–8
Doughty, Charles 153, 154, 167–8
Dover 208
10 Downing Street 43, **96**, 115–16, 172, 175
drawings
 Ardizzone's **174**
 L.M. Ward's 'Spy' 13–14, **15**
 Mortimer Menpes' 16, **17**
 Nemon's **138**
 Nicholson's 84
 Orpen's *Winston Churchill* (1916) **41**
 Sickert's **74**, 76
 Sutherland's 155, 157, **164**
 Winston Churchill à la Picasso (Bateman, 1949) **132**
 Winston Churchill in his Robes as Chancellor of the Exchequer (Sargent, 1925) **66, 68**
dress *see also* hats
 army uniforms **12**, 30–1, 38–9, **39**, 234
 bow tie 3, 13, 77, 106, 155
 in cartoons 67, 70, 76–7
 Churchill's distinctive style 3–4
 Churchill's like father's 13
 Elder Brother of Trinity House 218, 254 n.20
 in Evans' cartoons 67, 70
 Knight of the Garter robes 155, 157, 166, 170, 211
 as 'Mahatma Windhi' 80–1
 in Orpen's portrait 42
 Roberts-Jones maquette 211
 robes 64–6, 147, 155, 157, 166, 170, 211
 in Salisbury's portraits 107
 siren suit 4, 76, 82–3, 107–9, **108, 110**, 120, 125, 167
 spats 76, 83
 statue (City robes) 147
 in Sutherland portrait 154, 155, 157, 159, 166, 170
 Winston Churchill Wearing a Fez (Haines, 2010) 233–4
Dundee, Liberal MP for 32, 63
Dunkirk crisis 97, 101
Dunlop, R.O. 184

Eccleston Square house 35
Eden, Anthony 98, 103, 128, 146, 153, 175
Edward VIII, King 89
Egypt 11–13
Eisenhower, Dwight D. 153
Elder Brother of Trinity House 218, 254 n.20
Elgin, Ninth Earl of 19
Elgin Marble, An (Partridge, 1906) **19**
Elizabeth II, Queen 139, 143, 147, 175
Elliston, George 147
Enchantress (yacht) 27
'end of the beginning' speech 112
Epping, Conservative MP for 32, 64, 105, 269 n, 267 n.28
Epstein, Jacob 79–80, 119, 128–31, **129**, 185, 189
escape from POW camp 14
Evans, Powys 67–70, **69**
Evening Standard 24, 77, 96, **99**, 125, **126**, 147
eyes 31, 70, 103, 156, 157, 166, 192

Fascism 7, 72, 85, 129
Fayolle, General 38, **39**
female imagery 133
Finch, John 129–30
First Lord of the Admiralty (1911–1915) 19, 23, 27, 29, 30–1

First Lord of the Admiralty (1939–40) 33, 88, 89–90, **90**, 93
franchise, extension of 20
French, Daniel Chester 149
Frewen, Clara (née Jerome) 49, 52
Friell, James *see* Gabriel
funeral 200

Gabriel 133
Gallipoli 35
Gandhi, Mahatma 80, 117
Garland, Nicholas 226–7, **227**
Garter Knight robes 155, 157, 166, 170, 211
General Elections
 1910 4
 1918 45
 1922 32, 63, 274 n.70
 1924 32
 1929 78
 1945 125, 127, 128, **183**
 1950 105, 133
 1951 214
 1955 200
 1959 199
General Strike 70, 73, 78
George VI, King 109, 129, 139
Gerard, Ethel 28
Gibb, A.D. 39–40
Gilbert, Martin 42
Gillray, James 89
Glasgow 44–5
Glover, Brian 221
'Go To It' (Strube, 1940) **102**
God of War (Kennington, 1933–35) 85, **86**, 88
Goebbels, Josef 10, 89
Gold Standard 65
Gort, Lord 99
Gowing, Lawrence 190
Great Contemporaries (Churchill, 1937) 7, 8, 23–4
Grenadier Guards 30, 38
Guernica (Picasso) 131–2

Guest, Frederick 49–50, 52, 55, 114
Guildhall 147, 149, 151–2, 177
Gunn, Herbert James 153, 185
Guthrie, James 56–8, **56**, **59**

Haig, Douglas 121
Hailsham, Lord 170, 194
Hailstone, Bernard 179–81, **181**
Haines, Sarah 233–4, **234**
hair 56
Halifax, Lord 98, 99
Hamilton, Baillie 76
hands 13, 149, 151, 155, 190
Harmsworth, Harold 5
Harrow 13, 107
Hartwell, Lord (Michael Berry) 6, 76
Harvey, Marcus 228
hats
 Admiral's 89
 British army issue helmets 101
 in cartoons 4, 28
 Casque Adrian helmet 37, 38, 40, 101
 Churchill's distinctive style 4–5, 22
 whilst bricklaying 76
 Winston Churchill Wearing a Fez (Haines, 2010) 233–4, **234**
heart attack 222
Heaton, Frederick 107
Hecht, Alfred 166, 171
Hemingway, Ernest 83
Henley, Sylvia 137–8
Hindenburg, Field Marshal Paul von 7, 8–10, 101
Hitler, Adolf 8, 44, 85, 93, 95, 101, 125, 195
Hitler's Nightmare (Kem, 1944) 124, **125**
'Hobbies' (Churchill, 1925) 36
Hoe Farm, Godalming 36
Holofcener, Lawrence 221–2
Home Secretary (1910–1911) 19, 20–1, **20**, 24
Hore-Belisha, Leslie 3–4, 5, **94**, 96, 254 n.9
Hozier, Blanche 73
Hozier, Clementine *see* Churchill, Clementine

Hulton, Edward 240 n.17
Hyde Park Gate 128, 130, 172, 200
hydrogen bombs 153, 173
Hymen, J. 11, **12**

Ian Hamilton's March (Churchill, 1900) 16
Illingworth, Leslie Gilbert **97**, 98, 99, **100**
Illustrated London News 200
Impressionism 36, 131
India 58, 78, 80–2
Iraq 200
Ireland, Northern 24, 37, 58, 63
Ireland, Republic of 57, 58
'Iron Curtain' speech 128, 208
Ironside, Edmund 'Tiny' 85
Iskustvo 133, **135**
Israel 131

Jenkins, Roy 27, 29, 139
Jerome, Jennie *see* Churchill, Lady Randolph
John, Augustus 36
John Bull 75, 89–91
Joynson-Hicks, William 73
Juda, Elsbeth 165

Kaiser Wilhelm 19
Kamenev, Lev 53
Kansas City 221
Karsh, Yousuf 106, **107**, 227
Kelly, Gerald 140, 185
Kem (Marnego, Kimon Evan) 124, **125**
Kennington, Eric 8, 10, 85, **86**, 88, 119
'King's Party' 89
Knight of the Garter robes 155, 157, 166, 170, 211
'knuts' 23, 184
Kremlin 103
Kukrinikzi 133, **135**

La Mamounia hotel 6, 136
La Pausa, Rocquebrune 187

Lavery, Hazel 33, 36, 37
Lavery, John 29–30, 33–4, **34**, 36, 37, 40
Lawrence, T.E. 7–8, 85
Layton, Miss 116
Le Petit Parisien **125**
Lee, Jennie 153
Leicester West 63
Leigh, Lance-Corporal J. 122, **123**, 124
Lenin, Vladimir 53, 54, 55, 60
Leslie, Anna 116
Liberal Party 16, 27, 32, 63
Liddell Hart, Basil 88
Lieutenant-Colonel uniform 38–9
Lincoln Memorial 149
Lindemann, Frederick 73
lisp 13, 16
Lloyd George, David 6–7, 24, 27, 28, 29, 31, 32, 43, 44, 45, 47, 49, 57, 58
Locker-Lampson, Oliver 29–30, 37–8
London Blitz 95, 179, 231–2
London to Ladysmith (Churchill, 1900) 16
London Underground posters 120
Low, David 6, 33, 58–64, **60**, **62**, **64**, **65**, 70, 71, 72–3, 80–1, **81**, 85–6, **99**, 125, **126**, 133, 136, **137**, 145–6, **146**, 231, **233**
Lucas, John 124
Lutyens, Edwin 109, 114
Luxembourg City 208

MacDonald, Ramsey 78, 80, 250 n.2
Macmillan, Harold 199
Maisky, Ivan 83
Major, Army 30, 38
Malenkov, Georgy 153
Mallinson, Stuart 185, 193–4, 196
Manchester Guardian **146**
marble bust commissioned by Elizabeth II 139, 143, **144**, 147
Marlborough, Dukes of 8, 49, 75, 93, 139
Marnego, Kimon Evan (Kem) 124, **125**
Marrakech 6
Marsh, Edward 75
Marshall, Georg 9

INDEX

mascots 122
Matisse, Henri 131
Matthews, James 225
Maugham, Somerset 166
McEvoy, Ambrose 6, 50, 53, 55
McFall, David 106, 130, 185–99, **188**, **191**
McLeavy, Frank 153
Members Lobby, House of Commons 205, 206, **207**, 210
Men at Arms (Waugh, 1952) 5
Menpes, Mortimer 16, **17**
Menzier, Robert 208
Methuen, Lord 84
Mexico City 208
MI5 54
Middleton, H.H. 172
miners' strikes 21, 24
miniature figures 88
Minister of Munitions 31, 42, 44
Ministry of Information 104, 112
models/sitters (other than Churchill himself) 151, 157
Mohican 225, **226**, 228, **229**
Molotov, Vyacheslav 135
Montgomery, Field Marshal Bernard **110**, 191, 197
Moore, Henry 175, 186, 197
Moran, Lord 13, 103, 153–4, 159, 172–3, 216, 243 n.44, 252 n.32
Morning Post 14
Morshead, Owen 143, 147
Moss, Charles H. 185
Mountbatten, Admiral Lord 180
Moyne, Walter (Lord Guinness) 219
Mr Cat (Tango) 82
Muggeridge, Malcolm 145–6
Munnings, Alfred 131, 185
music halls 3, 75
Mussolini, Benito 7, 10, 85, 88, 99, 103, 116, 120, 214
My Early Life (Churchill, 1930) 228–30

Nash's Magazine 40
National Art Collection Fund 76
National Liberal Club 27–8, 30, 32, 33
National Portrait Gallery 6, 76, 172, 179, **182**, **201**
Nelson (cat) 232
Nemon, Oscar 136–8, **138**, 139–43, **144**, 147–52, **148**, **150**, 166, 175, 177, 183, 205–8, **207**, 210, 211, 217–20, **219**
New Bond Street 221–2
New Orleans 215–16
New Statesman 70
Nicholson, William 36, 81–2, 83–4, **84**
Nobel Prize for Literature 231
Norman, Montagu 65
Northcliffe, Lord 7
nuclear arms race 133, 143, 146, 153, 180

Oldham, Conservative MP for 13–14, 27
Omdurman, Battle of 14, 228–30
Operation Dynamo 101
Operation Shingle 124
orator, Churchill as 16, 23, 96–8, 101
Orpen, William 6, 36, 40, **41**, 42–4, 169, 174, 242 n.22
Other Club 246 n.13, 251 n.13
Ottawa 106
Our Heritage: Winston Churchill (Sargent Austin, 1943) 120–2

painting, Churchill's own 1, 2, 36, 40, 42, 43, 50–2, 73, 130, 156
'Painting as a Pastime' (Churchill, 1921) 36, 43
Pangolin King's Place 228
Pannett, Juliet 200, **201**
Paris Peace Conference 7
Parliament Square 210, 214, 222, 225–6, **226**
parliamentary skills 19–20
Partridge, Bernard **19**
Peace Conference 57, 58
peace sign 217
Philip, Terence 274 n.67
photographs
 Beaton's **96**, 98

Churchill as Minister of Munitions **45**
Churchill sending out signed photographs 103
Hymen's 11, **12**
Karsh's 106, **107**
Major Winston Churchill wearing a Casque Adrian helmet (1915) **39**
most-photographed statues 222
Mr Churchill Speaking at Walthamstow Stadium (1945) **183**
in Ottawa 43
portraits from 73, 121–2, 165
in siren suit **110**
Stoneman's 103–6, **104**
in uniform **39**, 234
Winston Churchill at his Desk as Home Secretary (Bassano, 1911) **20**
Picasso, Pablo 131
pictorial realism 36
Piper, David 179
pistols 11–13
'Plugstreet' (Churchill, 1924) 40
pneumonia 222
pocket watch 196 *see also* watch chain
Poland 60, 62–3, 103
portraits *see also* sculptures
 Ardizzone 173–5, **174**
 Bateman 131–2, **132**
 Birley 127, 172
 Cooper 110, **113**
 Guthrie 56–7, **56**, 172
 Hailstone 179–81, **181**, **182**
 Lavery 29–30, 34–8, **34**
 McEvoy 6, 50, 53, 55–6
 Menpes 16
 Nicholson 81–2, **84**
 Orpen 6, 40, **41**, 42–4, 169, 174, 242 n.22
 Pannett 200, **201**
 Salisbury 107, **108**
 Sargent 64–7, **66**, **68**
 Scarfe 200, **202**
 Sickert 6, 73–6
 Spear 181–5

Sutherland 6, 152–73, **158**, **159**, **160**, **161**, **162**, **163**, **164**, 179, 180
Townsend 27–33
Ward 13, **14**
posters 120–2
Potsdam Conference 134–5
Prague 222–3, 225
President of Board of Trade 21
Press Gallery, House of Commons 200
Prime Minister (1940–1945) 33, 43, **96**, **104**, **107**, 107, 195
Prime Minister (1951–1955) 139, 175
prison reform 20
prisoner-of-war, Churchill as 14
Private Eye 200, 203
profile portraits 110, 112
Punch **18**, **19**, **22**, **87**, 146
Punk Churchill (Harvey, 2008) 228–31, **229**

Rakovski, Christian 119
Ravenhill, L. **22**
Read, Herbert 186
Reed, Edward Tennyson **18**
Reform Club 29
Reginald, Lord Esher 43
Reid Dick, William 109–10, **111**, 112, 114, 119, 197
religion 141–2, 199–200
Reves, Emery 187
Reves, Wendy 187, 189
Reynolds Illustrated News 77
Rhineland 57
Richardson, Albert 194
River War, The (Churchill, 1899) 14–15
Roberts, Andrew 250 n.95
Roberts-Jones, Ivor 21, 211–17, **212**, **218**, 222–3, **223**, 225
Robinson, Geoffrey 42
rock, Churchill as 9, 156, 159, 169, 170
Rocquebrune Head 187, **188**, 189, 196
Rodgers, John 210
Rodin 211
Romeo y Julieta cigars 22

Roosevelt, F.D. 131, 216, **221**
Rothenstein, John 43, 131, 173, 175, 179, 181–2, 190, 206
Rothermere, Lord 5, 6, 7, 42, 112
Rowlandson, Thomas 184
Royal Academy 30, 43, 112, 114, 115, 119, 140–1, 181–2, 184–5, 190
Royal Fine Art Commission 210, 213, 214
Royal Oak, sinking 93
Royal Society of British Sculptors 210
Rutter, Frank 75

Salisbury, Frank Owen 107, **108**
Salway Hill statue **192**, 195–6
Sandys, Duncan 205, 213
Sargent, John Singer 64–7, **66**, 73
Sassoon, Philip 30, 42, 43, 66–7, 82
Scarfe, Gerald 200, **202**, 203
screen prints 233–4
sculpting, Churchill's own 52, 141
sculptures (of Churchill) *see also* statues
 Belsky's 208
 in cartoons **79**
 'Chartwell Bust' (McFall, 1958) 190–2, **191**
 Epstein 128–9, **129**
 Kennington 85, **86**, 88
 marble bust commissioned by Elizabeth II 139, 143, **144**
 McFall 185–99, **191**
 miniature figures 88
 Nemon 136–7, 139–43, **144**, 147–52, **148**, **150**, 175, 177
 Reid Dick 109–10, **111**, 114
 Roberts-Jones 21, **212**, **223**
 Sheridan 10, 50–4, **51**, 112–20, **118**
Seated Sir Winston Churchill (Nemon, 1954–1959) 147–52, **148**, **150**
Secretary of State for War 32, 47, 49, 53, 57, 63, 134
sense of humour 10, 20, 140, 206
Sermons by Artists (1934) 85, 88
Shepherd, Ernest 30

Sheridan, Clare (née Frewen) 7, 10, 44, 49–55, **51**, 62, 112–20, **118**, 127, 231
Sheridan, Oswald 53
Sheridan, Wilfrid 49
Shinwell, Emanuel 3, 176–7, 207, 208, 250 n.2
Sickert, Walter 6, 73–6, 84, 122, 181
Sidney Street Siege 21
silver wedding anniversary 82
Simplicissimus **94**, 95
Simpson, Wallis 89
Sinclair, Archibald 33
Singer Sargent, John 64–7, **66**, 73
Sinn Fein 58
siren suit 4, 76, 82–3, 107–9, **108**, **110**, 120, 125, 167
Sketch, The 197
Smith, F.E. 50, 52–3, 73, 75
Soames, Mary (daughter of Churchill)
 on Robert-Jones's memorial statues 217
 on siren suits 109
 on sitting for Birley 128
 and the Sutherland portrait 154, 168
 on William Nicholson 81–2, 83–4
 writing about father 1
Socialism 63, 85, 129
Society of Portrait Sculptors 191, 223
soldier, Churchill as 11–13, 38–42, 146, 157, 169, 211, 227, 228–30
Some Statesmen of the First World War (Guthrie, 1924–1930) 58, **59**
South Africa 14
Soviet Russia 45, 47–9, 53–5, 57, 58, 60–3, 103–4, 129, 133, 143, 180, 195
Spanish Civil War 83
spats 76, 83
Spear, Ruskin 181–5
'special relationship' 208
Spectator 172
speech defect/lisp 13, 16
'Spi' 76–7, **77**
Spiers, Edward Louis 38
Spirit of London (P&O Ferry) 271 n.13

St George's Westminster 63
Stalin, Josef 103, **105**, 109, 133–5, 143
Stanley, Louis 197
Star, The **60, 62**, 63, **64, 65, 233**
statues
 Allies (Holofcener, 1995) 221–2, **221**
 anti-Capitalist demonstrations 225–6
 Belsky 208, **209**
 Married Love (Nemon, 1977–1990) 217–20
 McFall 185–99, **192**
 Nemon 147–52, **148, 150**, 205–8, **207**, 217–20
 Punk Churchill (Harvey, 2008) 228, **229**
 Roberts-Jones 211–17, **212, 218**, 222–3, 225, **226**
 Woodford Green 192–5, **192**
Steadman, Ralph 231–2, **232**, 235
Stoneman, Walter 103–4, **104, 105**
Story of the Malakand Field Force, The (Churchill, 1898) 13–14
Strand Magazine 4
strikes 21, 24, 44, 70, 73
strokes 143, 145, 156, 187, 190, 200
Strube, Sidney George Conrad 24, **25**, 47, **48**, 49, 59–60, **61**, 79–80, **79**, 101, **102**, 133, **145**, 225, 231
Study for Breakfast at Chartwell II (Nicholson, 1934–1935) **84**
Sudan Campaign 11, 14
Suez crisis 184–5
Supreme Allied War Council 58
Sutherland, Graham 6, 76, 152–73, **158, 159, 160, 161, 163**, 179, 180
Sutherland, Kathleen 165, 166, 171
Swat Valley campaign 14

Tango (cat) 82, 115
Taro, Gerda 83
Tate Gallery 43, 186
Teheran Conference 234
Thatcher, Margaret 223
Third Home Rule Bill 24
Thornycroft, Hamo 211

Thoughts and Adventures (Churchill, 1932) 80–1
Tilden, Philip 66
Tilney, John 205, 210, 214, 215
Times, The 42, 185, 210, 214
Toby jug 89, **90**
Tonypandy strikes 21, 24
Toronto 208
Townsend, Ernest 27, 30–1
Trade Unions 16, 20–1, 63, 70, 77–8
Trinity House 254 n.20
Trotsky, Leon 54
Truman, Harry 195, 222
Turf War (Banksy, 2003) 227–8
'Two-Gun Winston' (Illingworth, 1940) **97**
typhoid 93

Ulster Unionists 24
Under-Secretary of State for the Colonies 19
uniform, pictures in 12, 30–1, 38, **39**, 234
united Europe 128
United States 106, 133, 136, 143, 180, 208

'V for Victory' sign 4, 131, **132**, 216, 217
vandalism 225–6
Vanity Fair **15**
VE Day 217, 222
Vicky 199
vigil 141
'Voice of Britain' 105
von Hindenburg, Field Marshal Paul 7, 8–10, 101

Wales 21
Wallis, Neville 185, 193
Wanstead and Woodford 105, 185, 192–3, 197, 200
War Artists Committee 89, 180, 184
war artists, official 88
war correspondent, Churchill as 14–16
War Impressions **17**
War Secretary 32, 47, 49, 53, 57, 63, 134
Ward, Edwin Arthur 13, **14**

Ward, Leslie Matthew 13, **15**
Ward, Simon 228
Warden of the Cinque Ports 179
Warhol, Andy 227
Warrender, Victor (Lord Bruntisfield) 119
watch chain 56–7, 106
Waugh, Evelyn 5, 6
'We shall fight on the beaches' speech 101, 121, 198–9
weapons (in pictures) 11–13, 31, 33, **97**
weight 56
Weisz, Victor 95, **96**
Wells, H.G. 251 n.13
Westerham Borough Council 208, 220
'Westfront Hurricane' (Illingworth, 1940) 99, **100**
Westminster College, Missouri 208, **209**
Wheeler, Charles 185, 190, 197, 215
Wilde, Oscar 168
Williamson, George C. 82
Wilson, Harold 210
Wilson, Henry 63
Windsor Castle 140, 143, 147
Winston Churchill Statue Committee 210–11, 213, 214
Winstonocerous (Low, 1922) **64**
Winstonsky (Low, 1920) **62**
Winterton, Earl 16, 19
women's suffrage 20
Wood, John Musgrave ('Emmwood') **198**
Woodford 192–3
World Crisis – The Aftermath, The (Churchill, 1928) 76
writer, Churchill as 4, 7, 8, 13–16, 23–4, 36, 40, 76, 80–1, 228–30

Yalta Conference 222, 234
Young Winston (film, Attenborough, 1972) 228

Zaharoff, Basil 67
Zec, Philip 96

www.ingramcontent.com/pod-product-compliance
Lightning Source LLC
Chambersburg PA
CBHW060823170526
45158CB00001B/65